ALFRED GILBERT

Sculptor and Goldsmith

Sponsored by

 British Alcan Aluminium

and the

with support from the
Friends of the Royal Academy

The Royal Academy is also grateful to
Her Majesty's Government for its help
in agreeing to indemnify this exhibition
under the National Heritage Act 1980.

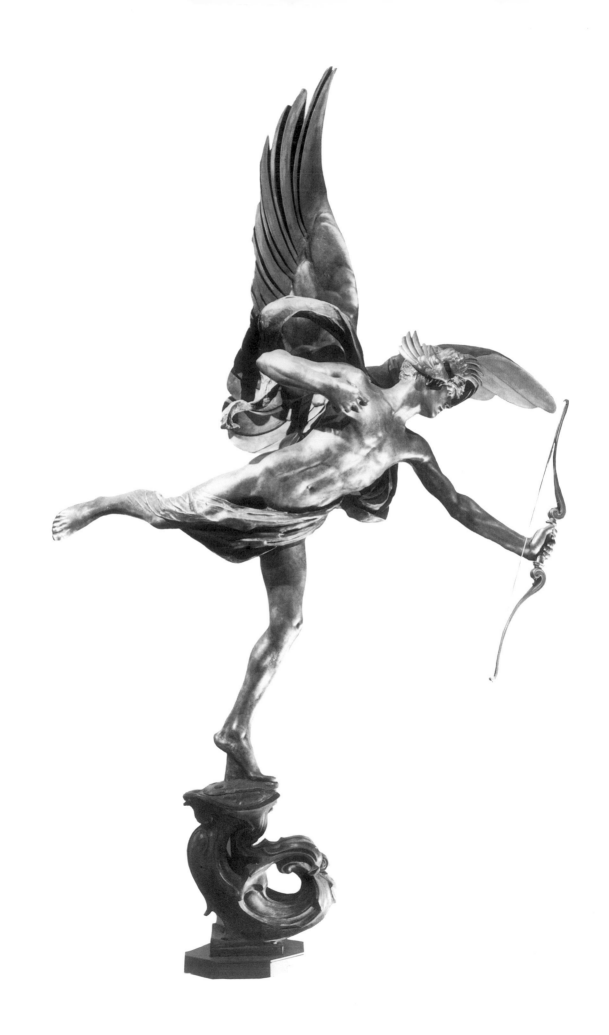

ALFRED GILBERT

Sculptor and Goldsmith

RICHARD DORMENT

WITH CONTRIBUTIONS BY
TIMOTHY BIDWELL, CHARLOTTE GERE,
MARK GIROUARD AND DUNCAN JAMES

Royal Academy of Arts, London, 1986
Catalogue published in association with
Weidenfeld and Nicolson, London

DATES OF EXHIBITION

The Royal Academy of Arts
21 March–29 June 1986

COVER ILLUSTRATIONS
Front *St George*, 1899 (Cat. 71)
Back *The Virgin*, 1899 (Cat. 75)

House editor Johanna Awdry
Designed by Harry Green for
George Weidenfeld and Nicolson Limited
91 Clapham High Street, London sw4 7ta

isbn 0 297 78875 2 (casebound)
0 297 78876 0 (paperback)

Filmset and Printed by BAS Printers Limited, Over Wallop, Hampshire
Colour separations by Newsele Litho Limited, Italy
Colour printed in Italy by Printers Srl, Trento, Italy

CONTENTS

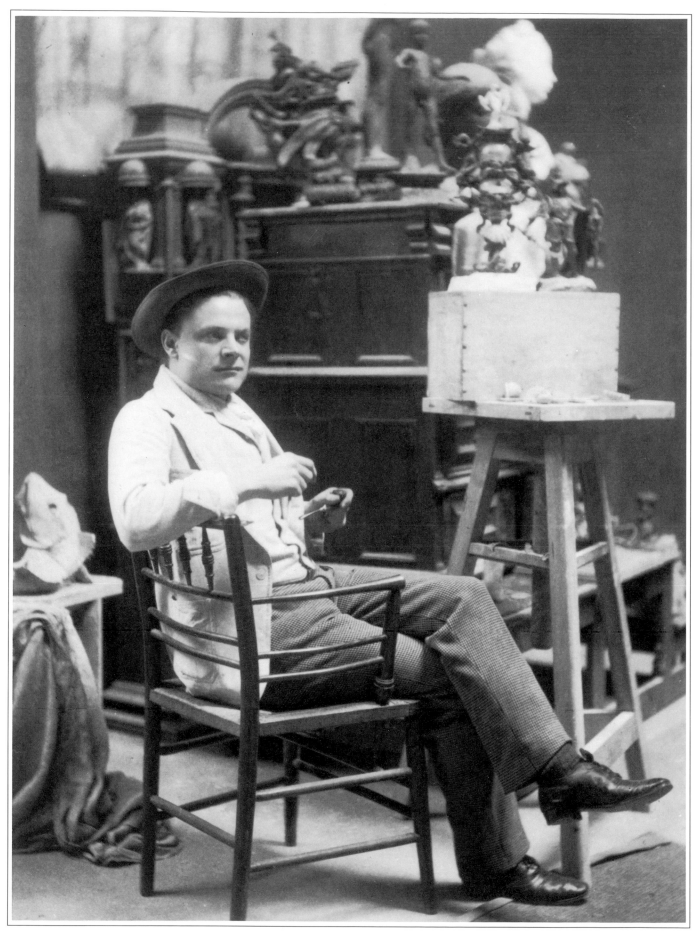

Frontispiece Alfred Gilbert in his studio, The Avenue, Fulham Road, 1891

FOREWORD

HE unveiling of the Shaftesbury Memorial on 29 June 1893 brought the name of its sculptor, Alfred Gilbert, to the attention of a wide, if not wholly appreciative, audience. For some, the winged figure of *Eros* caught in mid-flight, bow and arrow in hand, set atop an elaborate three-tiered bronze plinth of putti, fishes and waves seemed an inappropriate celebration of the life and work of the philanthropist Lord Shaftesbury. For others, the water jetting forth from fish and dish caused continual irritation and the threat of a soaking. Yet, despite public abuse and the sculptor's own disavowal of the monument as 'the utter failure of my intention and design', *Eros* established Gilbert as the most innovative and imaginative sculptor—in terms of the handling of the language of sculpture, the exploration of variety of scale and the manipulation of materials—that Britain had seen since Flaxman.

With the restoration of *Eros* now well advanced and promising to permit the return of the sculpture to its original glory, it seemed appropriate for the Royal Academy to celebrate the work of its creator. A member of the Royal Academy—albeit forced to resign, for professional misconduct which was subsequently pardoned, and reinstated only twenty-four years later—Gilbert was an intense, stormy genius whose singleminded commitment to his art encouraged continuous experimentation and created mounting difficulties, bankruptcy, years of exile from England and strong royal disapproval. His works ranged in scale from the monumental to the minute, from marble and bronze to fine filigree gilt and precious metals, from sculpture to jewellery and goldsmith's work. It is this extraordinary range which is enshrined in the central piece in Gilbert's output, the Tomb of the Duke of Clarence at Windsor, a project which stretched over some thirty-four years of his life.

Our deepest thanks go to Her Majesty The Queen, who has graciously agreed to lend major works to the exhibition and to undertake the restoration of the remarkable plaster model of the Tomb of the Duke of Clarence to permit its inclusion in the show. In this latter endeavour, our thanks must also go to Geoffrey de Bellaigue, to his assistant, Julia Harland, and to John Larson. We are also indebted to all the lenders, both public and private, whose enthusiasm for the exhibition was expressed in their generous responses to our requests for loans.

The Royal Academy is beholden to Richard Dorment, the biographer of Alfred Gilbert, for initiating the idea of the exhibition, selecting the works and writing the major part of the catalogue. The Academy also wishes to thank Charlotte Gere for her contributions on Gilbert's work as a jeweller and goldsmith, and Duncan James, Mark Girouard and Timothy Bidwell for their important essays in the catalogue. Our gratitude also to British Alcan Aluminium Limited, to the Greater London Council, to Mr and Mrs J. H. J. Lewis, to Mr Frederick R. Koch, and to those private sponsors who wish to remain anonymous. Without their faith in this exhibition expressed in terms of financial support this enterprise could never have been realised.

ROGER DE GREY
President of the Royal Academy

LIST OF LENDERS

H.M. The Queen, Cat. 53, 56, 67, 69

Barclay, David, Cat. 52

Bedford, Trustees of the Cecil Higgins Art Gallery, Cat. 71

Birmingham Museum and Art Gallery, Cat. 20, 32, 88

Blackpool, Grundy Art Gallery, Cat. 104

Burnley, Towneley Hall Art Gallery, Cat. 109, 110

Jean van Caloen Foundation, Cat. 43, 48, 50, 66i–iv, 122, 117i–xxiii

Cambridge, The Syndics of the Fitzwilliam Museum, Cat. 11, 57

Cardiff, National Museum of Wales, Cat. 12, 15, 121

Coleridge, A. D., Cat. 115

Cooper, Jeremy, Cat. 27

Duckworth, Sir Richard, Cat. 28

Edinburgh, National Gallery of Scotland, Cat. 22

The Faringdon Collection Trust, Cat. 58i–iv

Hampshire County Council, Cat. 33, 36

Irvine, Alan, Cat. 60

London, Army and Navy Club, Cat. 26

London, British Architectural Library, Cat. 9i–ii, 121i–iii

London, The British and Foreign Bible Society, Cat. 51

London, The Trustees of the British Museum, Cat. 39, 116

London, Fine Art Society, Cat. 7, 13, 17

London, Greater London Record Office, Cat. 44

London, The Worshipful Company of Goldsmiths, Cat. 62, 64

London, Museum of London, Cat. 112

London, Public Record Office, Cat. 45

London, Royal Academy of Arts, Cat. 46, 77, 78, 79, 80, 81, 111

London, Royal College of Music, Cat. 83

London, The Royal Institute of Painters in Watercolour, Cat. 54

London, Royal Society of Arts, Cat. 29

London, The Royal Hospital of St Bartholomew, Cat. 41

London, St George's Hospital Medical School, Cat. 82

London, Spink & Son Ltd, Cat. 40

London, The Trustees of the Tate Gallery, Cat. 2, 3, 8, 16, 24, 25, 30, 99, 103

London, The Trustees of the Victoria and Albert Museum, Cat. 63i–v, 65, 89, 90, 118

Maidstone Museum and Art Gallery, Cat. 5

Manchester City Art Galleries, Cat. 19

Melbourne, National Gallery of Victoria, Cat. 14, 61

Meynell, Mrs S., Cat. 85

Minneapolis Institute of Arts, Cat. 6

Morley, Sir Godfrey, Cat. 28

Nottingham, Castle Museum, Cat. 70

Oxford, The Visitors of the Ashmolean Museum, Cat. 34, 35, 91, 92, 93

Paris, Musée d'Orsay, Cat. 38

Perth, Museum and Art Gallery, Cat. 47, 94

Prinsep, Mr V., Cat. 85

Reed, Mrs Samuel, Cat. 97

Strachey, Barbara, Cat. 42

de Vesci, The Viscount, Cat. 37

Washington, National Gallery of Art, Cat. 23

Whippingham, Rector of, Cat. 96

Also many owners who prefer to remain anonymous

ACKNOWLEDGEMENTS

The Royal Academy's intention has been to mount an exhibition which would demonstrate the achievement of one of the most remarkable of all English sculptors. Where it has been possible to exhibit the first bronze cast of a statue, this has been done; in other cases casts have been selected which were felt to be of superior quality or which, for aesthetic or historical reasons, seemed to add to our knowledge of Alfred Gilbert's range and skill. At least one reduction of all the great bronzes is included, in the belief that these constitute an entirely different visual experience from the full-sized casts. In several cases a later casting of an early bronze demonstrates the importance of the casting method and founder.

The extent of Alfred Gilbert's work as a goldsmith has never been seen before; nor have his exquisite drawings. In any exhibition of the work of a sculptor it is frustrating to know that the most powerful works remain still in churches and squares. This is of course true for Gilbert. But we have been particularly fortunate in the loan from Her Majesty The Queen of the sketch-model of the most spectacular of all Gilbert's works, the Tomb of the Duke of Clarence. Our thanks therefore are to Her Majesty The Queen for this and other loans, as well as for granting permission to make use of material in the Royal Archives at Windsor Castle. The Royal Acedemy would also like to thank:

Gordon Balderston
Geoffrey de Bellaigue
R. D. Cook
Jeremy Cooper
John Culme
Richard Edgecumbe
Daniel Fearon
Simonetta Fraquelli
John Gere
Dorothy Girouard
Arthur Grimwade
Julia Harland
Henry Hawley
John Lambie
John Larson
Antoinette Le
 Normande-Romain
George Mancini
Fiona Pearson
Christopher Poke
Jane Preger
Anthony Radcliffe
Ben Read
Joseph Rishel
Peyton Skipwith
Mark Stocker
Keith Taylor
Andries Van den Abeele

PHOTOGRAPHIC ACKNOWLEDGEMENTS

The exhibition organisers would like to thank the following for making photographs available. All other photographs were provided by the owners of the works.

James Austin, Cambridge, figs 44, 45

A. C. Cooper, fig. 41

Documentation photographique de la Réunion des musées nationaux, Paris, fig. 43

Photos taken by Massimo Listri, by courtesy of *F.M.R.*, the magazine of Franco Maria-Ricci, Cat. 2, 3, 8, 10, 11, 16, 19, 20, 21, 24, 25, 26, 27, 28, 29, 30, 32, 33, 36, 39, 41, 42, 46, 51, 54, 55, 56, 57, 58i–iv, 62, 63, 65, 69, 71, 74, 75, 76, 77, 78, 79, 80, 81, 82, 83, 85, 87, 88, 89, 90, 99, 100, 104, 109, 110, 113, 114

National Monuments Record, figs 22, 23, 24, 25, 29, 48

National Portrait Gallery, fig. 60

Pieterse Davison Internal Ltd., Dublin, Cat. 37

Prudence Cuming Associates Ltd., Cat. 4, 12, 15, 50, 59, 66i–v, 72, 73, 86, 102, 121, 122

West Park Studios, Leeds, fig. 10

EDITORIAL NOTE

Works in the Catalogue have normally been grouped by subject, e.g. the Shaftesbury Memorial, Early Portraiture. Within each section, works have normally been arranged chronologically. When a section includes works by artists other than Gilbert, these are normally placed at the end of the section.

When a work was exhibited during Gilbert's lifetime, the title is normally that which was given when it was first exhibited. Those works which were not exhibited during Gilbert's lifetime follow the titles adopted by Richard Dorment in *Alfred Gilbert*, London and New Haven 1984.

A single date after a title indicates that the work was, in the case of terracotta, plaster and marble works and works on paper and board, executed or completed in that year; in the case of cast statues, it indicates the year in which the wax or plaster model was completed thereafter, differentiating whenever possible between the date of the first casting and the date of the casting of the example on exhibition. Thus the head of *Hon. John Neville Manners* (Cat. 86) was modelled in wax in 1903–4, but not cast in bronze until 1922. Two dates separated by a hyphen indicate that the work was definitely executed or cast between the two years, thus 1890–2. A date preceded by '*c.*' indicates that the work was executed or cast at around this date, thus *c.* 1892. A date followed by a question mark in parentheses indicates that, from external evidence, the work was probably executed or cast in that year, thus 1892(?).

The medium and support of each work, where applicable, are given. All dimensions are given in centimetres and inches, height preceding width. Given the difficulties in determining the exact overall dimensions of works of sculpture, the dimensions of sculptures are given in height alone in order to establish scale; where further information is deemed essential, height precedes width and depth. The following abbreviations for dimensions are used: ht (height); diam. (diameter); l. (length); w. (width); d. (depth).

All entries in the catalogue are by Richard Dorment unless initialled as follows: C.G. (Charlotte Gere), D.J. (Duncan James).

In cases of official or royal objects, where the commissioning history is stated in the title or catalogue entry, no provenance is given.

Abbreviations of published sources referred to throughout the catalogue are given in the Bibliography. Unpublished sources are referred to as MS.

Technical terms employed to describe processes in modelling and casting sculptural works are given as follows:

Lost wax/cire perdue The casting process in which the sculpture is formed in wax and cloaked in a fireproof slurry which hardens to form a mould. The wax is melted and burnt out ('lost'), and the cavity so formed is filled with molten metal. The mould is broken away to reveal the casting.

Direct method of lost wax The method whereby the sculpture is modelled in wax which is then cast directly by the lost wax process as described above. The sculptor risks the total loss of his work in the event of a casting failure.

Indirect method of lost wax The method whereby the original sculpture is made in clay, plaster or wax from which a mould is made to reproduce a copy or copies in wax. These copies are then cast in bronze by the lost wax process as described above. By this means a number of casts may be made, and the original is not destroyed in the casting process.

Investment The moulding material applied to the wax as a liquid slurry which hardens to form a rigid, fireproof mould. It usually consists of a mixture of plaster and grog (ground-up fired clay).

Waste mould The plaster mould used to cast a replica, in plaster, of the sculptor's clay model. In the process the mould is destroyed (i.e. 'wasted') when it is chipped away to reveal the plaster casting.

Piece mould A mould, usually made of plaster, constructed in small sections so arranged that they can be removed from a complex, undercut surface.

Reduction The process by which a small replica of a larger work is modelled by the sculptor and then cast in bronze or ceramic. A reduction produced in this way may vary from the original larger work (see Cat. 15–16).

Mechanical reduction An exact small-scale copy of a sculpture produced by means of a pantograph device working in three dimensions. The pattern is then used to cast a series of replicas in bronze.

Surmoulage Replica casting (see Cat. 39) made by moulding from a bronze cast.

Pointer A skilled assistant to a sculptor who transfers the measurements of his master's clay or plaster model into stone by means of an apparatus for drilling holes to the correct depth.

Patina A chemically induced colour on the surface of a bronze casting. A bright bronze surface will in time develop a natural patina, but it may take many years.

Pattern Models in metal from which moulds are made. In the case of complicated cast sculptures, a single piece would be subdivided into several small parts in order to simplify the mould-making (see Cat. 68).

THE SECRETARY OF
THE ROYAL ACADEMY
Piers Rodgers

EXHIBITIONS SECRETARY
Norman Rosenthal

EXHIBITION ORGANISER
AND EDITOR
MaryAnne Stevens

DEPUTY EXHIBITIONS SECRETARY
Annette Bradshaw

EXHIBITION ASSISTANT
Elisabeth McCrae

EXHIBITION DESIGNER
Piers Gough of Campbell,
Zogolovitch, Wilkinson & Gough

ASSISTANT EXHIBITION
DESIGNERS
Meredith Bowles
John Kember

GRAPHIC DESIGNER
Ashted Dastor

SIR ALFRED GILBERT 1854–1934

Richard Dorment

LFRED Gilbert (fig. 1) was born in London on 12 August 1854, the eldest son of hard-working professional musicians. He was educated at Aldenham, a minor public school in Hertfordshire unusual for its time in offering its boys scope to develop musical and artistic proclivities.

Later formal training (1872–3) at Hetherley's, a London art school relatively free from the conventions of academic art teaching and from personal restrictions on its students, and at the Royal Academy (1873–5) had less effect upon Gilbert than practical experience. A boy of immense ambition and energy, he attached himself to the fashionable sculptors Matthew Noble (1818–76) and William Gibbs Rogers (1792–1875), not staying long in each atelier, but learning his future profession in the same way as a stage-struck prop boy absorbs the spirit of the theatre. By the time he met and apprenticed himself to the Hungarian-born sculptor Joseph Edgar Boehm (1834–90) in 1872, he was competent enough to be of real use in the busy atelier in the Fulham Road. For his part, Boehm was remarkable in recognising and encouraging the birth of an independent talent, the successor to Alfred Stevens (1818–75) as the most original and ambitious sculptor of the Victorian era.

Gilbert's first surviving work in bronze appears on the baton in the hand of Boehm's statue of Sir John Fox Burgoyne (1877) in Waterloo Place: a small upside-down St George and the Dragon. As an apprentice in Boehm's studio between the years 1872 and 1875 he saw bronze cast and chased, marble pointed and carved, and worked on full-length statues (in period and contemporary costume), equestrian monuments, and portrait busts. Such was his precosity that by 1875 Boehm had no more to teach him. On his advice, Gilbert went to Paris to study at the Ecole des Beaux-Arts and thus became one of the first English sculptors to benefit from a rigorous Beaux-Arts training. He studied under Pierre-Jules Cavelier (1814–94) and Emmanuel Frémiet (1824–1910) and moved in a world where sculpture was taken far more seriously as a medium of expression than in England. At this moment French sculptors were at work on dozens of monuments commemorating the battles of the Franco-Prussian War—memorials to the French dead in the heroic, rhetorical, Beaux-Arts style. Whereas Boehm sought to distinguish in marble the texture of flesh, hair, pearls or fabric, at the Ecole des Beaux-Arts the primary subject of study was the idealised nude; in Paris Gilbert discovered gesture, pose, a striving after nobility and grandeur.

For Cavelier, Gilbert produced a sketch for the work that was to become *The Kiss of Victory* (Cat. 6), a straightforward exercise in the fashionable, heroic mode, reminiscent of works by Gustave Doré (1833–83) and Marius-Jean-Antonin Mercié (1845–1916). Gilbert conceived of his statue in marble, and much of its sensual effect depends on

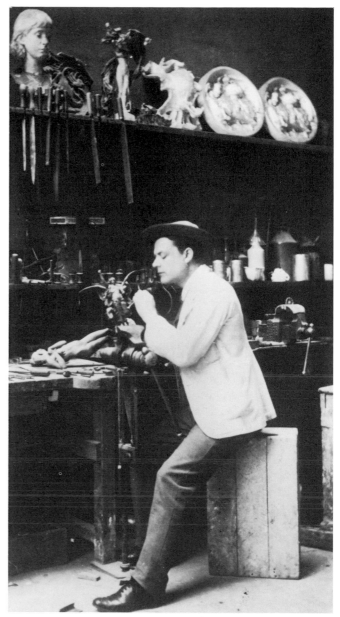

Fig. 1 Alfred Gilbert in his studio, The Avenue, Fulham Road, *c.* 1887–90

white marble creating the illusion of flesh barely touching flesh, arms drooping, limbs languishing. *The Kiss of Victory* is best compared with the work of Canova at his most intimate and tactile, as in *Cupid and Psyche* (1783–93; Louvre; see fig. 43) rather than with any contemporary work.

The Kiss of Victory was carved in Rome, not Paris. Alfred Gilbert travelled there with his young family in the autumn of 1878 and remained in Italy for six years. Rome at first impressed the sculptor for what he did *not* see there. In his first letter home he made it clear that his interest had already

shifted from marble towards bronze; he longed to see the works of Cellini and Donatello which, in his naïveté, he had imagined were to be found in Rome. Only in 1880 did he travel to Florence and even there was disappointed by Cellini's *Perseus and Medusa* (1545–54; Loggia dei Lanzi). To him it seemed 'cold', for he already possessed a sensibility for fastidious refinement, and in his first work in bronze he would set about the impertinent feat of demonstrating how Cellini should have treated his subject.

Although he failed to appreciate fully the great central figure of Perseus, he never forgot the small bronze niche statuettes at its base, and would return to them for the rest of his life; nor did he overlook the lesson that a base is potentially as fascinating as the statue surmounting it. But that lesson he could also have taken from Donatello's *David* (1428–30; Florence, Bargello), the statue that inspired him to travel, as soon as he could afford to, to Venice and Padua. In Padua he saw and learned from Donatello's *Gattamelata* (1445–50), but spent time too in the church of S. Antonio where the bronze figures of the saints by Donatello on the high altar (1446–50) determined the future course of his work.

Fired with enthusiasm for the newly-discovered medium of bronze, Gilbert was eager to explore the expressive possibilities of modelling and casting. *Perseus Arming* (Cat. 10) is an early essay in the Donatello-sized statuette; his pose is a variation of the dying soldier in Gilbert's own *Kiss of Victory*, but *Perseus* is no longer a Beaux-Arts figure. Of this moment in his life Gilbert was later to say that he was 'tired of the French influence', and, indeed, when *Perseus Arming* won honourable mention at the Paris Salon of 1883 it would have been seen as something quite original, a superb example of the neo-Florentine movement in sculpture. *Perseus Arming* had been commissioned by the potter Sir Henry Doulton (1820–97). Doulton left Rome after ordering a large marble group, *Mother Teaching Child* (Cat. 8), a conservative genre piece in the high French academic style. In comparison with *Perseus Arming*, Gilbert's boredom with the marble is perhaps just discernible, while his excitement with bronze is positively tangible.

The first statue by Gilbert fully to absorb the lessons of Donatello's *David* is *Icarus* (Cat. 15). Modelled for Frederic Leighton (1830–96) and cast in Naples by the *cire perdue* process, *Icarus* represented the great leap forward in Gilbert's career. In it he mastered the problems unresolved in *Perseus Arming*: how to achieve monumentality without sacrificing intimacy; how pose, expression, symbolism and medium could each contribute to the statue's perfection. Gilbert was an artist capable of exploring, mastering, and then dropping a style when he could no longer better his own achievement. *Icarus* exists because *Perseus Arming* was not a fully mature work. *Icarus* itself could not be bettered, but almost ten years

later Gilbert returned to the theme of the male nude to set it spinning in *Comedy and Tragedy* (Cat. 22). This last essay in the nude developed out of his earlier work as naturally as Giambologna followed Cellini.

Icarus created a sensation at the Royal Academy in 1884. On Gilbert's return to England later that year he did not at once try to repeat its success. His obsession was to introduce into his own country the process of *cire perdue* which had fallen into disuse. No statue by him appeared at the Royal Academy in 1885, and in 1886 he sent a plaster designed as a contrast and foil to his earlier works, *The Enchanted Chair* (fig. 38). A mixture of erotic realism and dark imagination, it shows a sleeping nude woman slumped on a throne composed of doves and the heads of cherubim. Behind her a lifelike vulture has perched on the back of the throne to serve as a symbol of the woman's subconscious fears, for the bird is a nightmare creature, her dream made visible.

It is no surprise to find that in Gilbert's first important public commissions in England he struck out in wildly different directions. The Fawcett Memorial of 1885–7 (p. 124) took London's breath away, so original did critics find this tribute to Cellini's *Perseus* base or (as Edmund Gosse noted) Peter Visscher the Elder's Tomb of St Sebald in Nuremburg. Seven symbolic virtues line up for our inspection beneath the portrait head of Fawcett—disarming nursery figures all intricately detailed and highly coloured, indeed painted, and (at one time) bejewelled—to give the richest possible effect in Westminster Abbey. Had the sculptor of naïve reliefs in terracotta, George Tinworth (1843–1913), worked with the most intense of the Gothic revival architects, William Burges (1827–81), this might have been the result. The monument changed the course of English sculpture.

So, too, did Gilbert's other commission, the Winchester Jubilee Memorial to Queen Victoria of 1887 (Cat. 32–6), an invocation to Bernini's Tomb of Urban VIII in St Peter's in Rome, but much more dramatic. Befitting Queen Victoria's dignity and importance, Gilbert clothed her in rivers of cascading bronze drapery, quite unheard of in English sculpture where drapery, if introduced at all, tactfully hung limp over the shoulder or fell in syrupy folds around the sitter's feet. Gilbert's Queen knows how to wear a cloak to effect, just as her own immense presence puts in its place as a mere brooch the Koh-i-Noor diamond. Gilbert may be said with justice to have gone over the top; one crown was simply not sufficient for a person whom he was here nearly deifying as Queen-Empress, so he gave her two: a 'real' one on her head, and a symbolic confection of tendrils and lilies suspended over her throne.

To have conceived of such an object took imagination; making it required of the artist the skill of the goldsmith,

which at that time Gilbert did not possess. He therefore trained himself as a goldsmith as well as a sculptor. The crown we see today is a highly-wrought affair in beaten metal, recreated from photographs after the loss of the first crown (Cat. 36). This earlier object may have been quite crude, a theatrical prop improvised towards the end of Gilbert's work on the statue to provide even more drama, as well as a sense of lightness and colour to the mass of bronze below.

Behind and above the throne he introduced small allegorical figures of different sizes and scales, so that the whole piece combined monumentality with intimacy as though Gilbert restlessly needed to demonstrate his astounding virtuosity within a single work. Susan Beattie has stressed the importance of the Winchester Queen Victoria to the generation of artists who would learn from it in the coming decades and whose work would be called 'The New Sculpture'.[1]

The Winchester Crown was followed by commissions for the Preston Mayoral Chain (colour pl. p. 71) and the Epergne for Queen Victoria (Cat. 53), pieces which took years to finish and into which Gilbert introduced new materials and techniques. By the early 1890s he was at work on spoons, keys, seals, and sword hilts; his materials now included ivory, seashells, and crystal, and he learned to use enamel and ormolu as well as the art of damascening.

Given that Gilbert was so used to dealing with bold metals, it was natural for him to experiment with new techniques of bronze polychromy. Silver or gold, substituted for zinc or tin in the alloy, created bronzes which, when treated with the correct pickle, resulted in silvery or purplish patinations. In this connection one cannot underestimate the influence of Sir William Chandler Roberts-Austen (1843–1902), Professor of Metallurgy at the Royal College of Mines. Roberts-Austen shared the results of his experiments with Gilbert and introduced him to the artists, scientists, and scholars who were lecturing and writing about these subjects at the Society of Arts in the late 1880s and early 1890s.

In the Fawcett Memorial Gilbert applied colour externally. In certain later casts (Cat. 89, 90) polychromy is the result of experiments in mixing the alloy. A sculptor less used to working with gold and silver may have been less willing to undertake presumably costly experiments in cire perdue casting. Similarly, in the later 1880s when it became possible to cast aluminium cheaply,[2] Gilbert employed the new alloy to create the soaring figure of Eros. To his contemporaries part of the modernity of the Shaftesbury Memorial was its use of contrasting colours: the three elements of basin, pedestal and Eros each registered as a different colour—golden bronze, green and silver—an effect of polychromy which time and the elements have softened. Eros is symbolic of Christian Charity, but he also

serves to infuse a light, silvery buoyancy to the molten base below. In writing of the base, Roberts-Austen described Gilbert's attempt to 'enrich the composition by the sparing use of coloured patina among the marvellously beautiful details of the work.'[3]

In the years 1888–93 and later, Gilbert also worked as a stuccoist. At the house of Stewart Hodgson in South Audley Street (1888), at Daly's Theatre off Leicester Square (1891–3) and in the Gaiety Theatre (c. 1892), his designs were certainly carried out. Other projects, such as the panelling for the dining room at Lord Rothschild's Tring house (1890–1) were never completed. His use of stucco is possibly the source of the great boldness and freedom characteristic of his modelling in the early 1890s. (This was to change as he began to work on the intricate figures of the saints for the Tomb of the Duke of Clarence.) Then too, he picked up the Adam-revival repertoire of the stuccoist: he made fish, mermaids, masks, swirls and arabesques his signature in bronze. This quite limited vocabulary turns up again and again—on spoon handles (Cat. 58), on the Memorial to John Howard at Bedford (1890–4), and on the Shaftesbury Memorial (Cat. 43–51).

Gilbert's blithe disregard for the dignity of bronze is part of his charm. The writhing fish-tails and frolicking putti in the base of the Shaftesbury Memorial are responsible for the sense of exuberance that makes the fountain eccentrically 'right' in its placement in the heart of London's theatre district. For though it is symbolic of the good Earl of Shaftesbury's love for mankind, its imagery is entirely secular. It is hardly surprising that Eros has so often been mistaken for Cupid, when the pedestal over which he flies is composed of chubby amorini wrestling with flying fish.

In some ways the undulations of the Shaftesbury Memorial echo those of the Epergne, which is only natural since Gilbert worked on both at the same time. In 1892, when he began the Tomb of the Duke of Clarence (Cat. 66–81), Gilbert returned to the disparity of scale first attempted on the Winchester Queen Victoria. The stunning recumbent effigy of the Duke, a technicolour feast for the eyes made of marble, aluminium, bronze, and brass, is as awe-inspiring in its way as the enthroned figure of Queen Victoria. Here the Prince surrenders himself to death with an Elinor Glyn-like abandon while behind him, like the figure of Victory in The Kiss of Victory, an angel rewards him with the Crown of Eternal Life.

To surround the tomb Gilbert erected an elaborate bronze grille composed of eighteen uprights buttressed by twin figures of embracing angels. Above each pair of angels he intended to place a polychrome bronze figure of a saint (see Cat. 69, 75–81). These are the ultimate refinement of the small virtues first introduced on the Fawcett Memorial. Each is witty, precious, and unlike anything else in English

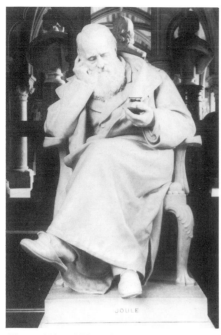

Fig. 2 Alfred Gilbert, *James Prescott Joule*, marble, 1890–4 (Town Hall, Manchester)

Fig. 3 Alfred Gilbert, Memorial to Randolph Caldecott, bronze and aluminium, painted, 1887, with additions 1900 (St Paul's Cathedral, London)

art. Just as *Icarus* summarised Gilbert's exploration of the nude, so these saints constitute his final statement on the small-scale bronze figure. Indeed, long before they were completed it seems Gilbert began to tire of the painstaking task: only seven of the twelve statues were in place at the time of his bankruptcy in 1901, and the missing five were not modelled and cast until 1927 (Cat. 77–81).

Gilbert's work for the Royal Family dragged on through the 1890s. They themselves delayed the completion of the Tomb of the Duke of Clarence by commissioning a memorial screen to the memory of Prince Henry of Battenberg, a work that took up most of the year 1896 (Cat. 96). However, Gilbert was almost incapable of refusing a commission and (astonishing though his output in the 1890s was, both in quantity and in quality) his correspondence is also filled with dozens of letters delaying or putting off patrons. The simplest portrait bust seemed to take four or five years to cast, whereas for anything really ambitious one might expect to wait eight or ten years—and then consider oneself lucky to have secured a monument at all (figs. 2–5).

For Gilbert only perfection—some would say neurotic perfection—would do. Delays meant no payment, but on the reasonable expectation that as the foremost living English sculptor he would make a great deal of money, Gilbert lived on credit. He borrowed thousands of pounds to cast the Shaftesbury Memorial, and borrowed again to build a large house and studio in Maida Vale (Cat. 121).

Fig. 4 Alfred Gilbert, Memorial Tablet to Edward Robert Bulwer-Lytton, First Earl of Lytton, bronze, 1892–1902 (St Paul's Cathedral, London)

His workshop was large, though he employed only labourers, not (to any significant extent) assistants. His materials were costly and he was no businessman. His prices were not especially high; he was wont to give statues away to his friends; and he was prone to spending years on each commission, refining objects of the utmost beauty, or destroying and beginning them again when they dissatisfied him. Gilbert worked by instinct. Few detailed drawings for his works exist; rather, he composed, altered, and embellished as the piece evolved under his hands. It was therefore all too easy to treat each object as being in transition.

Gilbert's bankruptcy and departure for Bruges in 1901 marked the end of his years of productivity. To some extent

Fig. 6 Alfred Gilbert, The Frankau Memorial, clay, 1905 (destroyed)

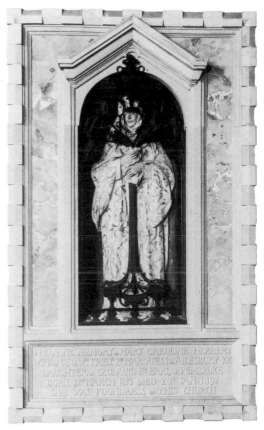

Fig. 5 Memorial to Mary Caroline Herbert, Marchioness of Ailesbury, aluminium and bronze, painted, c. 1892–1900 (St Katherine's Church, Savernake)

Fig. 7 Alfred Gilbert, The Leicester War Memorial, plaster, c. 1907–8 (destroyed; reproduced from a photograph in *The Studio*, 1908)

he may be said to have burnt himself out. Certainly depression and anxiety took their toll on his powers of creativity: he never stopped work, but whether a commission was actually cast or not became a question simply of hit or miss. The Frankau Memorial (fig. 6), the Leicester *Victory* (fig. 7), the *Call of the Sea* (fig. 8), *Circe*, and the first versions of *St Catherine* and *St Nicholas* for the Clarence Tomb are lost to us. *Mors Janua Vitae* (see Cat. 104) exists in bronze because

the client stoned Gilbert's studio windows until he surrendered the plaster. The Leeds Chimneypiece (1908–13, Leeds City Art Gallery; fig. 9) was cast in bronze by Gilbert himself, apparently without any setbacks; but the object is bizarre, an unintegrated amalgamation of grotesque symbols, referring entirely to Gilbert's private struggles, the embodiment in bronze of his own neuroses. To compare it to the cool clarity of *Perseus Arming* or *Icarus* is to measure

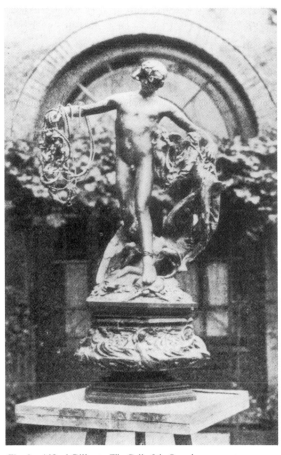

Fig. 8 Alfred Gilbert, *The Call of the Sea*, clay, *c.* 1907 (untraced; reproduced from *The Studio*, 1908)

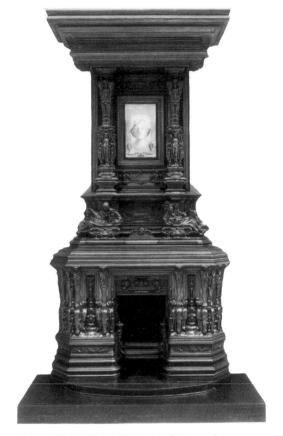

Fig. 9 Alfred Gilbert, The Leeds Chimneypiece (*A Dream of Joy During a Sleep of Sorrow*), bronze, 1908–13 (Leeds City Art Galleries)

the extent to which Gilbert's art turned from dream to nightmare.

After twenty-five years' residence in Bruges, in 1926 he was brought back to England. He then completed the Clarence Tomb and made one last elegiac masterpiece, the Alexandra Memorial at Marlborough Gate in London (1932; see Cat. 111–15), his last public work and one that looks lovingly to the past. This hymn to his old friend Queen Alexandra concluded his life's work on a sombre chord, but without bitterness, as though after the aberration of the Bruges years he was able to rediscover serenity, and in serenity, beauty, once again. On its completion in 1932 he received a knighthood. He died in London aged eighty in 1934 (fig. 10).

NOTES
1. Susan Beattie, *The New Sculpture*, New Haven and London 1983, p. 207.
2. See William Anderson, 'Aluminium and its Manufacture by the Delville-Castner Process', *Journal of the Society of Arts*, vol. XXXVII (15 March 1889), pp. 378–89.
3. W. Chandler Roberts-Austen, 'Alloys', *Journal of the Society of Arts*, vol. XLI (3 November 1893), p. 1015.

Fig. 10 Alfred Gilbert in the 1930s

ALFRED GILBERT AND HIS PATRONS: A CASE STUDY, THE ST ALBANS REREDOS

Richard Dorment

HE architect Arthur Blomfield (1829–99) first approached Alfred Gilbert in the spring of 1889 with a proposal that Gilbert should execute a reredos in beaten silver in the cathedral of St Albans (colour plate p. 76), which he was then renovating for Henry Hucks Gibbs, Lord Aldenham. Gilbert, who was to work with Blomfield on other projects—notably the Memorial to Christopher Wordsworth (1890–1, the chapel, Harrow School) and a pastoral staff in silver (c. 1890, untraced)—baulked at the notion of working in silver, because the reredos would, he felt, be 'entirely lost' unless carried out in very high relief.[1] He proposed a *Lamentation over the Body of Christ* and drew sketches to show how he would treat the subject,[2] but eventually settled on the *Resurrection* to be carved in alabaster (subsequently changed to marble).[3] The story of the St Albans Reredos is preserved in Gilbert's letters to Lord Aldenham in the archive of St Albans Cathedral. The best short summary of what happened was written by Lord Aldenham in a letter to Edward Poynter dated 20 November 1902: 'I gave him the commission in 1890 and he accepted it with apparent enthusiasm, but paid no attention to it for six years. In 1896, however, he made a sketch in clay of his proposed design—The Resurrection of Our Lord—and was paid ... one third of the agreed sum. It was roughed out in marble in July 1897, and further progress was made by June 1898. At that time he promised me that the work should be finished by the following Christmas—a promise which was postponed, in January 1899, to the end of the following month. The promise was again postponed in August 1901 to the end of the following September. Since that time, he has done absolutely nothing, and takes no notice of my letters. . . .'[4] Poynter's answer is quoted in part on p. 44. According to Bury, Gilbert was trying to complete the Reredos, working out of a studio in the Marylebone Road, as late as 1905.[5] A last pathetic letter from the archdeacon of St Albans to M. H. Spielmann asks the critic to use his influence to persuade Gilbert to finish the piece. It is dated 6 May 1927.[6]

Finished or not, Gilbert's Reredos is one of his most original and, if not beautiful, compelling creations. The nude marble figure of Christ appears to emerge from the tomb—the cathedral altar below—his head still wrapped in the shroud which falls in swirls on either side of his torso. Above, the disproportionately large hands of God the Father crown Christ with a crown of thorns. On either side are two angels in low relief, their feathers made of hundreds of painted and gilded seashells. The source of the composition may be Donatello's *Dead Christ Tended by Angels* in the Victoria and Albert Museum (c. 1434–6), but also any number of renderings of the theme of the *Raising of Lazarus*, for example, the altar screen at Winchester Cathedral.

On 2 November 1900 Alfred Gilbert wrote to Lord Aldenham that he was working on 'the enormous difficulty of colour'.[7] As his proposed use of alabaster shows, Gilbert from the first thought of his reredos as a colourful object.

Fig. 11 *The Resurrection of Christ*, 1890–1903. Marble (tinted), crystal and seashells (some painted and gilded). Recess l. 299.7 cm/118 in; w. 120.6 cm/47½ in. Inscribed: COME UNTO ME ALL YE THAT LABOUR. (St Alban's Cathedral)

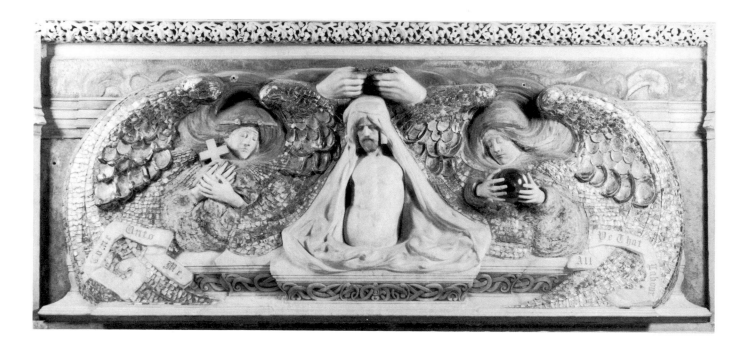

But what he referred to here was not only the seashells, nor even the painted faces of the angels and Christ, but also the tinting of the marble blue. This had a symbolic as well as a visual purpose: he stated that the blue represented the early dawn,[8] while the angels acted as attendant messengers of the Heavenly Father at the moment of the Resurrection. The cross and crystal globe 'show that the saviour at the moment [of the Resurrection] was thinking of those of the Earth for whom he had lain down his life'.[9]

In an interesting aside in reply to Lord Aldenham's query as to what the altarpiece symbolised, Gilbert replied that he believed in authorised descriptions of works of art because they were at least accurate, and came from the artist himself: 'Perhaps I have unwisely sought by my handiwork to gratify a too ambitious scheme, that of creating my own symbolism. I feel that it is impossible to justify, account for, or even describe certain moods + efforts in Art—And I am not sure but that, after all, the work that evokes speculation, or in other words, is suggestive rather than illustrates is not the more successful form.'[10] This gently symbolist (as opposed to obscurantist) attitude towards his work is very close to Burne-Jones's recorded attitude towards his later paintings, and there can be no doubt that the use of mosaic technique here was influenced by Burne-Jones's mosaic cycle at St Paul's Within-the-Walls in Rome, designed and executed between 1881 and 1894. Indeed, one of the huge inscriptions in that cycle, 'Come unto Me all Ye that Labour', is used by Gilbert in the St Albans Reredos.[11]

The Reredos is not finished: above the heads and at the side of each of the angels are holes. Before leaving for Bruges Gilbert went to St Albans and took away two grilles made of metal and gilded.[12] Though it is hard to see how the grilles worked on the Reredos, they must have slightly screened the sculpted reliefs, inviting, or forcing, the viewer to come close to the altar to see the colourful, flickering work of art above it. They would also have served to screen off certain defects in the carving. Gilbert referred in a letter to Lord Aldenham of 3 November 1899 to the fact that the heads of the angels had not been brought to the same standard of finish as the hands.[13] In fact, Gilbert was never satisfied with the Reredos. It had possibly gone fundamentally wrong at an early stage, for it is more than likely that he entrusted the preliminary carving to an assistant, possibly his son George, who certainly worked on the Reredos in the later stages. Pressure from the patron (and outside financial pressure) forced Gilbert to install the unfinished marble and work on it *in situ*, but neither paint, nor seashells nor grille were able to disguise the weaknesses in design and execution. Nevertheless, one may class the Reredos as one of Gilbert's brave, imaginative failures.

NOTES
1. Alfred Gilbert to Arthur Blomfield 23 April 1889 (St Albans MS, I, 551–2).
2. St Albans MS, I, fol. 55: 'Sketch of Pieta over altar as first intended by Gilbert R.A.'
3. Herbert Gilbert to Lord Aldenham, 25 November 1896 (St Albans MS, III, fol. 57).
4. St Albans MS, III, fol. 369.
5. Bury 1954, p. 18.
6. Spielmann to Gilbert, 6 May 1927 (SP/7/121).
7. St Albans MS, III, fols 312–13.
8. Alfred Gilbert to Lord Aldenham, 19 November 1900 (St Albans MS, III, fols 324–5).
9. Alfred Gilbert to Lord Aldenham (dictated), 17 December 1900 (St Albans MS, III, fols 341–6).
10. Ibid., fols 341–3.
11. Richard Dorment, 'Burne-Jones's Roman Mosaics', *Burlington Magazine*, vol. CXX (February 1978), pp. 72–82.
12. MS Air Chief Marshal Sir John Barraclough.
13. St Albans MS, III, fol. 249a.

ALFRED GILBERT AND HIS USE OF NINETEENTH-CENTURY FOUNDING TECHNIQUES

Duncan James

LFRED Gilbert's fascination with the technical aspects of making sculpture is evident in all his finest work. His successful exploitation of a lively, sensitive surface on statuettes such as *Perseus Arming* (Cat. 10) and *Icarus* (Cat. 15) is due in some measure to his use of the lost wax process (*cire perdue*). These early figures, which were cast in Italy, created considerable interest and did much to encourage the re-establishment of the technique in England. In addition, Gilbert's intimate understanding of casting methods (he experimented in his own small foundry) led him to push the various processes to extreme limits, producing entwined and undercut forms of great complexity. He also juggled with a profusion of alloys and patinations as he sought still further to extend the range of his palette.

In order to form an accurate assessment of Gilbert's achievements, it is helpful to be aware of the evolution of statue casting methods in the years before 1880. During the eighteenth century in England, sculpture was seldom cast in bronze and leading sculptors such as John Michael Rysbrack (?1693–1770), Peter Scheemakers (1691–1770), Joseph Nollekens (1737–1823) and François Roubillac (1695–1762) invariably worked in marble. However, a tradition of lead casting for garden statuary did flourish in the hands of John Nost and subsequently the Cheeres. Thus facilities were available for the casting in lead of equestrian statues, which, had they been carved in stone, would have been structurally unsound. It should be noted, however, that even the lead needed a hefty internal wrought iron frame to support its great weight.[1]

It was Sir Richard Westmacott (1775–1856) and Sir Francis Chantrey (1781–1841) who first began using bronze on a large scale and, in the absence of satisfactory existing facilities, they both organised the casting of their own work. Chantrey had built himself a foundry by 1830,[2] there utilising a brick-dust and plaster piece-mould technique which was probably supplemented by lost wax for complex work.[3] This busy foundry ceased operation following Chantrey's death in 1841, but the methods were redeployed in Scotland when Sir John Steell established his own foundry in 1850 under the direction of Chantrey's former assistant, a Mr Young.[4] Castings were still being made there in 1887, long after Steell's death and still using the by then outmoded systems of the 1820s.[5]

In England, however, brick-dust and plaster methods were discarded when it was realised that large statues could be produced using sand moulds formed within adjustable iron frames or flasks. This became the single most important technique of the second half of the century. It evolved from the highly sophisticated industrial iron founding processes of the 1850s when firms such as Hoole & Robson and Coalbrookdale were extending the range and complexity of their products; indeed, the latter even exhibited large sculptures in cast iron (*The Eagle Slayer*, London, Bethnal Green Museum, and *Andromeda*, Isle of Wight, Royal Collection, Osborne, both by John Bell) at the 1851 Great Exhibition. It was thus a simple step from iron to bronze. Compared to earlier methods, sand-casting must have come as a revolution, and its rapid adoption meant that the realisation of large statues in bronze became far less hazardous and unpredictable.

The first foundry to specialise in sand-casting bronze statues was Robinson & Cottam of Pimlico, London,[6] a well-established engineering firm which existed prior to 1843 under the name of Bramah.[7] An early art-casting from the firm (and possibly its first) was a statue of Sir Robert Peel by Edward Hodges Baily (1788–1867) erected in 1852 (Bury, Lancs.), an 8 ft 6 in-high, 2-ton bronze which, except for the head, was cast in one piece. Robinson & Cottam remained in production until at least 1866, but by the year 1870 there were three further statue foundries operating in

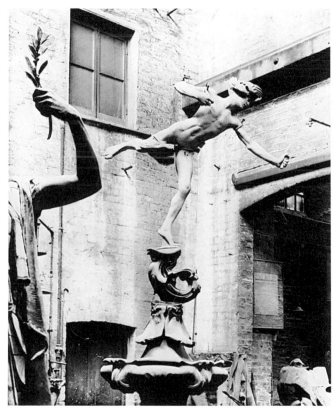

Fig. 12 The Thames Ditton statue foundry *c.* 1929, when it was owned by A. B. Burton. Castings were made on the premises from 1874 until 1939. The photograph shows a second casting of Gilbert's *Eros*—made from the plaster patterns which were originally used for the Piccadilly Circus cast of 1893. The figure has been made in about ten separate pieces by *cire perdue* casting, the sections pinned together using Roman joints. This copy was erected at Sefton Park, Liverpool.

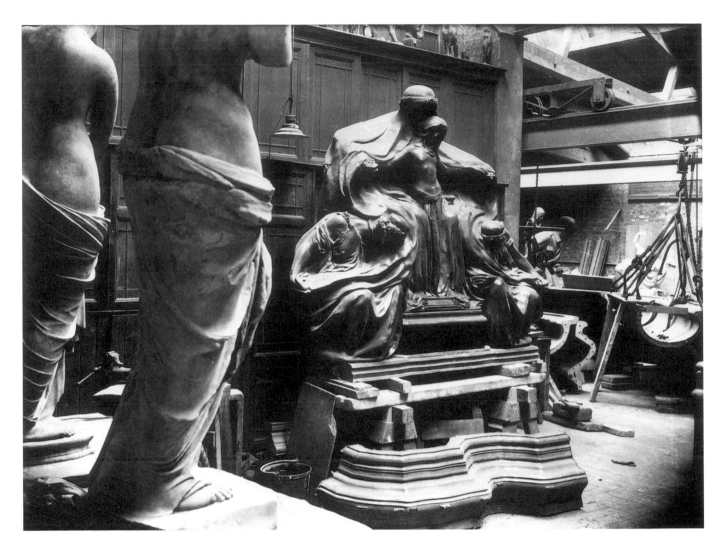

Fig. 13 The Thames Ditton statue foundry *c.* 1929. The 'chasing shop' showing the bronze casting of the central group of the Memorial to Queen Alexandra. The crowns on the three large figures have not been put in place at this stage. A section of the related bronzework stands in front of the raised group.

London, all of them almost certainly using similar techniques derived from English iron-founding skills. They were H. Prince & Co. (*fl. c.* 1865–75), Masefield & Co. (*fl. c.* 1870–8) and Young & Co. (*fl. c.* 1870–1904).[8] In addition, Cox & Sons built the well-equipped statue foundry at Thames Ditton (*fl.* 1874–1939)[9] which, under the later ownership of A. B. Burton (fig. 12), had the task of casting Gilbert's last major work, the Alexandra Memorial (fig. 13; see Cat. 112–13).

To add variety to the scene, the Birmingham-based firm of Elkington—famous for its pioneering use of electroplating—was also involved in casting statues. For over fifty years (*c.* 1849–1903) it produced traditionally cast work

alongside its speciality, the electrotype, an intriguing process by which metal was built up on the inside surface of a mould by electrochemical deposition to form an accurate, light and hollow 'casting'. Curiously, the electrotype, with its interesting possibilities, appears not to have been used by Gilbert himself, although at least one work of his was cast in Germany using the process.[10]

Thus it is clear that, by the 1880s, there was in England a firm tradition of sand-casting which, whilst excellent for reproducing large statues, was too coarse for smaller work. In contrast, the lost wax process if skilfully applied, offered a finer surface on the finished bronze, and generally demanded less retouching by the chaser. Above all, it was a process that could be used to cast work of great intricacy—work that would be impossible by sand-casting.

Before considering Gilbert's part in all this, it is important to understand the significant features of the lost wax process as it was used at the time, primarily in Italy. In principle the *cire perdue* method is very simple. The sculpture is made

in wax and covered with a liquid slurry (e.g. plaster/grog mix) which is allowed to set, thus forming a mould, a process known as 'investment'. The wax is then melted and burnt out and molten bronze poured in to replace it. Once cool, the friable mould material is broken away to reveal the casting. Obviously holes must be arranged in the mould to allow the wax out and the metal in, and these are constructed as solid rods of wax fixed on to the wax model prior to investment. A fundamental complication is that the bronze needs to be hollow. Therefore the wax sculpture must also be hollow, the centre being filled with moulding material to form a core. Steel pins are used to hold the core firmly in position within the mould once the wax has been eliminated. Of particular interest here are the means by which that original *hollow* wax was made.

Gilbert at various times used two variations of the lost wax process, and these are widely known as the direct and the indirect methods. The archetypal system, as used by Cellini in making his *Perseus*,[11] is the direct method, which could produce only one casting in metal. The artist constructed the figure slightly undersize using a grog and plaster composition. This formed a core on which he modelled a skin of wax with all the details. This unique wax statue was then invested and cast by lost wax into bronze. The advantage for Gilbert would have been that, since the artist's modelled sculpture was only one mould away from the finished sculpture, the quality was very high. The disadvantages would have been, first, that it was risky: mistakes or faults could mean that the work was irretrievably lost. Second, in order to make a copy it was necessary to make a mould from the 'autograph' or unique bronze and use it to create a hollow wax to be cast by *cire perdue* in the usual way. Thus, copies were each *three* moulds away from the original. In view of this, the master bronze needed to be retained for reference to ensure the accuracy of all subsequent casts. Finally, in order to model wax in a fluent manner, the sculptor really needed a warm climate: it is surprisingly difficult to manipulate beeswax in the moderate temperatures of England.

The indirect method, also used and described in detail by Cellini, was, and is, more usual. In the 1880s the sculptor would have modelled his statue in clay and, by using a waste mould, cast a replica in plaster. From this plaster pattern a flexible gelatine mould was made and used to reproduce a limited quantity of hollow waxes (a maximum of about six), before it deteriorated and had to be repoured. The advantages were considerable, because a gelatine mould could be used to transfer fine detail and deeply undercut forms into wax with relative ease. It will be seen that in the indirect method, unlike the unique master cast made using the direct method, the artist's original clay model is still three moulds away from the finished bronze.

An alternative means of making the wax for the indirect method was to form it from a complex piece-mould previously constructed on the sculptor's clay model.[12] By this means only two moulds stood between the clay original and the finished bronze. A serious drawback, of course, was the difficulty of coping with deep undercuts and delicate detail. The piece-mould also produced a wax casting with lines or slight 'jumps' where the joints were.

Given the complications of both lost wax methods, it is clear that Gilbert would have needed both help and practice in order to master the finer points of these complicated procedures. It was in the early 1880s that he encountered such assistance, at the foundry of Sabatino de Angelis of Naples.[13] Here Gilbert must first have acquired a working knowledge of *cire perdue*. It is possible that the re-establishment of lost wax in Italy had occurred only during the 1870s. A report in the *Art Journal* of 1874 refers to a Venetian founder named Giordani, who had 'discovered a new process of casting by the operation of which and at a single flow of the liquid metal, not only large statues, but groups of most elaborate complexity, can at once be produced, and with so fine a finish that no supplemental chiselling is required. . . .'[14] The references to 'elaborate complexity' and 'fine finish' do suggest lost wax rather than sand.

In view of the exceedingly high quality of Gilbert's first *cire perdue* castings undertaken in Naples, we have to conclude that they were something more than the usual indirect method of lost wax; indeed, it is almost certain that they were made using the direct method of modelling wax on to a prepared core. It is this which makes them exceptional.

However, there is every reason for thinking that Gilbert's very first bronze, the 29-in version of *Perseus Arming* (1882), was modelled in clay and cast to form a plaster pattern from which a mould was made to produce a number of waxes. As Richard Dorment points out in his biography of Gilbert: 'During the winter of 1880–1 Gilbert worked on *Perseus Arming*. Because it was not a commissioned work, there was no money to cast the plaster into bronze.'[15] This would mean that the first and all subsequent casts were good but did not have the 'fingerprint' quality of the *Icarus*. Richard Dorment states that the first casting of *Perseus* (for Henry Doulton) has not been traced.[16] This is probably because it would not stand out as being superior to other replicas made from the same plaster pattern.

It could be that the casting into bronze, by the indirect method, of *Perseus Arming* served to introduce Gilbert to the intricacies and advantages of the process in general, and the potential of the direct method in particular. He would surely have also read Cellini's technical account in the *Treatises* of the casting of his *Perseus*, and in order to achieve greater fidelity been drawn to experiment with the direct method, firstly in his *Head of a Girl* (Cat. 12) of 1883 which is a simple

basic shape, then more adventurously in the large *Icarus* of 1884.

The 42-in *Icarus* (Cat. 15) is the only known casting at this size. It was made for Frederic Leighton and would seem to have been a direct casting without clay or plaster prototypes. Apart from the fact that it would have been unethical to make copies since the august Leighton, President of the Royal Academy, had commissioned the work, the bronze was sent to England in the spring of 1884 and would therefore have been unavailable for mould-making. It should be noted also that to take satisfactory moulds from the bronze *Icarus* would have meant removing the wings and treating these separately. Of course, it may well be that, since this was a commission of great importance, Gilbert chose to make only the single large *Icarus*, and selected the ideal method.

In support of the unique nature of *Icarus*, M. H. Spielmann notes that this figure 'gave the artist so much trouble in the casting', and his reference to 'two busts called "Study of a Head", cast by the waste wax process—as, I believe, the "Icarus" had also been cast' suggests they were rather special cases. It is significant that he does not refer to the earlier *Perseus Arming* in like manner.[17] Lavinia Handley-Read also states that 'some . . . [small bronzes] he may have cast during the years when he was experimenting in the lost wax process, trials of which began in Rome when he cast his first *Icarus*'.[18] Edmund Gosse in his 1894 essays on the New Sculpture refers to *Icarus*, not *Perseus*, as the first example of *cire perdue*, adding that it was not perfectly successful, as 'in more than one place the process had slightly failed'.[19] Had the statuette not been cast by the direct method, it would probably have been scrapped and redone.

It is reasonable to assume that *Study of a Head* (Cat. 14) was, like its companion *Head of a Girl*, also modelled in wax and directly cast. In considering the elaborate surface of *Study of a Head* it is almost as if Gilbert was testing the technique—he could hardly have found a face with more lines and character. Later castings of both studies do exist, but since neither of the bronzes was a commission, they would have been available to Gilbert for moulds to be made. These later casts would of course be slightly smaller than the prototype bronze.

The last of the trilogy of Italian statuettes was the 29-in figure, *An Offering to Hymen* (Cat. 18). It is possible that this was a direct wax casting, because, like the 42-in *Icarus*, it appears also to be a unique bronze. Although Gilbert began the commissioned figure in Italy, it was finished in England and cast for the Grosvenor Gallery Exhibition of 1886.[20] Bearing in mind the comparatively large size, it seems unlikely that he cast the figure in his own studio foundry. This conclusion is reinforced by the fact that Gilbert claimed his Fawcett Memorial of 1887 (see Cat. 31) to be the first complete work cast in England by *cire perdue*.[21] This leaves Alessandro Parlanti (see below), who may not have been set up at this date, or the Compagnie des Bronzes in Brussels, established in 1853. The latter does seem the most likely firm, since they may have been responsible for the casting of Gilbert's Jubilee Memorial to Queen Victoria, Winchester (unveiled in August 1887; Cat. 32–6) which itself included small statuettes and, the most important point, in addition to sand-moulding, the firm had been using lost wax since 1880.[22]

The exhibition of Gilbert's early bronzes in London from 1882 did much to encourage the establishment of the lost wax process in England. In common with other artists, he carried out small-scale experiments, but the arrival of lost wax on a commercial scale may have come with the statue foundry at Parson's Green, London, which was set up by Parlanti between 1885[23] and 1893.[24] Having trained at the Fonderia Nelli in Rome, Parlanti brought with him the grog and plaster lost wax skills that are still in use today in sculpture foundries of Italian descent.[25] It is also probable that he brought with him the use of the gelatine mould which, as we have seen, allowed good replicas of deeply undercut statues to be made. (For large work, gelatine was not practical, so piece moulds were used.[26]) The gelatine mould was therefore a key feature in the successful application of the indirect lost wax process, and although it was well known in England at least from 1848, when it was used as a mould for the electrotype,[27] or for producing plaster casts,[28] its full potential was only realised when it was used in association with *cire perdue*.

But Parlanti was not alone, for in England the enthusiasm for lost wax spread rapidly. In 1888, John Webb Singer of Frome in Somerset (*fl. c.* 1882–1927)[29] supplemented his sand-casting facilities with a French/Belgian technique of lost wax which was different (and arguably inferior) to the Italian methods which Parlanti brought from Rome.[30] Most of Gilbert's contemporaries used either Singer[31] or the flourishing Thames Ditton statue foundry which appears also to have adopted Continental lost wax methods at about this time.

Gilbert's own efforts at casting his work were more than experiments, as shown by the Memorial to Henry Fawcett (1887) in Westminster Abbey. This work is of considerable technical interest and it was, according to Gilbert, entirely cast by him using *cire perdue*.[32] The seven small figures on the Memorial are complicated enough to have needed lost wax, and yet show clear evidence on their surfaces that the waxes were formed in piece moulds, thus limiting the advantages that the process had to offer. However, it is likely that the piece moulds were taken directly from the modelled clay originals, so the surfaces would have remained quite fresh.[33] The figure of *Sympathy* is within a mass of delicate foliage,

far too elaborate to have come from a piece mould. It is probable that this would have been modelled in wax onto the wax cast of the figure prior to investment. It is slightly puzzling that Gilbert did not take the trouble to remove the seam lines from the wax figures before casting.

The combination of indirect and direct lost wax, as used on the *Sympathy* figure, seems also to have been employed on certain parts of the Clarence Tomb at Windsor (Cat. 66–81). The bronze figure of *The Virgin*, in view of its complexity, can only be a *cire perdue* cast, and one can surmise that the basic form was modelled in clay, cast into plaster and thence, via gelatine, to a hollow wax. This figure has then been embellished by Gilbert, with enveloping wreaths of roses formed directly in wax and applied to the figure. The casting would have been made in a single pouring of bronze. The 1899 (Scottish Kirk) cast of *The Virgin* (Cat. 75) has a quite different arrangement to the modelled roses.

Gilbert certainly kept close control by retouching or modifying waxes when making copies. His studio diary entry of 8 May 1899 supports this: 'Parlanti delivers 3 wax "Courage" (Russell Mem:) 3 wax Charity (Russell Memorial:) and their models'.[34] The models would have been used for reference in correcting faults. Most sculptors would normally leave such work entirely to the foundry.

To summarise: it does seem that, although some directly modelled and cast work was done by Gilbert, he did abandon the casting of large unique bronzes by the direct method once he left Italy. He resorted to the indirect method which allowed him to cast a series of identical bronzes from a plaster pattern. It is worth noting that he may have been discouraged from modelling for direct casting by the greater difficulty in manipulating wax in the cool English climate. There are, however, two examples that do appear to be direct castings and deserve mention for their quality. They are the reclining figures on the Leeds Chimneypiece of 1908–13. Each female figure with her own bizarre and detailed collection of symbolic objects is a fine illustration of the high-risk business of direct method lost wax.

So far we have considered only the use of lost wax, but it must not be forgotten that much of Gilbert's work was cast by the sand process. He made use of the Compagnie des Bronzes in Brussels, then around 1890 began using the firm of George Broad & Son who, oddly, appear to have cast few bronzes for other artists. Most probably they made exclusive use of sand-moulding, and Gilbert certainly tested their skills in sculpture such as the Shaftesbury Memorial with its riot of undercut forms around the basin.

Much has been made of the fact that the *Eros* figure, which balances so charmingly on the Shaftesbury Memorial, was the first large figure to be cast in aluminium. Technically it would have presented the foundry with no serious difficulties, indeed the low melting-point of the metal would have proved advantageous. The innovation, such as it was, lay in the white colour of the metal, which Gilbert went on to use to far greater effect in the Clarence Tomb where we find the recumbent effigy of the Duke presented on a boldly modelled cloak, the inner lining of which is aluminium. The ethereal quality of the ensemble is enhanced by the grey lustre of the aluminium angel at the head. On a smaller scale, further use of aluminium is made in the 18-in figure of *St George* (Cat. 71),[35] which appears to have been sand-cast in about a dozen separate pieces held together using rivets. This would have facilitated the finishing work, and the result is crisp and precise.

Clearly Gilbert sought out techniques that would give him freedom, then he pushed them to their limits. Thus he exploited the sand process quite as fully as he did lost wax. It is difficult to gauge accurately Alfred Gilbert's influence on the re-introduction of lost wax into England. Certainly the process had a romantic, almost mystical appeal which he helped to foster, and the cause of lost wax, which was taken up by his contemporaries, undoubtedly prompted English foundries to adopt the process. The most tantalising aspect is the Italian connection. Could it be that Alessandro Parlanti brought his superior lost wax methods to England at the request of Alfred Gilbert? If this were so, it was an action that has had far-reaching consequences, as foundries with Parlanti ancestry are in business to this day, casting the work of contemporary sculptors.[36] Finally, it is fascinating to note that the five figures of saints which Gilbert at last added to the Clarence Tomb in 1927 (Cat. 77–81) were cast by Frederico Mancini[37] who as a young man had worked in Fonderia Nelli and then at Parlanti's, before setting up his own foundry.[38]

A feature that runs through the whole of Gilbert's life is the constant delay in finishing his work. There is no doubt that much of this was due to the difficulty he must have experienced in solving technical problems related to his often stunningly elaborate sculpture, and it may well be that his fascination with difficult processes and complex design played a significant part in his downfall.

NOTES

1. Examples may be found at Petersfield and Hull, *William III*; and Stowe, *George I*.
2. His statue of James Watt at Glasgow is inscribed 'F. Chantrey Sculptor & Founder 1830'.
3. Rev. D. Lardner, *The Cabinet Cyclopaedia*, 1831–4, vol. III, pp. 207–10.
4. *The Scotsman*, 18 August 1876, pp. 5–7.
5. *The Artist*, 1 April 1887, p. 122, records that *General Gordon* by T. Stuart Burnett (for Aberdeen) is to be cast at Steell's foundry.
6. *Art Journal*, 1852, pp. 98, 291.
7. *Illustrated London News*, 25 November 1843, p. 349.
8. Op. cit., 16 April 1881, p. 374, for a description of moulding methods as used in this foundry.
9. D. James, 'The Statue Foundry at Thames Ditton', *Foundry Trade Journal*, 7 September 1972, pp. 279–89.

10. *Eliza Macloghlin* (1906) was cast by the Württemberg Electro Plate Co.
11. *The Treatises of Benvenuto Cellini on Goldsmithing and Sculpture*, trans. C. R. Ashbee, London 1888.
12. See V. H. Wager, *Plaster Casting for the Student Sculptor*, London (n.d.), for details of the waste, piece and gelatine moulding procedures.
13. Dorment 1985, p. 40.
14. *Art Journal*, 1874, p. 184.
15. Dorment 1985, pp. 38–40.
16. Op. cit., p. 40.
17. M. H. Spielmann, *British Sculpture & Sculptors of To-day*, London 1901, pp. 76–8.
18. Lavinia Handley-Read, 'Alfred Gilbert: A New Assessment', Part I, *The Connoisseur*, 1968, pp. 23–4.
19. Edmund Gosse, 'The New Sculpture 1879–1894', *Art Journal*, 1894, p. 280.
20. Dorment 1985, p. 53.
21. Op. cit., p. 67.
22. Undated trade catalogue entitled 'Bronzes Monumentaux' issued by Compagnie des Bronzes, Brussels (*c.* 1903).
23. From R. Fiorini in conversation with author in 1971.
24. *Illustrated London News*, 3 October 1903, p. 484.
25. See C. D. Clarke, *Metal Casting of Sculpture*, Butler, Maryland 1948, for a very full description of the imported Italian grog/plaster, painted wax technique as it existed in America in the 1940s. It is identical to the process used by Italian foundries in England.
26. *Illustrated London News*, 3 October 1903, p. 499.
27. *Art Union*, 1848, p. 102.
28. *Art Journal*, 1849, p. 131.
29. *Somerset Standard*, 17 March 1888, p. 4; 16 September 1898, p. 4.
30. An outline of methods as used by Singer may be found in *The Engineer*, 2 May 1924, pp. 273–4.
31. Duncan James, 'A History of the Morris Singer Foundry' (1971) is held in manuscript form by Morris Singer of Basingstoke.
32. Dorment 1985, p. 67.
33. See M. H. Spielmann, op. cit., p. 80, for an illustration of what is presumably the clay model for the Fawcett Memorial.
34. Richard Dorment, 'Alfred Gilbert 1854–1934', in *Victorian High Renaissance* (exhibition catalogue), Manchester, Minneapolis and Brooklyn 1978–9, p. 191.
35. Dorment 1985, pp. 166–7.
36. Duncan James, 'Foundries', *Arts Review*, 13 February 1971, pp. 70–1, 87.
37. Dorment 1985, pp. 311–13.
38. Domenico Mancini (Frederico's son) in conversation with the author in 1971.

ALFRED GILBERT AS A JEWELLER AND GOLDSMITH

Charlotte Gere

N 1882 Oscar Wilde recommended his reader to 'search our your workman. When you want a thing wrought in gold, goblet or shield for the feast, necklace or wreath for the women, tell him what you like most in decoration, flower or wreath, bird in flight or hound on the chase, image of the woman you love or friend you honour. Watch him as he beats out the gold into those thin plates delicate as the petals of a yellow rose, or draws it into the wires like tangled sunbeams at dawn. Whoever that workman may be, help him, cherish him and you will have much lovely work from his hand as will be a joy to you for all time.'[1] It is hardly to be expected that Wilde would have had any notion of the practical application of the techniques of goldsmiths' work and jewellery: speaking for effect rather than to instruct the student, his flowery images would not have conjured up for his audience a picture of the ornaments available at that date, tangled sunbeams not being part of the stock-in-trade of the Victorian jeweller.

However, the date of 1882 is significant. Wilde's successful career as a writer was partly due to the fact that he was preternaturally sensitive to cultural straws in the wind. Perhaps he already had some apprehension of the liberating effect, just beginning to be felt outside the immediate confines of their circle, that the artistic tastes of the much-ridiculed aesthetes would soon have on the design of dress and personal ornaments. If an audience of 1882 could not be expected to visualise the effect of the tangling of golden sunbeams, we now are in a position to cite a small body of work which comes close to fitting this fanciful description. From the date of the 1887 Jubilee Memorial to Queen Victoria at Winchester (Cat. 32–6), with its amazing crown-canopy—so lamentably misunderstood by the cartoonist in *Punch* who has depicted a structure of eighteenth-century-style wrought iron (fig. 14)—Alfred Gilbert is revealed as a designer of jewellery who was completely unhampered by the mundane constraints of accepted workshop practice.

In this same year, 1887, although he was without training or experience in goldsmith's work, Gilbert embarked on the most ambitious jewellery project of his career, the designing and making of a gold and enamelled Mayoral Chain (colour pl. p. 71) for the Corporation of Preston in Lancashire. The sketch model for the Chain, exhibited at the Royal Academy in 1888, survives. It represents the ultimate in inspired improvisation; no stage jewel can ever have been so boldly executed simply by the cutting and folding and twisting and shaping of tin and wax. The finished jewel, though much altered in detail, is, in effect, a sophisticated version of the model, smoothly cast and worked and embellished with enamels of beautiful quality by Clement Heaton (1861–1940) of the Century Guild, but still, none the less, a magnificent piece of theatre. The most fundamental considerations of function, the logical starting-point for the trained goldsmith, have been overlooked or dismissed as irrelevant and the flat links with their regular rectangular form fight against any attempt to set the chain in the wide circle which would sit comfortably on the shoulders of the wearer.

Gilbert's achievement as a sculptor-goldsmith is spectacularly original, but it is not technically remarkable. His immaculately sensitive bronze-casting techniques, studied, significantly, from the writings of his celebrated sculptor-goldsmith predecessor, Benvenuto Cellini (1500–71), were applied to the execution of the Preston Chain with effect (see p. 23). Gilbert had no need of the hard-won expertise of the master-craftsman, whose first task is to produce a perfectly spherical ring with accurately machined angles of

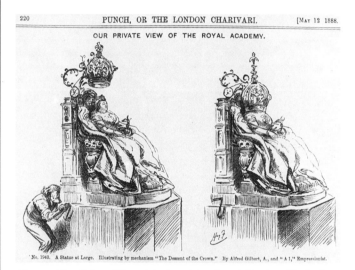

Fig. 14 'Our Private View of the Royal Academy', *Punch, or The London Charivari*, 12 May 1888

exactly ninety degrees, an achievement which provides the backbone of his subsequent production. The Arts and Crafts designers were to prove that such technical expertise can, to the benefit of inspiration, be dispensed with to a certain extent, particularly for large-scale ceremonial pieces. However, it is noticeable that very few of the Craft Revival jewellers had sufficient artistic assurance to dispense, as Gilbert did, with the finicking paraphernalia of gem-setting and festoons of chains and pearls, thus exposing their products to unfavourable comparison with the technically superior work of their professional counterparts in the trade. Ruskin was able to speak disparagingly of 'mere technique' simply because it was such a commonplace feature of Victorian manufactures of all kinds; this was a period notable for technical achievements in the decorative arts unsurpassed before or since. Ruskin expressed his beliefs repeatedly, but nowhere more relevantly to the achievements of the artist-

designers of the late nineteenth century than in this passage from *The Stones of Venice*: '. . . therefore, while in all things that we see or do, we are to desire perfection, and to strive for it, we are nevertheless not to set the meaner thing, in its narrow accomplishment, above the nobler thing, in its mighty progress; not to esteem smooth minuteness above shattered majesty; not to prefer mean victory to honourable defeat; not to lower the level of our aim, that we may the more surely enjoy the complacency of success'.[2]

The dedicated handcraftsmen of the Arts and Crafts Movement were to find the lack of fundamental technical expertise limiting and expensive, but their experiments with form pushed back the boundaries of jewellery design. In *The Theory of the Leisure Class*, published in 1899, Thorstein Veblen voiced a growing dissatisfaction with the craft ethic: '. . . the generic feature of the physiognomy of machine-made goods as compared with the hand-wrought article is their greater perfection in workmanship in greater accuracy in the detail execution of the design. Hence it comes about that the visible imperfections of the hand-wrought goods, being honorific, are accounted marks of superiority in point of beauty, or serviceability, or both.'[3] In striving after Ruskin's notion of perfection, a self-indulgent absence of technical discipline had led the craftsmen to neglect the worldly notion of perfection. Ironically, the greatest benefit, financially, of the craft jewellery experiments accrued to the commercial firms like Liberty's, who capitalised on the Ruskinian achievements of the artists while sticking rigorously to the conventional view of an acceptable technical standard.

Like all Gilbert's projects, the making of the Preston Chain occupied several years, and it was not finally delivered until after it had been shown at the Royal Academy in 1892. It was on the recommendation of the President of the Royal Academy, Sir Frederic Leighton, that Gilbert was invited to execute a Chain to celebrate the Golden Jubilee of Queen Victoria.[4] Composed of eight main elements united by flat links of silver striped with inlays of metal coloured with alloys, the chain is ornamented with enamelled heraldic shields, and with inscriptions in gold inset into the silver links. The centre-piece in the front of the chain is in the form of a double tailed mermaid flanked by two ships and surmounted with a crown composed of a castellated gatehouse with a portcullis, symbolic of the position of Preston as an ancient sea-port. The centre-piece at the back bears the Royal Arms surmounted by a gem-set Royal Crown; inset into the reverse of this piece is an enlarged Jubilee sovereign with a profile of the Queen designed by Gilbert himself. Of the remaining heraldic devices, two are those of the town of Preston and the other four are of sovereigns connected with the history of the town: Henry I, Henry II, Elizabeth I, and Charles II. The Mayoral Badge or Dress pendant can be attached to the centre-piece in the front; this bears the ancient arms of the town, also surmounted by a gem-set crown.

When it was decided to commission Mayoral insignia for Preston a number of guidelines were set down for the designer, including minute specifications of the materials to be employed in its manufacture: '. . . any Gold must be Fine Gold of 18 carat . . . all Precious stones should be of proper size and weight, without blemish and of full proportion, and any Diamonds, whether Brilliants or otherwise, of the first water, well proportioned, properly cut, and free from the faintest tinge of colour of any sort, and from any flaws, specks, marks, fissures in any part, and from "milk" or "salt" and any Rubies, fine and pure Rubies of the true blood-red tint, free from any flaws . . .'—and so on. The picture which this conjures up is far from Gilbert's world of experiment and improvisation. Such instructions were to prove quite irrelevant. The nature of this chain, which was only finally delivered to Preston after many anguished reworkings, is to be a work of sculpture in precious metal (silver-gilt, incidentally, not 'fine gold') rather than a piece of valuable jewellery. The result is a remarkable, sustained *tour de force* of modelling and casting which far exceeds the promise of the startling original sketch model.

It might be supposed that such an outstanding essay in goldsmith's work would have some impact on contemporary jewellery design, but there is little to suggest this outside the ornaments which embellish George Frampton's sculptured busts, *Lamia* of 1899–1900 (Royal Academy of Arts), and *Mysteriarch* of 1892 (Walker Art Gallery, Liverpool), which in any case seem to owe their inspiration to French work of the date.[5] Even this limited influence did not extend to Frampton's own venture into designing actual jewellery. The small group of enamelled and gem-set pieces dating from 1896–8 which Frampton designed for his wife does not bear any evidence of sculptural inspiration.[6] Otherwise, only a small group of silver pieces, mainly ornamental waist-clasps designed for Liberty's by the Birmingham painter Oliver Baker, who exhibited at the Royal Academy from 1883, seems to show any appreciation of Gilbert's innovative design.

However, in Gilbert's case one point is abundantly plain: the sculptor's training was of the greatest value to the aspiring artist-jeweller. A glance at the most notable names in the field in the second half of the nineteenth century reveals a great preponderance of architects, for example, A. W. Pugin (1812–52), William Burges (1827–81) and C. R. Ashbee (1863–1942), and a number of painters, like Edward Burne-Jones (1833–98) and Charles Ricketts (1866–1931). It is significant that the artist-jeweller who can match Gilbert in power and invention (fig. 15) is Henry Wilson (1864–1934; figs 16, 17) who, though he trained and

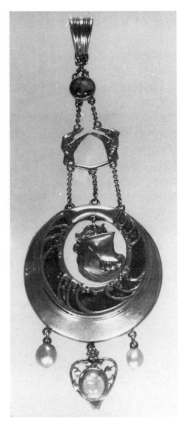

Fig. 15 Drawing by Alfred Gilbert for a jewel with a galleon from the van Caloen Album (Jean van Caloen Foundation, Loppem)

Fig. 16 Drawing by Henry Wilson for a pendant, figure of a mermaid (Department of Prints and Drawings, Victoria and Albert Museum, London)

Fig. 17 Pendant by Henry Wilson (Hessisches Landesmuseum, Darmstadt)

practised as an architect, was also a sculptor of some competence. The advantages of this experience in the case of both Gilbert and Wilson are most apparent in the confident handling of the human figure, always a great stumbling-block in jewellery design, and the way in which it is incorporated into the design as a whole. The contrast with contemporary English work by, for example, J. Paul Cooper (1869–1933) or Ashbee, is marked.

In his acceptance speech on receiving the Mayoral Chain at Preston in 1888, Alderman C. R. Jackson, quoting the President of the Royal Academy, Sir Frederic Leighton, identified Gilbert as 'the Benvenuto Cellini of this age'. The name Cellini was significant for Gilbert, not only because of his interest in the technical aspects of the *Treatises*, but also because a parallel was so frequently drawn between their artistic achievements, Gilbert being supposedly indebted to Cellini for his inspiration. No piece of jewellery now survives that can be confidently ascribed to the hand of Cellini, though there is a record in the form of a drawing of the celebrated Morse, made for Clement VII, which was destroyed to pay the vast indemnity demanded from the defeated Papal Government by Napoleon I; it bears no resemblance to any of Gilbert's designs. Gilbert's sources are, in fact, to a large extent, Germanic, exaggerated renderings of the arabesque and strapwork ornament favoured by the sixteenth-century goldsmiths of Nuremberg and Augsberg. It is not in the least surprising that Cellini's name was invoked since a large body of such work was then ascribed to him. A study published in 1911 by H. Focillon, inclusionist to a fault, illustrated as the work of the master numerous pieces of Northern origin, both genuine sixteenth-century pieces and some more or less skilful fakes.

This common source of inspiration was shared by Gilbert and Burne-Jones. The painter's own fanciful metalwork creations, armour and helmets, coronets and crowns, incorporate the same elements composed of stretched membranes whose extremities are prolonged into scrolling tendrils, as well as the flat, cut-out straps, like paper or leather with curled and splayed edges. In the course of his work on the armoured figures in his unfinished *Perseus* series of decorative panels commissioned by Arthur Balfour, Burne-Jones had some of the armour made up in order to make studies of

it; he remarked of this expedient: 'One of the hardest things to determine is how much realism is allowable in any particular picture . . . I make what I want, or a model of it, and then make studies from that. What eventually gets on to the canvas is a reflection of a reflection of something purely imaginary.'[7] Bearing this in mind, it is perhaps unprofitable to try to pin down the source of a 'reflection of something purely imaginary'.

That the good opinion of the President of the Royal Academy should prove of value was hardly surprising, but the commission which followed the Preston Mayoral Chain was intensely gratifying by any standards. A magnificent table-centre or 'épergne' was required by the officers of the Army as a Jubilee gift for the Queen. Gilbert seized the opportunity to make something immensely sumptuous. Based on the great Tudor nefs (or Galleon-shaped ornaments) which also served as table centre-pieces, and making use of rock crystal, lapis, oxidised and patinated silver, gold, enamel and gems, he has created an extraordinary piece in which the flamboyance of the curvilinear design distracts attention from the disunity of the individual elements (Cat. 53). The provision of space for fruit or sweetmeats is small; this Epergne is fundamentally an ornamental sculpture into which shallow depressions have been perfunctorily introduced. In this instance the parallel with Cellini is not so inappropriate. Cellini's famous gold and enamelled salt, made for François I and now in the Kunsthistorisches Museum in Vienna, is only incidentally functional, the bowl being the least conspicuous part of the design. It was with the Epergne that Gilbert came closest to being inextricably identified with the Art Nouveau Movement, a connection which he furiously repudiated. But this piece does spring from that meeting of 'the mannered late Renaissance of the South . . . with the mannered late Gothic of the North', recognised by Lavinia Handley-Read,[8] which forms the basis of Art Nouveau inspiration.

As always, these commissions took far too long to complete. C. Lewis Hind, writing about the Preston Chain, noted in 1890 that Gilbert 'added I forget how many hundreds of pieces to the chain, and altered, and altered, and altered again, in striving after perfection'.[9] Gilbert himself believed that to embellish was to improve, but the present-day view of his work might be different. By the time the Mayoral Chain and the Epergne were finally completed, Gilbert's most ambitious, but not his most innovative and original work as a goldsmith and jeweller had been done.

The Preston Mayoral Chain and the Epergne have identifiable historical precedents and both are recognisable—if exaggerated—examples of the late Victorian style. Other works of neo-Renaissance inspiration, with a leaning toward the attenuations of the 'New Art', were to follow, but, with two exceptions or precursors, the works which single Gilbert out as a jewellery designer far in advance of his time were done at the very end of his career, and were so little valued that they remained in his studio at his death.

In continuing his career as an ornamental metalworker Gilbert made designs for a ewer and dish (Cat. 56), standing cups (Cat. 62), keys (Cat. 55), spoons (Cat. 58, 63) and a gold racing trophy for the Duke of Portland (Cat. 64). Of these, the keys and spoons are the most beguiling, with their inventive finials in the form mainly of compact little figural sculptures of great refinement. As with so many of these small-scale pieces, the model is even more exciting than the finished object. However, the silver spoons made for Alexander Henderson of Buscot Park are exquisitely sculptural and encapsulate in their finial ornaments much of the essence of Gilbert's inventive genius. The Rosewater Ewer and Dish (Cat. 56) presented in 1901 to the Duke of York by the officers of the Brigade of Guards has wonderful examples of these sculptural elements forming part of the design— the handles of the Ewer, for example, go far beyond the conventional Herm or female torso of Renaissance style, from which the flying figures of an embracing knight and

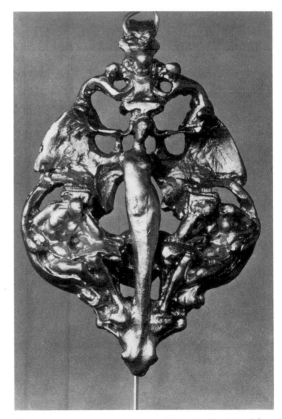

Fig. 18 Lost wax and plaster model for the Presidential Badge of the Royal Institute of Painters in Watercolour

mermaid are clearly derived—but the overall conception is hopelessly unwieldy and is without the curvilinear extravagance of outline which redeems the Jubilee Epergne. However, the *St George and the Dragon* which forms the impressive but over-large finial to the cover, if seen as a separate element, is an object of inspired beauty greatly enhanced by the subtle colouring of gold and silver and silvery shell.

The commission which spanned the creative gap between the pieces of neo-Renaissance inspiration and the abstract late works was the 1896 Badge (Cat. 54) for the Institute of Painters in Watercolour. The pendant has as its central element a sculptural conception of great purity, as can be seen from the sketch model which survived in the sculptor's studio at his death but is now lost, presumed destroyed (fig. 18). In the finished version it seems, however, that Gilbert was tempted again into adding 'hundreds of pieces' and in so doing he has 'Victorianised' the original idea. But with the chain we are given a foretaste of the forms to come, though Gilbert still adheres at this stage to the convention of separate uniformly-sized links. With the late abstract wrought wirework jewels (see Cat. 65) all conventional con-

Fig. 20 Drawing by Alfred Gilbert for a piece of Renaissance-style metalwork from the van Caloen Album (Cat. 117xv, reproduced in colour on p. 96; Jean van Caloen Foundation, Loppem)

Fig. 19 Drawing by Charles Ricketts, pendant with portrait head (Department of Prints and Drawings, British Museum, London)

straints are abandoned and a miraculously free, unbroken flowing line doubles and redoubles back on itself to produce the form swelling and diminishing within an outline that exists only in the mind's eye. These are jewels which might have been made today rather than half a century ago.

It is interesting to reflect on our conception of Gilbert as a jewellery designer, had his drawings been the only evidence of this activity to survive. In the context of his contemporaries the designs resemble those of Henry Wilson and

Charles Ricketts (fig. 19). The neo-Renaissance examples might seem appropriate to the workmanship of Carlo Giuliano (d. 1895); they would have been immaculately executed in enamelled gold set with coloured precious stones. In fact, the surviving pieces by these three artists are quite startlingly different, possibly owing to the conditions under which they were made: Gilbert's by himself; Wilson's in his own workshop by a professional jeweller closely supervised; Ricketts's by a fashionable firm, Carlo & Arthur Giuliano, the two sons of the aforementioned Carlo. Of these there is no doubt as to which are the most successful. Henry Wilson's jewellery is in a class apart, not only from these fellow artists but from most of his contemporaries, amateur and professional alike, because he had solved the Ruskinian dilemma and both design and execution were beyond reproach. However, Gilbert's drawings in the van Caloen Album (Cat. 117, fig. 20) do not seem to relate to the surviving pieces, which makes the entries from the Surrey Art Circle exhibition catalogues all the more tantalising. In 1898 he showed a 'Working model in tin to be executed in gold'; in 1901 a 'Case of objects from a workshop', which included 'no. 6 Preliminary stage of a pendant, wrought and cast, to be parcel gilt, no. 7 Pendant, pattern in tin, cast in one piece and in progress of chasing, to be reproduced in gold, no. 8 Pendant, silver, cast in one piece, to be chased and parcel gilt, and to be set with opals, no. 9 Sketch model

in wax coloured as a guide for enamelling, no. 10 Pendant, silver wrought setting to a topaz'.[10] These pieces, which might cause a reassessment of Gilbert's relative standing as a jewellery designer, are, like the pendant he achieved with so much travail for Mrs Humphry Ward,[11] lost to sight. It is to be hoped that one day some will come to light again.

NOTES

1. From a lecture entitled 'Practical Application of the principles of the Aesthetic Theory to Exterior and Interior House Decoration, with Observations upon Dress and Personal Ornaments', published by Methuen in a collection of Wilde's work in 1902.
2. *The Stones of Venice* 1853, vol. II, ch. VI, p. 11.
3. *The Theory of the Leisure Class* 1899, p. 115 (1970 edn).
4. The Preston Mayoral Chain, 1887–92. Silver gilt set with small diamonds, rubies and sapphires, enamelled armorial shields; on the reverse, a gold Jubilee sovereign beneath which is the artist's monogram, 'AG'. Total l. of chain 149 cm/58 in; centre front ht 15.2 cm/6 in; centre back ht 14.5 cm/5¾ in; dress chain pendant ht 12.3 cm/4⅞ in. The Mayor and Corporation of Preston, Lancashire.

EXHIBITIONS: London, Royal Academy, 1892; London, New Gallery, 1909, no. 287; London, Goldsmiths' Hall, 1961, no. 337; Brighton, 1984, no. 175.

LITERATURE: Spielmann 1901, p. 84; Spielmann 1910, p. 7; McAllister 1929, repr. opp. p. 83; Bury 1954, pp. 15, 18, 68; S. Tschudi Madsen, *The Sources of Art Nouveau* 1956, ill. p. 67; Graham Hughes, *Modern Jewellery* 1961, pls 193–5; Handley-Read 1967, p. 21, figs 10a & b, p. 24; Handley-Read 1968, I, pp. 25 & 26; Beattie 1983, p. 244; Dorment 1985, pp. 81–2, 89, 268, pls 42–4, col. pl. III.
5. For example, Moreau Vauthier's *Gallia*, exhibited in Paris at the Exposition Universelle, 1889 (reproduced in Beattie 1983, p. 153).
6. Jewellery and other enamel work by George Frampton ARA', *Studio*, XVI, pp. 249–52. George Frampton was born in 1860, died in 1928.
7. Quoted by John Christian in *Sir Edward Burne-Jones: An Exhibition*, catalogue of an exhibition at Fulham Public Library, 21 October–11 November 1967; see cat. no. 22.
8. Handley-Read 1967, pp. 17–24.
9. 'An Hour with Mr Gilbert, A.R.A.', *Globe and Traveller*, vol. 29, no. 535 (25 January 1890), p. 3.
10. London, Clifford Gallery, Haymarket, 'Surrey Art Circle Exhibition', May 1898; London, Continental Gallery, New Bond Street, 'Surrey Art Circle Exhibition', June 1901.
11. Commissioned in 1896.

THE BACKGROUND TO THE SHAFTESBURY MEMORIAL: MEMORIALS AND PUBLIC OPEN SPACES IN VICTORIAN LONDON

Mark Girouard

THE erection of memorials or monuments to individuals in public spaces was for long confined to kings and queens, both in the British Isles and on the Continent. From the early eighteenth century it became the convention for English town squares to have a royal statue, usually on horseback, in the centre; this convention had spread through Europe from Italy by way of France. Memorials to great commoners erected by public subscription or by public bodies, especially Parliament, began to appear in the mid-eighteenth century, but to begin with they were kept indoors. Westminster Abbey became an accepted repository for them; the many examples include monuments to Shakespeare, erected by public subscription in 1740, and to General Wolfe, erected by King and Parliament in 1772. In the great hall of the Guildhall the City Corporation launched what developed into a series of monuments to City heroes with Lord Mayor Beckford in 1772 (fig. 21) and Lord Chatham in 1782. Virtually all such monuments incorporated a bust or full-length statue, sometimes on its own, as in the Shakespeare monument, sometimes accompanied by allegorical figures or reliefs of notable events in the life of the person commemorated, as in the monument to Wolfe.

The provision of marble heroes developed into a major industry as a result of the Napoleonic Wars. In 1802 the Treasury set up a Committee of National Monuments specifically empowered to commission and pay for naval and military memorials. Its main achievement was the series of enormous monuments which still line the walls of St Paul's Cathedral. Modest but noble figures, some naked and some in contemporary dress, were accompanied by congratulatory angels or admiring allegorical figures, many larger than life. The inspiration clearly came from the Pantheon in Paris which had been converted from a church to a hall of national heroes in 1791: the Committee of National Monuments set out to make St Paul's a Christian Pantheon.

A new epoch started with the death of Nelson in 1805. The Napoleonic Wars were international wars on a scale hitherto unequalled, and Nelson became a new type of national hero. It was his cult which first broke the conventions and impinged on the ground which had been reserved for royalty. In 1805 subscriptions were opened in Liverpool for an open-air monument, and in 1813 a naked Nelson rising absent-mindedly from a froth of rigging, cannons and corpses, was erected on the main square of the city (fig. 22). By then Birmingham had already erected a more conventional statue of him in its Bull Ring. Other Nelsons followed all over the country, to be joined, on the younger Pitt's death in 1806, by a smaller, but sizeable, crop of Pitts.

The gates had been opened, and what started as a trickle had become a flood by the end of the century. Providing public memorials became the main source of income for

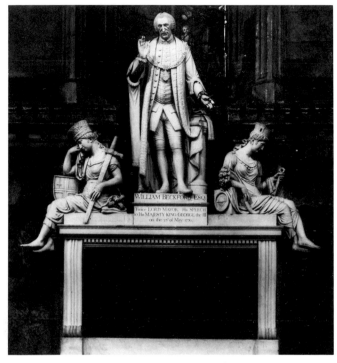
Fig. 21 J. F. Moore, *Lord Mayor Beckford*, 1772 (Guildhall, London)

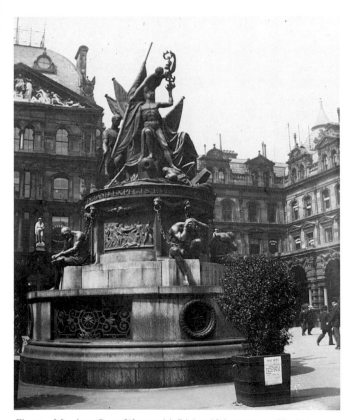
Fig. 22 Matthew Cotes Wyatt with Richard Westmacott, *The Nelson Monument*, 1813 (Exchange Flags, Liverpool)

Fig. 23 John Nash and Charles Barry, Trafalgar Square after the improvements of 1840

British sculptors. The industry reflected England's development into a constitutional monarchy, in which the nation's great men had a claim to commemoration equal to that of its monarchs. It was further encouraged by the development of that mighty feature of Victorian society and of the growing wealth and industry of the Victorian middle classes, the committee. Committees set up to promote almost every activity under the sun proliferated, among them committees by the dozen to collect subscriptions, find sites and commission artists for public memorials.

Some of these memorials were incorporated into bigger schemes of city townscaping or improvement. In 1840 Charles Barry was commissioned to design the layout for Trafalgar Square (fig. 23), in the space created as a result of John Nash's improvements of the 1820s but hitherto left empty. The Square as it finally emerged was considerably more elaborate than Barry had at first envisaged, and incorporated public memorials and statues of the great in a setting of terraces, steps, parapets and fountains around the centre-piece of Nelson's Column and against the back-cloth of the National Gallery. Barry's layout was designed after the National Gallery had been built, but was carefully calculated to set it off. This was the closest England was to come in the nineteenth century to Continental squares in which architecture, architectural embellishments and sculpture were combined in an integrated scheme, such as had already appeared in eighteenth-century Nancy and Paris in what later became the Place Stanislas and the Place de la Concorde. But in Victorian England the finest example of art, architecture and a public highway integrated together was not a square but the Holborn Viaduct (fig. 24), built in 1863–9 and mutilated by bombing and redevelopment in this century. Four great Victorian palazzos stood at the corners of an elaborate cast-iron bridge; allegorical figures surmounted the parapet of the

bridge, and statues of city worthies were incorporated into the four corner buildings.

In 1874 Baron Grant, the most famous, or infamous, of Victorian financiers and speculators, produced a modest imitation of Trafalgar Square, when he laid out Leicester Square to the design of James Knowles as a gift to the public. A statue of Shakespeare in the centre of the Square was accompanied by Hogarth, Reynolds, Newton and Hunter at the corners. In Waterloo Place the symmetrical layout of the buildings was gradually reinforced by a symmetrical layout of monuments, as the Guards Memorial to the Crimean War and Field Marshal Lord Napier (1891, later moved to Queen's Gate) were erected on the axis of the Duke of York on his column (1831–4) and monuments to Sir John Burgoyne (1877) and Sir John Franklin (1866) faced each other across the street. But on the whole, statues and monuments were set up with little reference to each

Fig. 24 William Hayward, Holborn Viaduct, London, 1863–9

other, although on occasion they were symmetrically aligned on the façades of an adjacent building.

Barry's fountains in Trafalgar Square were not very impressive, and were unkindly described at the time as 'pudding basins', but at least they were an attempt to introduce one of the most attractive features of Continental towns to England. There was little English tradition of public fountains, partly, perhaps, because of a feeling that England was wet enough anyway, but partly because of the nature of water supply in English towns. A running water system (if it existed at all) was not installed by popes or monarchs who

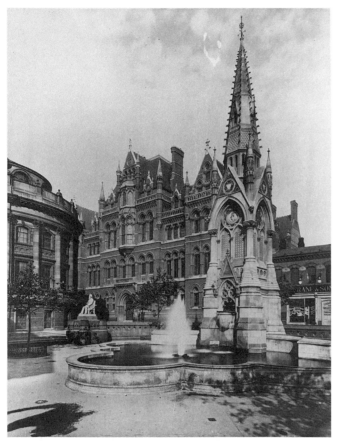

Fig. 25 J. H. Chamberlain, Chamberlain Fountain, Chamberlain Place, Birmingham, 1880

Chamberlain's honour in 1880, during his lifetime, in the main square of Birmingham. Drinking fountains were another matter altogether. The working-classes could seldom afford water-company water; they drank cheap gin, or water from wells or streams infected with sewage, and cholera was often the result. A drinking fountain was not only useful, but cheaper to install and run than an ornamental fountain: it was a natural vehicle for middle- and upper-class philanthropy. In 1859 the Metropolitan Drinking Fountain Association was founded, mainly by Quaker businessmen but with the support of a phalanx of titled

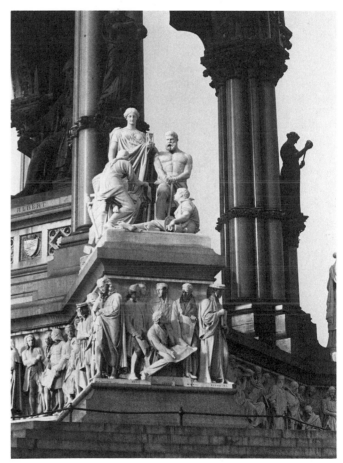

Fig. 26 Gilbert Scott, detail of the Albert Memorial, 1861–8

wished to commemorate their achievement, but by commercial water companies who lived off the rent paid by the users of their water and had no desire to pour their asset away in the form of fountains. Moreover, in English towns, London in particular, the water did not come down from high hills or mountains, and often lacked the head needed for a decent fountain. It was only gradually during the course of the nineteenth century that pressure was provided artificially, by steam-pumps pumping water into standpipes or high-level reservoirs. Barry's Trafalgar Square fountains were independent of the water companies; they were supplied from artesian wells in the neighbourhood, and the pressure was provided by steam-pumps pumping water into standpipes or high-level reservoirs. Barry's Trafalgar Square fountains were independent of the water companies; they were supplied from artesian wells in the neighbourhood, and the pressure was provided by steam-pumps in an engine house behind the National Gallery.

They found few imitators in or outside London; the grandest Victorian public fountain of this type was probably the Chamberlain Fountain (fig. 25), erected in Joseph

patrons, including Lord Shaftesbury. The Association scattered London with drinking fountains; many were very simple, but some were individually funded by rich donors and were more ambitious. Some incorporated figures of considerable charm, like the Greek nymph holding a pitcher installed at the expense of Lord Lansdowne at the south end of Berkeley Square, or the *Woman of Samaria* pouring out water for a cripple on the edge of Clapham Common. Some were purely architectural. Drinking fountains were also

Fig. 27　H. R. Pinker, *William Edward Forster*, Victoria Embankment, London, 1889

as a contemporary put it, as though he were 'throwing a School Board Primer into the Thames' from his pedestal on the Embankment. The tyranny of being forced to earn a livelihood by producing statues of conventionally dressed public men was much resented by those who agreed with John Gibson (1790–1866) that 'the human figure concealed under a frock coat and trousers is not a fit subject for sculpture'.

In this context it was inevitable that when Lord Shaftesbury died in 1885 a committee should be set up to commemorate him, and that one of the three projects on which it decided should be a portrait statue in a public place in London. From then on the story of the memorial was to be conditioned by the complex background history of public sculpture in nineteenth-century England (see pp. 135–8). Gilbert, who was one of the leaders of the movement for a new approach to public sculpture, persuaded his committee to accept the idea of a symbolic fountain instead of a full-length portrait statue. It was to the committee's credit that it accepted the idea and with it the nude surmounting figure, which was later to evoke howls of protest from the puritanical section of the public. But it still hankered after a portrait, and thought of fountains in terms of drinking fountains. As a result, by the time of the final unveiling in 1893, a portrait bust (not by Gilbert but by Edgar Boehm) had been clumsily incorporated into the outworks of the fountain, and it was designed to serve both as a drinking fountain and as an ornamental fountain. The bust quietly disappeared a few years later, but the double duty of the fountain was to bedevil its history, because on its constricted site the combination was unworkable. A decent flow from the ornamental fountain would soak those attempting to drink from the main basin; a drinking fountain could not use recirculated water, and the cost of running a proper fountain directly off the mains with water which had to be bought from the Water Company was prohibitive. As a result, a smaller flow of water than Gilbert had asked for was fed to the fountain, but even that proved unmanageable, partly because there was not sufficient expertise available to deal with the technical problems of running small jets directly off high-pressure water mains. The top half of the fountain was accordingly closed down a few months after it had been opened.

The site which produced some of these problems was eagerly sought after by the Memorial Committee because of its great prominence, but was far from ideal. The Metropolitan Board of Works had originally offered a site at what later became Cambridge Circus, on the new avenue which was in the process of being formed to improve north–south communications in Central London; the Board named the new street Shaftesbury Avenue just after their offer was made. The Memorial Committee preferred the site

erected in honour or memory of individuals, and in that case normally incorporated a statue or other representation of them.

Although some statues continued to have an accompaniment of symbolic figures (which in the Albert Memorial reached staggering proportions; fig. 26), one way or another portrait statues dominated public memorials. Memorials to individuals without a statue of them were a rarity; against the great nude Achilles erected by the 'women of England' to the honour of the Duke of Wellington on the edge of Hyde Park in 1822 could be set figures of Wellington on horseback erected all over England. Public nudity, in any case, grew unacceptable under Victoria, as did Roman dress. It was figures in contemporary clothing which spread across the British Isles and filled the streets and squares of London, ranging from Gladstone, imperiously pointing to the entrance of the public lavatory in the High Street of Stratford-in-the-East, to Forster (fig. 27), the instigator of the Education Act of 1870, looking,

Fig. 28 T. S. Boys, *Regent Circus* (Piccadilly Circus) *Looking Towards Lower Regent Street*, lithograph, *c.* 1840

in Piccadilly Circus (then called Regent Circus; fig. 28). After the demise of the Metropolitan Board of Works in March 1889, and its replacement by the London County Council, the Piccadilly Circus site was formally granted to the Memorial Committee on 14 January 1890.

By then, Piccadilly Circus was no longer the elegant circle originally designed by John Nash eighty years or so earlier. Shaftesbury Avenue had blown it apart. The new street was in fact a pathetic attempt to produce the equivalent of a Parisian boulevard on the cheap and without any sense of style: it was too narrow, and was lined with second-rate buildings, many on awkward sites resulting from not enough land having been bought up in the first place. A big triangular block of buildings, which had formerly closed one segment of the Circus, had to be demolished in order to link the avenue with Piccadilly and Lower Regent Street. The actual roadway went through the middle of the triangle, and divided it into two further triangles. On the smaller of these St James's Vestry, which was then the local authority, erected an extremely prominent public lavatory; the larger one was handed over for the Shaftesbury Memorial. Here the fountain arose, next to the public lavatory and in a space which had lost any kind of architectural form or coherence (fig. 29).

For the next ninety years both the Shaftesbury Memorial and Piccadilly Circus were to be the subject of constant schemes, mostly more or less abortive, and alterations of one kind or another, designed to improve the Circus, relate the Memorial satisfactorily to it, and in later decades to rescue it from the increasing weight of traffic which circulated round it. In the course of this period the Memorial itself gradually recovered from the attacks which had greeted its first appearance, and *Eros* rose to the status of one of the world's best-known and best-loved symbols.

Most of the earlier schemes involved 'squaring the circle'—getting rid of the three remaining convex sectors of the old Circus, demolishing the northern block of buildings to the west of where Shaftesbury Avenue emerges, rebuilding where appropriate and turning the Circus into a handsome open space, approximately square. Different schemes involved moving the Shaftesbury Memorial to different sites. All were the product of a movement to turn London into a suitably Imperial capital, of which the most prominent results were the rebuilding of Regent Street and the formation of a great triumphal way through the Admiralty Arch by way of the Mall and the Victoria Memorial to the new front of Buckingham Palace, all designed as one comprehensive whole by Aston Webb as a memorial to Queen Victoria.

Plans for rebuilding Regent Street included the remodel-

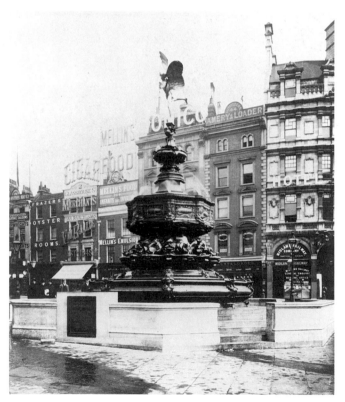

Fig. 29 Alfred Gilbert, The Shaftesbury Memorial, Piccadilly Circus, 1893

ling of Piccadilly Circus, but all that was carried out was the squaring off of the western sections to the design of Reginald Blomfield, in keeping with his rebuilding of the Regent Street Quadrant. In 1925 the *Eros* fountain was taken down and re-erected on a new island site aligned on the rebuilt façade of Mappin and Webb; here (but for the

traffic) Blomfield's façades provided a gay and elegant back-cloth to Gilbert's masterpiece. In 1930 it was taken down again for the construction of the Piccadilly Underground Station, but was re-erected a year later on much the same site, though with a different base. Post-war schemes have been more concerned with property development, traffic management and Piccadilly Circus's new rôle as a centre of London's entertainment and tourist industry than with Imperial dignity; but since they have all been abortive, there is little point in discussing them. The current scheme moves the Shaftesbury Memorial to a new site which provides some protection to *Eros* from the traffic and involves using new techniques to get the upper half of the fountain working again. These are great gains; but they still leave the ensemble of Piccadilly Circus in a mess, and destroy all vestiges of the fountain's relationship to the Circus's architecturally coherent portions. It seems likely that the restless story of the Circus and the fountain is far from over.

THE RESTORATION OF *EROS*

Timothy Bidwell

HE repair and restoration work recently carried out on the statue of *Eros* from the Shaftesbury Memorial Fountain, Piccadilly Circus, has highlighted several aspects both of the techniques employed in its creation, and of the problems which beset anyone embarking on the conservation of such a well-known monument.

The alterations to the traffic circulation in Piccadilly Circus currently being carried out have required the resiting of the Memorial in a new position some 12 m to the south of its original island. When the Memorial was examined in 1983, prior to dismantling, it was found that, not for the first time, both the statue and the bronze fountain needed repair and restoration. Indeed, the statue gave considerable cause for concern, since it appeared to be fractured in a number of places, including the supporting left leg, which seemed also to have been distorted and loosened from its support. The GLC, which was carrying out the road works in Piccadilly Circus, therefore decided to proceed as swiftly as possible with the repair of the Memorial, and in July 1984 the dismantling commenced with the removal of *Eros* to the workshop of Charles Henshaw & Sons, at Edinburgh. The work is under the control and supervision of the Council's Historic Buildings Division.

The choice of an Edinburgh firm to carry out this work may seem strange when the statue was originally cast in London, and has subsequently been repaired by London firms. However, apart from their unquestioned expertise as founders and metalwork craftsmen producing aluminium alloy castings, Henshaws have one unique advantage over other firms considered for the job: they employ as a consultant a sculptor/caster whose father worked for Gilbert himself during the last few years of his life—George Mancini. Mancini comes from a line of Italian craftsmen responsible for many of Rome's nineteenth-century statues, and he personally carried out or supervised most of the repair work needed on *Eros*, devoting an enormous amount of time and care to ensuring that the statue was restored to a condition that was compatible with his own experience of Gilbert's wishes and intentions.

The statue was cast in 1891–2 by the lost wax method at the foundry of George Broad & Sons, in London. The

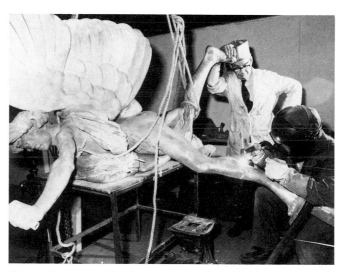

Fig. 31 Argon arc welding in progress on crack in left leg.

Fig. 30 Alfred Gilbert, *Eros* during restoration in Henshaws' workshop, Edinburgh, 1985; cleaning mainly completed, old repairs cut out.

metal used by Gilbert was aluminium, which in itself has always presented something of a challenge to repairers, since, because of the formation of a refractory oxide skin which prevents adequate fusion, it has in the past been extremely difficult to weld in new metal if needed. The use of the 'Argon Arc' method of welding has, however, overcome many of the problems associated with this aspect of the restoration work. Samples taken from the statue at various times for analysis have shown the metal used to be

very pure—more than 98%. Traces of copper, tin, lead and zinc have shown up in the samples, but these are thought to indicate contamination from the pots in which the aluminium was melted (which had been used for bronze) rather than deliberate additions. The high purity of the aluminium has been largely responsible for the excellent surface condition of the statue which has always been noticeable whenever it has been cleaned. When pure aluminium is exposed to the atmosphere, it quickly develops an inert and protective film of aluminium oxide. This has a high resistance to corrosion, which is reduced when the aluminium contains larger amounts of impurities or certain alloy elements. This can be clearly seen in the only full-sized copy to be made by Gilbert of the Memorial, at Sefton Park, Liverpool, where the aluminium used for the statue was much less pure, and has suffered severely from atmospheric corrosion as a result.

Eros has in fact been taken down on four other occasions since the Memorial was erected in 1893: during the First World War; from 1925 to 1931 while Piccadilly Circus Underground Station was being constructed; early in 1932, after being severely damaged on New Year's Eve; and during the Second World War. Each time it has been cleaned, and a considerable number of repairs have had to be carried out. The need for these has arisen chiefly because *Eros* has for many years been the focal point for all sorts of celebrations. Perhaps the worst damage occurred on 31 December 1931, when during the New Year's Eve festivities a reveller climbed up on to the statue, mutilating the bow and bowstring beyond repair, loosening the joint of the left arm, forcing one of the small head wings from its seating, fracturing one of the large wings and the right leg, and injuring the surface of the statue in several places. More seriously, however, the man swayed to and fro on the statue, loosening the aluminium of the left supporting leg from the armature which holds up the whole figure. Refixing was then attempted by pouring molten aluminium through the leg at several different points on to the armature, but it is now known that fusion will not take place in such circumstances, and the fixing remained loose. The other damage was skilfully repaired by the firm of A. B. Burton, of Thames Ditton.

The last time *Eros* was repaired was in 1947, before it was returned to Piccadilly Circus after the Second World War, when it was cleaned and restored in the workshop of J. Starkie Gardner Ltd. A careful record was then made of its condition, including previous repairs, and again a new bow was provided, of forged, rather than cast, aluminium.

In 1984, as in 1947, before any work was started on the statue, a detailed examination was made of it to locate and plot old repairs and new damage. This was carried out visually and with the aid of radiography, and it confirmed that, although the aluminium itself was generally in good condition, there were a number of defects which needed attention. The radiographic survey of the internal detail particularly revealed a number of interesting features, the most notable being the discovery that the standing leg, which was thought to be at least partly solid, was, like the other castings, hollow. Other features revealed were a number of thin iron bars at various positions in the arms and legs, which were inserted to support and ventilate the core during the casting of the individual sections from which the statue is made up. At least fifteen separate castings were used—head, torso, legs, arms, large wings, head wings, drapery and bow, as well as the seventeen flight feathers on the large wings. Most of the castings are hollow, and are joined together in the conventional manner for such sculpture by spigot and socket ('Roman') joints, fixed with aluminium pegs or rivets. In one or two places bronze rivets were used, presumably for extra strength. The casting of the statue is said to have been closely supervised by Gilbert, who then dressed and finished the joints himself, so that they became virtually invisible. During the early stages of the repair work it was suggested that because the statue was so exposed to damage, a complete and accurate copy of it should be made while it was in the workshop. The idea of using the original statue to make moulds from which the copy could be cast would not however have been practicable or desirable, since the moulds could not have been made without taking the statue to pieces, thus destroying some of Gilbert's original work at the joints. The compensation needed for the loss in dimensions on each casting—a copy taken in this way is always slightly smaller than the original—would also have been a most difficult undertaking.

The idea of casting accurate copies of at least the most vulnerable parts of the statue was nevertheless attractive, and was greatly helped by the discovery at the Victoria and Albert Museum of all Gilbert's original plaster casts for the statue, except the head wings, conch shell and bow (fig. 32). Agreement was readily obtained to the loan of the plasters of the left leg and both arms, so that repairs to the statue would match as faithfully as possible Gilbert's original intentions, and that moulds could be made for exact copies to be taken if needed.

A visual examination of parts of the interior using an 'endoprobe' indicated that there was no significant corrosion inside the statue. This removed one nagging worry, that moisture might be seeping into the statue through casting defects and cracks in the aluminium.

The repairs carried out this time were limited to those items considered vital to enable *Eros* to continue to occupy with safety its position in Piccadilly Circus for the foreseeable future. First, the whole statue was swabbed down to remove loose grime, and the surfaces of the wings and drapery were then cleaned using grains of aluminium oxide

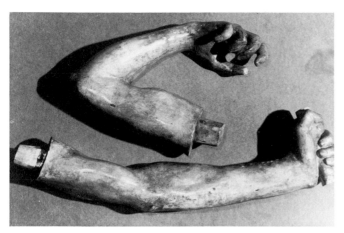

Fig. 32 Alfred Gilbert, original plaster casts for arms of *Eros* (Victoria and Albert Museum)

blown onto it from a very low pressure jet. Visual examination had shown that where the surface of the statue had been freely exposed to the weather, a dull grey continuous patina had developed, with no evidence of corrosion beneath it. Areas protected from the washing effect of rain, on the other hand—for example, the folds of the drapery, the undersides of the wings, and certain parts of the face—had developed a very much darker bulky corrosion product, due to acid gases such as sulphur dioxide and the accumulation of carbonaceous materials. Removal of this thicker deposit revealed only superficial pitting of the aluminium, though not enough to affect the character of the sculpture. The cleaning process used was a dry one, again to avoid any possibility of water penetration into the statue.

The cleaning also revealed the full extent of the repairs needed. These fell into three broad categories: the cutting out and filling of cracks and fissures, the renewal of unsightly discoloured old patches and repairs, and the repinning of defective joints. In more detail, crack-like fissures on the supporting (left) leg, left arm and both large wings were examined using dye penetrant detection techniques, and some were shown to be superficial while others were confirmed as serious. They were then chased out and repaired by welding, using metal of equivalent composition to the parent material.

Old patches in the left foot and thigh, both arms, and the drapery where it crosses the back of the neck behind the shoulders, had badly discoloured due to the use of differing alloys of metals. One patch on the left leg was beginning to lift away from the original aluminium. All these old patches were cut out, and it was noted that some of the castings in these positions had been filled with concrete reinforced with iron rods, or in one case, paper and sand, presumably to provide a firm bed to support the repairs, and to prevent molten metal running back down the inside

Fig. 34 Alfred Gilbert, left arm of *Eros* showing patch on shoulder during restoration

Fig. 33 Alfred Gilbert, left foot of *Eros* before restoration, showing old lead repair to toes

Fig. 35 Alfred Gilbert, left foot of *Eros* during restoration; old repair cut out and surface being prepared for new patch to be cast

of the casting. Before any of the patches were cut out, plaster moulds of the parts were made from which 'positive' models were produced. These were cast in the same metal as the statue, and were then welded into position. The surface was then hand-dressed to make the patches virtually invisible.

The left wrist showed some evidence of previous repairs, as a number of pins were visible. It was also felt that it might at some time have been bent, as the bow appeared to be out of alignment with the arm itself, and the wrist was awk-

Fig. 36 Alfred Gilbert, left foot of *Eros* showing completed repair

wardly placed in relation to the forearm. However, once the original plaster casts for the statue had been located, a comparison was possible, and it became clear that the slight distortion in the wrist was intentional on the part of Gilbert.

The bow itself had been severely damaged, and the lower half was out of alignment with the upper half. As this is perhaps the most vulnerable part of the statue, it was decided to cast several replicas, so that if it is badly damaged again, it can be replaced easily. The bow is in two halves which screw into a threaded sleeve grasped by the left hand, so it is readily dismantled. The bowstring is made of aluminium wire, and a number of replacements have also been made of this.

The flight feathers of the large wings were pinned separately to the main wing castings, and several showed signs of lifting. The joint of the left wing at the shoulder was not satisfactory, as there was a gap showing which could have allowed water to enter the hollow torso casting. There was also considerable pitting of the wing surfaces, probably due to casting flaws. All these defects were repaired by welding or pinning, using high-purity aluminium, and individually dressed afterwards.

During the repairs to the left leg, the iron armature supporting the statue was examined in some detail by means of the 'endoprobe', and was found to be clean and uncorroded. This armature runs right up inside the left leg, and is wound round with copper wire.

Repatination was necessary, as some parts of the statue had been cleaned down to bright metal in order that the repairs could be successfully carried out in metal that matched the original as accurately as possible. A number of ways were tried to achieve a varying degree of tone until the natural patination was re-established. Most of the traditional methods involved the use of mercuric chloride in one form or another, but it was established that this would have a corrosive effect on the aluminium, so it was avoided. In the end, a simple formula based on a well-known brand of black ink, plumbago and polishes was found to be the most successful and least damaging way of producing a weathered effect. The finished surface was then treated finally with lanolin.

One small but interesting feature revealed by cleaning was a series of incised marks at the base of the front of the neck, whereby with the aid of a plumb line Gilbert was able to make final adjustments to the vertical position of the statue when setting it on its base.

The bronze fountain which forms the main part of the Memorial is now undergoing similar treatment in Henshaws' workshop in Edinburgh, and a new internal supporting frame of stainless steel is being made to replace the brick and concrete structure which originally supported it.

'ILL-BALANCED GENIUS': ALFRED GILBERT
AND THE ROYAL ACADEMY

Richard Dorment

WHEN speaking of the Royal Academy in the years 1885–95 Alfred Gilbert referred to the influence on him of two men, the President, Frederic Leighton (1830–96) and Joseph Edgar Boehm (1834–90), Gilbert's former mentor. Leighton lured Gilbert back from Italy with the temptation of the commission (unfulfilled) for the Quadriga above the arch at Hyde Park Corner, and, smooth courtier that he was, dropped Gilbert's name in the right places at the right moments, constantly putting him forward for commissions calculated to further his career as a sculptor and goldsmith. The commissions for the Epergne (Cat. 53) for Queen Victoria, the Preston Mayoral Chain (colour pl. p. 71), and the John Howard Memorial at Bedford all came to Gilbert as a result of Leighton's recommendations. Boehm was responsible for the commissioning of the Shaftesbury Memorial from so young and relatively untested a sculptor, and Gilbert recalled that for the 1886 Royal Academy exhibition he modelled *The Enchanted Chair* in plaster (fig. 38) 'and pushed [it] forward for exhibition . . . against time at Boehm's instigation . . . unfinished as it necessarily was'.[1] If Boehm did pressure him, Alfred Gilbert may well

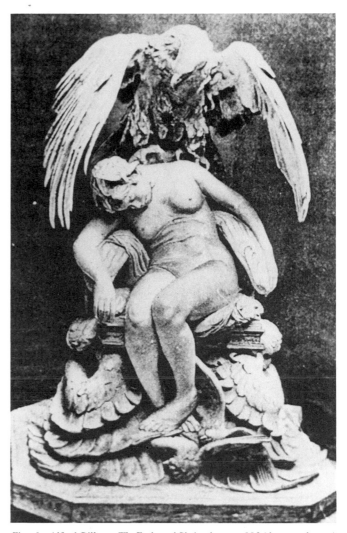

Fig. 38 Alfred Gilbert, *The Enchanted Chair*, plaster, 1886 (destroyed 1901)

have needed encouragement to declare his productions exhibitable, and *The Enchanted Chair* was a huge critical success, leading directly to Gilbert's election to the Academy as an associate the following year.

Both Leighton and Boehm also enlisted Gilbert in those activities of the Royal Academy, often overlooked by art historians, concerned not with exhibiting but with education. As early as June 1883 Gilbert and Boehm were lecturing together at the Academy on the *cire perdue* process of bronze casting.[2] Later Gilbert never hesitated to share his knowledge of the history of sculpture, his technical skills, and his organisational powers with colleagues and students. When he was elected to full membership of the Royal Academy in 1892 *The Morning Leader* for 12 December declared: 'it is safe to say that no Academician has ever been more popular among the students than Mr. Gilbert. He takes an interest in them, which is more that of a comrade than of

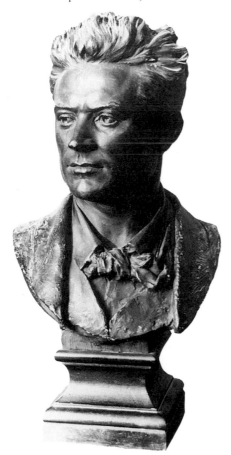

Fig. 37 Joseph Edgar Boehm, *Alfred Gilbert*, plaster painted black (ht 61.2 cm/24½ in), *c.* 1885 (Private Collection)

a master, and most of the work which he does for them—and it is not a little—is done outside the walls of the Academy.'

Of course, he exhibited at the Royal Academy regularly between 1882 and 1907, often contributing the most distinguished and original works in sculpture for any given year. He was also willing to undertake work behind the scenes: as a member of the Council in 1894 he served as one of the Inspectors of Property and on a sub-committee for inquiry into the terms of the refreshment contract. In the same year he served more conspicuously as a member of the Hanging Committee for the Summer Exhibition; and in June he was elected to mount the Winter Exhibition for 1895.[3] Not content with the usual Winter Exhibition, he proposed and selected a display of cinquecento jewellery, consisting of seven showcases of drawings and objects revealing the art of the sculptor-goldsmith. The backbone of the exhibition was formed by the collections of Sir A. W. Franks (1826–97) and Sir John Charles Robinson (1824–1913) comprising rings, necklaces, pendants, earrings, cameos, gems and intaglios, but the Press seized upon the pieces lent by the Royal Family as a personal favour to the sculptor.

Gilbert undoubtedly loved the Royal Academy; perhaps he loved it too passionately, too unrealistically. The saga of his diploma piece illustrates this and might serve to epitomise the way in which he seemed irresistibly driven into conflict with those things he most valued. On his election to full Academician in 1892 he was required to present one of his own works to the Royal Academy. He could easily have presented a cast of any one of his bronzes and so satisfied the Academy regulations at a stroke, with little expenditure of time or emotion. But (he wrote) his sense of the immense honour accorded him by his election, and of his duty in response to it, forbade him to comply with the regulations in the usual way. With the Academy's permission he deposited a small silver *Victory* belonging to his friend Seymour Lucas, not in lieu of a diploma piece but as a symbol of it, until he could finish the intended work.[4] On 13 November 1893 he wrote to the President and Council apologising for his delay. He had designed, 'and in great part executed', a large vase, 'adapted for use at any time for decorative purposes, in any of your Galleries'.[5] The vase would be of bronze, and easily movable.

The Council accepted this arrangement but continued to press for delivery. The pressures leading to the breaking up of Gilbert's studio in the later 1890s prevented his completion of this work, yet at no stage did he ask the Academy to accept another statue as his promised diploma piece. When the Academy's Secretary wrote to him in January 1900 inquiring once again, Gilbert replied that he was not then able to comply. In his studio, however, he had 'a model practically complete' of a jardinière to be cast in bronze, the ornamentation of which comprised an autobiographical catalogue of his life's aims. This he had designed specifically for the octagonal Central Hall at Burlington House. Its dimensions were about 6 ft square by 9 ft high, the size, very roughly, of the pedestal of the Shaftesbury Memorial.[6]

The impracticality of executing so huge a monument—far more elaborate than any other diploma piece in the Royal Academy—illustrates one reason why so much that Gilbert undertook turned to dust: the grandeur of his ideals had little bearing on reality. Lucas's silver *Victory* remained on deposit, and the jardinière was never produced. Only after the periodical *Truth* drew attention to the situation in 1906 did he write to the Academy asking for the return of Lucas's cast in exchange for a simple bronze one.[7] The exchange was not made, however, until 19 March 1909, by which time, ironically, Gilbert was no longer an Academician.[8] Like a love affair gone wrong, the relationship that had started so hopefully degenerated into distrust and then recrimination. Neither party seemed able to communicate with the other, and after 1903, when Alfred Gilbert began to live permanently in Bruges, he was not present at Burlington House to explain himself to the Academicians. The saddest aspect of what followed is the degree to which neither artist nor Academy wished the break to occur.

When he declared bankruptcy in 1901, Gilbert's most loyal supporters were his fellow Academicians. Privately they lent or gave him money and wrote sympathetically to him. As a body they commissioned from him their new gold medal with a portrait of Edward VII, a project he began but never finished (fig. 39). Above all, in 1900 they elected him to the Sculpture Chair, enabling him to deliver his celebrated series of lectures to the students in 1901, 1902, 1903 and 1905. The position carried with it a stipend, but its real value to Gilbert lay in the trust that the Academy publicly placed in him.

If Leighton had personified the Academy in the 1890s, then his successor, Edward Poynter (1836–1919), did so in the early years of this century. It was left to him to defend Gilbert against patrons like Henry Hucks Gibbs, Lord Aldenham (1819–1907), who in 1902 asked the Academy to censure the miscreant sculptor for accepting money but failing to finish commissions. Poynter's defence of Gilbert was anything but faint-hearted, and reveals the esteem in which he held the sculptor: 'The case of Gilbert is most distressing, + I fear that he treats every one in the same way; but that, as you say, does not make the matter better. There is no doubt that he hopes, + fully intends to carry out all the commissions which he accepts with such alacrity + enthusiasm, but his moral fibre I fear is gone + the more he becomes involved in difficulties the less energy he has for extricating himself by regular work.' Poynter refused to remonstrate with Gilbert simply because he doubted whether he would have an effect: 'We have all come to the

Fig. 39 Alfred Gilbert, *Edward VII* (sketch for a medal), wax on slate (25.4 × 17.8 cm/10 × 7 in), *c.* 1901 (Jean van Caloen Foundation, Loppem)

regretful conclusion that he is hopelessly incorrigible.' Poynter offered to bring the matter up with the Council but made it plain that he would regret doing so: 'He is so warm-hearted + has so many loveable qualities that it would be with great regret that we should require his retirement from our body, although, as you justly remark, he reflects no credit on the institution: and I am afraid it would only further help towards his ruin without bringing him to a better sense of his responsibilities.'[9] The Academy therefore did nothing.

Three years later, in 1905, Mrs Julia Frankau (1864–1916) appealed to Poynter asking whether there was any rôle the Academy could play in obtaining justice for her in the matter of the money she had given Gilbert for her husband's memorial, which he did not complete. She did this not to hurt Gilbert but to allow the Academy to intervene 'without the unpleasantness of a public exposure'. Poynter read out her letter at a Council meeting of 12 December 1905 but replied that the Academy 'have no power to interfere with any private obligation entered into by Mr. Gilbert as a sculptor'. However, the Council agreed to write to Gilbert with a copy of her letter.[10] Here, the reticence of the Academy may actually have done Gilbert harm, for when he failed to reply, Mrs Frankau took her story to *Truth*, who denounced Gilbert in two long articles published on 15 and 22 March 1906.

The Academy did everything in its power to avoid censur-

ing Alfred Gilbert, but by not doing so it placed itself in a position where its only course was to expel him. The crisis finally came when the powerful Duke of Rutland made complaints about the loss of his subscribers' money for the huge Leicester *Victory*, begun, but again not completed, by Gilbert. On 12 May 1908 Poynter brought the question before the Council: 'He thought the time had come when some decided action should be taken in regard to the conduct of Mr. Gilbert R.A.' During the Frankau affair Gilbert 'had taken no notice of any of [their] letters. Since then many other complaints of similar conduct on the part of Mr. Gilbert had been received which [Poynter] did not hesitate to characterize . . . as dishonourable + unworthy of a member of the Royal Academy'.[11] It was decided to write to him, 'drawing his attention to the above facts + stating that, as it was impossible, looking at the sources from which they came, to doubt the accuracy or question the justice of the complaint made, the President + Council felt that they had no alternative but to suggest to him the desirability of his resigning his membership of the Royal Academy'.[12] Should he fail to resign, he would be expelled.

Gilbert did not answer this letter. The Council resolved to bring the matter before the General Assembly on 25 November. Two more registered letters were sent to Bruges without reply, and on 9 July Poynter undertook to write privately to him. By 3 November no answer had been received. On 17 November Gilbert began to answer these letters, saying that he was preparing 'a categorical reply' to the Council.[13] Now, suddenly, with expulsion staring him in the face, he worked frantically to stay in the Academy. His mother telegraphed to the King. He himself sent a telegram begging Edward VII to listen to his son whom he despatched to England 'with facts and full explanations'. But it was too late. The King's equerry, Sir Dighton Probyn (1833–1924), telegraphed: 'Your request is quite impossible—The King cannot see your son. You had better therefore recall him'.[14] Not since 1799 had an Academician (James Barry, 1741–1806) been expelled, and rather than secure the dubious distinction of becoming the second member in its history thus treated, Gilbert wrote to the President and Council asking them to accept his resignation. The date of this letter was 24 November, the day before the General Assembly was to meet.

At the time of these events Gilbert maintained that he would eventually publish 'full particulars' stating his side of the case. He never did, but the wound was deep. So many of Alfred Gilbert's sculptures have an autobiographical symbolism that one might surmise that his pain would find expression through his art. However, his symbolism can be difficult to understand unless he himself provides the key. In the cases of *Perseus Arming*, *Icarus*, and *Comedy and Tragedy*, he spoke eloquently about their private symbolism; in other

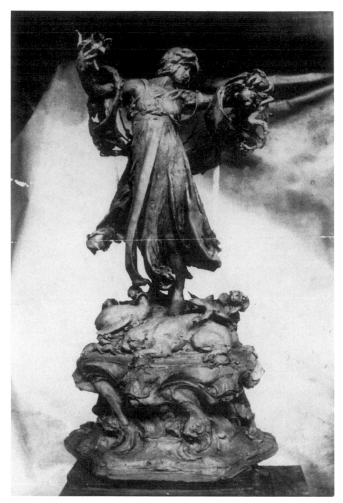

Fig. 40 Alfred Gilbert, *Circe*, clay, September 1912 (destroyed)

more accurately she is Leighton enticing the youthful Alfred Gilbert to leave Italy for England and so lose his soul to the commercial affair he felt art to be in his native country. Gilbert wrote to his patron, the Rev. Brocklebank, warning him against buying *Circe* which he called a 'lampoon upon a rotten and gradually decaying system'.[16]

Gilbert cannot have known how loyal many of the academicians actually had been, nor with what reluctance they had acted against him. It is true that his son George expressed surprise as early as 1906 that his father should wish to exhibit at the Royal Academy, as he knew, in the wake of the Frankau scandal 'the antagonistic attitude' of its members towards Alfred Gilbert. Yet the critic M. H. Spielmann (1858–1948), when asked many years later, could think of no artist whom he could characterise as an enemy of Gilbert.[17]

The fact remains that the Royal Academy never forgot Alfred Gilbert's behaviour. Twenty-four years passed before he was invited to resume membership, and then, although the vote was unanimously in favour of issuing the invitation, it was held only at the request of King George V, who wished to see Gilbert reinstated before knighting him in 1932. The last word should, perhaps, be Poynter's, who closed his letter to Lord Aldenham quoted above: 'It is in fact the saddest case of ill-balanced genius that I ever heard of'.

NOTES
1. 'Notes for incidental anecdotes belonging to middle period . . .', MS in the collection of Air Chief Marshal Sir John Barraclough.
2. George Simonds, 'The Art of Bronze Casting in Europe—I', *American Architect and Building News*, LIII, no. 1076 (18 July 1896), pp. 21–2.
3. Royal Academy Minutes of Council, CXX, 1894–9 (19 June 1894).
4. See Gilbert's letters to the President and Council of the Royal Academy preserved in the library of the Royal Academy: 13 November 1893 (RAC/I/GI/3 i); 21 November 1893 (RAC/I/GI/4); 10 January 1901 (RAC/I/GI/7 i and ii).
5. 13 November 1893 (RAC/I/GI/3 i).
6. RAC/I/GI/7 i–ii.
7. 'The Artistic Conscience', *Truth* (22 March 1906), p. 690; RAC/I/GI/9 i, 15 February 1907.
8. 'Passing Events', *Art Journal*, May 1909, p. 160.
9. St Albans Cathedral Archive, 'The High Altar Screen of the Cathedral Church of St Alban', vol. III, fols 371–2 (24 November 1902).
10. Royal Academy Minutes of Council, CXXI, 1900–6, fol. 471.
11. Royal Academy Minutes of Council, CXXII, 1907–12, fol. 137.
12. Op. cit., fols 137–8.
13. Op. cit., fol. 176.
14. Windsor Royal Archives, PP.ED.VII, D 30605.
15. Ganz 1934, pp. 14–15.
16. MS Oxford, Ashmolean Museum.
17. Spielmann to Lady Helena Gleichen, 9 November 1934, MS the late Roger Machell, London; quoted in Dorment 1985, p. 141.

cases, such as his *Circe*, he never wrote publicly about its meaning because it was never cast in bronze and was left incomplete in 1914 (fig. 40). *Circe* was a light, extravagant, over-elaborate masterpiece, a spinning elf streaming magic tendrils round her animal victims—who form the upper section of the base, above the babies, fish, and waves below. *Circe* symbolises England luring unwary artists to her island and there taking from them their humanity, turning them into beasts. Indeed, the statue's meaning is even more bitter, for in 1911 Henry Ganz described the work as 'a *small group of Circe turning her lovers into fish, birds and animals*, they typifying some of the R.A.'s [J.M.] Swan, [Eyre] Crowe, a Badger [Thomas] (Brock), and Poynter.'[15] So if Circe is England, then she is more precisely the Royal Academy and even

COLOUR PLATES

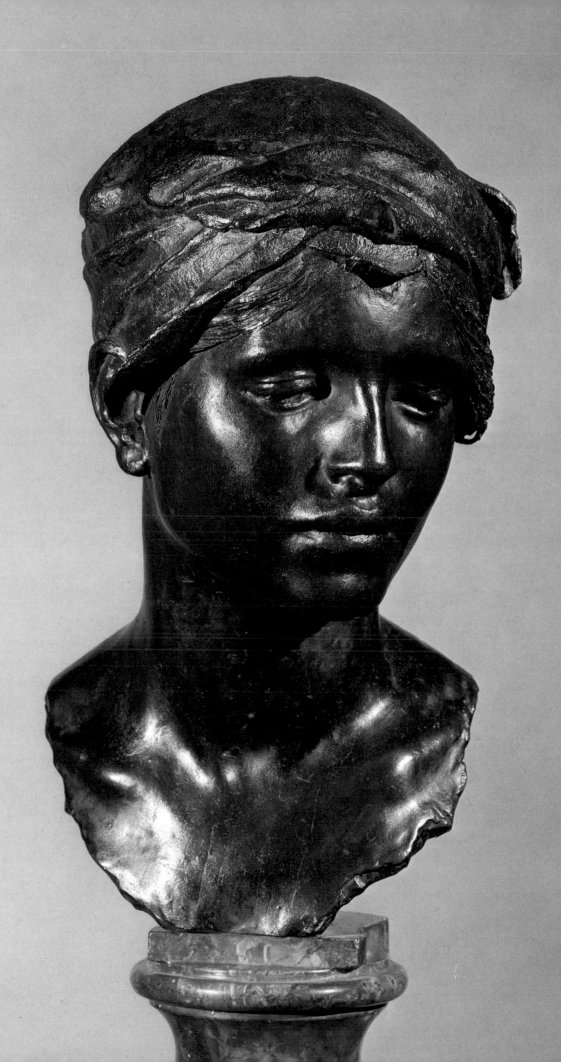

Cat. 12

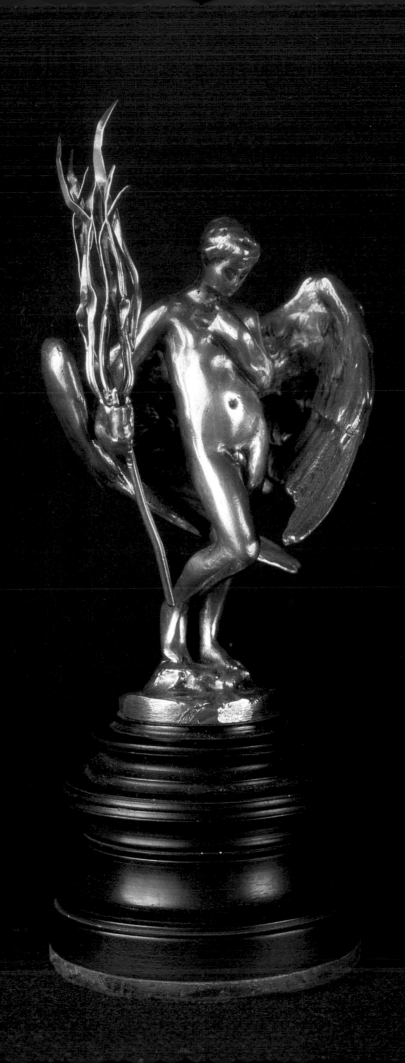

Cat. 20

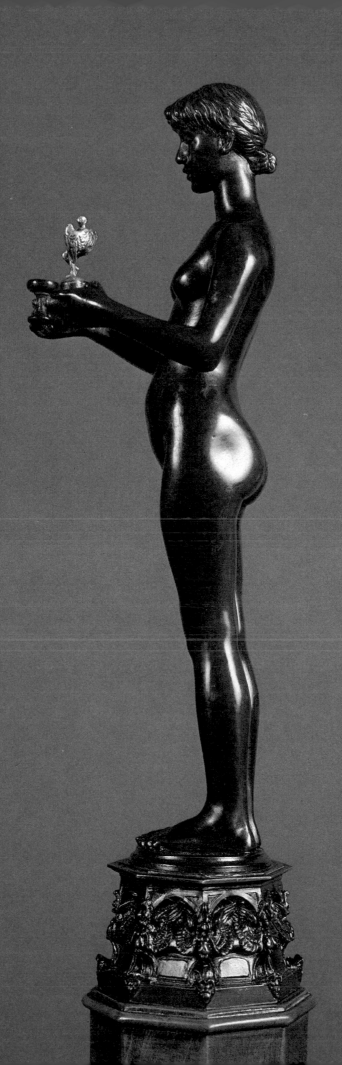

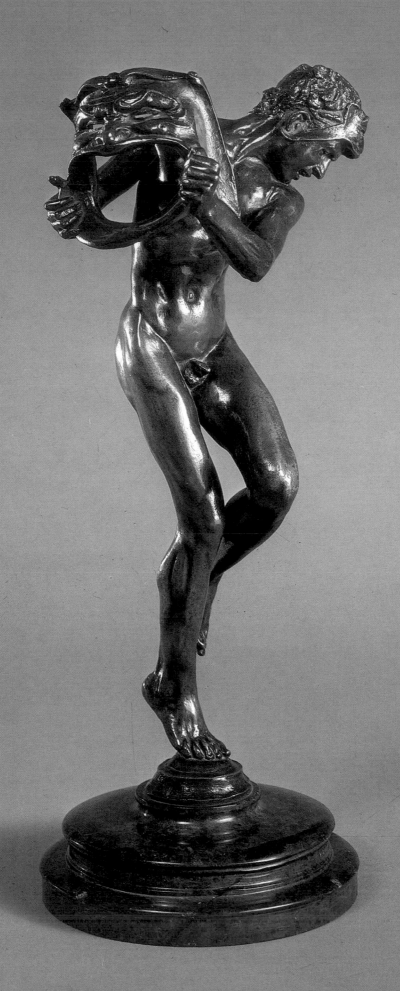

Cat. 23

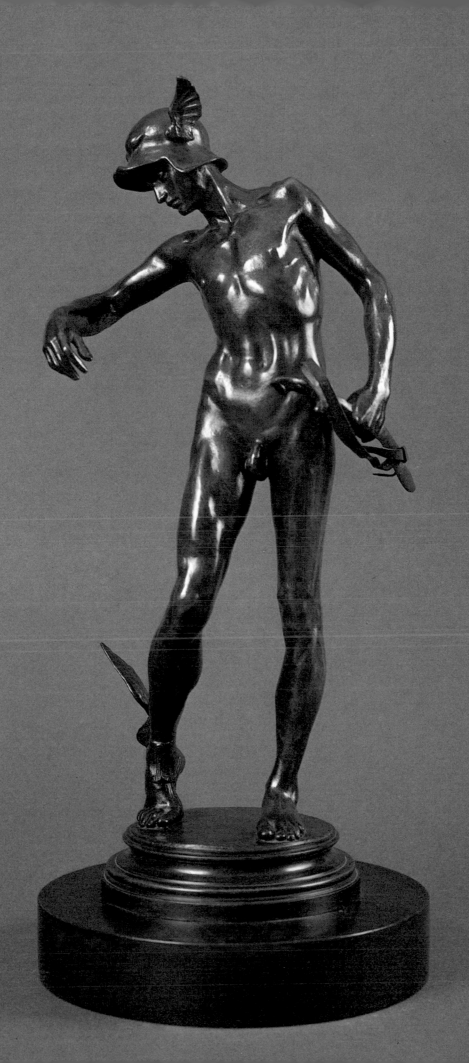

Cat. 11

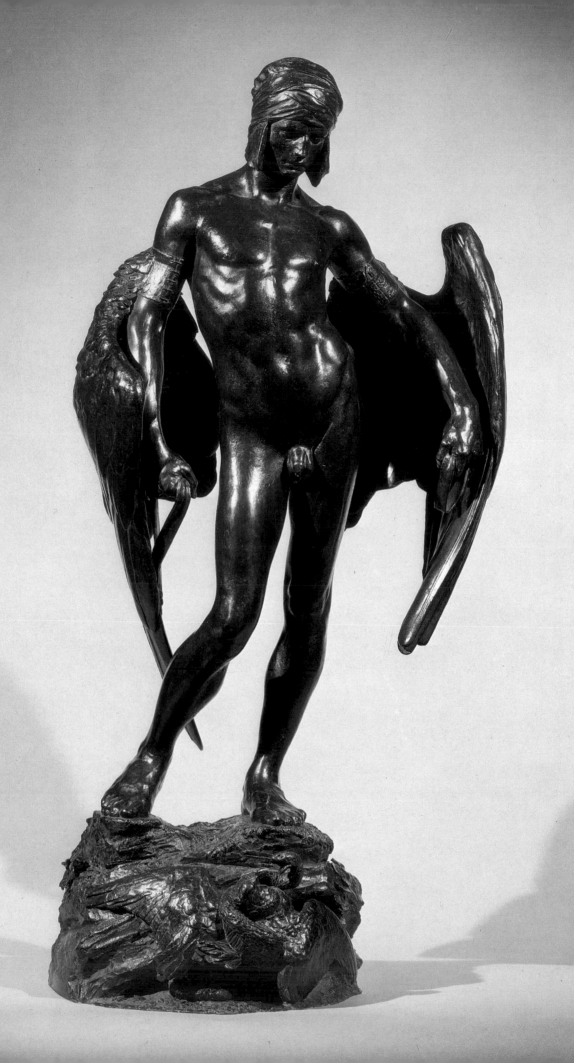

Cat. 15

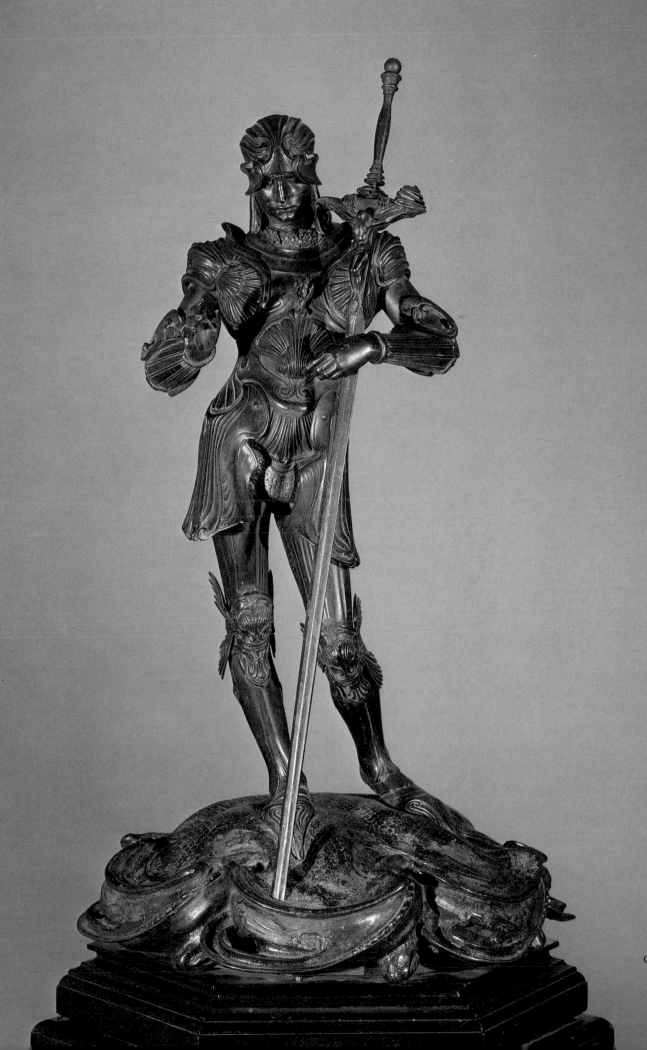

Cat. 72

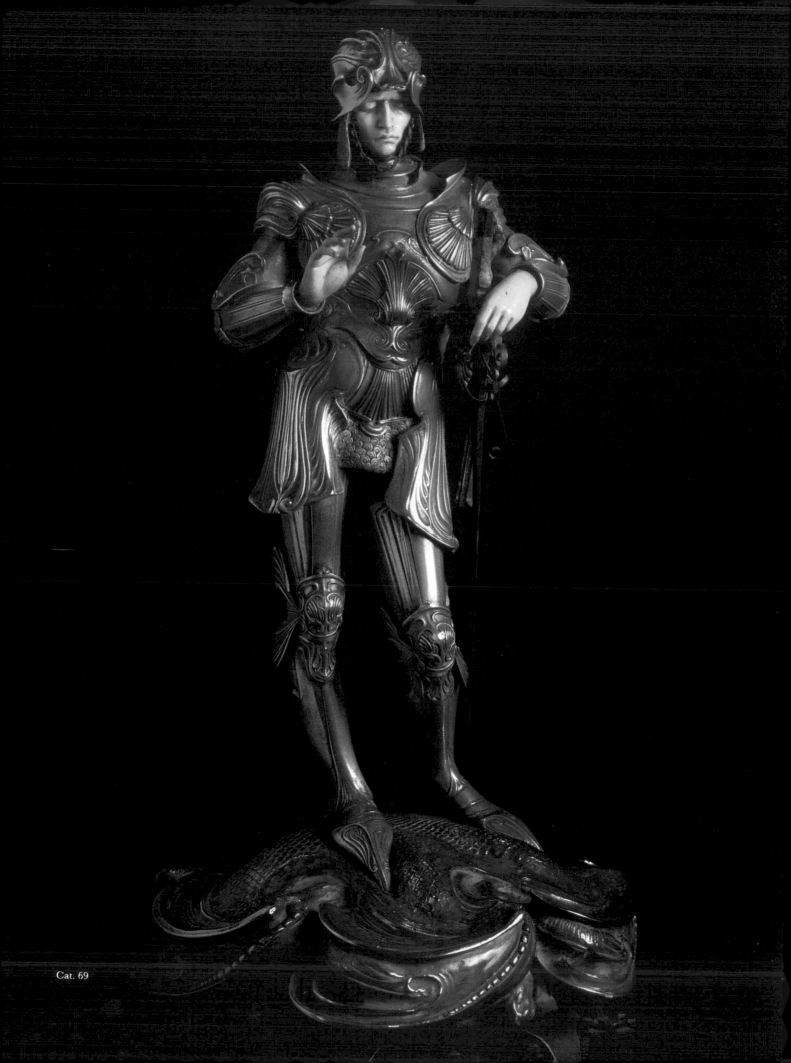

Cat. 69

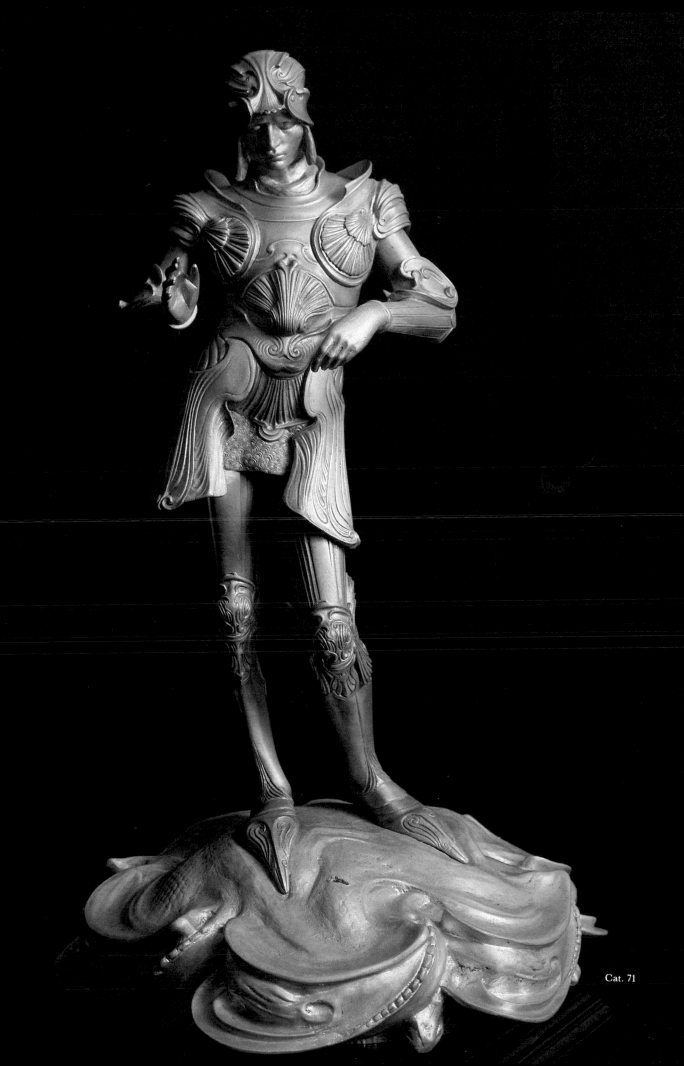

Cat. 71

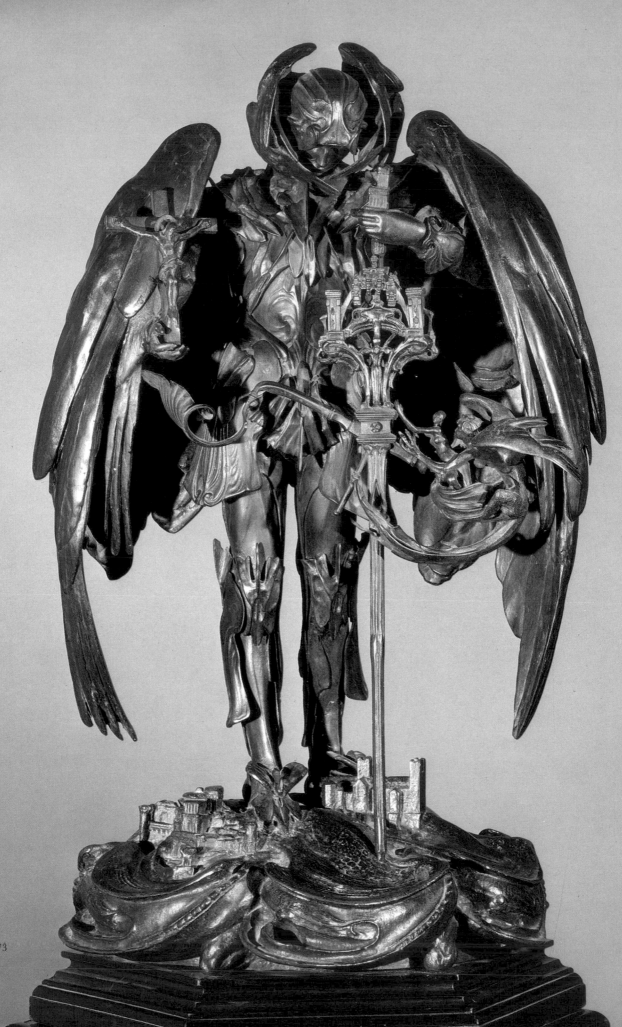

Cat. 73

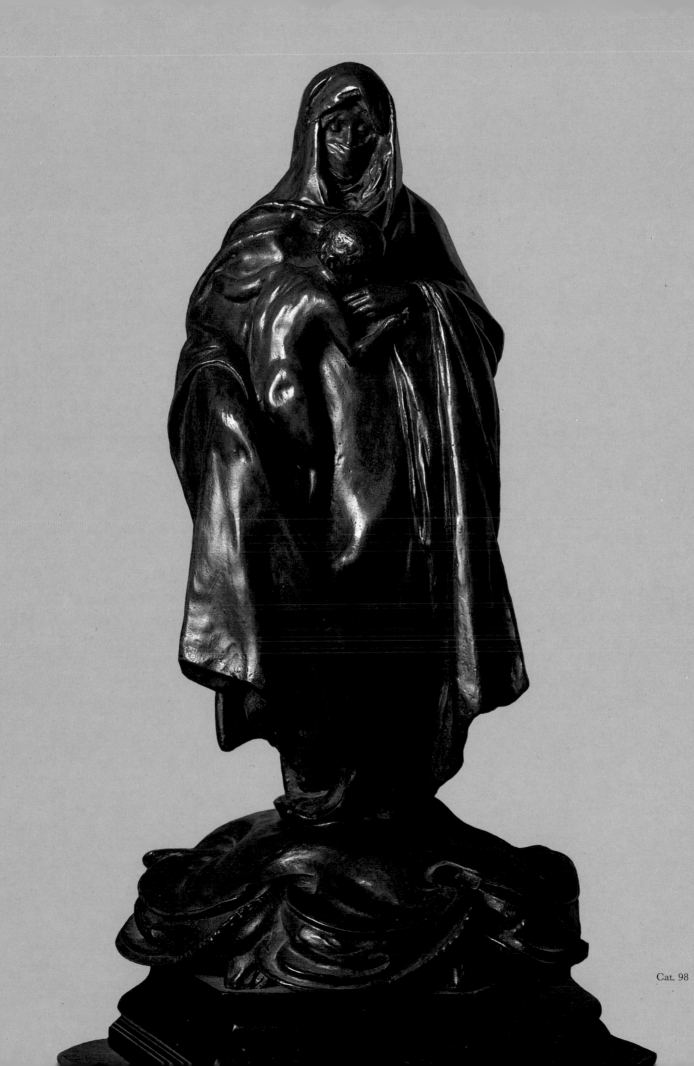

Cat. 98

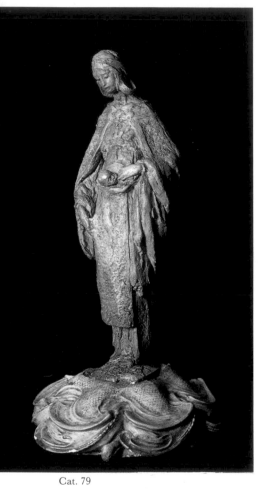

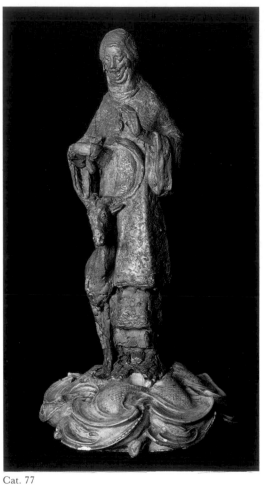

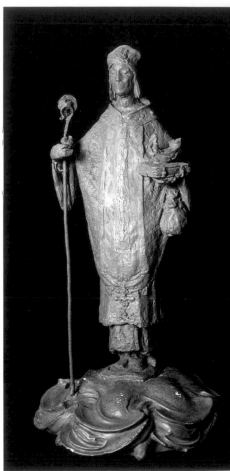

Cat. 79

Cat. 77

Cat. 78

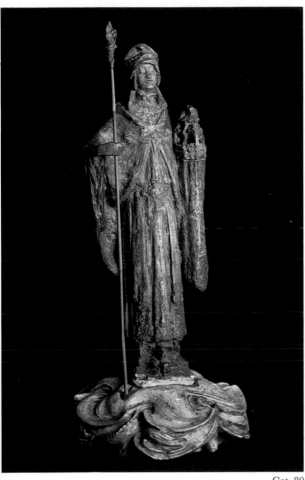

Cat. 80

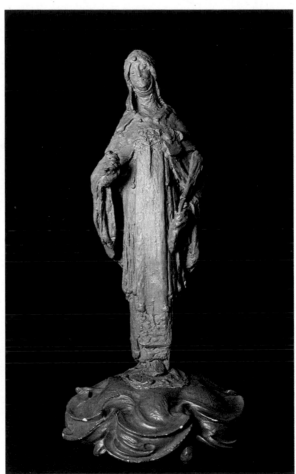

Cat. 81

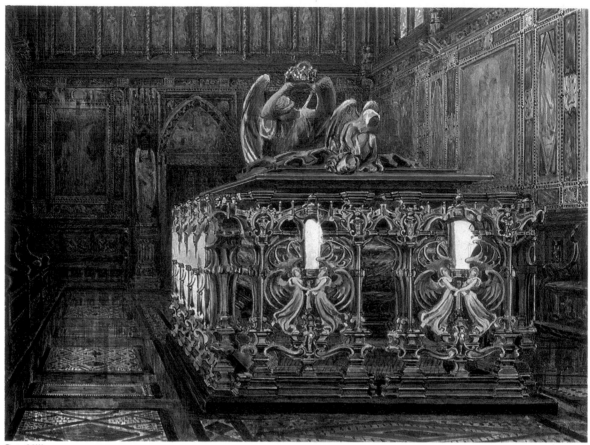

Cat. 66iii

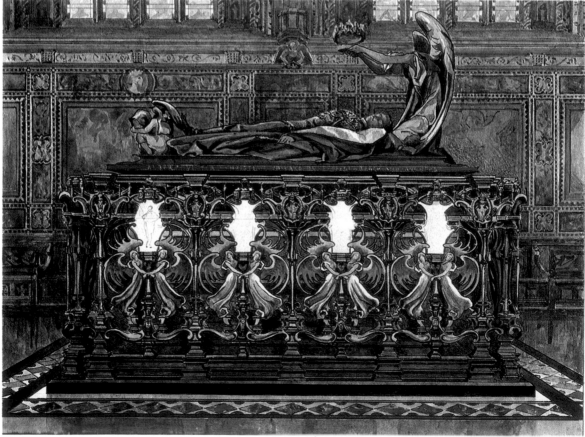

Cat. 66ii

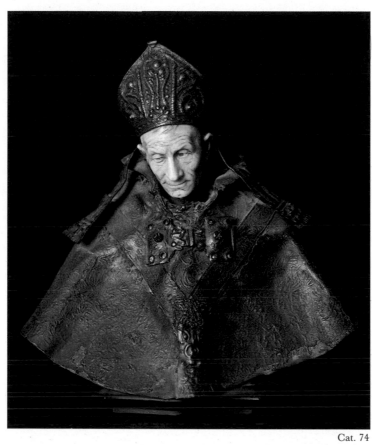

Cat. 74

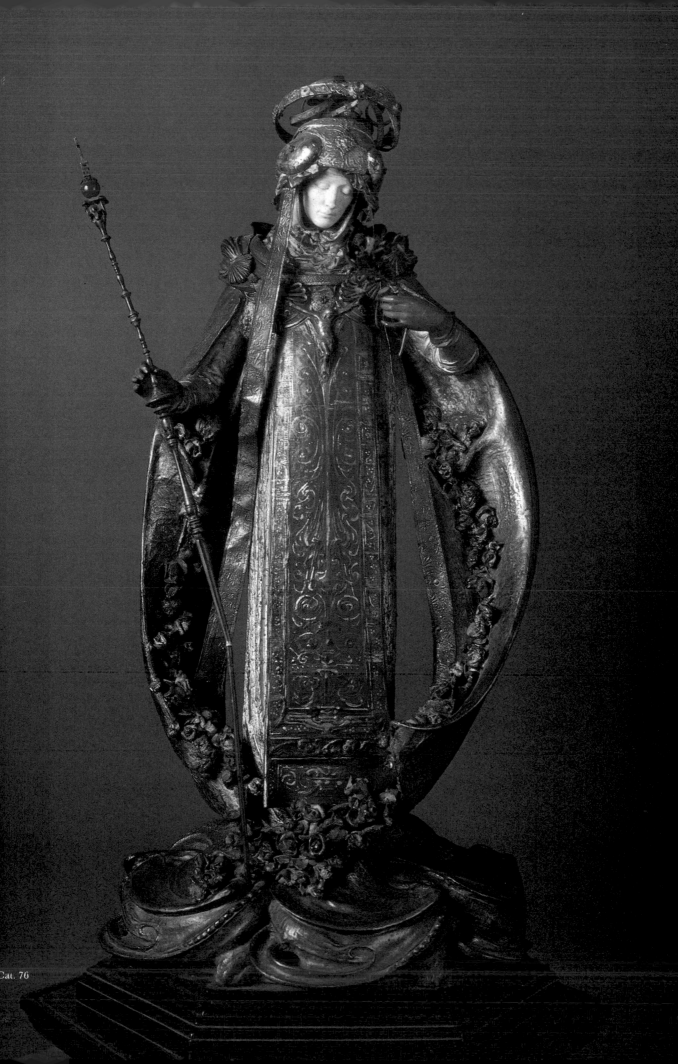

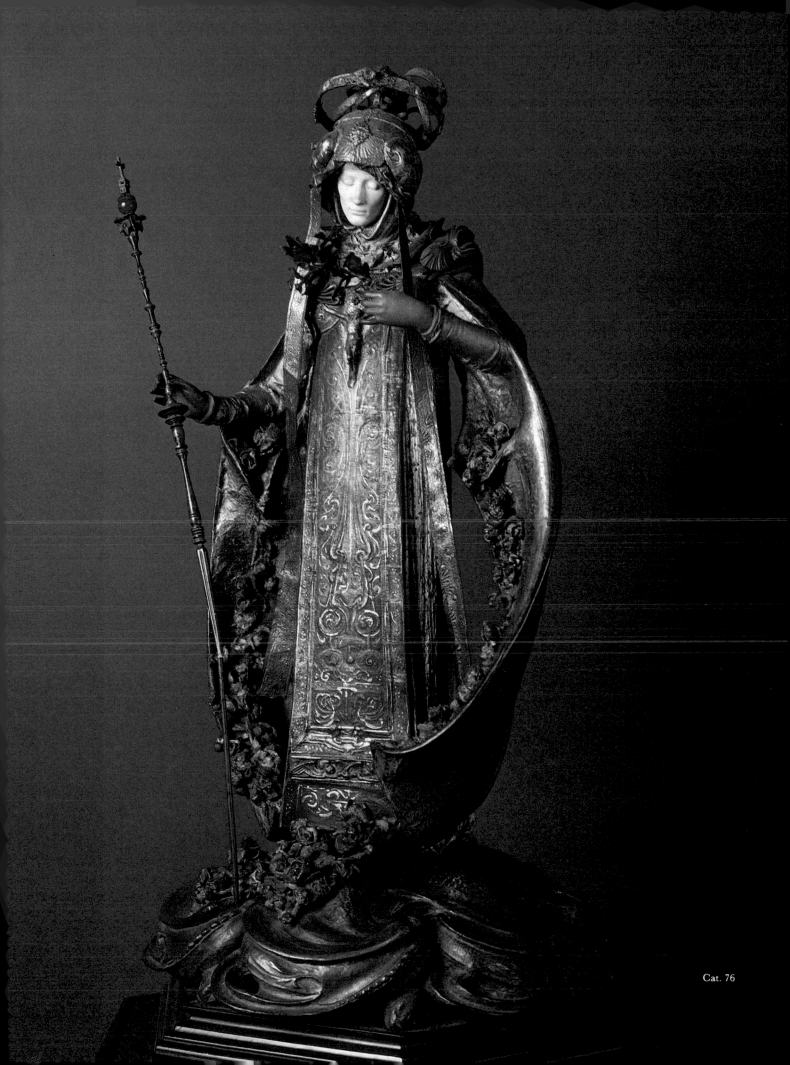

Cat. 76

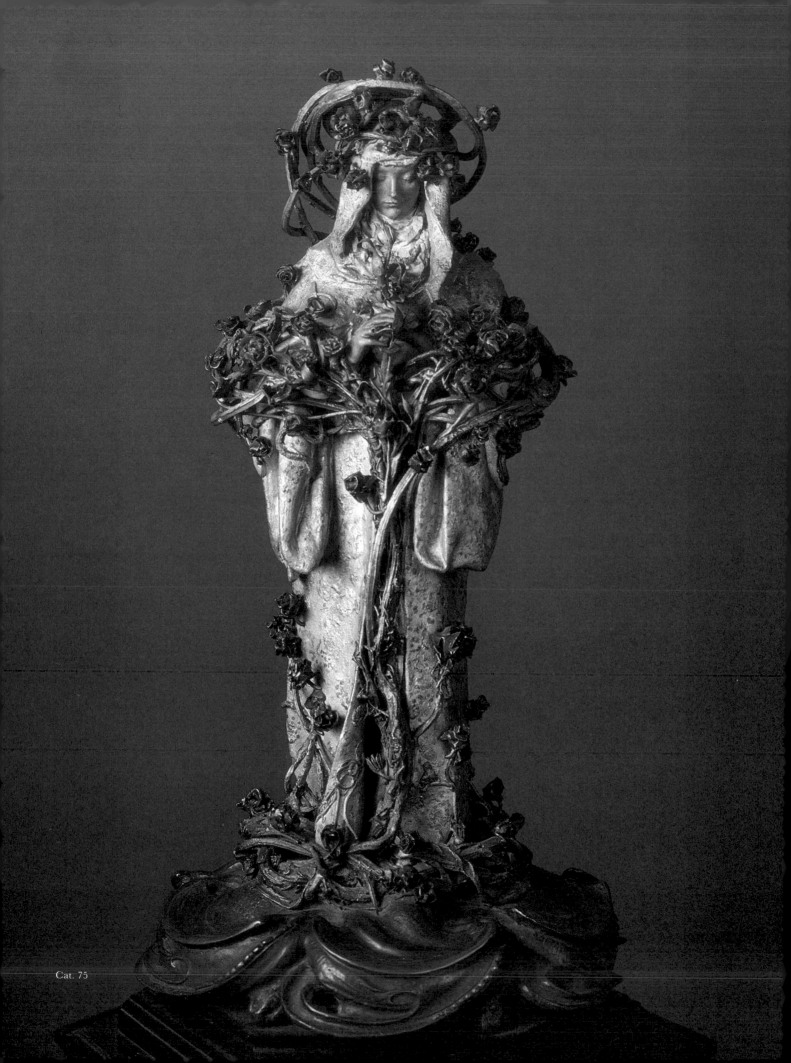

Cat. 75

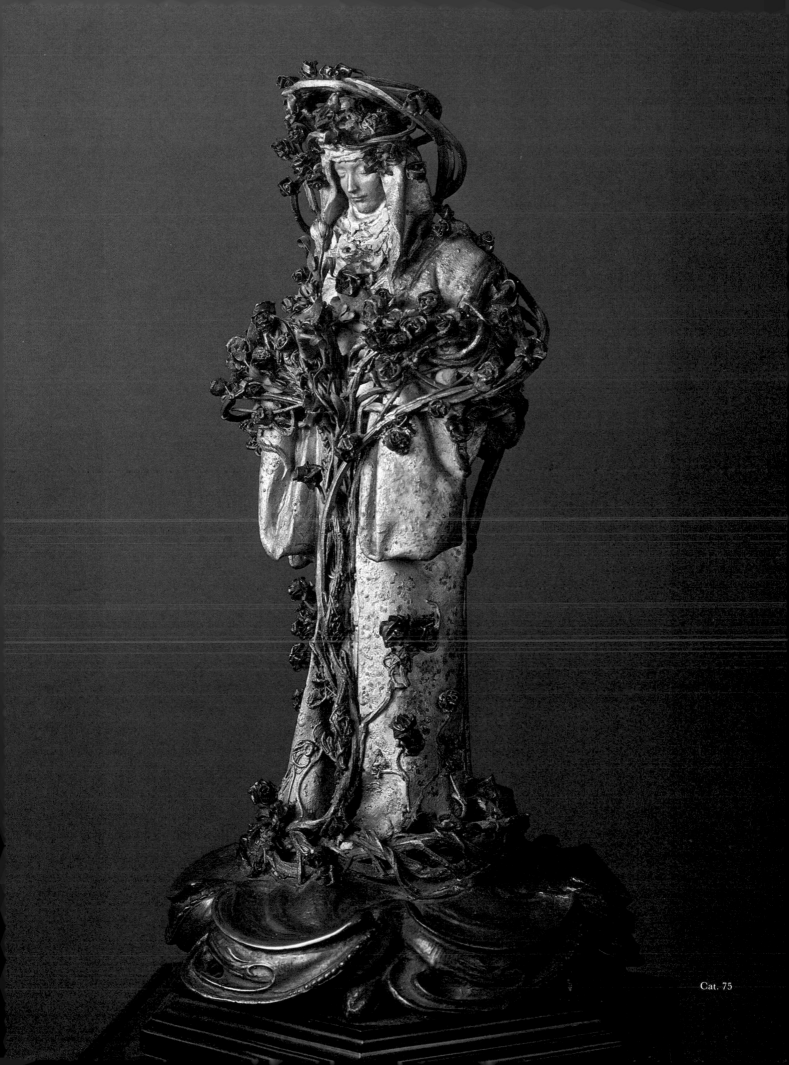

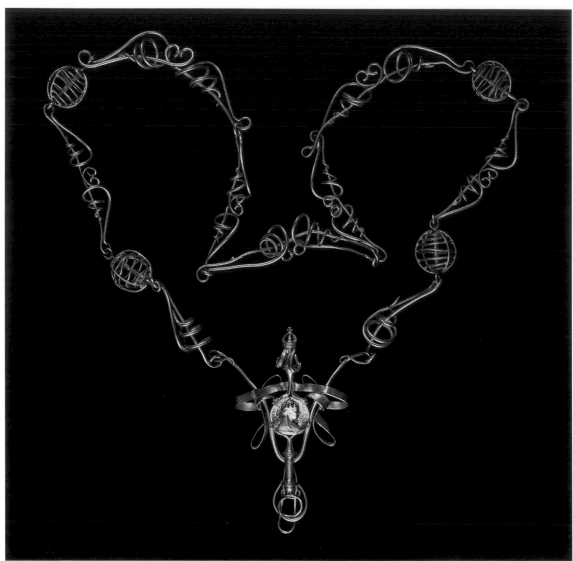

Cat. 54

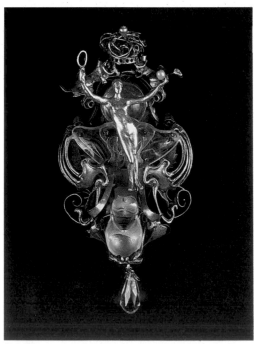

Cat. 54

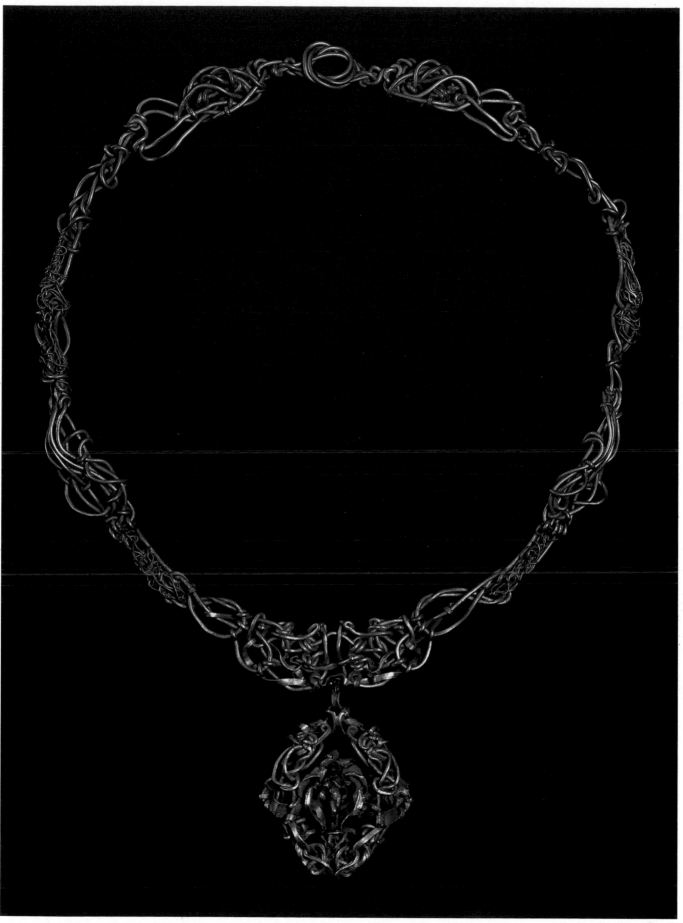

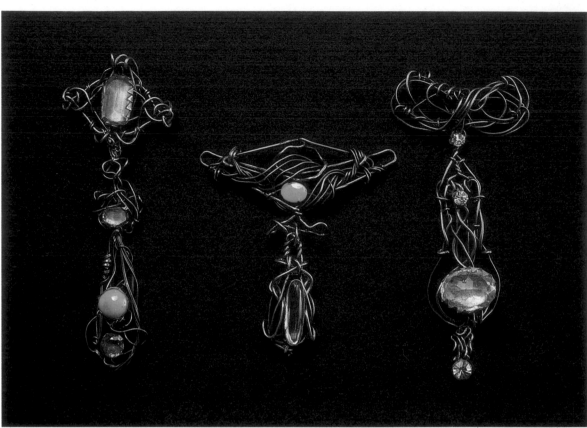

Cat. 65

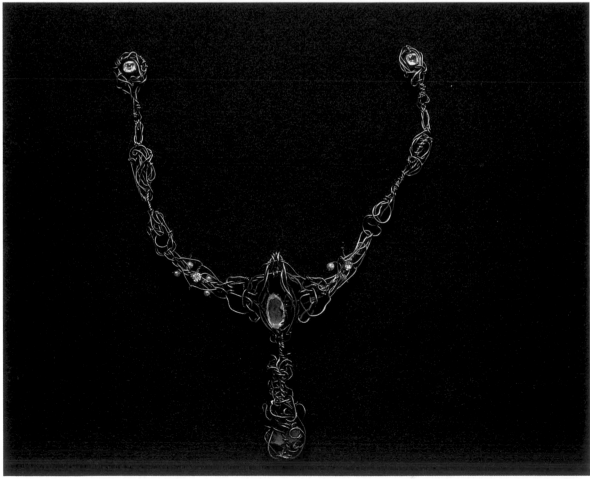

Cat. 65

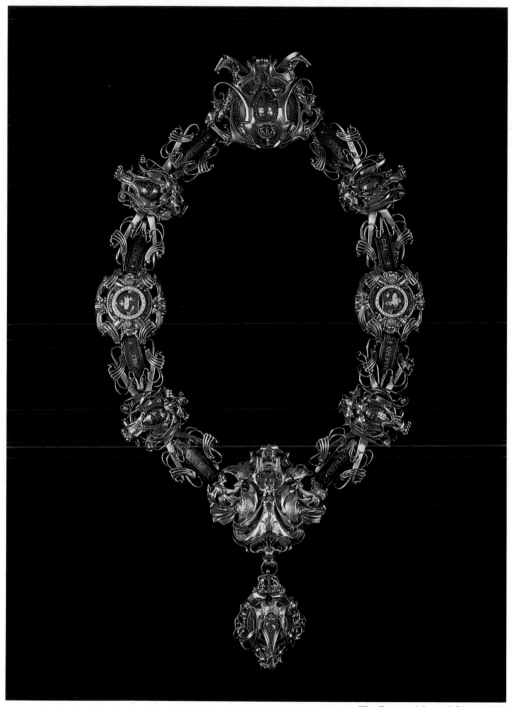

The Preston Mayoral Chain, 1894

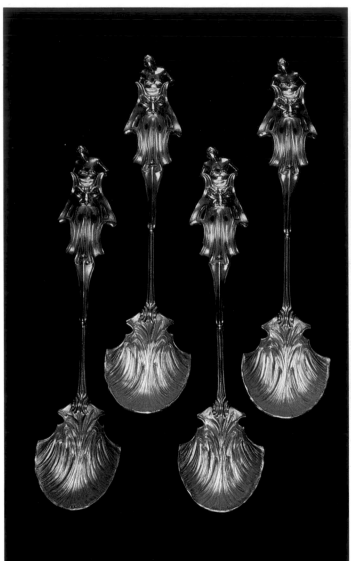

Cat. 58

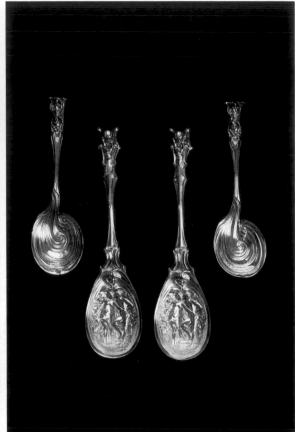

Cat. 58

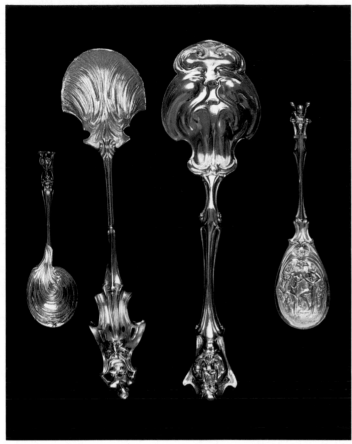

Cat. 58

Cat. 58

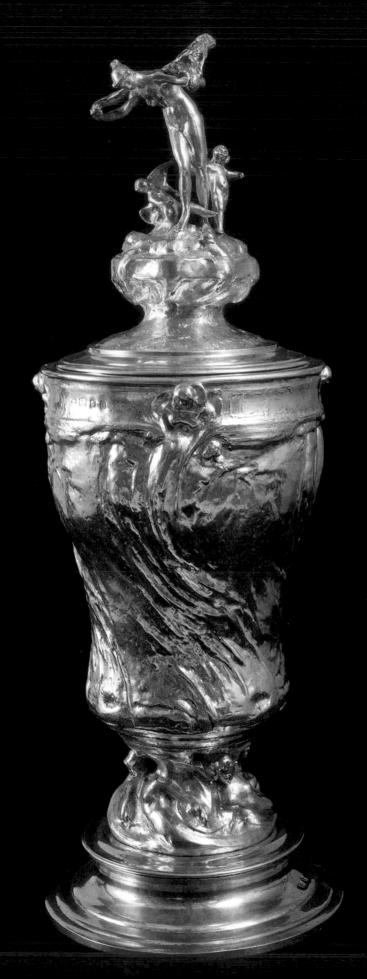

Cat. 62

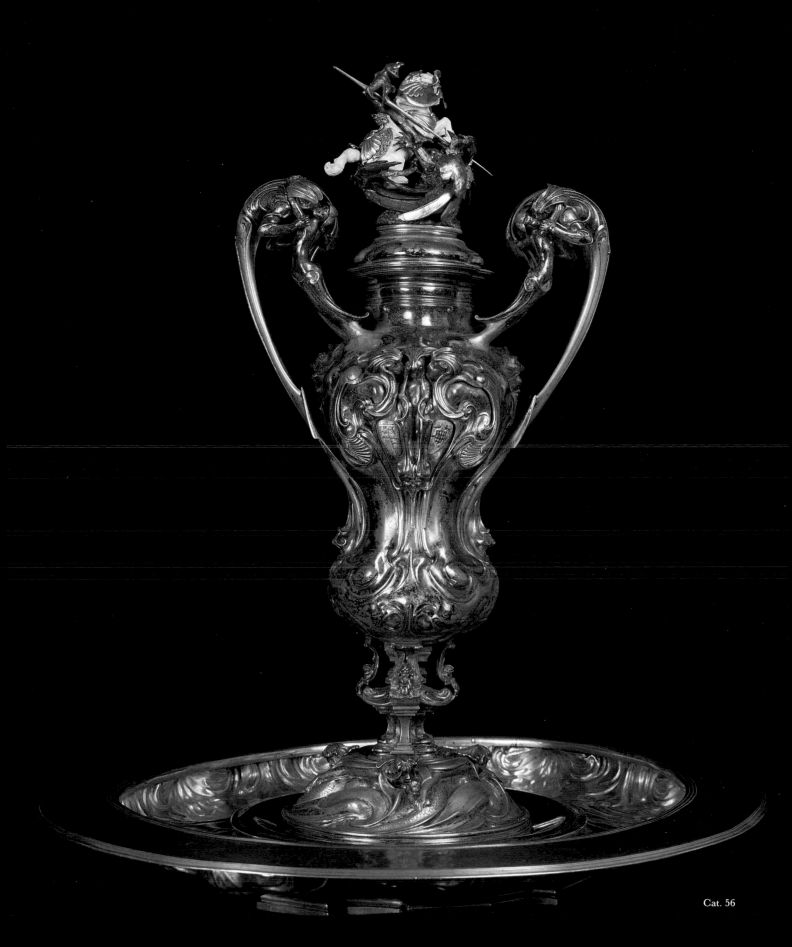

Cat. 56

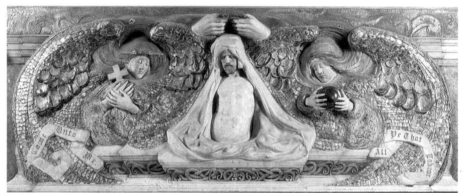

The St Albans Reredos, *c.* 1890 – 3

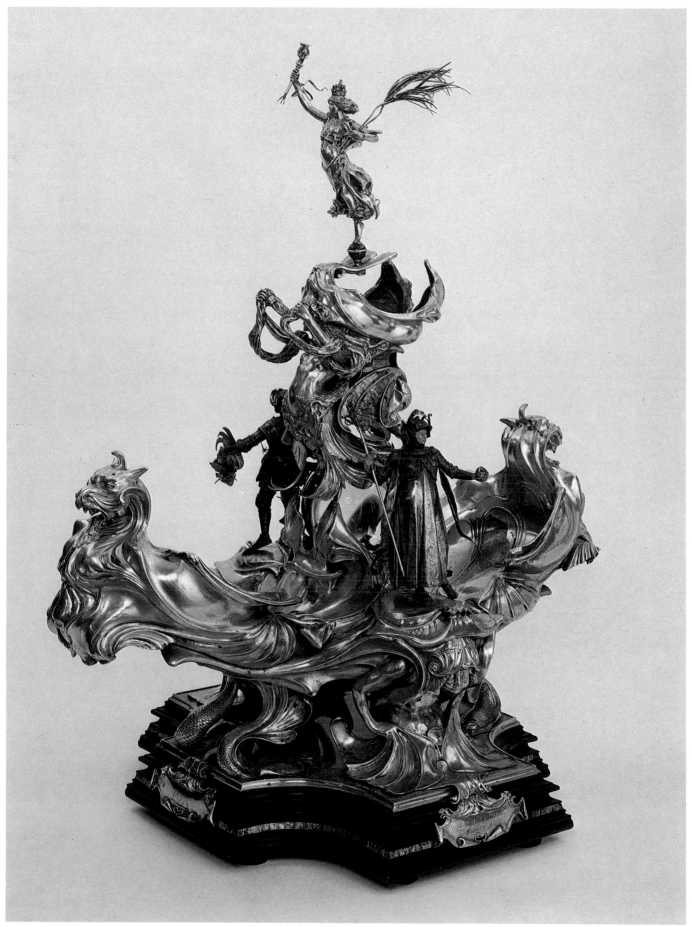

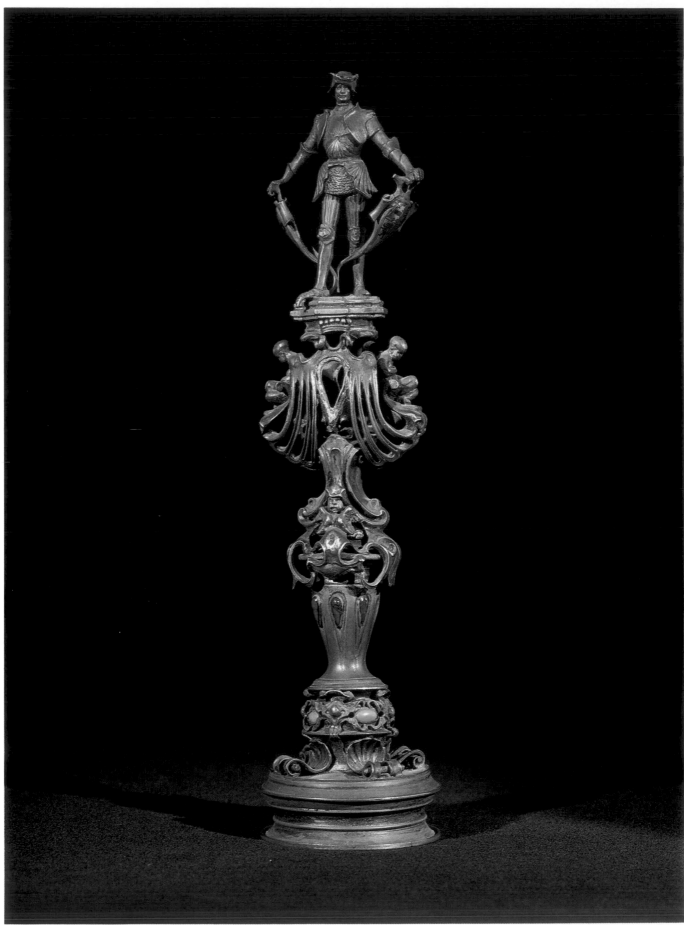

Cat. 59

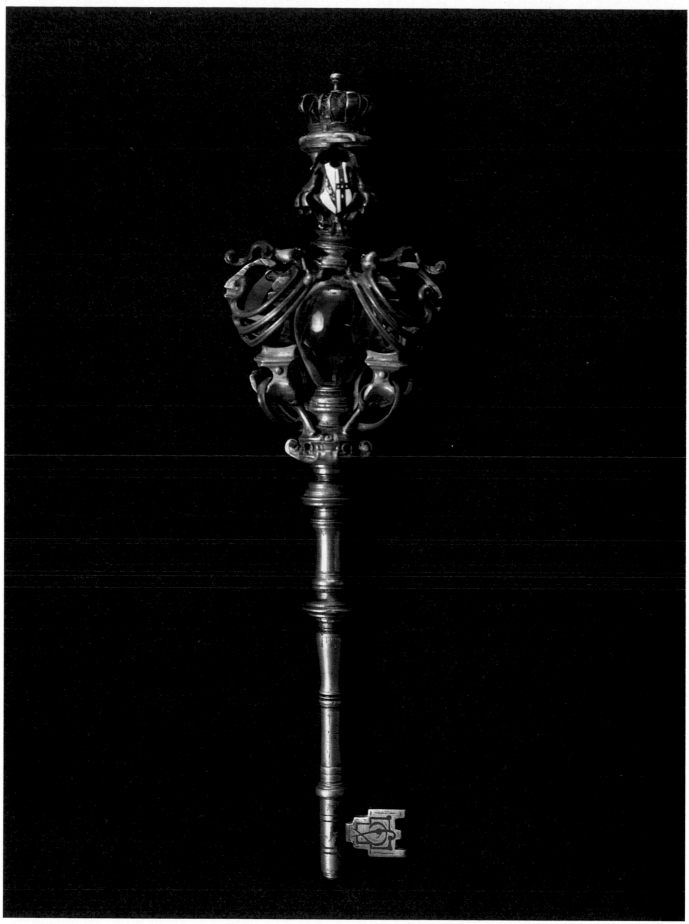

Cat. 4

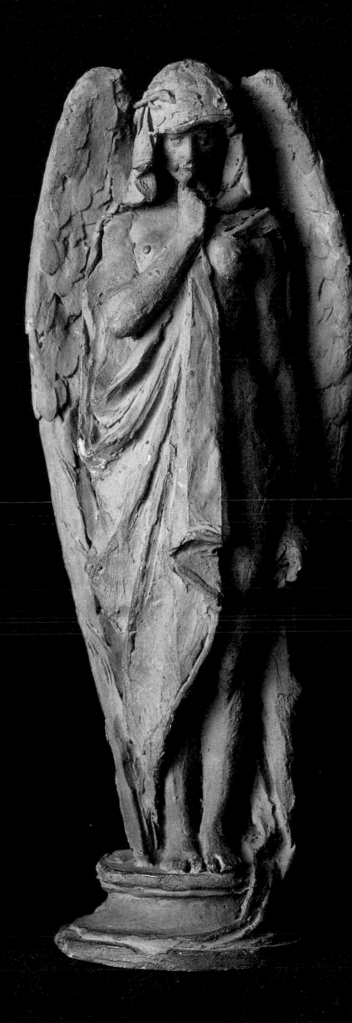

Cat. 3

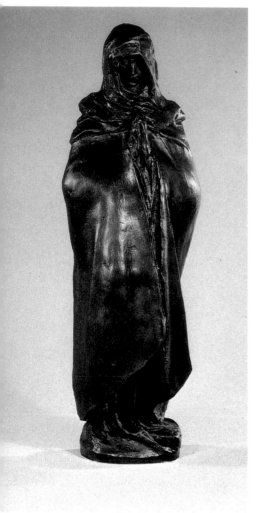

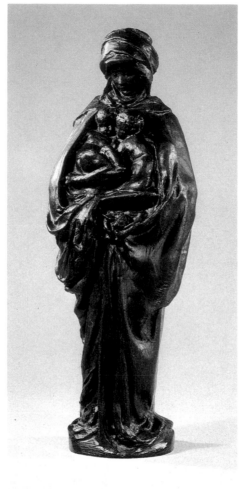

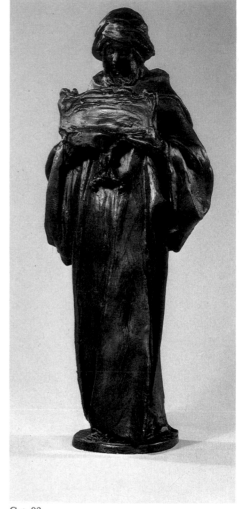

Cat. 93

Cat. 91

Cat. 92

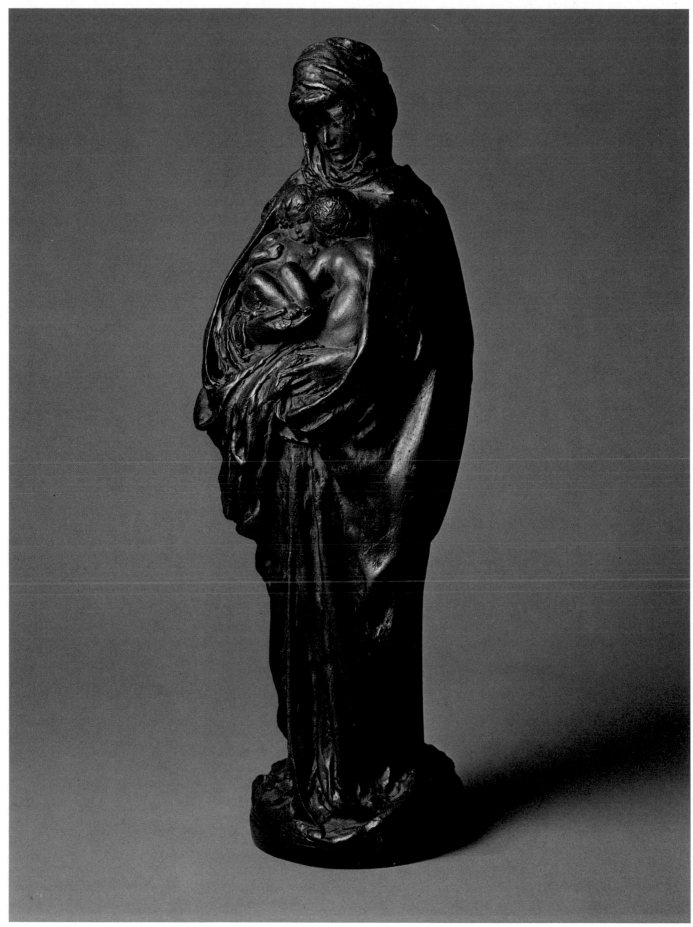

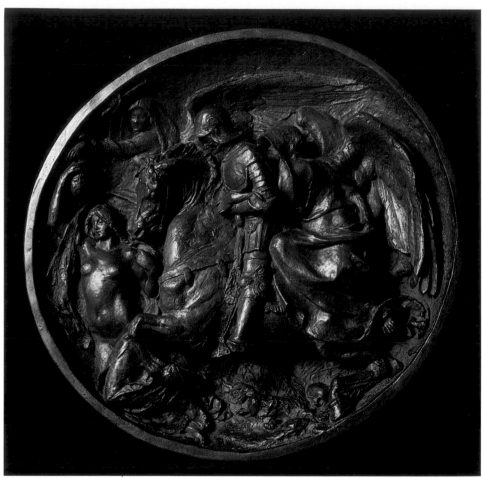

Cat. 89

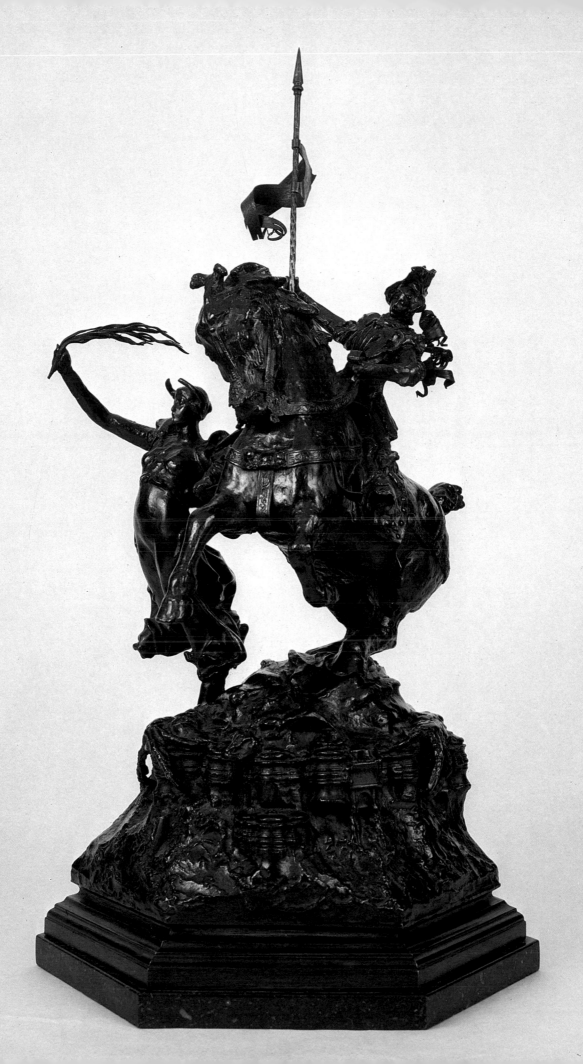

Cat. 101

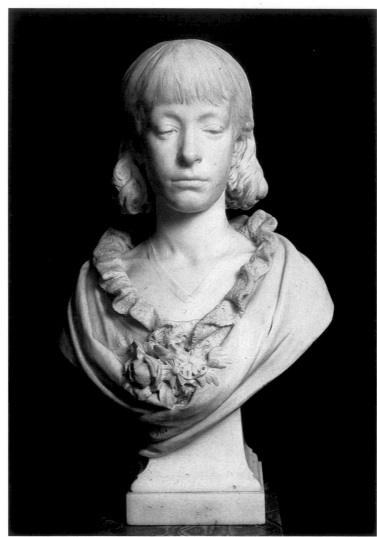

Cat. 28

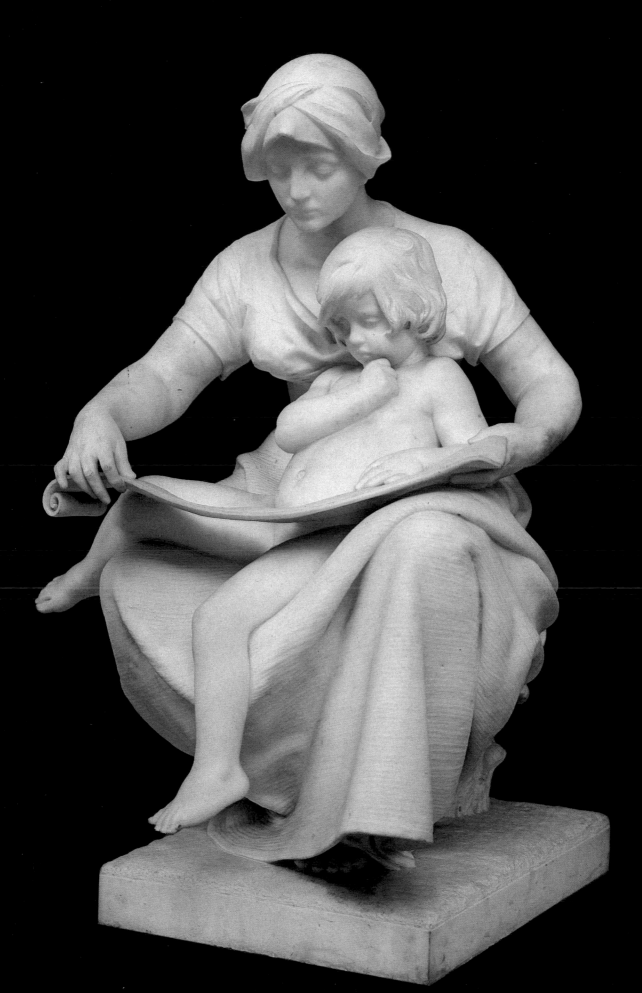

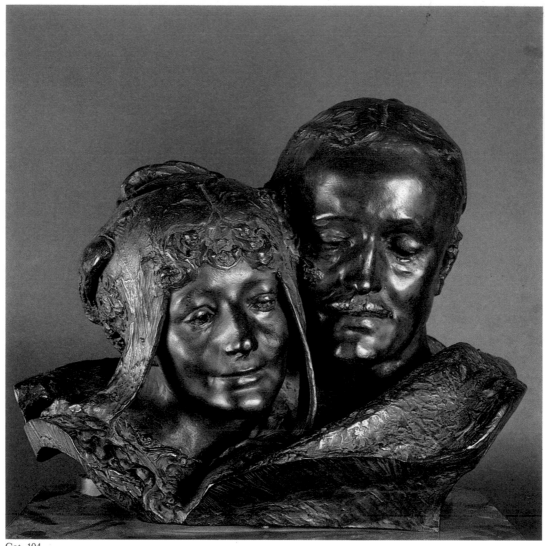

Cat. 104

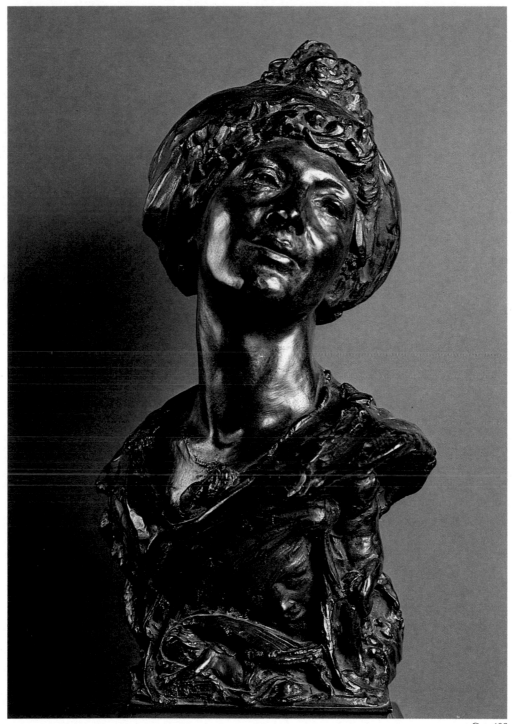

Cat. 103

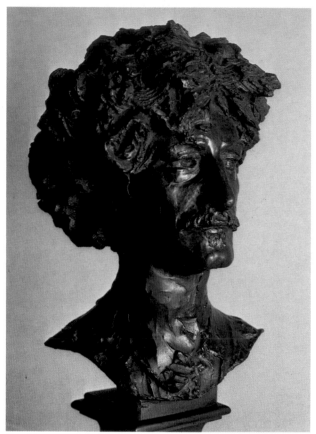

Cat. 30

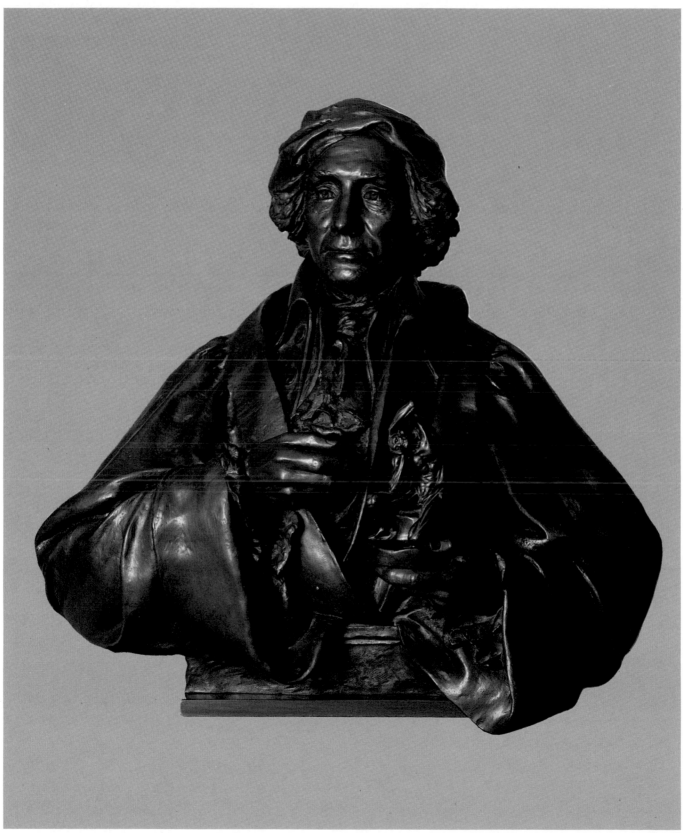

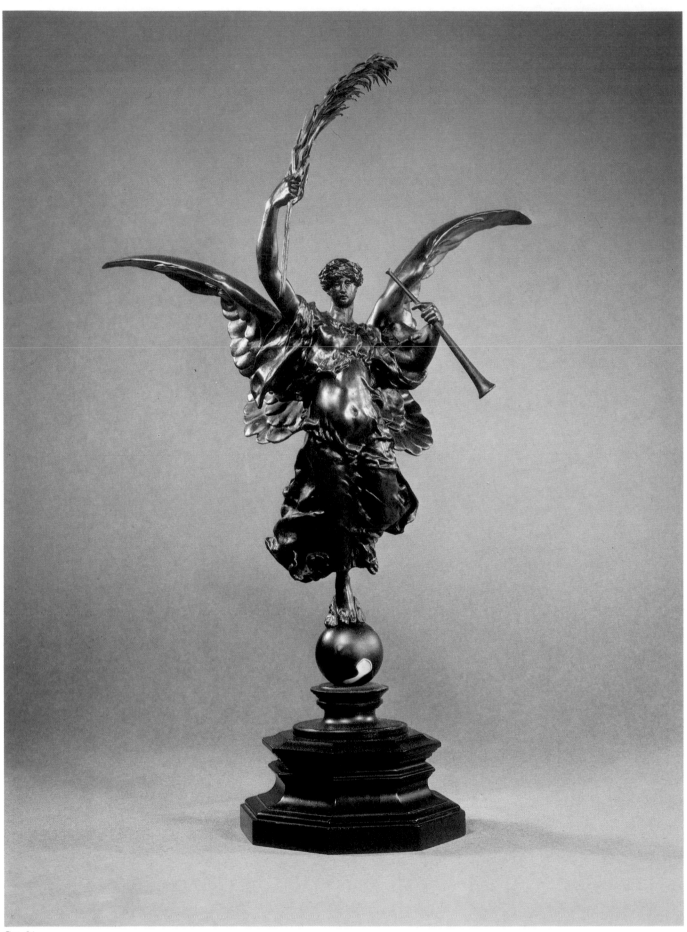

Cat. 34

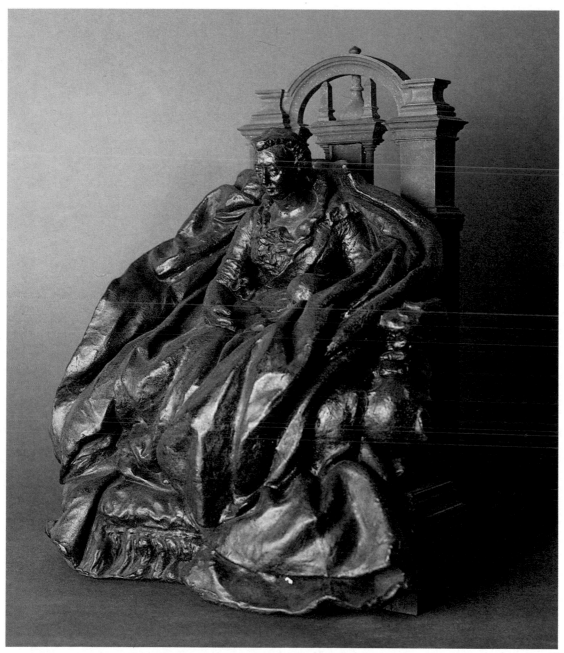

Cat. 32

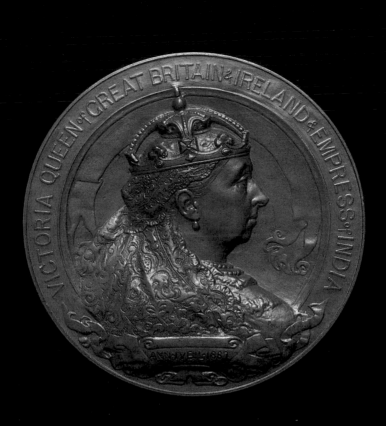

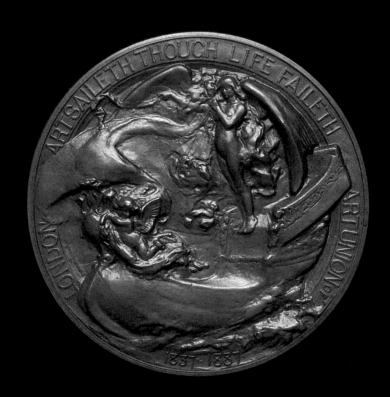

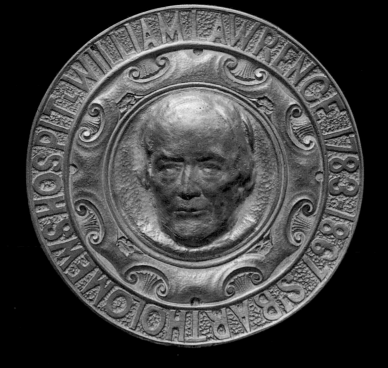

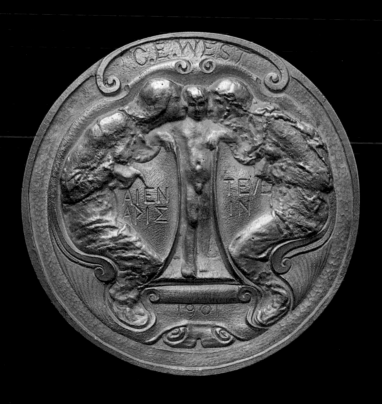

LONDON, PARIS, ROME 1870–1884: THE ECOLE DES BEAUX-ARTS AND THE BEAUX-ARTS STYLE

 LFRED Gilbert trained briefly at Hetherley's and later at the Royal Academy, and while at the latter he apprenticed himself to the Hungarian-born sculptor Joseph Edgar Boehm. From Boehm Gilbert learned a highly realistic sculptural technique, and benefited from his master's friendship with the French sculptor Aimé-Jules Dalou, resident in England from 1871 until 1880. In 1876, on Boehm's advice, Gilbert entered the Ecole des Beaux-Arts in Paris, where he responded immediately to the rigorous academic training, and standards of achievement far higher than those at the Royal Academy. Very few of his pre-Paris works survive, but the *Portrait of Alfred Leeman* (c. 1870; Cat. 1), executed while he was still at school, might serve to exemplify the conservative, 'Coat and Trousers' school of sculpture prevailing in England in the latter half of Queen Victoria's reign. Within a short period after his arrival in Paris, Gilbert demonstrated that, in works such as his *Mother and Child* (Cat. 4) and *Portrait of a Young Woman* (Cat. 5), his remarkable technical competence was united to a poetic vision of great intimacy and refinement. In two studies which incorporate the French heroic, allegorical style (Cat. 2, 3) he can be seen to edge towards a broader definition of what sculpture might be: namely, to be symbolic rather than merely descriptive, while retaining a degree of naturalism. Finally, in his *Kiss of Victory* (Cat. 6) and *Mother Teaching Child* (Cat. 8) he broke free from English constraint to produce two youthful but deeply personal exercises in the French Beaux-Arts style.

1 The Reverend Alfred Leeman

1870–2
Terracotta: ht 76.8 cm /30 in
The Letchmore Trust

Alfred Gilbert attended Aldenham School between 1865 and 1872. He described the Rev. Alfred Leeman, Headmaster from 1843 until 1876, as 'an artist at heart as well as a scholar, [who] went out of his way to favour a boy whose claims for scholarship were hopeless, but whose predilections for art were evident.'[1] The Gilberts were an Aldenham family: Alfred's younger brother Gordon (1856–78) joined him there in 1868; his father taught music at the school for more than thirty years; and his cousin, Herbert Gilbert, became a master in 1899. Apart from his respect for Leeman, Alfred Gilbert had little good to say of his schooldays. However, he retained an intense loyalty to Aldenham and sent his own sons there.

This piece is one of two works Gilbert is known to have modelled at Aldenham—although there were surely more. A *Satyr* in clay illustrating a passage from Virgil or Horace was seen by Adrian Bury in Gilbert's studio in the 1920s.

A younger friend of Gordon Gilbert, H. J. Carter, remembered that Alfred 'quite on his own . . . hired a room in the village (of Elstree) for 1/- a week (probably his whole pocket money) in which he set up a studio for his clay models, making his own tools.'[2] Bury also adds the information that

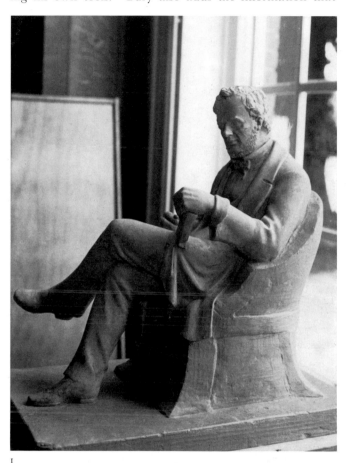

1

Cat. 1 was executed during Gilbert's school holidays: his mother Charlotte is known to have fired his early efforts in the kitchen oven. Gilbert's source might be one of any number of seated frock-coated figures. Perhaps closest is George Frederick Watts's *Lord Holland* of 1869–70 (London, Holland Park). He returned to the pose in his marble *James Prescott Joule* in 1895 (Manchester, Manchester Town Hall).

NOTES
1. Bury 1954, p. 90.
2. The published reminiscences of H. J. Carter are preserved in an undated and unheaded clipping (now on microfilm) in the possession of John Gifford, Ottawa.

PROVENANCE Gift of the artist to Alfred Leeman; Mrs Alfred Leeman; presented to Aldenham School by 1931.

LITERATURE 'A Plaster Model of Alfred Leeman By Alfred Gilbert', *The Aldenhamian*, vol. XVII, no. 12 (December 1931), p. 170, repr. opp. p. 170; Bury 1954, pp. 5, 75, 79, repr. pl. 1 opp. p. 2; Dorment 1985, p. 12, repr. pl. 2 p. 11.

2 *Charity*

1877
Terracotta: ht 33 cm/12$\frac{7}{8}$ in
Inscribed: ALFRED GILBERT JAN [UAR] Y 1877
The Trustees of the Tate Gallery

This figure is slightly cruder in execution than the *Mourning Angel* (Cat. 3) with which it forms a pair. This is Gilbert's first work surviving from the two years he spent at the Ecole des Beaux-Arts, but the subject is one to which he returned at intervals throughout his life (see Cat. 90, 99, 111).

PROVENANCE Presented by the Fine Art Society, 1958.

LITERATURE Chamot, Farr, Butlin 1964, p. 226, cat. T.167; Dorment 1985, p. 26, repr. pl. 9, p. 27.

3 *Mourning Angel*

1877
Terracotta: ht 33 cm/12$\frac{7}{8}$ in
Inscribed: ALFRED GILBERT PARIS SEPT. 77
The Trustees of the Tate Gallery

In her right hand the *Mourning Angel* holds an inverted torch (broken) and raises her left hand to her lips in a gesture of silence. Gilbert is known to have entered the competition for the Byron Monument at Hyde Park Corner in 1877 which was won by Richard Belt (1851–1920), and it is just possible that this figure is connected with that project.

This is Gilbert's first use of the winged figure—as important in his later art as the mother and child theme (see

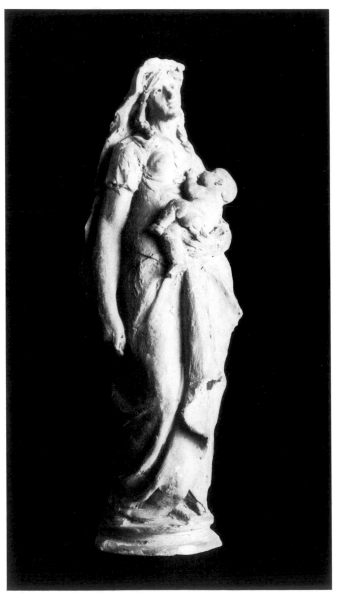

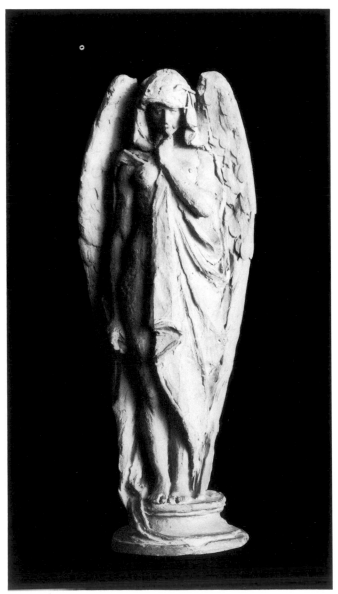

2 *reproduced in colour on p. 80*

3 *reproduced in colour on p. 81*

Cat. 6), and even at this date treated with extravagant exaggeration.

A comparison with its companion (Cat. 2), executed nine months earlier, shows Gilbert's swift maturation at the Ecole des Beaux-Arts.

PROVENANCE Presented by the Fine Art Society, 1958.

LITERATURE Chamot, Farr, Butlin 1964, p. 226–7, cat. T.167; Dorment 1985, pp. 26, 28, repr. pl. 8, p. 27.

4 *Mother and Child*

1876–7
Terracotta: ht 86.3 cm/34 in
Private Collection

Executed in Paris, *Mother and Child* shows Alfred Gilbert's first wife, Alice (1847–1916), in the costume of a French peasant woman. On her lap she dandles her first child, George. In her right hand Alice may have held a fictive object, a ball or fruit, so that the group's resemblance to Italian Renaissance prototypes—the works of Della Robbia, for example—was even more apparent. This is Gilbert's first full statement of the mother and child theme, which he was to explore until the last years of his life.

PROVENANCE Isabel McAllister; bequeathed to Miss Ida Cruttwell Abbott; Adrian Bury; presented to the present owner.

LITERATURE Bury 1954, pp. 7, 76, 80, repr. pl. IV opp. p. 19; Dorment 1985, p. 26, repr. pls 6–7 p. 25.

5 *Portrait of a Young Woman*

1878
Terracotta: diam. (excl. frame) 33 cm/13 in.
Inscribed: ALFRED GILBERT PARIS 1878
Maidstone Museum and Art Gallery, Maidstone, Kent

This is one of the few surviving works from Gilbert's years in Paris. The details of the unidentified girl's braided bun or high collar and pendant show Gilbert at his most sensitive; in later years he would recapture this simplicity only in his portraits of children (see Cat. 85, 86, 87). This portrait marks Gilbert's first use of the circular format, which he was to explore in plaques and medals throughout his career (see Cat. 38–42).

PROVENANCE Bt by present owner, 1974.

LITERATURE Dorment 1985, p. 28, repr. pl. 10, p. 28.

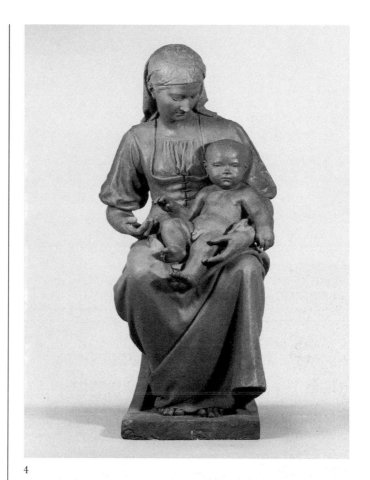

4

5

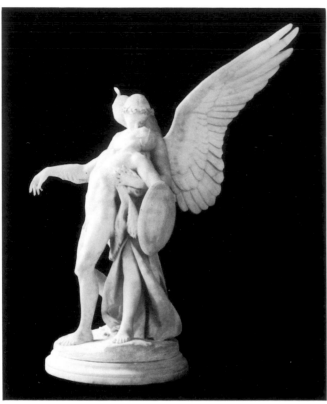

6 *(front)*

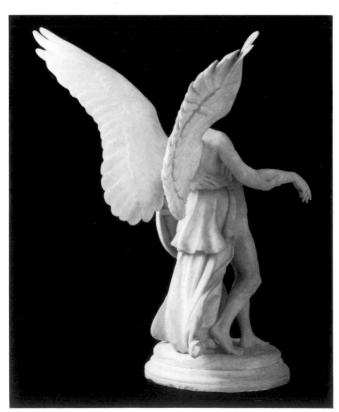

6 *(back)*

6 *The Kiss of Victory*

1878–81
Marble: 147.4 cm/58 in.
The Minneapolis Institute of Arts, the John R. van Derlip
Fund

The Kiss of Victory shows a Roman legionary fallen in battle embraced at the moment of death by the genius of victory. The notion of *génie*, a personified force or spirit—whether of victory, liberty, evil, sleep, revenge—is profoundly French, and Gilbert executed the sketch-model in Paris, at the Ecole des Beaux-Arts. Winged allegorical figures supporting nude youths surrounded Alfred Gilbert: Mercié's *Gloria Victis* (plaster exhibited at the Exposition Universelle of 1878; fig. 41); Doré's *Gloire* (Salon, 1878); and Auguste Rodin's (1840–1917) *Call to Arms* (1879; fig. 42) were all known to the English sculptor. His own version of the theme differed from those of his French contemporaries in its serenity and refinement; indeed, at 58 in (147.3 cm) high he meant it to be seen close to, in a drawing room, whereas Rodin, for example, planned his group as a public monument. Likewise, Rodin looked to Michelangelo's *St Matthew* (*c.* 1505–6; Florence, Accademia),[1] while Gilbert's ultimate source was Canova's *Cupid and Psyche* (1787–93; Paris, Louvre; fig. 43). The gentle eroticism of the group, the sense that the soldier is not dying but swooning, makes the work explicitly that of Gilbert: whatever precedents one may cite, Gilbert's own vision was already paramount. Although it cannot be proved, it is possible that he began this piece as a private commemorative statue to the memory of his brother Gordon, who had died in April 1878, months before he began work on the sketch.[2] Certainly the spirit of the piece is more of consolation than of a celebration of heroism.

Gilbert carved *The Kiss of Victory* himself in his Roman studio at 46 via Vantaggio, using only one assistant, his pointer Salvatore Biglione. The youth of the sculptor is betrayed in certain awkward passages—the left leg of Victory, for example, or the same figure's lumpen drapery and imperfectly resolved back view. On the other hand, Victory's wings, which almost double the volume of the statue, are brilliantly carried through. An account of the artist at work on the *Kiss of Victory* is provided by Walburga, Lady Paget (1839–1929), German-born wife of the British Ambassador to Rome: 'One day I found Gilbert in despair about a group of his—"Glory and Death". He saw the faults, without being able to remedy them. I sat down on a packing case, amidst the cats and pigeons . . . and began my criticisms, he, at the same time, cutting off ruthlessly the parts indicated. After three hours he had a huge heap of clay by his side and his lovely group stood out in the graceful proportions it now has.' Lady Paget then added one sentence that appears to be frivolous, but in fact tells us

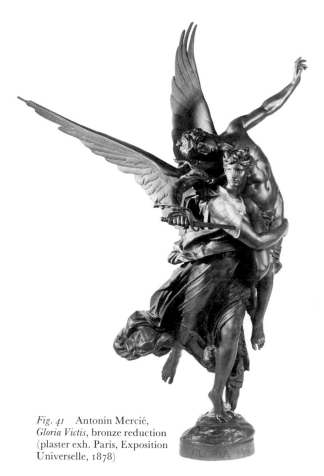

Fig. 41 Antonin Mercié, *Gloria Victis*, bronze reduction (plaster exh. Paris, Exposition Universelle, 1878)

something profound about the artist: 'Gilbert was short and extremely broad, and all sculptors and painters ought to beware of imitating the proportions of their own bodies unless they are quite normal.'[3] Thus the figure of the youth was originally a self-portrait: whether consciously or not Gilbert used his own figure for that of the boy. In later statues—*Perseus Arming* (Cat. 10), *Icarus* (Cat. 15), and *Comedy and Tragedy* (Cat. 22)—the element of portraiture would be symbolic. Here, at the very beginning of his career, we learn that he projected his own image into his statues.

The *Kiss of Victory* was commissioned by an English patron, Somerset Beaumont (1835–1921), who remained Gilbert's loyal friend and supporter throughout his turbulent career (see Cat. 88).

NOTES
1. John Tancock, *The Sculpture of Auguste Rodin, The Collection of the Rodin Museum, Philadelphia*, Philadelphia 1976, pp. 370–3.
2. Dorment 1985, p. 32.
3. Walburga Paget, *Embassies of Other Days*, London 1923, II, pp. 313–14.

PROVENANCE Commissioned from the artist by Somerset Beaumont for 150 guineas, bt back by Alfred Gilbert; sold to E. Blout Smith, 26 February 1891, for 450 guineas; Col. A. C. Howard in 1935; the Finch family, Burley-on-the-Hill; Heim Gallery, London; bt by the Minneapolis Institute of Arts, 1975.

EXHIBITIONS Royal Academy 1882, no. 1587; London 1935, no. 1; Royal Academy winter 1968, no. 368; Manchester, Minneapolis, Brooklyn 1978–9, no. 90.

LITERATURE Gosse 1894, pp. 202–3; Spielmann 1901, p. 78; Hatton 1903, pp. 8–9, 21, 32; McAllister 1929, pp. 43–4, 53–5, 88, 124, 194; Bury 1954, pp. 7–8, 38, 67, 73, 80; Handley-Read 1968, I, pp. 24, 27 (n. 5); William Gaunt, 'The Royal Academy's Bi-Centenary Exhibition', *Connoisseur* 170 (1969), repr. p. 8 (as *Icarus*); Read 1982, p. 294; Beattie 1983, pp. 138, 196, repr. fig. 125 p. 136; Dorment 1985, pp. 31–6, 38, 40, 42, 44, 324, repr. pl. 11 p. 30, pl. 12–13, p. 31.

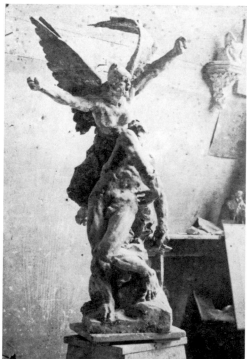

Fig. 42 Auguste Rodin, *Call to Arms* (*The Defence*), photograph taken of the model in Rodin's studio and formerly in the possession of Alfred Gilbert

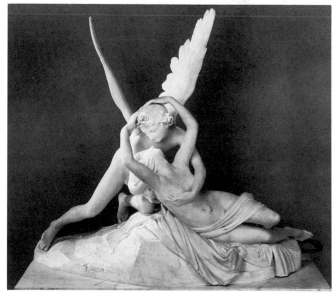

Fig. 43 Antonio Canova, *Cupid and Psyche*, 1787–93 (Musée du Louvre, Paris)

7

7 *The Kiss of Victory*

Cast after 1879
Bronze: 58.8 cm/23 in
The Fine Art Society, London

Gilbert told Joseph Hatton (1841–1907) that he entirely remodelled *The Kiss of Victory* (see Cat. 6) between the time of making the clay model and of carving the marble. Constant alteration and change from model to finished work was usual with Gilbert, so the fact that the composition of the small bronze so closely follows that of the finished marble might indicate that it followed, rather than preceded, the marble. In that case Cat. 7 would represent the casting of a *ricordo* rather than a preliminary sketch. The date of the first casting is not known. Given that the bronze is not mentioned in the studio diaries which Gilbert began in 1890, we should look for a date in the 1880s. When the piece was first published by McAllister in 1929, the caption to the reproduction (supplied by Gilbert) read '1879'. However,

this referred to the marble group. The coarse treatment of details such as the hands and feet are not the fault of the founder, but rather reflect the sketchy quality of the model. Yet the bronze has none of the exceptional crispness of Italian casts such as *Icarus* (Cat. 15) or *Head of a Girl* (Cat. 12). Nor, on the other hand, does it have the searching, flawed quality of Gilbert's early experiments in *cire perdue* in England as is found in some of the figures on the Fawcett Memorial (see Cat. 31) or, perhaps, in *An Offering to Hymen* (Cat. 18). One might propose that the bronze *Kiss of Victory* was cast by a professional founder such as George Broad & Sons in the later 1880s from a model brought back from Rome by Gilbert.

If he did allow his plaster model out of his studio for casting, it was easy for an unscrupulous workman to cast unauthorized or pirated casts. In the decade before the Great War Gilbert frequently complained that certain of his works had been cast without his authority. He wrote both to *The Times* and to the *Magazine of Art* warning the public against these pirated casts—one of which was the bronze *Kiss of Victory* (see also Cat. 98): 'I have been made aware of the traffic in my work over and above the number that I know to be in existence legitimately. Two new specimens have just come to my notice. These purport to be unique productions in bronze. They are both of them cast from very old sketches in plaster, which I believed I destroyed years ago. The one is entitled "Kiss of Victory". . . .'[1]

In pirated casts of *The Kiss of Victory* the wings are cast in one pouring with the figures. In authentic examples, such as Cat. 7, the wings are cast separately and fitted to the figure of Victory. Cat. 7 has an impeccable provenance going back to Gilbert's dealer Ernest Dawbarn (1874– retired 1954) of the Fine Art Society.

NOTE
1. McAllister 1929, p. 194.

PROVENANCE Presented by the artist to Ernest Dawbarn of the Fine Art Society; by descent; Christie's, 17 July 1984, lot 143, bt Fine Art Society; bt by present owner.

EXHIBITION London 1968, G57

LITERATURE McAllister 1929, p. 194, repr. opp. p. 10; Handley-Read 1968, I, p. 24; Dorment 1985, p. 233.

8 *Mother Teaching Child*

Marble: ht 103.5 cm/40¾ in
1881–3
The Trustees of the Tate Gallery

'Before dragging himself away from Rome, Henry Doulton gave Mr. Gilbert a commission for the noble group of a mother displaying a scroll to the child at her knee, which

is one of the rare works which Mr. Gilbert has executed in marble.'[1] Thus Edmund Gosse explained the genesis of this piece which Gilbert began in the spring of 1881, directly

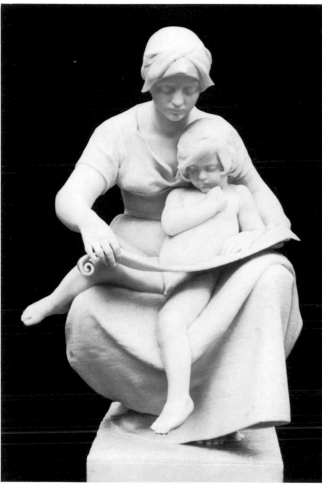

8 *reproduced in colour on p. 87*

after *Perseus Arming* (Cat. 10) commissioned by Doulton in bronze earlier that year.

The group shows Alfred Gilbert's second son, Francis (b. 1879) in the lap of his wetnurse, Michaelena. She is seated on a Corinthian column, reading to the child from an oversized scroll. These two details infuse the work with symbolic significance: in Spielmann's words (1901), the mother typifies 'traditional beauty in art and life, while she teaches the child from the record-scroll of the past.' Both Michaelena's bandeau and the scroll are references to Michelangelo's sibyls on the ceiling of the Sistine Chapel, while the positioning of the child between the mother's legs echoes Michelangelo's Bruges *Madonna* (1503–4; Church of Onze Lieve Vrouwe, Bruges) a cast of which Gilbert would have seen in the Royal Academy Schools. Spielmann suggests as a source Michelangelo's Medici *Madonna* (1524–34)

in the Medici Chapel in St Lorenzo in Florence, while Cox (London, 1936) was struck by the resemblance to the marble *Cornélie, la mère des Grècques* (1861; Paris, Musée du Luxembourg), by Gilbert's old master Cavelier. Certainly the statue looks to conventional French groups—the most obvious being Eugène Delaplanche's (1836–91) *Education Maternelle* (1875; Paris, Place Samuel Rousseau).

Mother Teaching Child is deceptively simple: its genre-like subject belies the immense strides Gilbert had taken in his art. To compare it to *The Kiss of Victory* (Cat. 6) or *Perseus Arming* (Cat. 10)—both of which preceded it—is to feel the greater gravity and monumentality derived from a closer study of Michelangelo.

Mother Teaching Child was sent directly to Doulton's country house at Ewhurst in Surrey and was not exhibited during Gilbert's lifetime, or indeed until the present exhibition. Gilbert also executed an independent study of Michaelena's head in bronze (Cat. 12).

NOTE
1. Gosse 1970, p. 114.

PROVENANCE Commissioned from the artist by Sir Henry Doulton; presented to the Tate Gallery by his son Lewis Doulton, 1931.

LITERATURE Monkhouse 1889, I, p. 3, engraving by C. Carter repr. p. 5; Spielmann 1901, p. 76, repr. opp. p. 77; Spielmann 1910, p. 7; McAllister 1929, repr. opp. p. 16; London 1936, pp. 11, 12 (n. 1); Bury 1954, pp. 70, 77; Chamot, Farr, Butlin 1964, p. 223, cat. 4586; Edmund Gosse, *Sir Henry Doulton: The Man of Business as a Man of Imagination*, ed. Desmond Eyles, London 1970, pp. 114, 175; Dorment 1985, pp. 36, 42, 44, 279, 322, repr. pl. 17 p. 41.

HOWARD INCE

9 *Designs for a Mausoleum on a Sloping Site*

1884

i) Longitudinal section looking east
 Watercolour: 32 × 36 cm/12⅛ × 14½ in
 Inscribed: HOC·MAUSOLEUM·EDIFICAT·AD·MDCCCLXXXIV

ii) Perspective of the interior showing the eastern apse and the Tomb in the centre of the Chapel
 Watercolour: 31 × 31 cm/12 × 12 in
 Inscribed along the entablature: DEUM·EDIFICATUM·EST·
 AD·MDCCCLXXXIV·IN·PIAM·MEMORIAM·ET·AD·
 GLORIAM

The British Architectural Library Drawings Collection

James Howard Ince (*fl.* 1882–1904; d. before 1926) trained at the Royal Academy Schools. There he met Alfred Gilbert with whom he was to be closely associated during his short career. In 1882 he won the Royal Academy Gold Medal for architecture with a design for a casino, and in the next few years travelled on the Continent where he was reunited with Gilbert in Rome. Thereafter all his commissions seem to have been associated with Gilbert, although he continued to exhibit his own designs for other works at the Royal

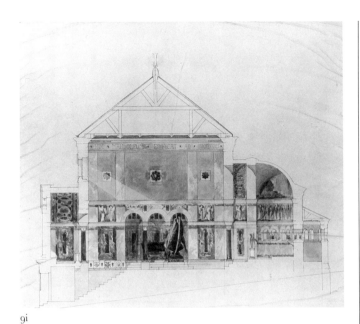

9i

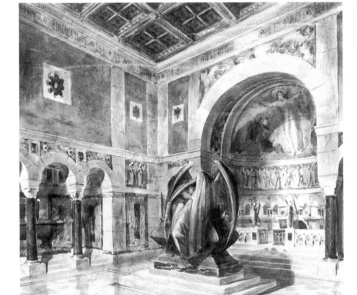

9ii

Academy from 1882 until 1904 and at the Paris Exposition Universelle in 1900. He was responsible for extensive architectural work on the Shaftesbury Memorial, including the parapet which no longer exists (see Cat. 52); he designed the surround of the Caldecott Memorial and the base of the Jubilee Memorial to Queen Victoria (see Cat. 32) at Winchester. His only known building was Gilbert's house and studio in London, 16 Maida Vale (1891–3; demolished; see

Cat. 121), during the building of which he seriously exceeded the estimate, thereby landing Gilbert deeper in debt. He took his own life in the 1920s.

These two designs by Ince are for the Mortuary Chapel of the Baroness von Fahnenberg showing Gilbert's sculptural sarcophagus cover in the centre. The Baroness von Fahnenberg was born Sally Strother on 15 May 1833 at St Louis, Missouri, the daughter of George French Strother, a member of the United States Congress. She married a member of the family of Fahnenberg from Baden in Austria who were registered in 1835 as Barons (*Freiherren*, among the lowest ranks of the Continental nobility).

In 1883 the Baroness went to Rome to select an artist to carry out 'a cherished wish' to erect a memorial to the memory of her mother and son, buried together in the cemetery at Spa in Belgium. Her friend in Rome, the American painter John Rollin Tilton (1833–88), asked his neighbour Alfred Gilbert to undertake the task, and Gilbert finished the designs in six weeks. She inspected the model and approved it, yet asked whether Gilbert would object to a competition. The German sculptor Joseph von Kopf (1827–1903) therefore made a model which she liked less, and the Roman artist Giovanni Costa (1833–1903), Kopf's nominee, settled the matter by judging Gilbert's as better. We know what the model looked like at this stage from a passage quoted by McAllister in which an unnamed writer recalled Gilbert's Roman studio: 'I found in Mr. Gilbert's studio a terra-cotta design for a tomb, which could not fail to attract attention. A classical sarcophagus-shaped tomb, with a single figure sitting upon it. The drapery is such as might be that of a monk or nun, with a large cowl very much drawn over the head, and the figure slightly stooping, for the purpose of writing with a stilus on the top of the sarcophagus.'[1] Having approved this design, the Baroness went to Paris. What happened next is recorded in Gilbert's own testimony to solicitors written in 1887 (Collection of Air Chief Marshal Sir John Barraclough). After a contract had been drawn up, Tilton gave Gilbert 2,000 francs, on account, to travel. The young sculptor followed the party to Paris where he visited the Baroness twice or even three times a day to discuss the Mausoleum. From Paris they went to Spa, and there Gilbert found the cemetery in a state of overgrown neglect; nevertheless, he made all arrangements for the purchase of land for the Mausoleum. At this point the Baroness would not sign any agreement, so Gilbert left Spa for London. He and Ince resorted to litigation in order to recover a portion of the money due to them, but dealt only with the executors of the Baroness after her death in March 1885. Gilbert and Ince each received a 'compromise' settlement of £1,000, indicating that the project had gone far beyond the sketch stage. But Gilbert's real distress was at the amount of time lost: 'At the time I undertook the

commission, I had just achieved my first success in my profession. I was in receipt of several commissions, all of which I put aside with a view to giving myself up entirely to the work entrusted to me by the Baroness. Seeing in it an opportunity rarely occuring to an artist, to make an effort which would give me reputation in my Art.'[2]

Ince's designs, dated 1884, are for a mausoleum on a sloping site—which might suggest a date after Gilbert's visit to Spa. That they are later rather than earlier in the episode is probable because the central sculptural group no longer shows the figure with a stylus, but appears to be a cowled figure (Death) cradling a child (Sleep) in its arms. This reflects the title Gilbert's father gave in his list of his son's work (under the year 1883): 'Studies sculptural and architectural for a memorial chapel to be erected at Spa commissioned by the Baroness de Falkenburg [sic]. Sleep to Death, group sketches.'[3] That Ince's watercolours should post-date Gilbert's first difficulties with the Baroness is perfectly possible: he did not necessarily stop work on the project the moment she demurred at signing the contract. Moreover, as quoted by McAllister (p. 116) the *Morning Post* declared as late as the spring of 1886 that '. . . our prophecy of his [Gilbert's] future has been already in a measure fulfilled by the selection of his designs for the Baroness Fahnenburg's [sic] mortuary chapel.'

Ince's design is remarkable, comprising as it does coffered ceiling, coloured marbles, and a procession of saints leading to a fresco or mosaic showing the Resurrection in the semi-dome of the apse. The tomb of the Baroness's mother was presumably in the chapel-like niche, while at the centre stood her son's sarcophagus designed by Gilbert, with the group of Sleep and Death. The imagery is revealing: it looks back to G. F. Watts (see Cat. 25), whose retrospective exhibition Gilbert had seen on his visit to London in 1881. In particular, it owes much to the symbolist vocabulary of Watts's *Love and Death* (first version 1868–9; first completed version 1870; Bristol City Art Gallery). The terracotta in Gilbert's Roman studio was presumably destroyed or abandoned, but the cowled figure reappears almost at once in *Post Equitem Sedet Atra Cura* (Cat. 88).

NOTES
1. McAllister 1929, p. 54.
2. Letters concerning the commission for the Mausoleum for the Baroness von Fahnenberg, all *c.* 1887 (Air Chief Marshal Sir John Barraclough).
3. Gilbert Sr, MS.

PROVENANCE Mrs I. M. Ince; presented to the Royal Institute of British Architects, 1947.

LITERATURE Jill Lever (ed.), *Catalogue of the Drawings Collection of the Royal Institute of British Architects*, Farnborough, Hants, 1973, p. 155, cat. 6 nos 5, 6.
(The Fahnenberg Mausoleum) McAllister 1929, p. 116; Bury 1954, p. 76; Dorment 1985, pp. 51–2, 59, 215, Cat. 9ii repr. pl. 23 p. 50.

I N a series of bronzes executed between 1881 and 1892, Gilbert explored the expressive possibilities of a medium he had only discovered after leaving the Ecole des Beaux-Arts to work in Rome. His introduction in Italy to foundries specialising in *cire perdue* bronze casting came as a revelation, and with missionary fervour he was lecturing on the process in England as early as 1883. In 1882 he began to exhibit in London at the Royal Academy and at the Grosvenor Gallery; each year he received acclaim as the foremost talent of his generation, and in each exhibited statue he demonstrated his ability to work in the styles of Cellini, Donatello, Michelangelo, Giambologna and Bernini. But he was more than a facile imitator: each statue held for him deep personal meaning, as he sought to 'write' his autobiography in bronze. Thus, *Perseus Arming* (1882; Cat. 10, 11) refers to the artist's need to train adequately before entering the arena of the public exhibition; *Icarus* (1884; Cat. 15–17) symbolises Gilbert's ambition to free himself at whatever cost from material constraints; and *Comedy and Tragedy* (1892; Cat. 22–24), his homage to Giambologna, also refers to the violent contrasts between his public success and profound private unhappiness.

Later reductions, casts with varying patinas, and inferior casts illustrate the variety of choices open to a sculptor. No artist of his generation was more intrigued by colour, variations in scale, or the importance of the founder's skilled collaboration.

10 *Perseus Arming*

1882; this cast undated
Bronze: ht 73.7 cm/29 in
Private Collection

11 *Perseus Arming*

This cast undated
Bronze: ht 35.5 cm/14½ in
The Syndics of the Fitzwilliam Museum, Cambridge

Gilbert told Joseph Hatton that after his visit to Florence in 1879 he had '. . . become convinced that after all there might be nothing more original as to a subject for artistic treatment than the banal or old-time story; but that in its exposition every story has two sides—the one being the accepted and literal text, and the other that which the text suggests'.[1] Thus, the artist has the freedom to retell myths or to invent incidents which never appear in the original tale if his own version better expresses his own thoughts and feelings. This is a profoundly literary as well as a romantic approach to sculpture.

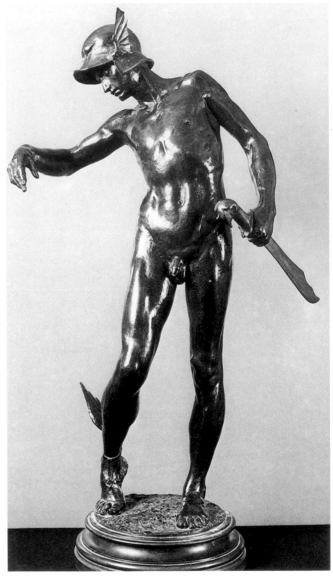

10

Gilbert modelled *Perseus Arming* after seeing Cellini's *Perseus and Medusa*, a masterpiece that yet 'failed to touch my human sympathies'. He was not exactly criticising the statue on artistic grounds, but saying that at twenty-five, he, Alfred Gilbert, did not identify with Cellini's masterful Perseus holding up Medusa's severed head. The solution was to create a statue in which Alfred Gilbert *was* Perseus, but as no incident in the myth fitted Gilbert's circumstances, he made one up: 'As at that time my whole thoughts were of my artistic equipment for the future, I conceived the idea that Perseus before becoming a hero was a mere mortal, and that he had to look to his equipment.'[2]

In this statue Gilbert began a cycle of myths and stories which would illustrate the course of his life: that he began

this consciously seems evident from his words about *Perseus Arming* after it had gained honourable mention at the Paris Salon of 1883: 'This gave me great encouragement to continue the task I had set myself—that was, to go on writing my own history by symbol.'[3] 'Writing' and 'symbol' are the two words to pick out here, for he referred to *Icarus* (Cat. 15) and *Comedy and Tragedy* (Cat. 22) as subsequent chapters in his autobiography—though certainly *Post Equitem Sedet Atra Cura* (Cat. 88), the *Broken Shrine* (Cat. 99) the Leeds Chimneypiece and *Atalanta* (Cat. 119) might be cited as further instalments in a story which clearly fascinated Gilbert.

Sir Henry Doulton commissioned the first cast of *Perseus Arming*. Gilbert had modelled the statue after his return from Florence, but needed a patron to order a cast in bronze. According to Edmund Gosse, Doulton came through Rome in the spring of 1881. Gilbert 'had striven and failed, and now, in deep indigence, with a wife and two children to support, had almost come to the very confines of his courage. ... At their first interview, Henry Doulton saw, admired and gave a commission for the statuette by which Mr.

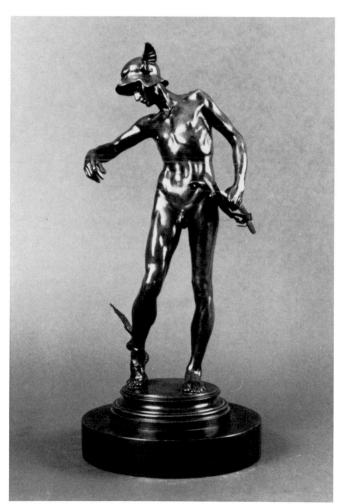

11 reproduced in colour on p. 53

Gilbert first became generally recognized in London and Paris, the now well-known "Perseus".' However, McAllister (p. 57) states that J. P. Heseltine (1843–1929) acquired *Perseus Arming*, which may be correct because the artist Louise Jopling (1843–1933) recalled visiting Heseltine's house in the spring of 1883 where she saw 'the very first work of that incomparable genius, Gilbert R. A. – a small statuette of a nude figure'.[4] At this date *Perseus Arming* is the only possible candidate and it is pertinent that in all early exhibitions Heseltine, not Doulton, lent his cast. In an essay in the present catalogue, Duncan James puts forward the thesis that Gilbert's finest castings – *Study of a Head* (Cat. 12) *Icarus* (Cat. 15), and possibly *An Offering to Hymen* (Cat. 18), were all cast by the direct method of lost wax casting, but that the earliest of the great bronzes, *Perseus Arming*, is technically inferior because it was made by the indirect method (see pp. 23–4). In that case, there would be no difference in the quality of the Doulton or Heseltine casts.

Gilbert sent *Perseus Arming* to the Grosvenor Gallery in 1882—the same year that he placed the marble *Kiss of Victory* (Cat. 6) in the Royal Academy. The choice meant no more than a wish to exhibit before the widest possible audience. Two years later, for example, he would send a marble, which he called at different times *Astronomy* or the *Diviner* (untraced), to the Grosvenor Gallery, and two bronzes to the Royal Academy. Still, when Leighton commissioned *Icarus*, he specified bronze, as though he meant to ensure that Gilbert did not get into the habit of differentiating by medium between the Grosvenor Gallery and the Royal Academy.

The pose of Perseus is almost that of the youth in *The Kiss of Victory*: he is an adolescent dandy gracefully trying on the winged sandals; the sensation of a wing on his heel makes him turn halfway around, splay his leg gently out, and raise his right arm in an exquisitely natural, yet limp arc. This lethargic figure is curiously unlike what we know of Alfred Gilbert himself. However, as in all of Gilbert's great bronzes before *Comedy and Tragedy*, Perseus is poised on the brink of taking action, doing little, but looking troubled and anxious at what lies before him.

Cat. 10 is a superb *cire perdue* cast with no markings.

NOTES
1. Hatton 1903, p. 10.
2. Loc. cit.
3. Loc. cit.
4. Louise Jopling, *Twenty Years of My Life, 1867 to 1887*, London and New York 1925, p. 229.

PROVENANCE (Cat. 10) Danny Katz; bt by the present owner in 1985. (Cat. 11) Sigismund Goetze; his wife, Constance Goetze; presented to the Fitzwilliam Museum by Mrs May Cippico, 1951.

EXHIBITIONS (of casts) Grosvenor Gallery 1882, no. 380; Paris Salon 1883, no. 3700; Manchester 1887, no. 552 (as *Mercury*, lent by J. P. Heseltine); Paris 1889, no. 312; London 1900, no. 131 (lent by Robert

Demthorne [*sic*]); Glasgow 1901, nos 123 (lent by Heseltine) and 125 (silver, lent by David Murray); London 1902, no. 6; London 1909, no. 285 (lent by Heseltine); London 1909, nos 8, 10, 17; London 1935, nos 5, 8, 14; London 1968, no. 58G; London 1972, no. F18; London, The Fine Art Society, 'Centenary Exhibition', 1976, no. 175; Manchester, Minneapolis, Brooklyn 1978, no. 91.

LITERATURE Monkhouse 1889, II, pp. 37–9, repr. p. 39; Michel 1889, p. 404; Hind 1890, p. 3; Quilter 1892, p. 345; Gosse 1894, pp. 202–3; Spielmann 1901, p. 76, repr. p. 78; Hatton 1903, p. 10, repr. p. 10; Ganz 1908, p. 110; Rinder 1909, p. 123; Spielmann 1910, p. 7; Macklin 1910, p. 117; McAllister 1929, pp. 55–7, repr. opp. p. 24; Maryon 1933, p. 62, repr. fig. 43; London 1936, p. 11; Bury 1954, pp. 8, 38, 41, 79–80, repr. pl. II; Handley-Read 1968, I, pp. 22, 24, repr. p. 22; Handley-Read Dec. 1968, p. 715; London 1968, pp. 10, 11, 15; Edmund Gosse, *Sir Henry Doulton: The Man of Business as a Man of Imagination*, ed. Desmond Eyles, London 1970, p. 113; Read 1982, pp. 60, 294, 301–2, 306, 308, 313–14, 319, repr. fig. 356 p. 295; Beattie 1983, pp. 3, 44, 73, 138, 141, 143, 150, 156, 184, 196, 244, 260 (n. 61), repr. fig. 129 p. 139; Dorment 1985, pp. 38, 40, 42, 44–6, 49, 99, 190, 192, 227, 233, 277, 279–80, 322, repr. pl. 16 p. 39.

12 *Study of a Head (Head of a Girl)*

1883
Bronze: ht 38.1 cm/15 in
The National Museum of Wales, Cardiff

Gilbert modelled *Study of a Head* in 1882 and exhibited it at the Royal Academy the following year. There 'it brought about a new outlook in sculpture' according to the sculptor William Goscombe John (1860–1952),[1] who referred to the

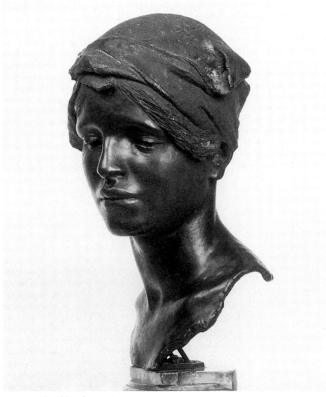

12 *reproduced in colour on p. 49*

electrifying quality of the *cire perdue* cast, the superb chasing and original gilding, traces of which are still visible in the figure's incised hair straying from beneath her turban. This was the first bronze Gilbert exhibited at the Academy. He claimed that he made it as an answer to critics who had declared him capable of the heroic nude but not of portraiture. In it he united technical brilliance with a depth of feeling rare in English sculpture at this date. Thus *Study of a Head* may be seen together with *Perseus Arming* and *Icarus* (Cat. 10, 15) as the fountainheads of the New Sculpture in England.

The model was Francis Gilbert's wetnurse in Rome, Michaelena, who also posed for *Mother Teaching Child* (Cat. 8). Gilbert had taken her in after witnessing the harsh treatment she received at her husband's hand, but he was obviously moved by her exotic, sensual face. The pierced, downcast eyes convey a look of intense melancholy.

NOTE
1. William Goscombe John to John Steegman (1899–1966), director of the National Museum of Wales, Cardiff, 31 May 1946 (MS National Museum of Wales).

PROVENANCE Bt from the sculptor by Sir Luke Fildes, RA, in 1883 for 100 guineas; Sir William Goscombe John, RA, who presented it to the National Museum of Wales, 1946.

EXHIBITIONS Royal Academy 1883, no. 1600; Paris 1889, no. 315; Glasgow 1901, no. 99; London 1908, no. 1454; London 1909, no. 284; Manchester, Minneapolis, Brooklyn 1978, no. 92.

LITERATURE Monkhouse 1889, I, repr. p. 3; Michel 1889, p. 404; Hind 1890, p. 3; Quilter 1892, p. 346; Edmund Gosse, 'The New Sculpture, 1879–1894, III', *Art Journal* 1894, p. 278 (as 'Head of a Boy'); Spielmann 1901, p. 78, repr. p. 79; Hatton 1903, p. 32, repr. p. 3; Spielmann 1908, p. 74; Spielmann 1910, p. 7; McAllister 1929, pp. 57–8, repr. opp. p. 33; Bury 1954, pp. 8, 53, 67, 80 repr. pl. III; Beattie 1983, pp. 141, 143, 155–6, 174, 180, 233, 244, repr. fig. 130 p. 140; Dorment 1985, pp. 40, 44, 49, 61, 99, repr. pl. 18 p. 43.

13 *Study of a Head (Head of a Girl)*

This cast undated
Bronze: ht 38.1 cm/15 in
The Fine Art Society, London

This piece is included in the exhibition for comparison with the *Head of a Girl* (Cat. 12) cast in Italy in 1883. This cast is undated, without provenance, and the name of the founder is not known.

14 *Study (Head of a Capri Fisherman)*

First cast 1884; this cast undated
Bronze: 41.9 cm/14½ in
The National Gallery of Victoria, Melbourne

The first cast of Cat. 14 was exhibited with *Icarus* at the Royal Academy of 1884. After praising *Icarus*, *The Illustrated London News* (10 May) added: 'But still more extraordinary

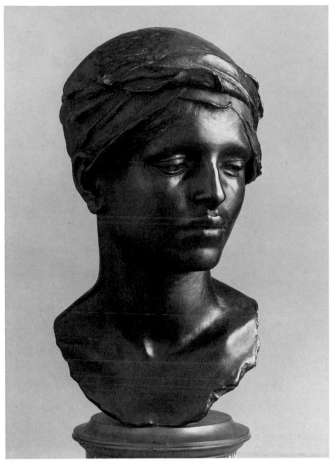

13

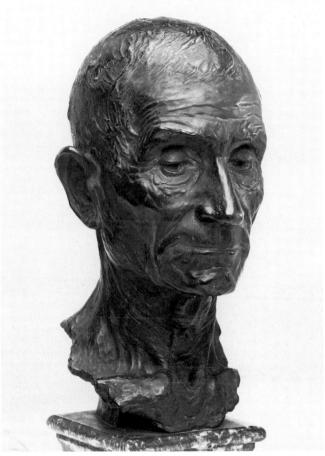

14

is the "Study of a Head", with its thousand wrinkles and markings of age. It is difficult to believe this is not cast from life; nothing closer to nature have we seen—nothing so wonderful in its way. If Mr. Gilbert's rare faculty of imitation admits of full artistic development, there will be no greater sculptor in our time.'

When he exhibited the head at Manchester in 1887, Gilbert identified the study as that of a fisherman, and his father's list gives the further information that the head is that of a Capri fisherman. For part of the year 1883 the Gilberts were living in Capri, so the model was certainly a picturesque local inhabitant. *The Architect* (31 May) compared the head to Roman portrait busts, though a less obvious source of inspiration may have been Rodin's *Mask of the Man with the Broken Nose* (1863–4), exhibited in London at the Grosvenor Gallery in 1882.

The 1884 cast has not been traced. J. P. Heseltine owned it, and it is this cast which was lent to every exhibition until 1910. Like his cast of *Perseus Arming*, it seems to have been sold, but not at public auction. Since the Melbourne cast was purchased through the Felton Bequest in 1905, the cast

exhibited here cannot be the 1884 one. In May 1905 Alfred Gilbert ordered a cast from M. Charles de Coene of the Compagnie des Bronzes in Brussels. Later that year his son George corresponded over a cast—but it is difficult to tell whether he is ordering a second cast or whether the first cast had simply not been delivered.[1] A Compagnie des Bronzes cast is in a private collection in London, stamped on the reverse with the medallion '&&'.[2]

NOTES
1. Papers of the late Lavinia Handley-Read, MS, Library of the Royal Institute of British Architects, London.
2. Dorment 1985, pl. 19 p. 44.

PROVENANCE Purchased for the Felton Bequest, 1905.

EXHIBITIONS (of the 1884 cast) Royal Academy 1884, no. 1, 699, as 'Study'; Manchester 1887, no. 553; Paris 1889, no. 314; Glasgow 1901, no. 99A; London 1909, no. 294; London, Whitechapel Art Gallery, 'Twenty Years of British Art (1890–1910)', 1910, no. 79; London 1932, no. 12; London 1935, no. 12.

LITERATURE Monkhouse 1889, II, repr. p. 38; Michel 1889, p. 404; Spielmann 1901, p. 78, repr. p. 78; Hatton 1903, p. 32, repr. p. 3; Muthesius 1903, p. 85, repr. fig. 14; Macklin 1910, repr. p. 100; McAllister 1929, p. 58; Bury 1954, pp. 8, 80; Dorment 1985, pp. 37, 45, 99, 201, 233, repr. pl. 19 p. 44.

15 *Icarus*

1884
Bronze: ht 106.7 cm/42 in
Inscribed on rock below right heel: ALFRED GILBERT ROME
1884
The National Museum of Wales, Cardiff

Impressed by seeing *Perseus Arming* at the Grosvenor Gallery in 1882, Frederic Leighton resolved to encourage its young sculptor by the most practical means possible: he commissioned a bronze from him, leaving the choice of subject and treatment entirely to Gilbert. Still intoxicated by Donatello's *David*, Gilbert chose a solitary nude adolescent; his love of wings and winged figures—already explored in *The Kiss of Victory* (Cat. 6) and *Perseus Arming* (Cat. 10)—perhaps led him to the subject of *Icarus*, and the theme lent itself neatly to the autobiography he was writing in bronze: 'It flashed across me that I was very ambitious: why not "Icarus" with his desire for flight?'[1]

Gilbert cast *Icarus* himself, by the direct method of *cire perdue*, at the foundry of Sabatino de Angelis in Naples. Its exceptional quality was at once recognised when it was shown at the Royal Academy in 1884. The crisp casting of the laced thongs binding the frankly artificial wings to the boy's arms and the serrated feathers of these wings were singled out for discussion by the Press. So, too, was the ingenious device of creating a base which itself would comment on the theme: if a bird, with its natural means of flight, can be devoured by a snake, this boy, with his man-made wings is doomed. One particularly well-informed critic, writing for *The Times* on 19 May 1884, considered the statue 'supremely successful' and drew attention to the casting method 'which is beginning to be greatly preferred by the most accomplished sculptors to the ordinary method of casting in sand. Certainly the crispness and sharpness of mould . . . should direct general attention to this method, which enables the actual touch of the artist to be far more clearly seen than in statues cast on the older plan.'

Of all his statues, Gilbert told the collector William Vivian (1827–1912), his favourite was Cat. 15.[2] His method of work when modelling *Icarus* is worth recounting. After a lengthy search for exactly the right model, 'I set to work . . . and for more than two years did again and yet again a study of this youth, never destroying the whole, but learning how to represent him in the character I decided. I began by the most realistic model to scale, measuring every point, reducing it to the size of a small model, copying every vein and tendon, making uglinesses galore; but they were dominated by an extraordinary beauty of form which covered them, till I began to feel I had learnt his form and could model it from memory.'[3]

Despite the use of a model, there can be no doubt that Alfred Gilbert saw himself as Icarus, and the troubled,

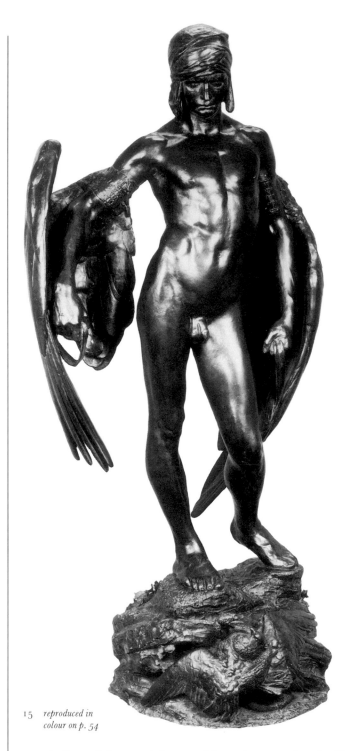

15 *reproduced in colour on p. 54*

moody face of the youth is something of an emotional self-portrait of the artist at the age of twenty-six. In 1900 William Vivian commissioned a companion to *Icarus*, which he then owned. This was to be *Galatea*, but Gilbert only began the statue in clay.

Lavinia Handley-Read first pointed out that the scale of *Icarus* and *Perseus Arming* was something new in England,

where Royal Academicians were used to making life-sized statues for exhibitions, then having them reduced mechanically for sale at a size appropriate for a mantelpiece. Gilbert's statues demanded a new respect, for they put the work 'above that of bibelot'.[4]

Gilbert had first used a bandeau to emphasise the beauty and suffering in the face of Michaelena in the *Study of a Head* exhibited at the Academy in 1883 (Cat. 12). From turban and helmet to crown and aureole was only a short step, and from this point onwards he became fascinated by his figures' headgear, which becomes progressively more elaborate.

Cat. 15 is unique, and reductions are relatively rare (see Cat. 16, 17). William Goscombe John (1860–1952) guessed that not more than a dozen of these were made, 'at the outside', for 'Gilbert broke up the plasters of these reductions before he went to Bruges'.[5] On 4 July 1905 Francis Gilbert wrote to his grandmother urging her to influence Alfred Gilbert to remodel the wings of *Icarus* (which had been lost), thereby implying that the torso was available and could be cast once the wings had been added. He noted that for this statue there was a great demand. In Gilbert's correspondence with the Compagnie des Bronzes between the years 1900 and 1920 (Library of the Royal Institute of British Architects) no mention is made of a casting of *Icarus*, so it seems likely that all reductions date from the nineteenth century.[6]

NOTES
1. McAllister 1929, p. 62.
2. 2 December 1899, MS, National Museum of Wales.
3. McAllister 1929, p. 63.
4. Handley-Read 1968, I, p. 22.
5. William Goscombe John to Sir Cyril Fox, 7 June 1938, MS, National Museum of Wales.
6. Handley-Read (London 1968) catalogued the patterns for *Icarus*. This was, however, an error. According to the Compagnie des Bronzes these do not exist and therefore could not have been exhibited.

PROVENANCE Commissioned by Frederic Leighton for £100; his sale, Christie's, 8 July 1896, lot 104, bt Robert Dunthorne for £300; sold to Somerset Beaumont for £500; bt back Robert Dunthorne; sold to Mr. William Vivian for £600, 1899; by descent to Lieut.-Col. Valentine Vivian in 1935; bt Robert Dunthorne; Sir William Goscombe John, RA, who presented it to the National Museum of Wales, 1938.

EXHIBITIONS (Cardiff cast) Royal Academy 1884, no. 1855; Manchester 1887, no. 555; Paris 1889, no. 311; London 1908, no. 1434; Manchester, Minneapolis, Brooklyn 1978–9, no. 94.
(Other casts) London 1932, no. 14; London 1935, no. 7; London 1968, nos 59G, 60G; Royal Academy winter 1968, no. 688; London 1972, no. F19.

LITERATURE Walter Armstrong, 'Sculpture', *Art Journal* 1887, p. 180, repr. p. 180; Monkhouse 1889, II, pp. 37–8, repr. p. 40; Michel 1889, p. 404, repr. p. 395; Hind 1890, p. 3; Quilter 1892, pp. 348–51; Edmund Gosse, 'The New Sculpture, 1879–1894, III, *Art Journal* 1894, p. 280; Spielmann 1901, p. 76, repr. p. 78; Hatton 1903, pp. 10–11, 32–3, repr. p. 10; Muthesius 1903, p. 77, repr. fig. 2 p. 74; Ganz 1908 Preface, p. 110; Spielmann 1908, p. 74; Macklin 1910, p. 117; Spielmann 1910, p. 7; McAllister 1929, pp. 62–6, 70, 92, repr. opp. p. 40; Maryon 1933, p. 203 (plaster? repr. fig. 267 as 'bronze'); Ganz 1934, pp. 5, 11; London 1936, p. 11; Bury 1952, pp. 8–9, 38, 41–2, 67, 73, 82, repr. pl. VIII opp. p. 34;

Handley-Read 1968, I, pp. 22–4, repr. p. 22; Handley-Read Dec. 1968, p. 715; Leonée and Richard Ormond, *Lord Leighton*, New Haven and London 1975, p. 94, repr. fig. 128; Read 1982, pp. 294, 306, 308, 313, repr. fig. 353 p. 290, col. pl. III p. 299; Beattie 1983, pp. 36, 143–4, 150, 153, 156, 186, 218, 244, repr. fig. 133 p. 142; Dorment 1985, pp. 40, 45, 46, 49, 51, 58, 99, 108, 192, 227, 233–4, 322, repr. pp. 20–2, col. pl. 1 p. 55.

16 *Icarus*

c. 1889(?)
Bronze: ht 49.9 cm/19½ in
Inscribed in circle on back near base: AG
The Trustees of the Tate Gallery

Reductions of *Icarus* differ from the first cast (Cat. 15) in the handling of the pedestal: the fully-developed *animalier* group in the full-sized cast is by comparison only suggested in the reduction. The Tate Gallery cast differs from others known to the compiler in the snake's having a forked tongue; other casts can have a rich, reddish patina, or, in

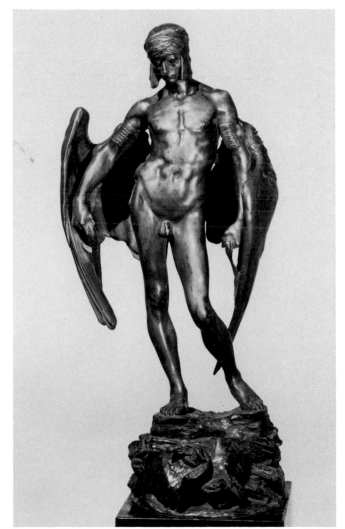

16

one case (Cat. 17) be silvered by electroplate. Gilbert strove to make each cast as 'unique' as he reasonably could. The dating of individual casts of *Icarus* is particularly difficult. The relatively early date here suggested is based on the even black patination—perhaps pointing to a period before Gilbert experimented successfully with alloys and pickles (see Cat. 90).

PROVENANCE Bequeathed to the Tate Gallery by Frederick Harrison, 1936.

LITERATURE Chamot, Farr, Butlin 1964, p. 224, Cat. 4827.

17 *Icarus*

1895
Silvered bronze: ht 49.9 cm/19½ in
The Fine Art Society, London

This piece was commissioned by an unidentified committee which wished to present a cast of *Icarus* to Sir Henry Doulton on his birthday. The Director of the Lambeth School of Art, John Sparkes, acting for the committee, called at Gilbert's Maida Vale studio on 7 May 1895, and the statue was presumably cast soon after that date.

The statue was silver plated using conventional electroplating techniques, which were firmly established and widely used by 1895. This is the only silvered cast of *Icarus* that has so far come to light, although silvered casts of *Perseus Arming* and *Victory* exist. In each case where the provenance is known, the silvered cast was owned by a friend of Gilbert, usually an artist such as Sir David Murray (1849–1933) or John Seymour Lucas (1849–1923). By the end of the 1890s Gilbert seems to have abandoned the practice of electroplating any of his bronzes, preferring instead, if he wished to achieve a silver colour, to cast his statue in aluminium (see Cat. 71).

PROVENANCE Sir Henry Doulton; by descent; Christie's, 30 April 1979, lot 106; Jeremy Cooper.

18 *An Offering to Hymen*

1884–6?
Bronze: ht 78 cm/30¾ in
Private Collection

The manuscript catalogue compiled by Gilbert's father suggests that *An Offering to Hymen* was begun in Rome and finished in London. The relevant sentence reads: '1884 Rome.—London. Statuette "Young Girl with Votive to Hymen", purchased by Hasseltine [*sic*] esq. Bronze. Exh. Grosvenor Gallery.' Ganz reported Gilbert telling him in 1907 that he modelled the statue from 'Miss Pettigrew'—

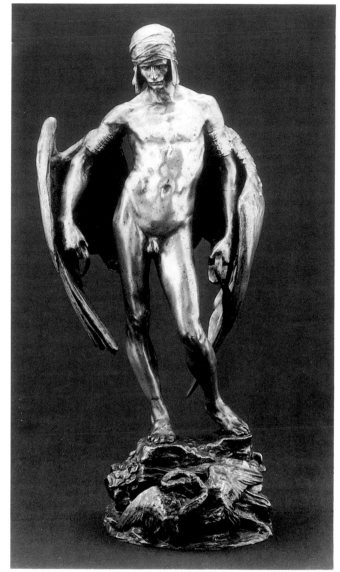

17

one of the three Miss Pettigrews, Hetty, Lily, and Rose, professional models who posed for Leighton, Whistler, Poynter, Holman Hunt, Millais, Onslow Ford, and Philip Wilson Steer. This must have been in 1885–6, soon after Gilbert's return from Rome. The bronze cast was exhibited at the Grosvenor Gallery in 1886. Until the appearance of Cat. 18, no full-sized cast had come to light, and *An Offering to Hymen* tended to be looked upon as a relatively minor work, cast in one size only, 29 cm high (Cat. 19). This recently discovered bronze shows that Gilbert conceived of it as the third statue in the progression from *Perseus* to *Icarus*, of adolescents facing the passage from youth to maturity. He regarded the piece as fully equal to the other two masterpieces. In it, a young girl stands before the altar of

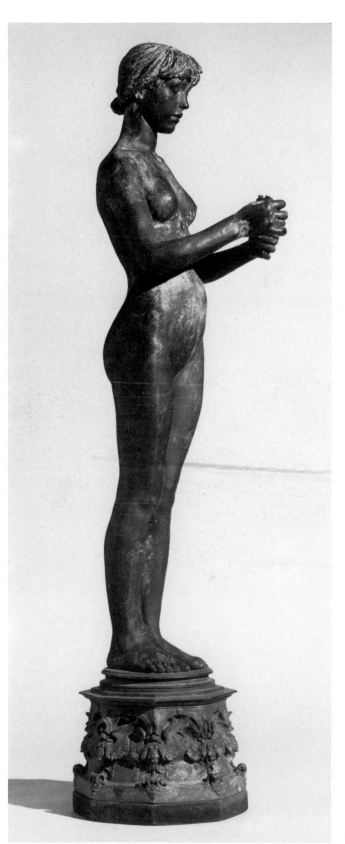

18

the god of marriage with votive offerings. The pose is particularly sensitive and makes a fascinating contrast to the easy grace of *Icarus*: Gilbert conveys anxiety by the girl's stiff carriage; he magically tells us through pose and gesture that the child will perform the ceremony with exaggerated solemnity and formality. In reductions, which are among the most popular of Gilbert's bronzes, she holds various objects—a cup (in bronze, silver, or aluminium), a rose, a sprig of hawthorn made of wire, a tiny figure of Anteros (Cat. 20) or a putto with an inverted torch (Cat. 21). In Cat. 18 the presentation objects are modern additions. The large cast possesses a sensuality which the reductions lack. Her base, like the base of *Icarus*, gently alludes to the statue which it supports, the classical grotesques suggesting a Roman altar.

The question remains: where and when was Cat. 18 cast? The statue has suffered from exposure to the weather, and has been recently restored and repatinated. Nevertheless, one might suggest that it represents one of Gilbert's earliest works cast in England. The quality of the *cire perdue* casting is rough—it is not an Italian cast because it does not possess the superlative technical quality of Gilbert's known Italian bronzes (Cat. 12, 15). One must therefore put this piece into the context of the technology for casting bronzes available to the sculptor in England in 1885–6. It was at this date that Gilbert was experimenting with the lost wax process together with Edward Onslow Ford (1852–1901) and Thomas Stirling Lee (1857–1916) in the latter's studio in Trafalgar Square.[1] In one of his first letters to M. H. Spielmann, dated 2 April 1885, Gilbert replied to the critic's query as to whether he would exhibit at the Royal Academy that year with the words: 'I have been away from my studio for some time past working in my foundry on experiments in the "Cera perduta" system of casting, and I have been entirely taken up by them, and so thoroughly absorbed that I have been obliged to neglect everything else.'[2] If *An Offering to Hymen* was under way, he may well have cast her in Lee's studio. On the other hand, whether Gilbert would have attempted a figure the size of *An Offering to Hymen* at such an early stage in his own handling of the *cire perdue* technique is questionable. Certainly the small *cire perdue* figure of *Sympathy* on the Fawcett Memorial (see Cat. 31), unveiled in January 1887 but cast in 1886, is still fairly crude.

A photograph of Gilbert in his Fulham studio in about 1890 shows a plaster of the full-sized *Offering to Hymen* in the background.[3] When the collector Douglas Illingworth (1882–1949) commissioned a number of casts from Gilbert in 1909, the sculptor wrote back saying that the plaster for the large size *Offering to Hymen* was in store at Maples warehouse where he had left it at the time of his bankruptcy. Gilbert tried to find this plaster, but finally admitted that

it was lost, and Illingworth never got his cast. It is therefore possible that other examples of the 78-cm size will come to light.

NOTES
1. McAllister 1929, p. 87.
2. SP/7/2.
3. Dorment 1985, repr. opp. p. 1.

PROVENANCE Possibly J. P. Heseltine.

EXHIBITIONS (first cast) Grosvenor Gallery 1886, no. 367; Paris 1889, no. 313 as *Une Offrande à Vénus*; Glasgow 1901, no. 127; London 1902, no. 39; London 1909, no. 292.
(Other casts) London 1932, no. 3; London 1935, no. 6; London 1968, no. 61; Manchester, Minneapolis, Brooklyn 1978–9, no. 95.

LITERATURE Michel 1889, p. 404; Hatton 1903, repr. p. 23; Muthesius 1903, p. 77, repr. fig. 8 p. 79; Ganz 1908, p. 110; Rinder 1909, p. 123; McAllister 1929, pp. 88, 144–5, repr. opp. p. 49; Ganz 1934, p. 9; Bury 1954, pp. 8, 70, 74; Handley-Read 1966, pp. 14–15; Handley-Read 1968, I, pp. 23–4, repr. p. 22; London 1968, p. 15; Beattie 1983, pp. 143, 150, 155–6, 162, 180, 199, 260 (n. 61), repr. fig. 134 p. 143; Dorment 1985, pp. 53, 59–61, 67, 99, 131, 175, 183, 220, 233, 253, 277, 279, 322, repr. pl. 25 p. 54.

19 *An Offering to Hymen*

This cast undated
Bronze and silver: ht 29 cm/11⅜ in.
Manchester City Art Galleries

The reduction of *An Offering to Hymen* is one of Gilbert's often reproduced statues. In this example the girl carries a silver cup and the winged figure of Anteros, itself an allotrope of an independent work in white metal (Cat. 20).

PROVENANCE Purchased from Messrs Brown & Phillips, 1912.

EXHIBITION Manchester, Minneapolis, Brooklyn 1978–9, no. 95a.

LITERATURE Dorment 1985, repr. pl. 32 p. 68.

20 *Anteros*

Cast 1893–6
White metal: ht 11.4 cm/4½ in
Inscribed underneath base: BY ALFRED GILBERT RA
 MARQUESS OF SLIGO
Birmingham Museum and Art Gallery

A recently discovered full-sized cast of *An Offering to Hymen* (Cat. 18) throws new light on the date of Gilbert's first model for *Anteros*. In that cast the girl originally held a figure of Anteros which, apart from the base and the feet, was miss-

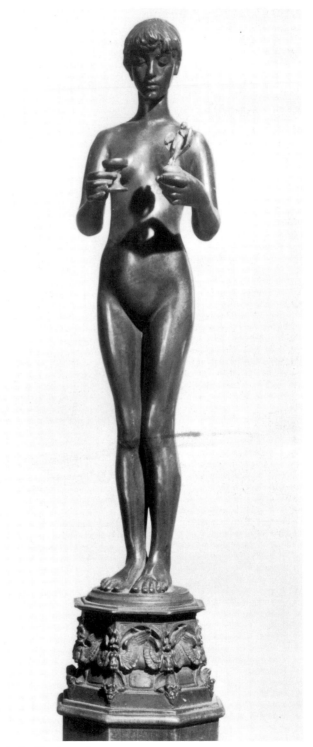

19 *reproduced in colour on p. 51*

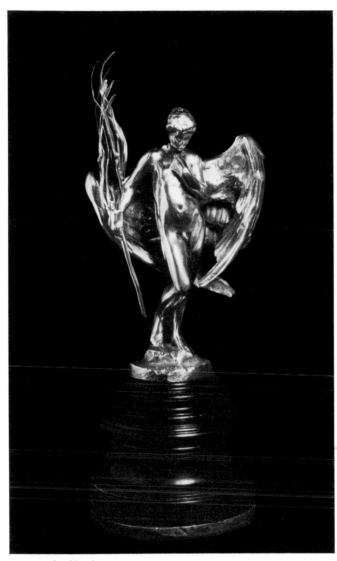

20 *reproduced in colour on p. 50*

ing when the cast came to light. The size of the feet enabled restorers to estimate the height of the original statuette to have been about $4\frac{1}{2}$ in (11.4 cm), the height of Cat. 20. In addition, the feet were identical with those in Cat. 20,

making it certain that this piece is a later cast of the original figure held in *An Offering to Hymen*. The first cast would therefore date to about 1884–6.

The inscription on Cat. 20 (recorded by Handley-Read [1966] but since covered over) enables us to date the casting of Cat. 20 to between the year of Gilbert's election to full Academician, 1892, and the death of the Marquess of Sligo in 1896. Lord Sligo would have known Gilbert through his wife, the sister of the artist's patron, Lady Arthur Russell (see Cat. 90–3). Since he met Lady Arthur in 1893, we can further narrow the date of the cast.

Anteros stands in the pose of *Icarus*, but holds a palm branch in his right hand. The palm was a changeable symbol for Gilbert: it can denote martyrdom or, as here, peace. Gilbert first used the name 'Anteros' in 1893 to identify the winged god atop the Shaftesbury Memorial (see Cat. 48, 49). For him the terms Eros and Anteros meant ego and alterego, violent destructive love and his younger brother, mature reciprocal love. In Greek myth the rival brothers were equally powerful, and with time they came to symbolise the concepts of profane and sacred love. Whatever his source, Gilbert refashioned the neo-platonic idea to explain the wildly contrasting and contradictory elements in his own nature. Thus when he spoke of Eros and Anteros later in his life he implied the ego and the id. So seriously did he treat the myth that he asked Miss McAllister to structure her biography of him by dividing it into sections entitled 'Eros' and 'Anteros', but she found this impossible.[1]

Anteros appears on the breastplate of *St George* at Sandringham (Cat. 69), and later still on the cinerarium held in the hands of Dr and Mrs Macloghlin in their effigies on *Mors Janua Vitae* (see Cat. 103–5). His final appearance is on the Leeds Chimneypiece of 1908–13.

NOTE
1. McAllister 1929, p. 216.

PROVENANCE Purchased from the Handley-Read Collection, 1973.

EXHIBITIONS London 1968, no. 67; London 1972, no. F23; Manchester, Minneapolis, Brooklyn 1979, no. 98.

LITERATURE Handley-Read 1966, pp. 14–15; Handley-Read 1968, I, pp. 23–4, repr. p. 23; Dorment 1985, p. 67, repr. pl. 33 p. 68.

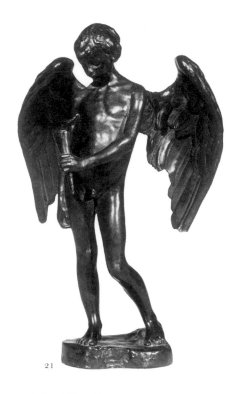

21

21 *Putto with a Torch*

1880s (?)
Bronze: ht 26.6 cm/10½ in
Private Collection

This is an undocumented cast and one that cannot be associated with any larger memorial. On stylistic grounds, particularly the hair and wings, the statue can be attributed to Gilbert. Confirmation of the authorship appeared in a cast of *An Offering to Hymen* (see Cat. 19) at Christie's (4 November 1983, lot 58). Instead of the usual *Anteros* or goblet, this statue held a much reduced figure of the *Putto with Torch*. Whether Cat. 21 is an enlargement of that figure or the figure a reduction of Cat. 21 is unclear. The simplicity of the base might suggest a date close to *Perseus Arming*, before Gilbert began to elaborate his bases, or it may mean that the figure was part of a larger sculptural scheme.

PROVENANCE Sotheby's, Belgravia, 26 March 1980, lot 135.

LITERATURE Dorment 1985, p. 67, repr. pl. 34 p. 69.

22 *Comedy and Tragedy: 'Sic Vita'*

1891–2
Bronze: ht 73.7 cm/29 in
The National Gallery of Scotland

Gilbert spoke of *Comedy and Tragedy* as 'the climax to my cycle of stories' begun with *Perseus Arming* (Cat. 10), and continued with *Icarus* (Cat. 15).[1] Like these, it is autobio-

graphical, a commentary on Gilbert's state of mind at the time of its creation: mounting debt, difficulties with patrons, and a sick wife forced him to live with continual anxiety, though what the world saw was a supremely successful sculptor and social figure publicly moving from one triumph to another.

The statue shows a stage prop-boy running with the mask of Comedy in his hands at the moment he is stung by a bee. From one side, the statue is dominated by the comic mask; from the other, the boy's expression forms the tragic mask. Just as he had worked in earlier statues in the style of

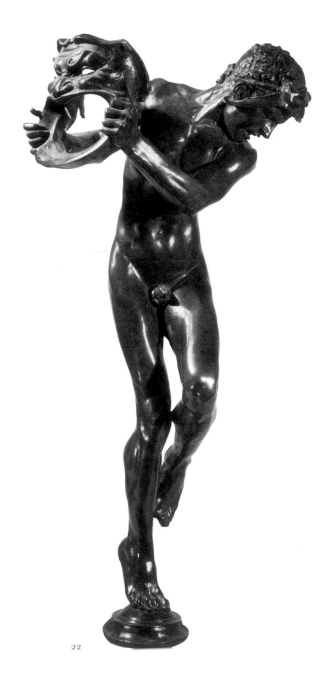

22

Donatello (Cat. 15), Michelangelo (Cat. 8) and Bernini (see Cat. 32), here Gilbert made a Mannerist bronze in the style of Giambologna. The statue needs to be seen in-the-round to appreciate the twisting of the angular, muscular body into a complex and artificial pose. The artistic problem was a difficult one—combining in one figure opposite actions and opposite emotions while retaining an abstract ornamental perfection. Gilbert's sources at this date are so various that it is hard to point to one alone—and, indeed, Gilbert's mastery of his medium was so complete that the question of sources is almost irrelevant. Perhaps Jean-Baptiste Carpeaux's (1827–75) *The Genius of Dance* (Paris, Opera; unveiled 1869) may stand in the far distance as an inspiration, while Frederic Leighton's *Needless Alarms* (London, Royal Academy; 1886) may have provoked Gilbert to try his hand at the same sort of subject.

The title (but only the title) comes from W. S. Gilbert's one-act play, *Comedy and Tragedy*, which was staged in a revival at the Lyceum with Gilbert's friend, the American actress Mary Anderson, in the leading role.

A pen and ink sketch inscribed '"Comedy and Tragedy" (first idea) Dec. iii 90 Alfred Gilbert' (Cat. 117 xiii) shows a winged putto leaping to avoid an arrow shot at his right leg. Gilbert was just beginning to think about the figure of *Eros* for the Shaftesbury Memorial at this date, so the arrow in the drawing may be identified as the one Eros has just shot from his bow. The model for *Eros*, Angelo Colorossi, recalled that before posing for that statue he had posed for *Comedy and Tragedy*.[2] The latter was begun on 2 February 1891 and advanced throughout the month. Gilbert noted in May of that year that he had worked on the top of the Shaftesbury Memorial, so *Eros* followed immediately upon *Comedy and Tragedy*.

The polychromed plaster (London, Victoria and Albert Museum) was exhibited at the Royal Academy in 1892.

NOTES
1. Hatton 1903, p. 11.
2. Angelo Colorossi to M. H. Spielmann's son Percy, 14 June 1947 (SP/20/6).

PROVENANCE George McCulloch; Mrs George McCulloch (Mrs James Coutts Michie); Christie's, 23 May 1913, lot 100; bt Fine Arts Society; bt Alexander Maitland, 1920; bequest to the National Gallery of Scotland, 1965.

EXHIBITIONS London, Royal Academy of Arts, 'The McCulloch Collection', winter 1909, no. 356.
(Full-sized plaster) Royal Academy 1892, no. 2004; London 1936, no. 8.
(Casts) London 1900, no. 132 (lent by Robert Dunthorne); London 1902, no. 8; London 1908, no. 1446; London 1932, nos 2, 15; London 1935, nos 2, 16; London 1968, no. 69; London 1972, no. F25; London, Hayward Gallery, 'Pioneers of Modern Sculpture', 1973, no. 25; Manchester, Minneapolis, Brooklyn 1978–9, no. 97; Detroit, Detroit Institute of Arts, 'The Influence of Paris: European and American Sculpture 1830–1931', 1981, no. 11.

LITERATURE Claude Phillips, 'Sculpture of the Year', *Magazine of Art*, 1892, p. 380; Spielmann 1901, p. 78; Hatton 1903, pp. 11–12, 32, repr. p. 12; Ganz 1908, Preface and p. 110; Spielmann 1908, p. 74; McAllister 1929, p. 88, repr. opp. p. 142; Maryon 1933, p. 203, fig. 268; London 1936, p. 10; Ganz 1934, pp. 8–9; Bury 1954, pp. 59, 68 (plaster), 70, 92; Handley-Read 1968, I, p. 27, repr. fig. 15, p. 27; London 1968, p. 15; Read 1982, p. 341; Beattie 1983, pp. 162, 177, 244, 260 (n. 61), repr. fig. 157 p. 162; Dorment 1985, pp. 108, 131, 134, 211, 215, 227, 233, 279, repr. pls 81–3, pp. 132–3.

23 *Comedy and Tragedy: 'Sic Vita'*

This cast 1905
Bronze: ht 36.8 cm/14½ in
Inscribed with monograph of artist's initials in a cipher, applied as a cachet to the self-base
Founder: Compagnie des Bronzes, Brussels
The National Gallery of Art, Washington, Pepita Millmore Memorial Fund. 1984. 67. 1.

Between 1902 and 1905 Gilbert or his son ordered casts of several of his most famous (and best-selling) works through M. Charles de Coene of the Compagnie des Bronzes. These were *Perseus Arming* (see Cat. 10, 11) in the large and small

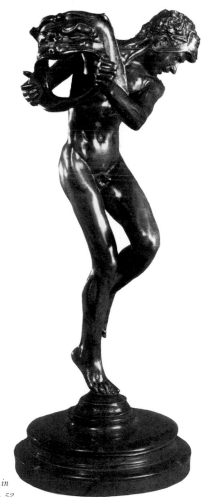

23 *reproduced in colour on p. 52*

size; *Comedy and Tragedy* (large and small); *An Offering to Hymen* in the small size only (see Cat. 19); and one cast of the *Study of a Head* (see Cat. 14).[1] During the whole of the period in which Gilbert dealt with the Compagnie des Bronzes in the casting of these bronzes, 1902–18, the number of statues cast was fairly small—only two of *Comedy and Tragedy* in the small size, both ordered in November 1905, and seven or eight in the large size (but there could be a variance here since not all Gilbert's business was done by correspondence and the fact that Gilbert ordered a cast did not necessarily mean that it was completed). The quality of known casts from the Compagnie des Bronzes is uniformly high: certainly Gilbert himself was responsible for the exceptional golden brown patina on Cat. 23, and certainly he chased each example himself and sold a piece only when it met his exacting standards. All works known to the compiler from this period bear the lozenge or cachet, which Gilbert changed at intervals: his initials, the double ampersand and the treble clef are three of these. By this device he began to keep track of his own works and develop some system whereby he could recognise authorised casts. Around 1903 he discovered that several of his bronzes had been pirated—that is, cast from his models without his permission. Before that date casts would not be signed or marked because Gilbert was unaware that this traffic was taking place; in unique works from his later career such as the Leeds Chimneypiece, there was no need to mark the piece.

Gilbert was associated with the Compagnie des Bronzes from at least 1893 until 1920. In 1935 the foundry sent back to England three cases of plaster models, although it did keep the patterns for *St George* (Cat. 68).

NOTE
1. Papers of the late Lavinia Handley-Read, Library of the Royal Institute of British Architects, London.

PROVENANCE Danny Katz.

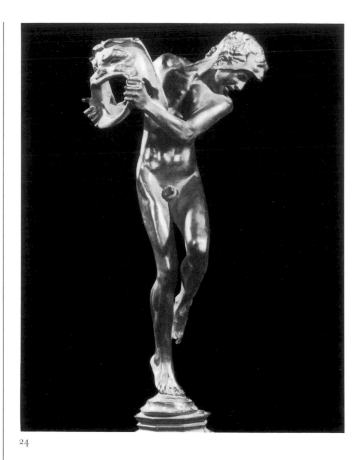

24

24 *Comedy and Tragedy: 'Sic Vitae'*

Date of this cast unknown
Bronze: ht 36.8 cm/14½ in
The Trustees of the Tate Gallery

PROVENANCE Bequeathed by Frederick Harrison (sole lessee and manager of the Haymarket Theatre), 1936.

EARLY PORTRAITURE

ORTRAITURE is the least experimental branch of the sculptor's art and inevitably Gilbert was slowest to introduce innovation in his early portrait busts. Instead, his work in the 1880s tends to cling to the formulae learned in Sir Joseph Edgar Boehm's studio. An exception is the posthumous bronze bust of Elizabeth Duckworth (Cat. 27) where the artist, forced to work from lifeless photographs, tried to experiment with the iconography by introducing two pendant medallions with portraits of the child's parents. It may or may not be significant that his patron owned not the bronze but the far more conservative marble portrait of Miss Duckworth (Cat. 28).

25 *G. F. Watts*

1888
Bronze: ht 58.4 cm/23 in
The Trustees of the Tate Gallery

In the summer of 1888 G. F. Watts's (1817–1904) wife, Mary, wrote to Alfred Gilbert from Aix-les-Bains asking him to undertake a portrait of her husband. In so doing, she was reviving a plan of the sculptor Hamo Thornycroft (1850–1925) who had tried and failed to pursuade Watts to sit for Gilbert in January 1885. Mary Watts's description of her first meeting with Gilbert and the subsequent progress of his work on the portrait is one of the earliest, fullest and most lively descriptions we have of Gilbert at work.[1]

In August he arrived by cab at Watts's Melbury Road studio: 'I found in the hall a man who looked so young he might still have been called a boy. Almost his first words were, "I cannot tell you how great an endeavour I shall make".' Clearly Gilbert idolized Watts long before their meeting. He had eighteen sittings that summer and autumn—only stopping work, it would appear, because the Wattses left London for Brighton on 1 November. Mary Watts continues: 'In the early stages he tried to give the more transient expression of keen interest and endeavour. "That keen look of his that is like a war horse" were his words; but as he grew to know Signor better the graver look appeared to him to be the most characteristic.' Gilbert generally stayed for luncheon and toured Watts's private gallery afterwards. 'One day, shaking his fist at some design, he exclaimed, "He steals all the best subjects away from the sculptors", and he went on to remark, "Mr Watts tells me things that are of such infinite value, and they are so simple!"'

In fact, in the designs for the Fahnenberg Mausoleum (Cat. 9) and *Post Equitem Sedet Atra Cura* (Cat. 88) Gilbert had already drawn on Watts's heroic metaphysical symbolism, absorbed no doubt when he visited the great Watts

retrospective exhibition of two hundred pictures shown at the Grosvenor Gallery in the winter of 1881–2.[2] The experience of sculpting the bust can only have deepened his respect for the painter: indeed, long after he had come to feel the influence of Edward Burne-Jones (1833–98) to have been 'unwholesome',[3] he continued to praise Watts. In his Royal Academy lecture of 1903, he said: 'In our Renaissance we owe a great deal to a man who . . . as a child went to study the Elgin marbles and learnt his art from them—a man who had influenced more English artists than any man ever did before.'[4] Gilbert was here pinpointing just the quality in Watts's art that would have appealed to him, for, of all Victorian painters, Watts is the one whose work is most profoundly influenced by the study of sculpture. In the

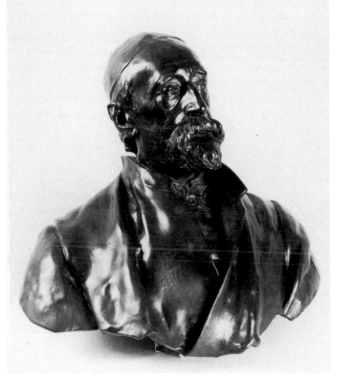

25

1890s Gilbert's own style concentrated on the exploration of the goldsmith's side of his art—experimenting with texture, material, colour, and scale, more or less ignoring Watts's bold, monumental style and sweeping symbolism. Only around 1901, with the *Broken Shrine* (Cat. 99), and later still in *Mors Janua Vitae* (see Cat. 103–5) and the Leicester *Victory* (fig. 7) did Gilbert re-examine his early essays in Wattsian symbolism.

There is, however, a darker side to Gilbert's admiration for Watts—though the same might be said of his early friendship with Burne-Jones. Watts had no sense at all that

a painting should leave his studio until he was absolutely satisfied with it, which might mean a period of as long as twenty or thirty years. When Thoby Prinsep asked Watts why he did not finish one picture before he began another, Watts replied, according to his wife: 'If, while it was still unfinished, he could improve a picture in any way, he would work upon it for any number of years.'[5] This is very different from that practical and sympathetic mentor of Gilbert, Frederic Leighton, whose counsel, Mrs Watts reports, 'was usually against delay in completing pictures'.[6] Watts was also a man above the market-place. He gave away pictures on which he had worked for many years rather than accept money for them, and this attitude Gilbert adopted in his own work. But the materials of a painter are relatively cheap compared to those of a sculptor, so he can afford to work without the burden of the commission, the advance, the deadline. Then, too, Watts (like another artist Gilbert was dangerously friendly with, James Abbott McNeill Whistler [1834–1903]) would scrape pictures after long hours of work on them and begin again. This is exactly what Gilbert would be doing with bronze and marble in the 1890s.

Gilbert shows Watts wearing his skull cap (which made the painter look like Titian in his *Self-portrait* in the Berlin-Dahlem Staatliche Gemäldegalerie). 'It could not be better,' said Frederic Leighton, whom Mrs Watts remembered 'passing his hand over the planes of the cheek-bone and then to the planes of the coat. . . .'[7] In fact, Cat. 25 is a highly competent exercise in the Boehm style of portraiture (see Cat. 51). Later bronzes by Gilbert are perhaps more immediate as he shook off the slightly staid formulae learned in Boehm's atelier.

Gilbert refused to accept money for the work, but presented the original bronze and the 6½-in-high (16.5 cm) reduction to the painter. In return, Watts painted Gilbert's portrait and exhibited it at the Royal Academy in 1895 (see Cat. 122).

NOTES
1. For this description see Watts 1912, II, pp. 133–5.
2. Evidence for Gilbert's visit to London in 1881 is indirect. It is known that he took Carlyle's death mask (McAllister 1929, pp. 35–6), and a letter from Mary Carlyle addressed to Boehm (7 February 1881) complained about the length of time the process took (MS, Beinicke Rare Books Library, Yale, kindly pointed out to me by Mark Stocker).
3. Ganz 1908, p. 6.
4. W. T. W., 'The Art of Sculpture Set Forth by Alfred Gilbert, R. A.', *Magazine of Art*, n.s., I, London 1903, p. 544.
5. Watts 1912, I, p. 234.
6. Ibid., p. 235.
7. Watts 1912, II, pp. 133–5.

PROVENANCE Presented to G. F. Watts by the sculptor; presented to the Tate Gallery by Mrs Watts, 1904.

EXHIBITIONS (Plaster) Royal Academy 1889, no. 2153; New Gallery 1896–7, no. 156; Newcastle-upon-Tyne, Laing Art Gallery, 'Special Loan Collection of Works by the Late G. F. Watts, R.A., O.M.', 1905, no. 221; Manchester, City Art Gallery, 'G. F. Watts Memorial Exhibition', 1905,

no. 205; Dublin, Royal Hibernian Academy, 'Watts Memorial Exhibition', 1906, no. 81; London 1936, no. 2.
(Tate cast) Royal Academy winter 1968, no. 369; Manchester, Minneapolis, Brooklyn, 1978–9, no. 86.
(Casts) London 1972, no. F24.

LITERATURE 'Sculpture of the Year', *Magazine of Art*, 1889, p. 370; Hind 1890, p. 3; Spielmann 1901, p. 79; Hatton 1903, p. 32, repr. p. 31; Otto von Schleinitz, *George Frederick Watts*, Bielefeld and Leipzig 1904, repr. p. 112; Spielmann 1910, p. 7; Watts 1912, II, pp. 133–5; Edward Rimbault Dibdin, *George Frederick Watts, 1817–1904*, London 1923, p. 70; McAllister 1929, repr. opp. p. 86; Bury 1954, pp. 53–4, 68–70, 80–1, repr. pl. V opp. p. 34; Chamot, Farr, Butlin 1964, p. 222, cat. 1949; Handley-Read Dec. 1968, p. 715; Dorment 1985, pp. 91, 94, 102, 121, repr. pl. 50 p. 93; MS Thornycroft Papers, Leeds City Art Gallery.

26 *Queen Victoria*

c. 1888
Marble: ht 96.5 cm/38 in
The Army and Navy Club, London

This portrait has its origins in the Jubilee Memorial to Queen Victoria (see Cat. 32) at Winchester. Gilbert and the patron of the Memorial both conceived of the statue as being carried out in marble and only changed the material to bronze when they learned that the city authorities had decided to place the statue out of doors. Gilbert's father lists

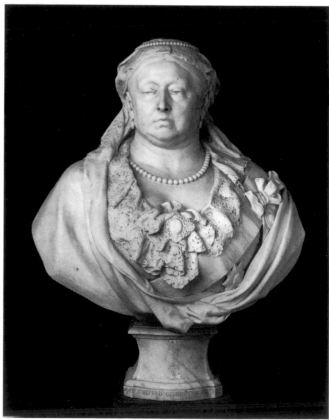

26

the work under 1888 as having been commissioned by the Army and Navy Club, and it was this commission which allowed Gilbert to carry out his original intention for the Winchester Memorial.

PROVENANCE Commissioned by the Army and Navy Club; on loan from the Army and Navy Club to the Government Art Collection (Royal Courts of Justice) since 1961.

EXHIBITION (Plaster) London 1936, no. 1.

LITERATURE Bury 1954, p. 77.

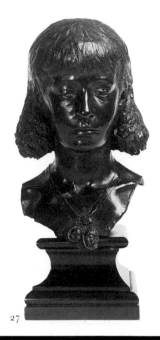

27

27 *Elizabeth Dyce Duckworth*

1884–c. 1890
Bronze: ht 52 cm/20½ in
Jeremy Cooper

28 *Elizabeth Dyce Duckworth*

c. 1890
Marble: ht 111.1 cm/43¾ in
Sir Richard Duckworth and Sir Godfrey Morley

Sir Dyce Duckworth (1840–1928) was a physician of note who specialised in kidney complaints. He attended Queen Victoria and later Edward VII. His daughter, Elizabeth (Elsie) Dyce Duckworth, died at the age of thirteen on 20 March 1884. Gilbert's father lists the bust under that year as 'Posthumous Bust of Miss Duckworth, commissioned by Sir Dyce Duckworth. Bronze'. It is possible that the commission for the bronze (Cat. 27) was actually given in Rome, although the bust was probably modelled and certainly cast after Gilbert returned to England; the marble (Cat. 28) was executed in 1890. An Italian named Castini delivered the marble bust to Gilbert in February 1890; he may have been a supplier of marble, or, more likely, a pointer who prepared the bust for Gilbert to finish. Sir Dyce and his second wife (not the mother of Elsie) called at Gilbert's studio on 8 January 1891, were delighted with the work, and asked Gilbert to exhibit it at the Royal Academy. The critic for *The Academy* (6 June 1890) criticised the marble for 'an unusual lack of taste in the adjustment of the lines of the dress with those of the head', but admitted that the bust was 'simple and charming'. A photograph of Gilbert in his Fulham Road Studio, taken in about 1887–90, shows a plaster cast of Cat. 27 on a shelf above the sculptor (fig. 1).

The differences between the bronze and marble busts are instructive. The bronze is far more daring, including as it does two bronze miniatures dangling from the child's neck. The larger of the two is a portrait of her deceased mother; the smaller, her father. Gilbert very rarely attempted a woman's hair in bronze unless it were pulled back (see Cat. 12, 83). The treatment here is not altogether successful,

28 *reproduced in colour on p. 86*

which may be one reason why he carved the bust in marble. Then, too (even granting the need to work from photographs or a portrait), the bronze is rather more sombre than the marble. This is because in the latter Gilbert is able to divert our attention from the expressionless, lifeless face towards the lace and flowers in the bodice, while the use of marble itself lends a translucence to the piece that makes it an altogether more seductive object. The marble is, however, a far more conservative rendering, depending as it does on well-known French formulae in the rococo revival style, whether by Dalou, Carpeaux or Rodin. It is not known whether the Duckworths ever owned a cast of the bronze or whether they rejected the rendering in bronze and asked for a bust in marble. Cat. 27 is the only bronze cast that has so far come to light.

PROVENANCE (Cat. 27) Sotheby's, London, 29 March 1983, lot 200. (Cat. 28) Commissioned by Sir Dyce Duckworth; by descent to the present owners; on loan to the Ipswich Museums.

EXHIBITION (Cat. 28) Royal Academy 1891, no. 2060.

LITERATURE (Cat. 28) Hatton 1903, p. 32; McAllister 1929, repr. opp. p. 139; Bury 1954, pp. 68, 77; Dorment 1985, p. 122, repr. pl. 61 p. 116.

29 *Sir George Birdwood, KCIE, CSI*

1891 (this cast 1894)
Bronze: ht 76.2 cm/30 in
The Royal Society of Arts

This bust represents Gilbert's first essay in the half-length portrait, a change in format that evolved naturally as the artist exhausted the head and shoulders formula of the 1880s (see Cat. 25). Furthermore, his association with the South Kensington Museum as advisor or 'referee' on purchases of sculpture made him familiar with the Museum's sculpture holdings, and as a source for the pose and handling of this figure we can cite the sixteenth-century Emilian *Bearded Man* (VAM 120–1869) in which the half-length figure holds a scroll. When the gilded plaster version of Sir George Birdwood was exhibited at the Royal Academy in 1892, the critic Claude Phillips commented upon the innovation of representing the arms and hands in a portrait bust. That he did so suggests that the type was relatively little known in English sculpture.

Sir George first sat to Gilbert in October 1891. At the second sitting, on 14 October, Gilbert decided to make the statue in the half-length size and gave Sir George an eighteenth-century Tibetan bronze figure of the Bodhisattva Avololcitesva from his own collection to hold.

The date of the first cast is not known: that bust was unveiled on 27 March 1894 by Lord Harris, Governor of Bombay, at Bombay University. According to the plaque underneath that cast, Sir George Birdwood (1832–1917),

an orientalist who had served for fourteen years as registrar and curator of the museum there, is commemorated for his services to the city of Bombay and for his long devotion to the study and exposition of the industrial arts of India. Whether or not Gilbert knew Birdwood before the sittings began is unclear: Sir George was friendly with Gilbert's early patron, Sir Henry Doulton (see Cat. 8, 10), and also with William Chandler Roberts-Austen (see p. 15). Birdwood also moved in the circle of scientists and artists who lectured and attended lectures at the Society of Arts in the 1880s and 1890s.

The Bombay cast was commissioned by Birdwood's friends, Mr Bharanagree and Mr Lock. Cat. 29 was finished and placed in the studio on 5 February 1894. It is not known why Gilbert made a second bronze cast. It was for sale when exhibited at the Surrey Art Circle in 1901, but who finally bought it and how it entered the Royal Society of Arts is unclear.

PROVENANCE The Royal Society of Arts by 1909.

EXHIBITIONS (Plaster) Royal Academy 1892, no. 1964. (This cast) London 1901, no. 121; London 1909, no. 286; London 1968, no. 70; Manchester, Minneapolis, Brooklyn 1978–9, no. 87.

LITERATURE Claude Phillips, 'Sculpture of the Year', *Magazine of Art*, 1892, p. 380; 'Some London Exhibitions', *Art Journal*, Aug. 1901, p. 253; Spielmann 1901, p. 79; Hatton 1903, p. 32; Spielmann 1910, p. 7; Henry Trueman Wood, *A History of the Royal Society of Arts*, London 1913, p. 520; Bury 1954, p. 68; Handley-Read Dec. 1968, p. 715, repr. fig. 92 p. 714; Dorment 1985, pp. 91, 122, 268, repr. pl. 65 p. 118.

29

30 *Ignace Jan Paderewski*

1891 (cast 1934)
Bronze: ht 60.3 cm/23¾ in
Inscribed at back on base of neck: ALFRED GILBERT
The Trustees of the Tate Gallery

Gilbert struck off this portrait of the Polish pianist, patriot and first Prime Minister of Poland in one sitting (13 July 1891) at the request of his mother, Charlotte. The head was finished in two hours, while Paderewski (1860–1941) played the piano in Gilbert's studio. The sculptor gave the plaster to his parents.

At the death of Charlotte Gilbert in 1909, her furniture and the bust of Paderewski were placed in storage at Maples warehouse. In about 1930 arrears in storage costs were paid and the bust was released to Gilbert, then living in Kensington Palace. Early in the year 1934 Mrs Hadley, the wealthy wife of Gilbert's last physician, bought the plaster and paid for it to be cast in bronze. She contacted Miss McAllister to ask that the bronze be exhibited at the Royal Academy in 1934, and sold, with the proceeds to go into a testimonial fund for Alfred Gilbert. This was done and the bust was bought for the Chantrey Bequest. A replica is in a private collection in England.

A bronze reduction (ht 21.4 cm; Birmingham, Museum and Art Gallery) from the original plaster (Manchester, City Art Gallery) was made for Lady Lewis, the musical patron and wife of the solicitor Sir George Lewis. Lady Lewis had taken up the pianist soon after his arrival in London.

PROVENANCE Purchased for the Chantrey Bequest, 1934.

EXHIBITION Royal Academy 1934, no. 1595.

LITERATURE McAllister 1929, reduction repr. opp. p. 214; Bury 1954, pp. 38, 55, 87–8, plaster repr. pl. XXII opp. p. 58; Chamot, Farr, Butlin 1964, pp. 223–4, cat. 4755; Dorment 1985, pp. 128, 131, 220, repr. pl. 79 p. 129.

30 *reproduced in colour on p. 90*

LMOST upon the moment of his return to England in 1885 Gilbert was inundated with commissions for public and private memorials. The degree to which confidence was placed in the young man is underlined by the importance and location of these memorials.

The Fawcett Memorial

In April 1885, within months of Gilbert's return to England, the Fawcett Memorial Committee (Leslie Stephen, Lord John Manners and Lord Granville) invited him to create a memorial to the blind Postmaster-General (1833–84) in Westminster Abbey.[1] Set in a Gothic trefoil high up in the first chapel to the right as the visitor enters the Abbey, the memorial consists of a roundel with a portrait of Fawcett hovering above seven figures which symbolise his virtues.

The monument as a whole is a mixture of sculpture and metalwork: its design is not particularly well integrated— Gilbert was not an architect—but the figures of the virtues have a sculptural monumentality which his work of the later 1890s lacks. These allegorical bronzes could have been carved in stone, whereas by the time Gilbert executed *St George* on the Tomb of the Duke of Clarence (see Cat. 69), metalwork had become predominant. The Fawcett Memorial was Gilbert's last work completed before the experience of designing Queen Victoria's Epergne (Cat. 53) and, even more important, was designed before over-work and debt began to weigh on his spirit. The seven virtues, each in its own niche, are really like nothing else in English art of the nineteenth century; even in the saints on the Tomb of the

Fig. 44 Alfred Gilbert, The Fawcett Memorial, 1885–7 (Westminster Abbey, London)

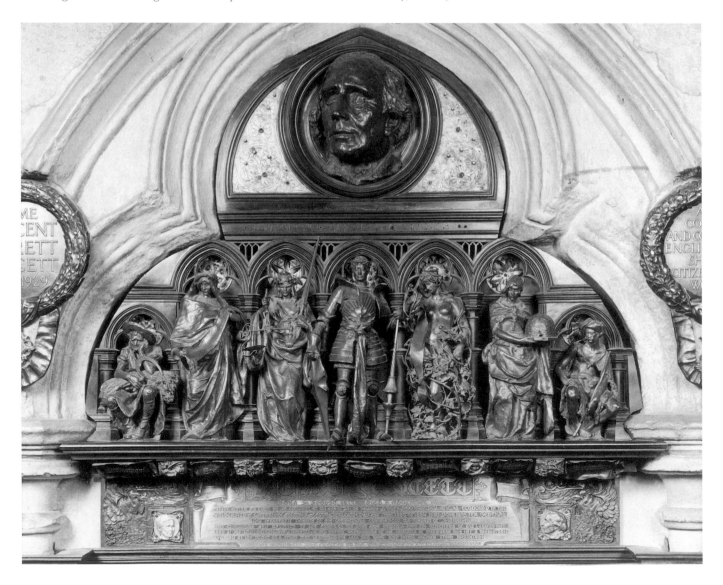

Duke of Clarence (see Cat. 69–81) Gilbert is neither as light-hearted, nor as charming. Sitting on either end are two figures denoting brotherhood, a farmer with his scythe and sheaf on the left, and a turbaned and ragged youth with a hoe on the right. In between we meet Zeal with her scroll and seals (Cat. 31); Justice with her scales; Fortitude, a knight in armour; Sympathy, a nude lady enveloped by thorns; and Industry, who holds (what else?) a beehive. These are not the traditional virtues and come out of no Iconologia. Here Gilbert has shown himself to be irreverent towards ecclesiological exactitude, an attitude very different from that of an artist of an earlier generation such as Burne-Jones, who took endless pains to ensure that the saints in

Fig. 45 Alfred Gilbert, The Fawcett Memorial, 1885–7: detail showing *Zeal* (Westminster Abbey, London)

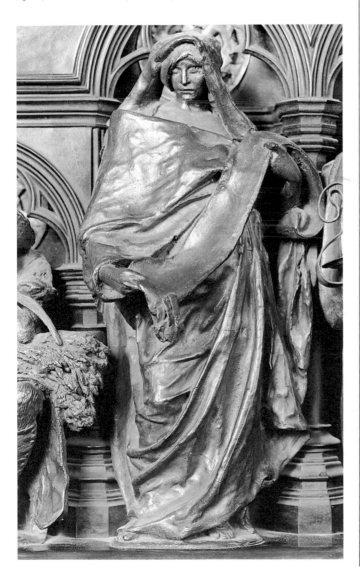

his stained glass held the correct attributes.

Gilbert's wish to carry out the Memorial by the *cire perdue* casting process may have determined the small scale of the figures, and they, in turn, dictated the composition and iconography. Certainly he cast these figures himself. Sympathy is a flawed cast—perhaps the first to be completed; and a heavily restored cast of Zeal (Cat. 31), perhaps discarded by Gilbert, suggests that the figure on the monument may be a second casting. The statues are selectively painted gold; the attributes are sometimes left in the natural bronze, and the figure of Fortitude is more liver-coloured than gold. At one time the Memorial was flecked with vermilion and studded with turquoise and garnets, but the stones, together with the knight's banner, vanished during the coronation of Edward VII. Gilbert included a second portrait of Fawcett in profile on a medallion below the saints, and in 1932 adddded a portrait of Fawcett's wife, the suffragette leader Dame Millicent Garrett Fawcett (1847–1929).

The most beautiful details are almost invisible at first sight. Beneath six of the virtues are emblems—a dragon, a putto, a pomegranate, a putto's head, a crowned death's head and a spider on a butterfly.

Even before the work was unveiled on 29 January 1887, its importance was noted. Joseph Edgar Boehm wrote to George Howard (1843–1911) on 11 January 1886: 'Gilbert has nearly completed a monument to Fawcett for Westminster Abbey which will be one of the loveliest works done in modern days. England will be yet proud of so talented a sculptor[–] better than any we have yet had.—Do not miss to see it when in town.'[2]

NOTES
1. Warriors Chapel, Westminster Abbey. Bronze lunette with portrait medallion and seven bronze allegorical figures.
2. Castle Howard Archive, J 22/96/136. Mark Stocker kindly drew my attention to this letter.

LITERATURE Leslie Stephen, *Life of Henry Fawcett*, London 1886, p. 468; *The Times*, 29 January 1887, p. 12; *Pall Mall Gazette*, 29 January 1887, pp. 3, 7; Walter Armstrong, 'Sculpture', *Art Journal* 1887, p. 180; J. Belcher, 'The Alliance of Sculpture and Architecture', *Transactions of the National Association for the Advancement of Art and its Application to Industry, Liverpool Meeting, 1888*, London 1888, p. 376; 'Memorial to Henry Fawcett, Westminster Abbey', *The Builder* (7 January 1888), pp. 9–10, drawing by Gerald Horsley repr. opp. p. 9; Monkhouse 1889, I, p. 4, repr. p. 1; Monkhouse 1889, II, pp. 37, 39, 40; Hind 1890, p. 3; Edmund Gosse, 'The New Sculpture 1879–1894, III, *Art Journal* 1894, p. 282; Spielmann 1901, pp. 81–2, repr. p. 80; Hatton 1903, plaster repr. p. 1; Muthesius 1903, p. 76; Macklin 1910, p. 102; Ganz 1908, p. 110; Winifred Holt, *A Beacon for the Blind, Being a Life of Henry Fawcett*, London 1915, p. 323, repr. opp. p. 322; Lawrence Weaver, *Memorials and Monuments Old and New: Two hundred subjects chosen from seven centuries*, London 1915, pp. 162, 167, repr. p. 165; McAllister 1929, pp. 123–4, repr. opp. p. 73; Bury 1954, pp. 10, 17, 66; Handley-Read 1967, p. 19; Handley-Read 1968, I, pp. 23–5, repr. pp. 23, 24, 25; London 1968, p. 12; Manchester, Minneapolis, Brooklyn 1978–9, introductory notes for no. 102 pp. 184–5; Read 1982, pp. 314–15, 327; Beattie 1983, pp. 145–6, 162, 244; Dorment 1985, pp. 62–3, 168, repr. pl. 28 p. 62, pls 29–31 pp. 64–5, col. pl. 11 p. 56.

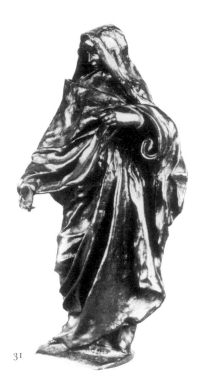

31

31 *Zeal*

> *c.* 1886
> Bronze: ht 37.5 cm/14¾ in
> Private Collection

One might make a case for this figure as being the first of Gilbert's *cire perdue* bronzes cast in England, and therefore the first in the English revival of the technique in the late nineteenth century. The heavily restored arm might indicate a badly flawed or ruined casting rectified in the figure on the Memorial itself. The date of the restoration is not known. The long right arm and small head are evidence of Gilbert's adjustment of the figure to be seen from below. The statue of Zeal recalls sculpted *pleurants* on fifteenth-century Burgundian tombs or the bronze kings and queens of Visscher the Elder. In an oft-quoted letter of 12 July 1887, Edmund Gosse described Visscher's Shrine of St Sebald in Nuremberg to Hamo Thornycroft as 'pure Gilbert, only glorified and enlarged—tier on tier of bronze figures, all exquisitely finished, all moving, not any gesture or form repeated, and invention, fancy, beauty, truth in every line of the great composition'.[1]

NOTE
1. Evan Charteris, *The Life and Letters of Sir Edmund Gosse*, London 1931, pp. 210–11.

PROVENANCE Handley-Read Collection; The Fine Art Society.

EXHIBITIONS London 1968, no. 64; London 1971, no. 97; London, The Fine Art Society, 'Centenary Exhibition', 1976, no. 174; Manchester, Minneapolis, Brooklyn 1978, no. 102.

LITERATURE Handley-Read 1968, I, repr. p. 24.

The Jubilee Memorial to Queen Victoria

The High Sheriff of Hampshire, William Ingham Whitaker, presented the Jubilee Memorial to Queen Victoria to the town of Winchester in 1887.[1] Gilbert modelled and cast the statue in eight months, working from photographs of the Queen and using his own mother as a model for the figure and drapery. The portrait of the Queen—one of the finest of her ever made—is a mixture of extreme realism and gross exaggeration. Her aged, jowled face and imperious expression might almost be thought unflattering, while her huge proportions, quite at variance with Queen Victoria's tiny stature, accounts for the figure's glacial dignity and commanding presence. The artist convinces us that this giantess is the Queen by the device of seducing the viewer into admiring the gorgeous textured robes of state, the profusion of realistic details such as the Order of the Garter, the Koh-i-Noor diamond, and her awesome bracelet and apparently

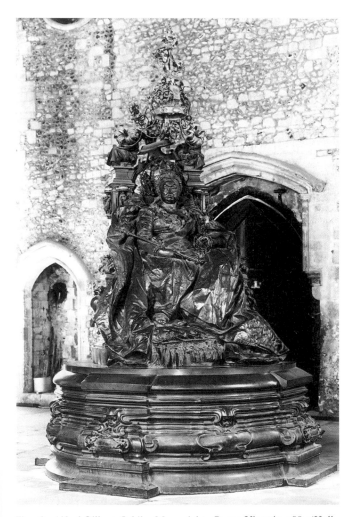

Fig. 46 Alfred Gilbert, Jubilee Memorial to Queen Victoria, 1887 (Hall of Winchester Castle, Winchester)

bejewelled sceptre. Even the tasselled cushion at her feet, richly textured like her robes, is cast with attention to minute detail. It is all the more effective and insistently symbolic, then, when Gilbert introduces three non-realistic elements: the globe-like orb over which Victory flies referring to England's imperial power; the second, suspended crown representing a spiritual rather than temporal authority; and the throne, alive with allegorical figures of varying scales, expressing Queen Victoria's position and virtues.

When the plaster was exhibited at the Royal Academy in 1888 Rodin called it 'the finest thing of its kind in modern times',[2] and recently Susan Beattie has described the statue as 'the most important single influence on memorial sculpture in England'.[3]

Almost on its erection, however, the statue ran into difficulties. A vandal wrenched *Victory* (Cat. 33) from its orb and flung it into a nearby garden; the statue was moved; later a tarpaulin covered it; and later still it was crated. In 1908

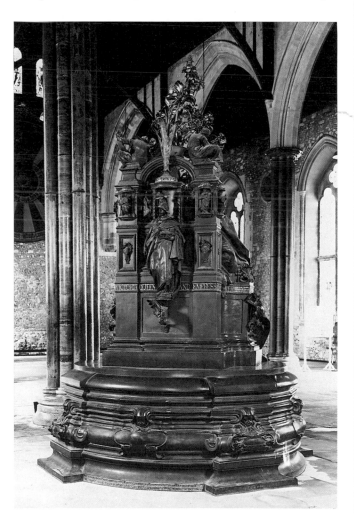

Fig. 47 Alfred Gilbert, Jubilee Memorial to Queen Victoria, 1887 (Hall of Winchester Castle, Winchester)

a Buildings Committee report noted: 'The statue is more suited for an indoor light than out of doors. . . . Where it is placed at present much of the beautiful detail of the work is lost in the out-of-door light, which is so strong and diffused as to obliterate detail.' In 1910 it was moved indoors and restored. At the same time Gilbert cast and placed on the throne of the Memorial the small allegories he had originally planned but had executed only in painted plaster (see Cat. 35). By 1912 he had remade the suspended crown (which had years before collapsed) and elevated the work on to a new socle and base. Thus the statue we see today represents work carried out over a period of twenty-five years.

In 1900 Gilbert cast a replica of the Memorial for the city of Newcastle-upon-Tyne, using the Compagnie des Bronzes in Brussels as his founders.[4] In 1903 the same foundry cast a second replica for the British Embassy in Bangkok, unveiled in the following year by Crown Prince Maha Vachiravvdh.

NOTES

1. Jubilee Memorial to Queen Victoria, 1887–1912. Bronze, beaten metal, gold paint, crystal. Inscribed: COMMEMORATION OF FIFTY YEARS GLORIOUS REIGN OF VICTORIA QUEEN AND EMPRESS WM INGHAM WHITAKER GAVE THIS STATUE ANNO DOMINI MDCCCLX [*sic*]; signed in the bronze at the side of the throne: ALFRED GILBERT ARA/ DEVISED AND MADE IT AD 1887. The Great Hall of Winchester Castle, Winchester.
2. Spielmann to McAllister, 25 April 1927, SP/8/22/1.
3. Beattie 1983, p. 207.
4. Though the founder of the original statue at Winchester is not documented, Duncan James has suggested that it may have been the Compagnie des Bronzes, Brussels. He points out that the Cie. des Bronzes trade catalogue entitled *Bronzes Monumentaux* (undated, but *c.* 1903) clearly lays claim to casting 'The Statue of Her Late Majesty Queen Victoria at Winchester by A. Gilbert RA'. However, this may refer to the Newcastle or Bangkok casts. The Cie. des Bronzes cast Boehm's *Gordon Memorial* in St Paul's Cathedral (1886), so it is possible that they had a London-based agent even at this early date.

EXHIBITION (Plaster) Royal Academy 1888, no. 1940.

LITERATURE [Claude Phillips], 'Sculpture at the Royal Academy', *Magazine of Art* 1888, pp. 366–70, plaster repr. p. 368; Claude Phillips, 'Correspondance d'Angleterre: Les Expositions d'été de la Royal Academy, de la Grosvenor Gallery et de la New Gallery à Londres', *Gazette des Beaux-Arts*, 2nd series, vol. 38 (1888), p. 76; Frederic Leighton, 'Presidential Address', *Transactions of the National Association for the Advancement of Art and Its Application to Industry, Liverpool Meeting, 1888*, London 1888, p. 24; Monkhouse 1889, I, p. 4; Monkhouse 1889 II, pp. 37, 39, 40; Hind 1890, p. 3; Quilter 1892, pp. 366–7; Edmund Gosse, 'The Place of Sculpture in Daily Life: III, Monuments', *Magazine of Art* XVIII (1895), p. 410; Spielmann 1901, pp. 80–1, repr. pp. 82–3; Hatton 1903, pp. 2, 5, 32, plaster repr. p. 8, bronze repr. p. 8 and opp. p. 8; Muthesius 1903, p. 76; Spielmann 1910, p. 7; 'The Queen Victoria Statue at Windsor', *Hampshire Observer and Basingstoke News*, 22 May 1912, p. 6; McAllister 1929, pp. 125–6, repr. opp. p. 80; Bury 1954, pp. 10, 17, 43–4, 66, 81–2, repr. pl. VI foll. p. 34; Handley-Read 1968, I, p. 25; Elfrida Manning, *Marble & Bronze The Art and Life of Hamo Thornycroft*, London and New Jersey 1982, p. 111; Read 1982, p. 369, repr. fig. 457 p. 370; Beattie 1983, pp. 6, 193, 196, 207–11, 213, 219, 230, 244, repr. figs 207–8 pp. 208–9; Dorment 1985, pp. 72, 77, 79, 115–16, 206, 213, 220, 277, 284–5, repr. pls 36–8 pp. 74–6; MS Administrative County of Southampton, Reports of the Public Works and Buildings Committees 1889–1912, preserved in the Castle, Winchester.

32 *Sketch for the Jubilee Memorial to Queen Victoria at Winchester: The Queen Enthroned*

1887
Figure of blackened wax on bronze throne mounted on
 wooden base: ht 35.6 cm/14 in
Birmingham Museum and Art Gallery

This sketch-model was clearly made to give the patron a general idea of the composition of the Memorial, but just as clearly Gilbert had no intention of following the model closely. The drapery here overwhelms the relatively tiny figure of the Queen, who wears no crown and none of the regalia that makes the bronze statue so impressive. Gilbert worked by instinct, and his instinct was to lighten continually the mass of bronze by embellishment with numerous component parts, culminating in the golden crown over the Queen's head. It is noticeable, too, that rather than diminish the dramatic swags of drapery to compensate for the disparity between it and the figure, in the final version he enlarged the figure to accommodate the drapery.

PROVENANCE In the sculptor's studio at the time of his death in 1934; bt and presented to the museum by Sigismund Goetze and the National Art-Collections Fund, 1936.

EXHIBITIONS London 1936, no. 7(a); London 1981, no. 4.

LITERATURE Bury 1954, p. 71; Dorment 1985, pp. 72, 77, repr. pl. 35 p. 73.

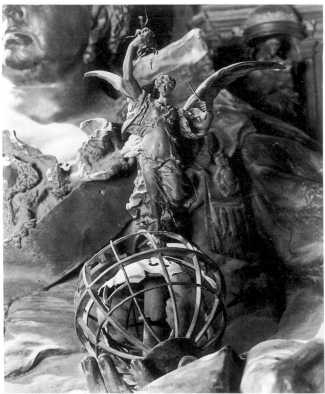

33

33 *Victory and Orb from the Jubilee Memorial to Queen Victoria*

1887
Bronze: Victory ht 35.6 cm/14 in; Orb diam. 22.8 cm/9 in
Hampshire County Council

Gilbert's flying Victory of 1887, like the figure of Victory in *The Kiss of Victory* (Cat. 6) looks back to *The Winged Victory of Samothrace*, discovered in 1863 and installed in the Louvre around 1868. Perhaps an even closer source is Canova's *Victory* on the orb in the hand of *Napoleon as Mars the Peace-Maker* (marble, 1802–6; London, Apsley House). Gilbert sometimes referred to this figure as Peace (the two concepts being interchangeable during Queen Victoria's long *Pax Britannica*) and also (referring to the trumpet she once held in her left hand) as Fame. *Victory* was one of Gilbert's best known and most often reproduced statues, executed in different sizes either in bronze or in silver, often balanced on spheres of onyx or marble, and sometimes with intricate bronze bases. In 1903 Gilbert returned to the theme of Victory, attempting to enlarge it to at least 16 ft (4 m 88 cm) high as a memorial to the Boer War dead of the City of Leicester. The attempt was a failure and the commission was never completed. In 1904 a variant of the figure reappeared on the small group, *St George and the Dragon, Victory Leading* (Cat. 101).

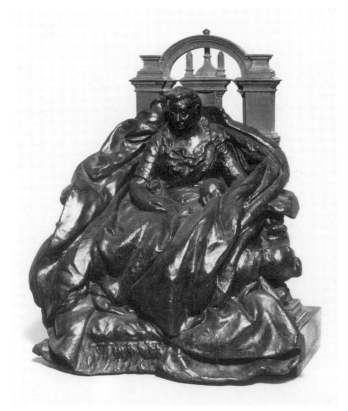

32 *reproduced in colour on p. 93*

The splendid *cire perdue* cast was damaged, soon after the original unveiling, by a drunkard who threw it into a garden. It was recovered and restored by Gilbert.

EXHIBITIONS (Silver casts) Royal Academy 1891, no. 2069; London 1908, no. 1442; Paris, Musée des Arts Décoratifs, 'Exposition Britannique', 1911, no. 1125; London 1932, no. 9.
(Bronze casts) London 1909, no. 316; London 1932, nos 7, 11; London 1935, nos 4, 17; London 1968, nos 62, 63; Royal Academy winter 1968, no. 685; London 1972, no. F21; Manchester, Minneapolis, Brooklyn 1978–9, no. 96.
(Plaster) London 1936, no. 31.

LITERATURE Hatton 1903, p. 32, repr. p. 17; Spielmann 1908, p. 74 (silver); Ganz 1908, p. 110; 'Passing Events', *Art Journal*, May 1909, p. 160; Rinder 1909, p. 123; Spielmann 1910, p. 7; Macklin 1910, repr. p. 115; McAllister 1929, pp. 126, 161; Bury 1954, pp. 43, 68, 70, 73, 81; Handley-Read 1966, p. 14; Handley-Read 1968, I, p. 25, repr. p. 26; Handley-Read 1968, III, p. 140; Handley-Read Dec 1968, p. 715; Beattie 1983, pp. 196, 207; Dorment 1985, pp. 115, 152, 180, 183, 230, 233, 276, 279, repr. pl. 38 p. 76.

34 *Victory*

1887; this cast 1910
Bronze on black onyx sphere mounted on black octagonal wood pedestal: ht (with pedestal) 46.4 cm/18¼ in; ht (without sphere and pedestal) 34 cm/13⅜ in
Founder: Compagnie des Bronzes(?)
The Visitors of the Ashmolean Museum, Oxford

Victory was cast in several sizes, in both bronze and silver, and often mounted on spheres of onyx or coloured marble. It was a favourite present which

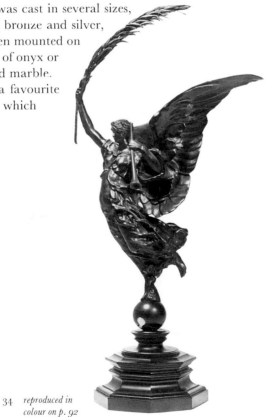

34 *reproduced in colour on p. 92*

Gilbert gave to friends: John Singer Sargent (1856–1925), Seymour Lucas, Henry Irving (1838–1905), and Mark Senior (1863–1927) were all presented with casts, very often completed with elaborate bronze bases below the spheres.

This particular example was bought by the Rev. J. W. R. Brocklebank. In a letter written on New Year's Day 1911, Gilbert remarked: 'You say that of the four statuettes you have of mine, the one most admired is "Victory". You are not aware, possibly, that [its] apparent joyousness is due to the fact that it was conceived and executed during the very few hours of happiness I have known, in a now, almost long, and eventful life. Even the original bronze (Cat. 33) brought me sorrow. . . .'[1] The last sentence refers to the vandalism of the first cast.

In an earlier letter to Brocklebank, dated 20 January 1910,[2] Gilbert replied to Brocklebank's request to purchase a cast of *Victory*; since it was in Brocklebank's possession by January 1911, we can date this cast to 1910.

NOTES
1. Alfred Gilbert to Brocklebank, in correspondence preserved in the Ashmolean Museum, Oxford.
2. Loc. cit.

PROVENANCE Purchased from the artist, 1911; the Rev. J. W. R. Brocklebank Bequest, 1927.

LITERATURE C. F. Bell, 'Report of the Keeper of the Department of Fine Art and the Hope Collection of Engravings for the Year 1927', *Report of the Visitors of the Ashmolean Museum*, Oxford 1927, p. 29; Dorment 1985, repr. pl. 39 p. 78.

35 *Wisdom (Literature)*

Modelled 1887; first cast in bronze by 1906; a bronze cast placed on the Jubilee Memorial to Queen Victoria in 1910
Bronze: ht 25.6 cm/10 in
Inscribed on paper under base in the hand of Alfred Gilbert:
REPLICA OF STAT ON THRONE OF Q VICTORIA AT
WINCHESTER A GILBERT
The Visitors of the Ashmolean Museum, Oxford

Wisdom (Literature) was one of the virtues modelled in 1887 and placed on Queen Victoria's throne in a painted plaster version for the unveiling of the Jubilee Memorial on 17 August of that year. Immediately after the ceremony Gilbert removed the statues, and the niches remained empty for many years. One of the reasons why the Memorial was subsequently treated so badly, one infers, was that the authorities considered it to be unfinished. The Committee report for 23 May 1910 reads: 'The Committee in their last report mentioned that Mr. Gilbert had delivered to the Compagnie des Bronzes the models of two of the statues, he has now delivered to the Company the models of four more of the statuettes, and directions have been given for the casting of these statuettes in bronze. To complete the statue there only remain two further statuettes and the

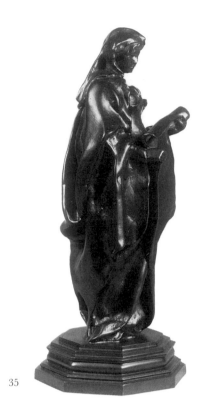

35

Crown. . . .' This does not, however, mean that this *Wisdom* was cast in 1910, the year in which the figure of *Wisdom* was cast for the Memorial. George Gilbert recorded in his diary (23 June 1906) that Mr Horace Littlejohn of the John Baillie Gallery, 54 Baker Street, took away 'a small bronze (belonging to Winchester Queen statue) which I called Literature'. The price was 10 guineas. Since Alfred Gilbert was dealing exclusively with the Compagnie des Bronzes in these years, we may assume that this piece was cast by that foundry.

The Hampshire Observer noted that the smaller allegories on the throne of Queen Victoria represented Faith, Hope, Charity, the Law, the Constitution, and the Colonial Empire. George Gilbert called Cat. 35 'Literature', and it has also been referred to as 'Wisdom'. The truth is that these allegorical figures were all but interchangeable; Gilbert seems not to have placed as much importance on their iconography as he did, for example, on similar figures on the Fawcett Memorial (Cat. 31).

In 1901 Spielmann published photographs of the Winchester Memorial which show the original plaster figures in place. These photographs must date from August 1887.

PROVENANCE Bt from the artist by the Rev. J. W. R. Brocklebank; Brocklebank Bequest, 1927.

EXHIBITIONS (Plaster, Birmingham) London 1936, no. 7 b–c; London 1981, no. 4.

LITERATURE C. F. Bell, 'Report of the Keeper of the Department of Fine Art and the Hope Collection of Engravings for the Year 1927', *Report of the Visitors of the Ashmolean Museum*, Oxford 1927, p. 29.

36 *Crown of the Jubilee Memorial to Queen Victoria*

1887; this version 1910
Beaten metal, gilded and set with white and ruby crystals:
 ht 76.2 cm/30 in
Hampshire County Council

The original crown above Queen Victoria in the Winchester Jubilee Memorial can be seen to have been relatively modest (if that term can be used for so extraordinary an object) in the 1887 photograph reproduced by Spielmann (1901, p. 83). This deteriorated and eventually fell to the ground; the pieces were collected and stored, but were eventually lost, and what we see today is Gilbert's reconstruction of 1910–12 based on photographs. In the intervening twenty-five years Gilbert had of course learned much about the art of the goldsmith (see Cat. 53–6), and the present crown is a far more elaborate, more outlandish confection even than its prototype. The model for the original crown was owned by the musician George Henschel.

LITERATURE Repr. in most photographs of the Jubilee Memorial to Queen Victoria; 'George Henschel', *The Musical Times*, 1 March 1900, p. 158; Spielmann 1901, repr. pp. 82–3; Hatton 1903, p. 5; Bury 1954, p. 43; Beattie 1983, pp. 207, 213; Dorment 1985, pp. 77, 189, 285.

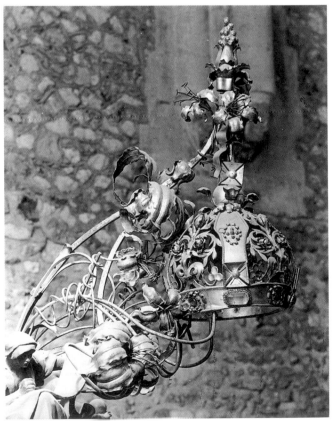

36

37 *Tomb Cover in Memory of the Hon. Eustace Vesey*

1889
Bronze and enamel: 254 × 125.7 cm/100 × 49½ in
Inscribed: IN MEMORY OF THE HON[BLE] EUSTACE VESEY
CAPTAIN 9TH LANCERS BORN JAN/31ST 1851 DIED NOV
18TH 1886/SON OF THOMAS VIS[CT] DE VESCI/AND OF EMMA
HERBERT HIS WIFE/ALSO OF EUSTACE VESEY/BORN AUG[ST]
18TH 1878/DIED APRIL 9TH 1882/ELDEST SON OF EUSTACE
AND CONSTANCE VESEY
Inscribed on the central escutcheon: SUB HOC SIGNO VINCES
The Viscount de Vesci

The motif of a seal and cross set upon bronze modelled to look like flowing drapery may have been suggested to Gilbert by the sight of a soldier's bier, where a cross and wreath would be placed upon a flag covering the coffin. This tomb cover is one of the first works in bronze in which Gilbert experimented with polychromy. The cross is made to register visually by its colour, which is lighter than that of the bronze on the rest of the tomb cover. The intricate decorative motif running down the borders of the cover includes flowers and butterflies in an embossed design of a slightly different shade of bronze. Gilbert also added colour externally: the lettering and the inscription show traces of blue paint, while the central armorial shield is inset with enamelled mosaic in burgundy, light blue, green and yellow. Each of the four corners is decorated with the head of a putto, while two Celtic-style decorative insets are placed above the cross.

The monument was cast in separate pieces and sent to Abbey Leix for assembly. The date of the commission is not certain, but the de Vescis were among Gilbert's earliest clients (see Cat. 59). The first letter concerning the tomb was written by Gilbert to Constance Vesey (widow of Eustace Vesey) on 28 May 1889, and stated that the monument was in the hands of the bronze founder: 'There is an enormous amount of work in the monument and the casting requires great care and precision.'[1] The bronze had been cast by 5 January 1890 when Clement Heaton (1861–1940) began work on the enamelling. On 12 February 1890, Lord and Lady de Vesci (the parents of Eustace Vesey), the Countess of Pembroke, and Earl Cowper assembled in Gilbert's Fulham Road studio to view the monument. (This list is significant because Gilbert would draw his patronage over the next ten years from these families or their extensive connections among the aristocracy.) The tomb cover was shipped to Ireland and Gilbert received his final payment from Mrs Vesey on 10 October 1890. In 1891 (May–June)

37

Gilbert worked on the 'restoration' of the tomb, but what this phrase implies is not known.

NOTE
1. Gilbert's correspondence with Constance Vesey and Lady de Vesci is in the possession of Mrs Edward Grant.

PROVENANCE Commissioned by Mrs Constance Vesey, 1889.

LITERATURE Hind 1890, p. 3; Bury 1954, pp. 18, 67; Dorment 1985, pp. 88, 91, 99, repr. pl. 49 p. 92.

MEDALS

ILBERT'S medals were both cast and struck, incorporating portraiture and his own highly original imagery and symbolism. He was working within a circular format for portraiture as early as 1877 (Cat. 5) and continued to do so in plaques (Cat. 88–9) and portrait roundels on monuments (see introduction to Cat. 31) throughout the 1880s and 1890s. As late as 1901 he began but failed to complete a medal with the head of Edward VII for the Royal Academy (see fig. 39). Yet the number of completed medals is small. In addition to the Art Union Jubilee Medal (Cat. 39) and the Lawrence Memorial Medal (Cat. 41), only one other is known and this is untraced: it is a medal in bronze for the Lord Mayor of London, commissioned by Mr J. Hemming in 1889.

38 *Matthew Ridley Corbet*

1881
Bronze: diam. 11.1 cm/4¾ in
Inscribed: ALFRED GILBERT PERUGIA 1881
Museé d'Orsay, Paris

Matthew Ridley Corbet, ARA (1850–1902), landscape painter and pupil of Giovanni Costa, was Gilbert's close friend in Rome and Perugia. The two had known each other

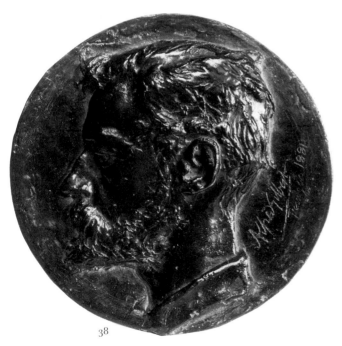

38

since Gilbert's days at Hetherley's, and re-met, apparently by chance, in Rome. Gilbert's biographer, Isabel McAllister, writes: 'During the years that ensued in Rome, Corbett [*sic*] and the Gilberts made many expeditions together, and their minds were so perfectly attuned, though they ran in

different grooves, that, of all the men of Gilbert's youth, this one remains in his memory closest to his heart.'[1] The two apparently shared a teacher in Giovanni Costa, whom McAllister describes as Gilbert's master in painting—though no paintings from his Roman period have survived.

The identification of the profile in this bronze as Matthew Ridley Corbet is due to Thomas Stainton, who has pointed out the likeness to Corbet's portrait by John M'Lure Hamilton of 1893 (London, National Portrait Gallery). A plaster measuring 11 cm in diameter is in the possession of Mrs Joan Martin; the number of medals cast may have been quite small, and, to date, Cat. 38 is the only one known.

NOTE
1. McAllister 1929, p. 59.

PROVENANCE With the Musée du Luxembourg by 1931.

EXHIBITION Royal Academy 1886, no. 1912.

LITERATURE M[artin] H[ardie], 'Corbet, Matthew Ridley', *The Dictionary of National Biography Supplement 1901–11*, vol. I, Oxford 1976, p. 417; Dorment 1985, repr. pl. 15 p. 37.
(Plaster model) Mark Jones, *The Art of the Medal*, London 1979, pp. 138, 185, cat. 373, repr. no.373 p. 140.

39 *Art Union Jubilee Medal*

1887
Struck bronze: diam. 6.4 cm/2½ in
Inscribed obv.: VICTORIA QUEEN OF GREAT BRITAIN & IRELAND & EMPRESS OF INDIA; at base of bust: ANN. IVBIL. 1887
Inscribed rev.: ART SAILETH THOUGH LIFE FAILETH. ART UNION OF LONDON 1837–1887
The Trustees of the British Museum

The Art Union, founded in 1837, was a society formed to encourage a general interest in the arts, and specifically to promote British artists and decorators. For an annual fee of one guinea subscribers were entitled to receive one engraving or a bronze medal. They were also eligible for the yearly lottery in which the prizes were always paintings, bronzes, or silver medals—the last, amounting to thirty each year, were presented to winners who did not qualify for more valuable prizes.

The medal shown here was the last Art Union medal to be commissioned and distributed, and commemorates the Jubilee of the Art Union as well as that of the Queen. The reverse shows a nude winged figure, perhaps Fortune, testing the direction of the wind as she floats above the stern-castle of an ancient ship, symbolising art. In Mark Jones's words, the reverse, 'with its misty forms and sinuously flowing lines, is the false harbinger of an English Art Nouveau that never fully developed'.

Beaulah states that thirty medals in silver and forty in

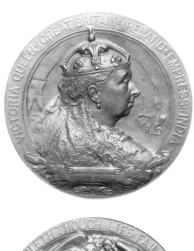

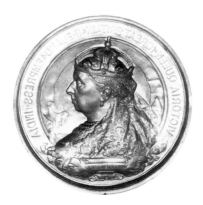

39 *reproduced in
colour on p. 94*

40

bronze were allotted as prizes in the Art Union lottery of
1887, and the same number in the two metals in 1888. He
adds that Cat. 39 is a reduction by pantograph (reducing
machine) of the original wax model with no attempt to con-
ceal unevenness of surface.

PROVENANCE Commissioned by the Art Union, 1887.

EXHIBITIONS Royal Academy 1889, no. 2065 ('Design for the reverse
and obverse of medal for Art Union of London'); London 1972, no. F20;
London 1968, plate o; Royal Academy 1968, no. 847.

LITERATURE Hatton 1903, p. 32, repr. p. 9; L[ouis] Forrer, *Biographical
Dictionary of Medallists*, II, London 1904, p. 263; Bury 1954, p. 68; G. K.
Beaulah, 'The Medals of the Art Union of London', *The British Numismatic
Journal*, vol. XXXVI (1967), pp. 180–1, 185, no. 30; Mark Jones, *The Art
of the Medal*, London, 1979, pp. 138, 185, cat. 374; repr. col. pl. 6 opp.
p. 113; Daniel Fearon, *Spink's Catalogue of British Commemorative Medals
1558 to the Present Day*, Exeter 1984, no. 338.3; Lawrence Brown, *British
Historical Medals*, II (September 1986).

40 *Dies for the Art Union Jubilee Medal*

1887
Steel: obv. die ht 6.3 cm/2½ in; diam. 5 cm/2 in;
 rev. die ht 7.1 cm/2 13/16 in; diam. 7.8 cm/3 1/16 in
Spink & Son Ltd

It is not known if Spink & Son were commissioned to strike
Gilbert's Art Union Jubilee Medal: all records were
destroyed during the last war. 1887 is an early date for Spink

to be striking medals, and the SPINK signature is not found
on a medal before 1890. It is possible that the company was
simply given the dies for safe-keeping.[1]

NOTE
1. Information from Daniel Fearon, Esq.

PROVENANCE Unknown.

41 *Gold medal, cast and chased for St
Bartholomew's Hospital in memory of Sir
William Lawrence, Bart.*

1897
Gold: diam. 5.4 cm/2⅛ in
Inscribed obv.: WILLIAM LAWRENCE 1783–1867 ST
 BARTHOLOMEWS HOSPITAL
Inscribed rev.: C.E. WEST ΑΙΕΝ ΑΡΙΣΤΕVΕΙΝ 1901
The Royal Hospital of St Bartholomew

The Lawrence Memorial Medal was commissioned by Sir
William Lawrence's children, Sir John Lawrence and his
sister, on 22 April 1891. A medal in gold was sent to the
Royal Academy in April 1897, but on 18 June 1897 Gilbert's
founder, O'Neill, cast a further medal in eighteen-carat gold
for Miss Lawrence. On 21 December 1897 Gilbert's sec-
retary, Herbert Gilbert, recorded in the studio diaries that
two gold medals for Miss Lawrence would arrive on the

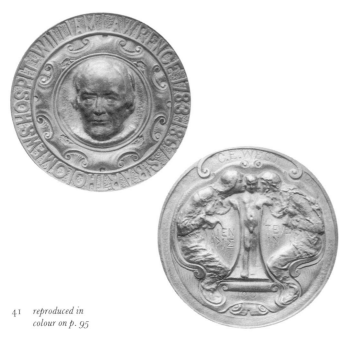

41 *reproduced in colour on p. 95*

NOTE
1. Information kindly supplied by Janet Foster, District Archivist, St Bartholomew's Hospital.

EXHIBITIONS Royal Academy 1897, no. 1979.
(Plasters) London 1936, no. 24 a–g.

LITERATURE Hatton 1903, p. 32; L[ouis] Forrer, *Biographical Dictionary of Medallists*, II, London, 1904, p. 263; Bury 1954, p. 68; McAllister 1929, another cast repr. opp. p. 163; N[orman] M[oore], 'Lawrence, Sir William', *The Dictionary of National Biography*, vol. XI, Oxford 1973, p. 728; Manchester, Minneapolis, Brooklyn 1978–9, p. 44; Dorment 1980, p. 52, repr. fig. 78; Dorment 1985, p. 253, repr. pl. 153 p. 252.

42 *Sir Richard Strachey*

1899
Bronze: diam. 20.3 cm/8 in
Barbara Strachey

On 12 December 1899 Gilbert delivered four bronze medallions to 'Strachey 69 Lancaster Gate'. Presumably this meant four casts of the same portrait of Sir Richard Strachey; the other three have not been traced. Sir Richard Strachey (1817–1908) was a lieutenant-general in the Royal (Bengal) Engineers.

PROVENANCE By descent.

LITERATURE R[obert] H[amilton] V[eitch] 'Sir Richard Strachey', *The Dictionary of National Biography Supplement 1901–11*, Oxford 1976, p. 442; Dorment 1985, p. 122, repr. pl. 64 p. 118.

following day. The one shown here is engraved (not by Gilbert) with the name of the recipient and the date 1901. Presumably four medals were cast in 1897 and presented annually to the scholarship winners, appropriately engraved. The hospital may have considered that further casts could be made as needed. But Cat. 41, the 1901 medal, had to be used permanently because Gilbert's bankruptcy that year stopped studio production. For this reason the reproduction in McAllister shows a medal engraved with a name different from that on Cat. 41. Gilded plaster models and variants are preserved in St Bartholomew's Hospital, and a bronze sketch of the reverse is in the collection of Patrick Synge-Hutchinson, London.

William Lawrence (1783–1867), employed at St Bartholomew's Hospital for sixty-five years, was generally acknowledged to be a brilliant surgeon and one of the best lecturers in London. His practice included many opthalmic cases and he is now regarded as one of the founders of British opthalmology. He was appointed Sergeant Surgeon to Queen Victoria in 1857 and knighted in 1867, the year of his death, two years after retiring from St Bartholomew's.

The Lawrence Scholarship and Gold Medal were founded in 1873 by Lawrence's son and daughter to commemorate their father. Both continued to be awarded into the 1960s but have now been amalgamated with other scholarships.[1]

The reverse design, showing a male child guided by two whispering genii, is a theme which would appear in its most developed form in the Alexandra Memorial (Cat. 111) but which can be seen in the low reliefs on the base of *Mors Janua Vitae* (see Cat. 105). The inscription means 'always the best'.

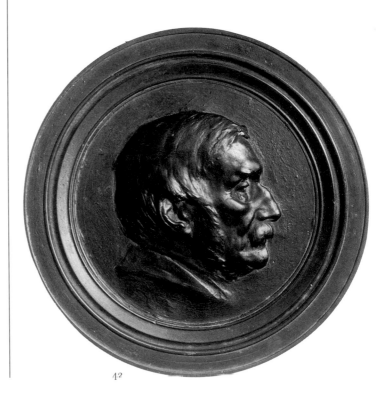

42

THE SHAFTESBURY MEMORIAL 1886–1893

HE Memorial to Anthony Ashley-Cooper, Earl of Shaftesbury,[1] in Piccadilly Circus is one of the first public monuments in Britain symbolic simply of an idea: the virtue of Christian Charity. Gilbert conveyed this first by the monument's form, an overflowing fountain to suggest the abundance of the philanthropist's love for mankind; then in the figure of *Eros*, or *Anteros*, as Gilbert himself called it, ancient symbol of selfless love; and finally in the inclusion of drinking cups (see Cat. 50) as the embodiment of one of the seven acts of mercy.

Eros (as he must be called) is London's most famous—and most charming—statue. He is part of the progression of Gilbert's nude compositions beginning with *Perseus Arming* (Cat. 10) and *Icarus* (Cat. 15) and ending with *Comedy and Tragedy* (Cat. 22). But the Memorial as a whole should be compared to Gilbert's work as a goldsmith, and particularly to the Jubilee Epergne (Cat. 53), finished in 1890. The intricacy and sophistication of the casting, the use of polychromy in the bronze, and above all the selection of aluminium for the figure of *Eros*, all required an intimate setting. Gilbert's admirers saw this: 'They tell me that it is inappropriate to the surroundings,' the sculptor George Frampton told Ellen Terry. 'It is. That's the fault of the surroundings. In a more enlightened age than this, Piccadilly Circus would be destroyed and rebuilt merely as a setting for Gilbert's jewel.'

NOTE

1. Memorial to Anthony Ashley-Cooper, Earl of Shaftesbury, Piccadilly Circus, London. 1886–93. Bronze and aluminium: figure ht approx. 188 cm/74 in; base 1097 × 518 cm/432 × 204 in. Inscribed on the faces of the octagonal pedestal within the large ornamental basin: ERECTED BY PUBLIC SUBSCRIPTION TO ANTONY [*sic*] ASHLEY COOPER [*sic*], K.G. SEVENTH EARL OF SHAFTESBURY BORN. APRIL XXVIII. MDCCCI. DIED. OCTOBER I. MDCCCLXXXV DURING A PUBLIC LIFE OF HALF A CENTURY HE DEVOTED THE INFLUENCE OF HIS STATION. THE STRONG SYMPATHIES OF HIS HEART. AND THE GREAT POWERS OF HIS MIND. TO HONOURING GOD BY SERVING HIS FELLOW MEN. AN EXAMPLE TO HIS ORDER. A BLESSING TO HIS PEOPLE. AND A NAME TO BE BY THEM EVER GRATEFULLY REMEMBERED. Founder: George Broad & Son.

LITERATURE Monkhouse 1889, II, p. 40; Hind 1890, p. 3 (plaster); 'The Lay Figure', *Studio*, vol. 2 (1893), p. 168; Spielmann 1901, p. 82; Hatton 1903, pp. 4–5, 11, 13–17, repr. pp. 14–15; Muthesius 1903, p. 77; Ganz 1908, Preface and pp. 109–10; Spielmann 1910, p. 7; Macklin 1910, p. 117, repr. pp. 110–11; McAllister 1929, pp. 83, 86, 103–12, 120–1, 164, 230, repr. opp. p. 102; Maryon 1933, p. 22; Ganz 1934, pp. 7, 9; London 1936, nos 12, 20a–b; Bury 1954, pp. i, 11–13, 15, 17, 38, 44–5, 47, 60, 67, 83–4, 98, repr. pl. 11; Leslie Aitchison, *A History of Metals*, II, London 1960, pp. 543–4, repr. p. 544; Sheppard (ed.) 1963, XXXI, pp. 85–110 and XXXII, pls 152, 154–8; Handley-Read 1966, p. 14; Handley-Read 1967, p. 20; Handley-Read 1968, I, pp. 24–5; Handley-Read 1968, III, p. 144; Manchester, Minneapolis, Brooklyn 1978–9, pp. 185–8; Read 1982, pp. 298, 314, repr. fig. 360 p. 300; Beattie 1983, pp. 162, 214, 217–18, 244, repr. figs 218–19 p. 215–16; Dorment 1985, pp. 100–3, 108, 111–15, 206, 213, 215, 230, 316, repr. pl. 52 p. 104, pls 53–4 pp. 109–10.

The memorial service for Lord Shaftesbury was held in Westminster Abbey on 8 October 1885. Every seat was filled. Poet's Corner was reserved for the representatives of 196 societies, missions, and schools associated with his name. Outside the Abbey a crowd lined the streets—a crowd of paupers, cripples, the blind—all standing bare-headed in the driving rain: a ragged army of the helpless to whom Lord Shaftesbury had devoted his life. A few weeks later the Shaftesbury Memorial Committee announced that two statues of the much-loved philanthropist would be raised, one in marble in Westminster Abbey, the other 'in bronze, the pedestal of which should record in bas-relief Lord Shaftesbury's principal labours. . .' to be erected 'in one of the most frequented public thoroughfares in London'.[1] The commission for the first statue was given to Joseph Edgar Boehm (unveiled on 1 October 1886). At his insistence, the second commission went to the young Alfred Gilbert, but, according to Gilbert, Boehm 'would not answer as to what form his young friend would suggest for the memorial . . . and . . . anything approaching what is known as the "coat-and-trousers" style, would, if insisted upon, lead to his pupil's instant renunciation of so important and tempting an appointment'. Gilbert told the Committee: 'I can't undertake the statue of Lord Shaftesbury; I prefer something that will symbolize his life's work.'[2] This was bold. The Commitee had in mind an effigy; Gilbert was like an understudy who, when offered the lead rôle, wants to rewrite the stage directions. The successful completion of so important a public monument would make his career.

On 6 May 1886, more than six months after approaching Boehm, the Committee announced that Alfred Gilbert had been chosen as sculptor, but 'the form of the memorial is not yet definitely settled. . . . The site of the bronze monument is still undecided'.[3] The first outright announcement that the Memorial would take the form of a bronze fountain appeared in a note in *The Builder* for 3 October 1888—three years after Shaftesbury's death, and the Piccadilly Circus site was not finally decided upon until January 1890.

Late in his life, Gilbert presented his biographer McAllister with a highly romantic picture of himself, madly inspired, dashing off the sketch-model for the Shaftesbury Memorial in a few hours. In this version of the story, Boehm wanders into his studio and cries: 'Gott in Himmel! Don't touch it again. Don't touch it.' In fact, we have preparatory drawings (Cat. 43) that show Gilbert painfully working out a design for a covered font decorated (as the Committee requested) with bas-reliefs illustrating the good deeds of Lord Shaftesbury. These were abandoned, and the font evolved into a fountain (Cat. 44) which even by 1889 looked little like the one that was eventually cast. As late as January 1890 the Committee could come to no conclusion as to the artistic suitability of an unfinished model in Gilbert's studio. He worked so completely by instinct that when *The Daily Graphic* interviewed the Secretary of the Shaftesbury Memorial Committee about the general design of the foun-

tain on 28 February 1893—four months before the unveiling—H. R. Williams could only answer helplessly: 'Mr. Gilbert is taking immense pains over it, and constantly keeps modifying his ideas, so that there is no chance of getting a completed design until the fountain is actually finished.' In fact, the Committee must have taken Gilbert on trust, without seeing a finished sketch-model.

This Committee, represented by Mr H. R. Williams, gave Gilbert endless trouble. After accepting his design Williams demanded the addition of a bust of Lord Shaftesbury on the Memorial (Cat. 51); still later he insisted on the artist providing a low basin to give drinking water to humans and dogs. At this point the recently created London County Council, as owners of the Piccadilly Circus site, stepped in to order Gilbert to reduce the size of this basin, thereby ensuring that the fountain would drench passers-by and anyone foolhardy enough to attempt to drink from it. To prevent this, Gilbert was forced to suppress many of the water-jets upon which the effect of the work depended—and it was rendered necessary to make other jets so small that they were almost useless. In the autumn of 1891, long after the first section of the octagonal pedestal had been sent to Broad & Son in Hammersmith for casting, the Council discovered an ordnance stipulating the enclosure of all public monuments, and so Gilbert asked his friend Howard Ince (see Cat. 52) to design a stone parapet around the basin. Happily (or unhappily) combining the whims of both bodies, Gilbert then placed Shaftesbury's bust on this parapet. Both were removed in 1895 and replaced by a

second flight of stone steps. To be perfectly fair, Gilbert was not an engineer—still less an hydraulic engineer—and the jets never worked properly. Then, too, he was more goldsmith than architect, and it is noticeable that in the preparatory drawings he seems to have made no provision for any kind of basin to catch the water as it overflowed from the cistern. This may have alarmed both the Committee and the County Council: instinct was not necessarily the best guide when working on this scale.

The worst of all Gilbert's troubles was still to come. The Government reneged on its promise to provide gun-metal for casting the Memorial, thus compelling the sculptor to procure copper at an inflated price because a lengthy delay in casting would destroy the moulds. Instead of costing £3,000, therefore, the fountain suddenly cost £7,000 and Gilbert was plunged into debt at the outset of his career.

The use of copper, however, now allowed him more leeway in the patination, and he was able to cast the pedestal in a greenish bronze, while he gave a golden colour to the basin, and capped the whole with a silvery aluminium *Eros*. When first unveiled, the technicolour effect must have been startling. *The Daily Telegraph* (30 June 1893) noted that 'true to his well-known views with regard to the introduction of polychromy in decorative sculpture, Mr. Gilbert fashioned his imposing fountain—standing, with its crowning figure, 36 ft. high—mainly out of green and golden bronze, the one contrasting and relieving the other, while the winged genius shooting an arrow, which is the crown and apex of the work, is of aluminium . . .'. And *Bazaar* for 2 July 1893 exclaimed that the fountain was 'all done in bronze of different colours, how charming it is!'

When the Duke of Westminster unveiled the fountain on 29 June 1893, the Memorial startled London. Gilbert's work was the most original public monument in England, and its originality lay as much in its iconography as in its design. The overflowing fountain was intended to symbolise Shaftesbury's love for humanity; the drinking cups represented one of the Seven Acts of Mercy; *Anteros* on top was, of course, Selfless Love. The only direct reference to Shaftesbury is Gladstone's beautiful inscription—and many Londoners today have no idea who or what is commemorated by the Memorial. But this was not true in the 1890s when the memory of Shaftesbury was still fresh. Gilbert was attacked (and defended) from every side. The monument was called 'ugly', 'pretentious', 'indecent', 'ludicrous', 'hideous', and 'a dripping, sickening mess'. The figure of *Eros* was thought to be inappropriate on account of his nudity and also because he was believed to be Cupid, a highly dubious God to preside over a notorious haunt for prostitutes. The neighbourhood rabble congregated on the steps; the mud of London's streets was made muddier by the spray of ill-performing jets of water; ragamuffins, unmindful of the

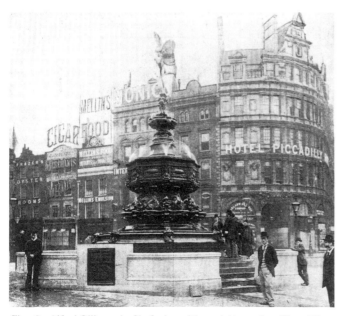

Fig. 48 Alfred Gilbert, the Shaftesbury Memorial in *c.* 1893 (Piccadilly Circus, London)

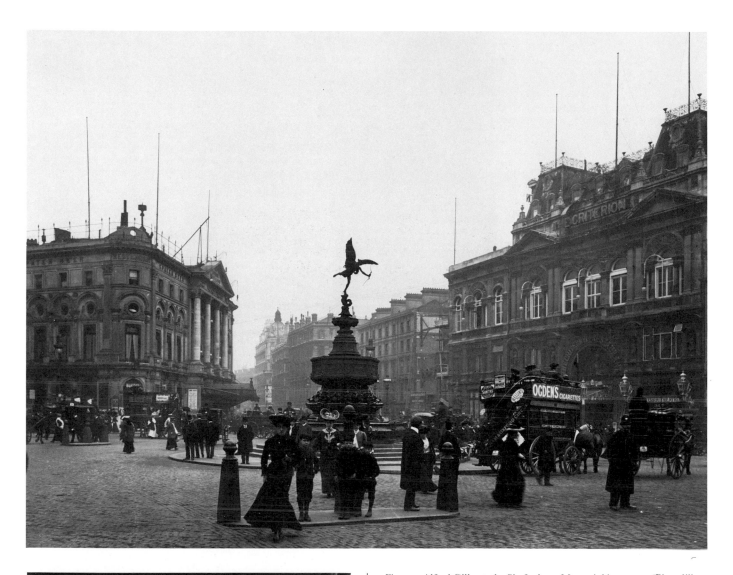

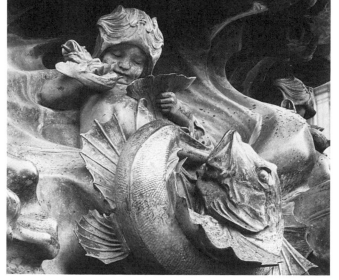

Fig. 49 Alfred Gilbert, the Shaftesbury Memorial in *c.* 1900 (Piccadilly Circus, London)

Fig. 50 Alfred Gilbert, the Shaftesbury Memorial, 1886–93: detail of the base of the fountain

symbolism of the water, squirted each other as well as passers-by. The fountain was a disaster, 'a decided nuisance'.[4]

These attacks seared Alfred Gilbert because he was criticised for faults imposed on his work by Committee and Council. He had hoped to build a slim spiral of a fountain rising up out of a low reflecting pool around which dozens of water-jets played, bathing the glistening Eros in a gauze of light spray. All this came to nothing. By 2 July 1893 he had to write to the County Council: 'Since the ceremony of unveiling I have had the painful experience of witnessing the utter failure of my intention and design. . . .' Gilbert

Fig. 51 'Sensational Incident in Piccadilly Circus, as seen by Our Artist', *Punch, or the London Charivari*, 21 October 1893

never recovered from these blows. As late as 1911 he wrote in bitterness to the Press asking why the fountain could not be melted down and the money used to build shelters for the homeless. But no one, including Gilbert, has ever said why, for all its imperfections—its stubby proportions, spiritless waterworks, or unfortunate placement—the fountain became dear to flower-girls, music-hall singers, tommies and GIs as the cosy symbol of London. This is because it has, not humour, but high spirits: *Eros*, wearing only a fluttering loincloth and his eccentric helmet (the wings point the wrong way) flies past his tazza and conch shell above a seafood platter full of flying fish, seashells, and helmeted babies grasping slippery fishtails: the Shaftesbury Memorial succeeds because it is, finally, London's most charming statue.

NOTES
1. *The Times*, 29 October 1885.
2. McAllister 1929, p. 104.
3. *The Daily News*, 7 May 1886.
4. For documentation on the reception of the fountain see Dorment 1985, p. 114.

43 *Detailed Sketch in Two Parts for the Base of the Shaftesbury Memorial*

From the van Caloen Album (fol. 58 no. 96; see Cat. 117 viii)
c. 1886
Pencil on paper: upper part 17.6×16.2 cm/$6\frac{7}{8} \times 6\frac{3}{8}$ in; lower part 5.9×16 cm/$2\frac{1}{4} \times 6\frac{1}{4}$ in
Inscribed in another hand: PICCADILLY CIRCUS FOUNTAIN FIRST IDEA (SEE 97.98.99)
The Jean van Caloen Foundation, Loppem

This very highly evolved design for the base of the Shaftesbury Memorial has been so constructed as to allow one piece of paper to slide up and down over the other in order to arrive at the correct proportions for the union between the basins and the ornamented plinth.

Together with three related drawings in the van Caloen Album (Cat. 117), this is the earliest idea for the Shaftesbury Memorial. Gilbert designed not an ornamental fountain but a font, reminiscent of Donatello's baptismal font in Siena Cathedral (1423–34). If this was his source, then each face of the octagonal cistern would have held one of the basreliefs representing scenes from the life of the Earl of Shaftesbury which Spielmann recorded that Gilbert had made but abandoned.[1] At this early date two sites for the Memorial were under consideration—Piccadilly Circus and Cambridge Circus. Possibly when the larger site had been chosen Gilbert needed a more impressive statement to compete with the surrounding buildings.

On this sheet Gilbert has drawn a Gothic font and then added enveloping tendrils around the base in a remarkable amalgam of Gothic and Art Nouveau motifs. The upper portion of the font would have had figures of saints or virtues

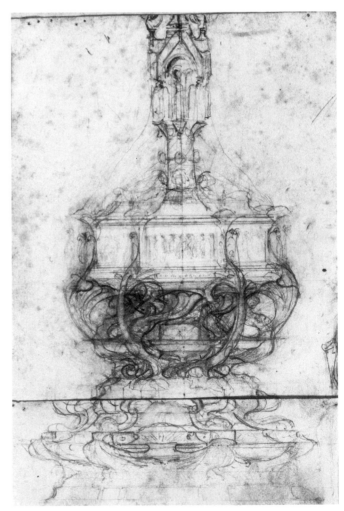

43

in the niches of the ornamental pinnacle. As this design shows, from the first Gilbert saw the fountain as divided into three separate components of base, cistern, and pinnacle.

NOTE
1. M. H. Spielmann, 'An Artistic Causerie', *Churchwoman* (12 October 1893); and repeated in Spielmann 1901, p. 82.

PROVENANCE As for Cat. 117.

LITERATURE Handley-Read 1967, fig. 3 p. 18; Manchester, Minneapolis, Brooklyn 1978–9, p. 187.

44

44 *Sketch for the Shaftesbury Memorial*

19 September 1889
Pen and ink: sheet 17.6 × 22.5 cm/6$\frac{15}{16}$ × 8$\frac{7}{8}$ in
The Greater London Record Office

In this sketch Gilbert has not yet decided on the figure for the upper portion of the fountain. The cistern and lower basin are nowhere to be seen. The hypothesis that this represents Gilbert's first idea for a fountain, as opposed to the earlier sheet with the font (Cat. 43), is attractive. Even granting the hasty nature of the scheme, the mere suggestion of playing water designates this design to be for a fountain, and the water is optimistically shown to fall neatly into an upper basin. There is no doubt that this is roughly the shape

Gilbert would ideally have given the Shaftesbury Memorial had practical considerations (such as cistern and lower basin) not intervened.

The sketch is contained in a letter of 19 September 1889 from Gilbert to the Clerk of the London County Council (Improvements Committee Paper, 25 September 1889, item 24, bound in vol. IIa, London County Council Archives, County Hall).

LITERATURE Sheppard (ed.) 1963, XXXII, pl. 156a; Manchester, Minneapolis, Brooklyn 1978–9, p. 187.

45 *Sketch for the Shaftesbury Memorial*

26 February 1890
Pen and ink: sheet 17.8 × 11 cm/7 × 4$\frac{3}{8}$ in
Inscribed: GILBERT — 76 FULHAM ROAD
Public Record Office

45

This sketch is still so vague that one cannot identify what Gilbert is illustrating—although the best guess is the lower half of the fountain only, roughly comparable to the Royal

Academy's plaster model for the basin and cistern of *c.* 1890 (Cat. 46) but without any of the details.

On 26 February 1890 the Duke of Westminster, Chairman of the Shaftesbury Memorial Committee, called on the Commissioners of Woods and Forests and declared that his committee was unable to supply plans for the Shaftesbury Memorial (because none existed). In their place he left this sketch by Gilbert (Crest 35/2639 File 14044 E [Plan and Drawing with 1331/9.3.1890 Shaftesbury Memorial Fountain], Public Record Office, Chancery Lane).

LITERATURE Sheppard (ed.) 1963, XXXII, pl. 156(b); Manchester, Minneapolis, Brooklyn 1978–9, p. 187.

46 *Model for the Cistern*

c. 1890
Wood and plaster: ht 22.9 cm/9 in
The Royal Academy of Arts

This wood and plaster model is not the first sketch for the Memorial which Gilbert told McAllister he made in 1886. Rather, it is a model made after January 1890, possibly for the Shaftesbury Memorial Committee, which was granted the site at Piccadilly Circus at that date. Given that it is more fully worked out, it may be later than the comparable drawing of February 1890 (Cat. 45). Almost four years after the original commission, then, Gilbert had still given no indication as to how he would finish the fountain at the top. When the journalist C. Lewis Hind visited his Fulham studio in January 1890, he did not report that any figure would even appear on the fountain: 'Mr. Gilbert has not finally decided on the character of the upper portion.' In this sketch the rectangular spaces left for narrative reliefs are still prominent (they are much reduced by ornamental

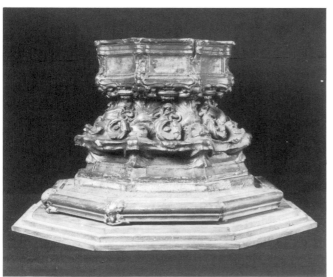

46

plaques on the bronze monument). When the narrative reliefs were abandoned Gilbert compensated for their loss by enlarging the scale of the figures of fish and putti on the lower middle tier of the memorial.

PROVENANCE In the artist's studio at the time of his death, 1934; bt Sigismund Goetze and the National Art-Collections Fund, and presented to the Royal Academy, 1936.

LITERATURE Sheppard (ed.) 1963 XXXII, pl. 156C; Manchester, Minneapolis, Brooklyn 1978–9, p. 188 (n. 9).

47 *Model for the Shaftesbury Memorial*

c. 1891 (?)
Wood and plaster: ht 47 cm/18½ in
The Museum and Art Gallery, Perth

This piece is a step beyond Cat. 46 in being a full compositional model. It dates to *c.* 1891, certainly before Gilbert began work on the sketch for *Eros* (Cat. 48), which is very

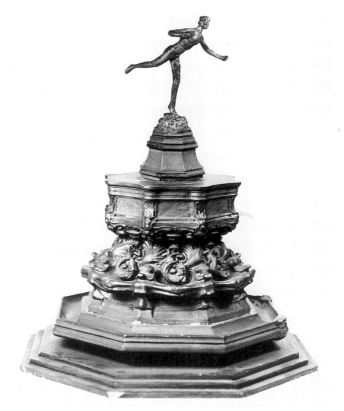

47

different from the first idea here, where the figure—one might venture—is female. The conch and tazza motif on which *Eros* stands is not worked out and the spaces for bas-reliefs are still prominent. One might place this model near in date to November 1891 when Howard Ince submitted a plan with a basin.[1]

NOTE
1. London County Council Improvements Committee Papers, 4 November 1891, item 15 cited in Sheppard (ed.) 1963, p. 104.

PROVENANCE In the artist's studio at the time of his death, 1934; bt and given to present owners by Sigismund Goetze and the National Art-Collections Fund, 1936.

EXHIBITIONS London 1936, no. 12; London, Victoria and Albert Museum, '"Marble Halls": Drawings and Models for Victorian Secular Buildings', 1973, no. 151.

LITERATURE Bury 1954, pp. 73, 83, repr. pl. x following p. 34; Sheppard (ed.) 1963, XXXII, pl. 157.

48 *Design for the Figure at the Top of the Shaftesbury Memorial (Eros)*

From the van Caloen Album (fol. 55 no. 93; see Cat. 117 vii)
c. 1891
Pencil on paper: 16.5 × 10 cm/6½ × 3⅞ in
Inscribed on folio in another hand: SHAFTESBURY
MEMORIAL PICCADILLY CIRCUS FIRST IDEA
The Jean van Caloen Foundation, Loppem

This is so close to the final solution of the conch and tazza on the Shaftesbury Memorial that we are justified in placing it chronologically near to the sketch for *Eros* of 1891 (Cat. 49).

PROVENANCE As for Cat. 117.

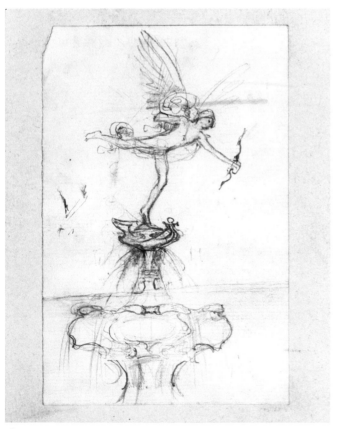

48

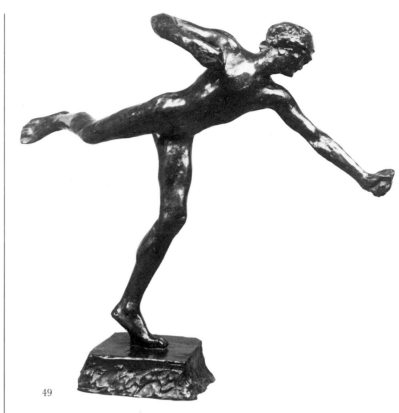

49

49 *Eros*

1891; cast 1925
Bronze: ht 60.9 cm/24 in
Founder: Alessandro Parlanti
The Royal Academy of Arts

This bronze was cast from the first sketch for *Eros*, modelled in 1891 from Gilbert's studio 'boy', the fifteen-year-old Angelo Colorossi. Gilbert kept the plaster in his Maida Vale studio until his bankruptcy in 1901 when, in an orgy of frustration, he broke many of his plaster models so that none could be cast by his creditors in limitless inferior editions. The sculptor who bought his house, Herbert Hampton (1862–1929), found and mended the piece. In 1925 the painter Sir George Clausen, RA (1852–1944), saw the model and wrote to Gilbert (then living, briefly, near Rome) to ask whether he would allow the plaster to be cast and offered to the Chantrey Bequest. With the sculptor's permission this was done, and Parlanti's beautiful cast is now in the Tate Gallery. On 28 July 1925 Clausen again wrote to Gilbert mentioning his hope that a second cast might be bought by the Royal Academy.[1] Most of the Royal Academicians who had known Gilbert contributed to the cost of the piece, for which Gilbert was paid £500.

The sources of *Eros's* pose are not so much problematic as multifarious: Giambologna's *Flying Mercury* (1564, Florence, Bargello), but—more eccentrically—the figure of

Bacchus in Titian's *Bacchus and Ariadne* (London, National Gallery) and even John Bell's *The Eagleslayer*, if tipped on its side (1851; London, Bethnal Green Museum).

NOTE
1. This entry is based on cat. 103 in Manchester, Minneapolis, Brooklyn 1978–9.

PROVENANCE Cast for the Royal Academy, 1925.

EXHIBITIONS Royal Academy 1925 (ex-catalogue); London 1968, no. 66; Royal Academy winter 1968, no. 686; Manchester, Minneapolis, Brooklyn 1978–9, no. 103 (Tate Gallery cast).

LITERATURE London 1936, no. 12; Bury 1954, pp. 38, 69, 97–8, repr; Sheppard (ed.) 1963, XXXII, pl. 156(d); Chamot, Farr, Butlin 1964, pp. 222–3, cat. 4176; Dorment 1985, pp. 219, 303–4, repr. pl. 56 p. 112.

50 *Ladle or Drinking Cup*

Cast 1893
Bronze alloy possibly containing zinc and lead: 1.25 cm/ 9⅞ in; w. 14.5 cm/5¾ in
Founder: possibly Compagnie des Bronzes
The Jean van Caloen Foundation, Loppem

Six of Gilbert's eight aluminium drinking cups for the Shaftesbury Memorial, each attached to the basin by a chain composed of interlocking letter 'S's, were stolen within weeks of the unveiling.[1] At least one of these was found

50

nearby, smashed, indicating that the deed was an act of vandalism rather than one of theft. According to McAllister, 'the sculptor found that workmen entertained a grievance because the casting had been done in Brussels, and the name of the firm had been engraved on the work'.[2] So far, none has been recovered—nor do any contemporary photographs give us an idea of what they looked like. The identification of this piece, then, as a casting in bronze of one of these cups, is pure speculation—a guess based on the attractive but dubious question: 'what else could it be?'

The shell-like hollow of the massive ladle is of the right

size and proportion to fit into one of the eight dishes surmounting the elaborate knobs which punctuate the corners of the lower basin. In aluminium, so large a cup would be far lighter and more serviceable. This bronze cast may be a prototype, cast before the aluminium cups, or, alternatively, it may represent a souvenir of the fountain cast after the cups had been stolen. Gilbert kept it in his studio in Bruges where he left it at the time of his death. His widow Stéphanie sold it to Baron Jean van Caloen.

NOTES
1. *The Telegraph*, 10 July 1893.
2. McAllister 1929, p. 126.

PROVENANCE The artist's widow, Stéphanie; bt Baron Jean van Caloen, 1935.

LITERATURE McAllister 1929, pp. 107, 126.

JOSEPH EDGAR BOEHM

51 *Anthony Ashley-Cooper, 7th Earl of Shaftesbury*

Modelled before 1885; bronze cast 1891–2(?)
Bronze: including base 71.1 cm/28 in
The British and Foreign Bible Society, London

The Builder (3 October 1888) noted that Boehm's marble statue of the Earl of Shaftesbury in Westminster Abbey 'was executed from a bust by the same artist, which was finished

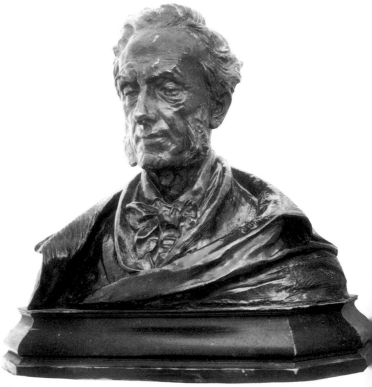

51

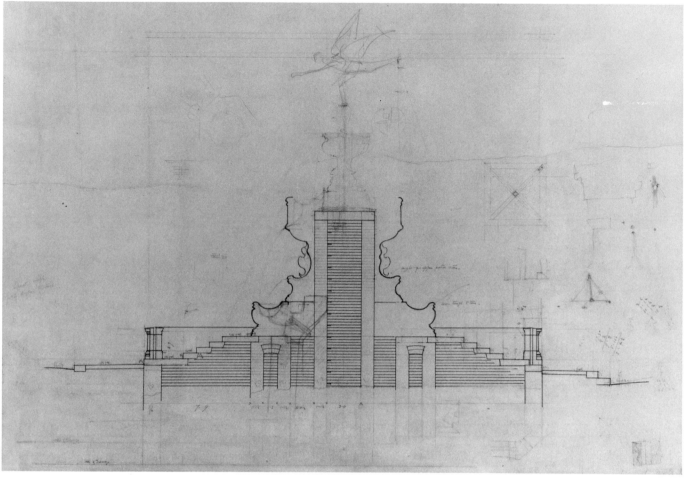

52

from life a few years before his lordship's death'. Before his own death in December 1890 Boehm gave the model to Gilbert to cast and place on the Shaftesbury Memorial. When set on Ince's parapet the bust looked absurd. *The Daily Telegraph* (30 June 1893) commented: 'This bust is a fine and realistically faithful work, but it is unfortunately placed under a kind of toy pediment or baldacchino supported by balusters—the whole thing on far too small a scale.'

Gilbert sold this bust to H. R. Williams, Honorary Secretary of the Shaftesbury Memorial Committee, in February 1895.[1]

NOTE
1. Letter from Williams to Gilbert 15 February 1895 (MS, Air Chief-Marshal Sir John Barraclough).

PROVENANCE Purchased from the artist by H. R. Williams, 1895; presented by him to the present owners.

LITERATURE Hatton 1903, p. 17; McAllister 1929, p. 107; Manchester, Minneapolis, Brooklyn 1978–9, p. 187; Beattie 1983, p. 217; Dorment 1985, p. 103.

HOWARD INCE

52 *Elevation of the Shaftesbury Memorial*

c. 1893–4
Pencil and ink on paper: sheet 68.6 × 88.9 cm/27 × 35 in
David Barclay, Esq.

Whereas Gilbert was responsible for the design and modelling of the Shaftesbury Memorial, he was not himself an architect and therefore worked with his friend Howard Ince on the architectural elements of the fountain. Gavin Stamp (*Spectator*, 15 June 1985) drew attention to the fountain's powerful architectural quality—expressed, for instance, in the cornices and mouldings articulating its base, which is due to Ince's collaboration. Gilbert only called him in after he had designed the fountain, and after his detested committees insisted upon fundamental changes in that design. Ince is therefore responsible for the two low flights of steps leading to the basin, and, as this drawing shows, for the parapet which originally surrounded that basin.

PROVENANCE Howard Ince; by descent.

GOLDSMITH'S WORK

ILBERT created his first work as a goldsmith in 1887 (Cat. 36). From then on his inspiration played upon necklaces and pendants (Cat. 60, 61) as well as spoons and cups. His own view of the nature of his achievement as a goldsmith was not generally shared by his contemporaries. His technical mastery of the complexities of the goldsmith's art seemed to them merely to add an extra dimension to his work as a sculptor. But now that half a century has passed since his death, and his career can be seen in perspective and judged as a whole, it has become apparent that his goldsmith's work is an integral part of his sculpture. The two cannot be separated, for one might almost say that Gilbert's goldsmith's work is sculpture in miniature and his sculpture enlarged goldsmith's work. On the whole, the drawings in the van Caloen Album (Cat. 117) give no notion of scale. The exquisitely detailed studies for ornamental silverware or jewellery were often transformed into elements of monumental sculpture while the boldly executed designs for spoons dwarf the minutely modelled drawings for balusters or lamp standards. Gilbert had, in fact, a remarkable ability to adapt the scale of his sources. The Tomb of the Duke of Clarence, for example, suggests an enormously enlarged ornamental casket or reliquary of the first half of the sixteenth century as much as it does other, often cited sources such as Torrigiano's Tomb of Henry VII in Westminster Abbey.

In his goldsmith's work, Gilbert completed the circle by realising, on a small scale and in precious materials, ideas such as Tacca's fountain originally intended for monumental execution in stone or bronze (see Cat. 53).　　　c.g.

53 Epergne or Table Centre

1887–90
Silver, variously patinated and gilded, rock-crystal and
　shaped iridescent shell: ht 112 cm/44 in
Inscribed on the plaques attached to the plinth: VICTORIA
　QUEEN EMPRESS/1837–1887/THE OFFICERS OF HER
　COMBINED MILITARY FORCES
H.M. The Queen, on loan to the Victoria and Albert
　Museum

This large piece, nearly 4 ft (122 cm) high and nearly 3 ft (91 cm) in length, was commissioned by the Officers of the Army as a gift for Queen Victoria on the occasion of her Golden Jubilee in 1887, but was not delivered until May 1890. It consists of a central vertical element from the base of which project two ovoid shell-like bowls terminating in grotesque animals' heads. The central element is composed of a rock-crystal sphere on which is seated a double-tailed mermaid supporting a third, smaller, shell-like bowl surmounted by a standing figure of *Victory*. Free-standing silver statuettes, with painted faces and hands, of *Britannia* and

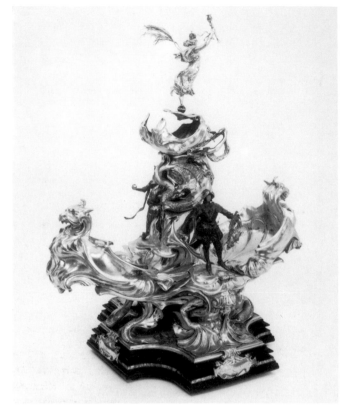

53　*reproduced in colour on p. 77*

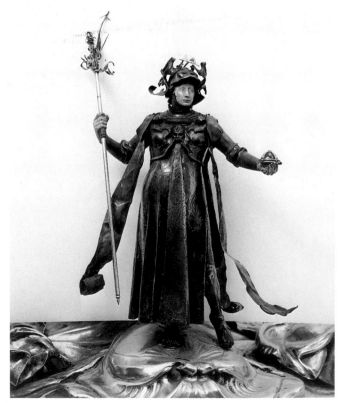

53　*(detail)*

St George on flat, lily-pad shaped projections flank the central element, and the whole is supported on the shoulders and tails of double-tailed mermen crouching on a cruciform greenish-grey marble base set into an ebony plinth.

This exuberant combination of shell and marine forms is in the direct line of descent from one fanciful aspect of mid-eighteenth-century goldsmith's work. Gilbert would certainly have known the covered cup (1735) ascribed to Paul de Lamerie (1688–1751) and the set of sauceboats (1743–4) by Nicholas Sprimont (*c.* 1716–71), both in the Royal Collection.[1] The Epergne might be described as the meeting point in Gilbert's work of 'Rocaille Revival' and art nouveau. It should be noted, however, that whereas Rocaille decoration is essentially assymmetrical, Gilbert's obsessive preference for axial symmetry is evident even here.

On the other hand, the taste for such forms is also characteristic of a certain kind of late Mannerism found in the early seventeenth century in Italy, especially in Florence. The resemblance is surely too close to be coincidental between the general design of the Epergne and the fountains by Pietro Tacca in the Piazza del Annunziata (1627), in which two elongated shell-shaped basins similarly project from either side of a central vertical element.

Contemporary accounts of the Epergne dwell on the subtlety of colour produced by the combination of laminated and patinated metal and parcel gilding—an effect unfortunately lost when, at a later date, the piece was completely gilded. Only the iridescent shell inlay on the tails of the mermaid and the chased silver of the two statuettes were spared, with the result that the figures are given a greater prominence than the artist intended. C.G.

NOTE

1. See Charles Oman, 'The English Royal Plate' in Erich Steingraber (ed.), *Royal Treasures*, 1968, pls. 8 & 14.

EXHIBITIONS Chelsea, 'Military Exhibition', 1890 (see McAllister 1929, p.127); Paris, 'Les Sources du xxᵉ Siècle' 1960.

LITERATURE Claude Phillips, *Magazine of Art*, vol. XIII, 1890, pp. 362–3; Spielmann 1901, p. 84, repr. p. 81; Spielmann 1910, p. 7; Muthesius 1903, p. 77; Hatton 1903, p. 2, repr. opp. p. 16 and detail p. 16; Macklin 1910, repr. p. 101; Handley-Read 1967, *passim* with ills; Handley-Read 1968, I, p. 25; Beattie 1983, p. 244; Dorment 1985, pp. 83–4, repr. pp. 85, 87, pls 45, 46, 47, col. pl. IV.

54 *Presidential Badge and Chain, Royal Institute of Painters in Watercolours*

1891–7
Silver-gilt, pearls, rock-crystal and other gemstones: pendant ht 6 cm/2¾ in; chain diam. 61 cm/24 in
Royal Institute of Painters in Watercolours

This Badge and Chain was made by Gilbert as a gift to the Institute after his election to membership. A figure symbolising 'watercolour' stands on a nautilus shell and holds up

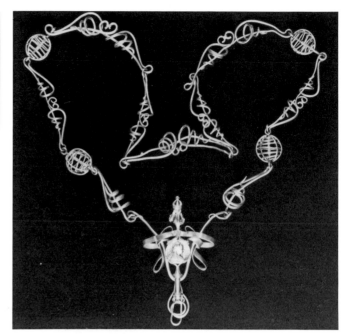

54 *reproduced in colour on p. 68*

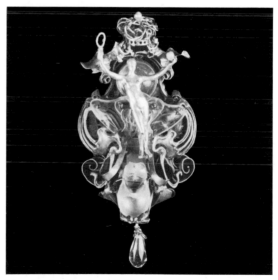

54 *reproduced in colour on p. 68*

a hand-glass (the mirror of nature) and a pearl (the pearl of art). The design culminates in the crown of 'art achieved'. A gold-painted plaster model was exhibited at the Royal Academy in 1891, the Badge itself in 1894 (ex-catalogue), though in an unfinished state. It was not completed until 1897.[1] As Gilbert believed that to embellish a design was to improve it, in this piece he has played with the symbolic elements until the elegant spare sculpture which formed the first idea has been lost in a thicket of wrought and twisted wirework, a presage of the way in which his jewellery was to develop in the later years (see Cat. 61, 65).

When the Badge was finally handed over to the Institute it was submitted to the Queen for her approval. In March 1897 the President, Sir James D. Linton, received the following letter: 'Sir,—The Lord Chamberlain has received the Queen's command to inform you that Her Majesty has been graciously pleased to permit that you and the future Presidents of the Royal Institute of Painters in Watercolours shall wear the Collar and Badge which have been submitted to her, and which are being herewith returned to you when attending Her Majesty's Levées, and on such other occasions as may be considered fitting. I am, Sir, your obedient servant S. Ponsonby Fane.' C.G.

NOTE
1. *The Magazine of Art* 1897, p. 227.

EXHIBITIONS Royal Academy 1891, no. 2068 (working model); Royal Academy 1894; London 1909, no. 290(b); London, Goldsmiths' Hall, 'International Exhibition of Modern Jewellery', 1961, no. 338; London 1968, no. 68 (not exhibited).

LITERATURE Spielmann 1901, p. 84; Hatton 1903, repr. p. 23; Graham Hughes, *Modern Jewellery*, 1961, p. 110, repr. p. 113.

55 *The Preston Key*

1893
Silver, steel, rock-crystal and enamel: ht. 19.3 cm/$7\frac{5}{8}$ in
Private Collection, on loan to the Victoria and Albert
 Museum

This ceremonial key was presented to the 16th Earl of Derby by the Mayor of Preston on 26 October 1893; the occasion was the opening of the Harris Museum, built to house important collections of pictures which had been presented to the town. On one side an enamelled shield bears the arms of the Borough of Preston and on the other those of Lord Derby (Stanley impaling Villiers). The key belongs to a group of ornamental metalwork which includes the de Vesci Seal (Cat. 59), which has an ostensible function, but is, in fact, too purely sculptural in conception to be practical. The technical difficulties of carrying out this design in the metal appropriate to the manufacture of a key, i.e. steel, have been overcome with great subtlety of effect by the incorporation of scrolling elements in silver. C.G.

PROVENANCE By descent.

EXHIBITIONS Glasgow, 1901, no. 126; London 1909, no. 290c (lent by the Earl of Derby).

LITERATURE Dorment 1985, p. 182.

56 *Rosewater Ewer and Dish, Presented to HRH The Duke of York, KG, by Officers Past and Present of the Brigade of Guards*

1894–1901
Silver, with a statuette of bronze, ivory, metal painted gold
 and iridescent shell: ewer ht 63.5 cm/25 in; dish diam.
 62.2 cm/$24\frac{1}{2}$ in
H.M. The Queen

This piece was commissioned by the Brigade of Guards as a wedding gift for the Duke of York and Princess Mary of

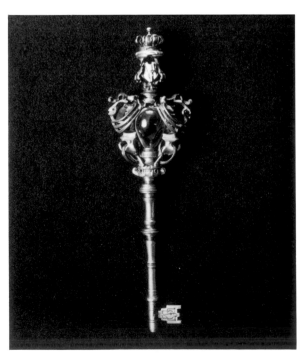

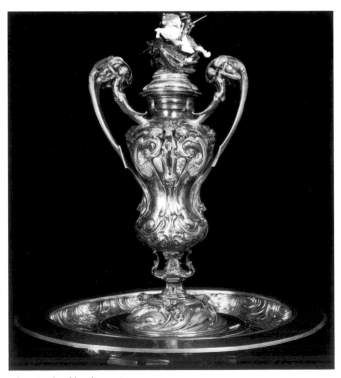

55 *reproduced in colour on p. 79*

56 *reproduced in colour on p. 75*

Teck, later King George V and Queen Mary. The wedding was in 1893, but as usual with Gilbert, completion of the work was delayed and the piece was not delivered until 1901.

Very elongated in its proportions, the Ewer is of chased silver, with handles in the form of two figures, an armour-clad knight embracing a mermaid. The cover is surmounted by a figure of St George on horseback slaying the dragon, worked in bronze and ivory and with iridescent shell and mosaic tesserae. The Ewer may have been inspired by the covered cup in the Royal Collection ascribed to Paul de Lamerie and dated *c.* 1735, which is likewise ornamented with the marine *rocaille* that so attracted Gilbert.[1] In the design of the Ewer and Dish the ornament is more severely formalised than in de Lamerie's cup or Gilbert's own earlier essay in the rococo style, the Epergne commissioned in 1887 (Cat. 53), but the familiar motifs, marine creatures and plants, shells and swirling wave-like forms, are all present.

C.G.

NOTE
1. Charles Oman, 'The English Royal Plate' in Erich Steingraber (ed.), *Royal Treasures*, 1968, repr. pl. 8.

EXHIBITIONS Royal Academy 1897, no. 2090; London 1909, no. 307.

LITERATURE Spielmann 1901, p. 84; Hatton 1903, p. 22 (plaster model repr. p. 32); McAllister 1929, p. 163, repr. opp. p. 169; Bury 1954, repr. pl. XIX; Dorment 1985, repr. p. 209 & pl. 136.

57 *Sketch for St George and the Dragon atop the Rosewater Ewer and Dish Presented to HRH The Duke of York, KG, by Officers Past and Present of the Brigade of Guards*

1899
Bronze, painted: ht 25 cm/9⅞ in; base ht 14. 2 cm/5⅝ in
Private Collection

This is a working model for the ivory and bronze equestrian group atop the Rosewater Ewer and Dish (Cat. 56). Gilbert painted the *cire perdue* cast to give it the appearance of ivory, bronze and gold. The powerful composition has an immediacy absent from the carved ivory and bronze group on the Ewer itself. Here the dragon and horse are modelled almost as one form, an impression enhanced by the casting in bronze of both, as the bird-beaked dragon wraps its body under the horse's belly, clutching its flanks with huge claws.

The wax model is in the Victoria and Albert Museum (ht 19.7 cm/7¾ in).[1]

NOTE
1. Bury 1954, repr. pl. XVIII following p. 42.

PROVENANCE Sold by the artist to Robert Dunthorne, 1900; Fischer Fine Art, London.

EXHIBITION London 1902, no. 9.

LITERATURE ?Bury 1954, p. 63; Dorment 1985, repr. col. pl. IX p. 222.

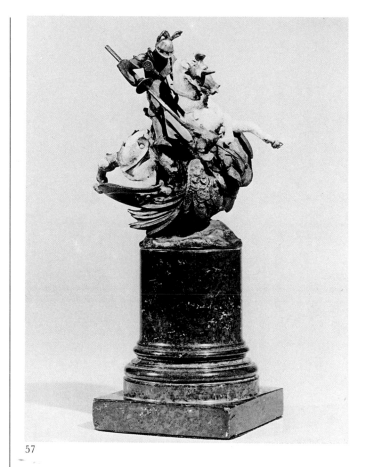

57

58 *Ornamental Silver Spoons*

1893–1903(?)
i) Four large serving spoons: l. 33 cm/13 in; hallmarked for 1903, sponsor's mark SG for Sebastian Garrard, cased by R. & S. Garrard, 25 Haymarket
ii) Four smaller serving spoons: l. 31.5 cm/12½ in; marked as (i) above
iii) Six spoons with bowls ornamented with a figure group, possibly Adam and Eve: l. 21 cm/8½ in; hallmarked as (i) above
iv) Twelve dessert spoons: l. 16 cm/6⅜ in; not hallmarked
Faringdon Collection Trust

On 28 July 1895 Gilbert recorded in his diary that he had received a commission from Mr Alexander Henderson (later Lord Faringdon, 1916) for a set of silver tableware together with a payment on account of £800. He stated his intention of delivering the 'centrepiece' in that same year. The total price was to have been £2,375. On 6 December he records a further payment of £250.

Such a commission was not an entirely new departure: in a diary entry for January 1891, headed 'spoons for Mr Newall' (an otherwise unrecorded patron) Gilbert records work 'on a spoon head: helmet with visor formed from a winged monster', and in the following month work on

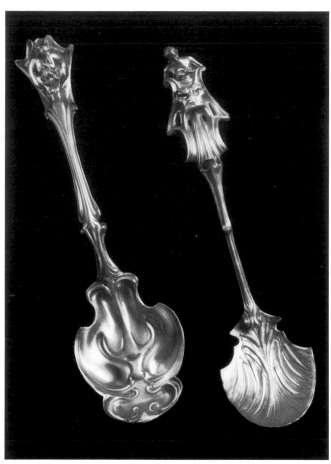

58 *reproduced in colour on pp. 72–3*

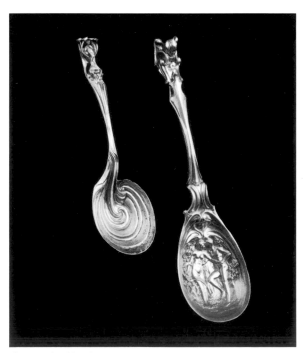

58 *reproduced in colour on pp. 72–3*

another, 'the mermaid and man carrying the mask of love'. On 24 December 1900 he records that he sent (presumably to Henderson) a dozen silver spoons and four salt cellars. The salt cellars cannot be traced at Buscot, and it must be said that Gilbert was in the habit of reclaiming items on which he wished to do further work, some of which were never seen by their owners again.

Of the twenty-six Gilbert-style spoons at Buscot, fourteen are hallmarked with the date-letter 'h' for 1903 and the sponsor's mark of the London silversmith and jeweller Sebastian Garrard (nos i–iii above). These do not follow at all closely the models for spoons found in Gilbert's studio after his death, the finials of which are composed of figural sculptures on a miniature scale (see Cat. 63), but are quite unintegrated with their bowls, for which Gilbert adopted the expedient of attaching ready-made Japanese spoons of lacquered wood. In the hallmarked spoons at Buscot the finial ornament is carefully integrated into the design as a whole and the result is a traditional interpretation of the ceremonial spoon, close in style to the then widely distributed pieces made to celebrate Queen Victoria's Golden Jubilee by this same firm of R. & S. Garrard. It seems possible that Gilbert's designs were reinterpreted by a professional silversmith. The remaining twelve dessertspoons (iv), which are not marked, do not share this smooth professional rationalisation: they are closer to Gilbert's conception as revealed by the sketch-models, and are peculiar to this group in having bowls with assymmetrical swirling ornament. These twelve may well have been carried out under Gilbert's supervision by his founder, Parlanti, who on 15 February 1899 brought to the sculptor 'two Henderson spoons and one spoon-bowl in silver'. C.G.

PROVENANCE By descent.

EXHIBITION Paris, Louvre, 'Arts décoratifs de Grande-Bretagne et d'Irlande', 1914, no. 748 (as 'collections de cuillères et salières en argent d'Alexander Henderson, dessin et éxécution d'Alfred Gilbert').

LITERATURE Hatton 1903, plaster model for large serving-spoon repr. p. 18; Dorment 1985, pp. 183, 206, repr. pls 134–5 p. 206.

59 *The de Vesci Seal*

1891–6
Bronze with various patinations including silver, set with
 deep blue and turquoise gemstones; at the base, in
 intaglio, the arms of Vesey impaling Charteris,
 surmounted by a viscount's coronet: ht 19 cm/7½ in; base
 diam. 5 cm/2 in
Private Collection

Commissioned originally on 1 January 1891, Gilbert took five years to complete this piece. In 1896 the 4th Viscount de Vesci presented it to his wife (née Lady Evelyn Charteris) on their silver wedding anniversary. The figure in armour

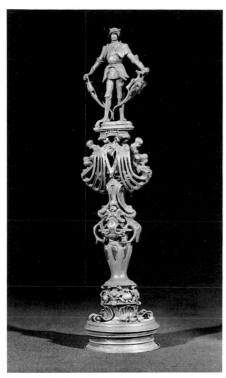

59 *reproduced in colour on p. 78*

which surmounts the seal holds two shields enamelled respectively with the arms of Vesey and Charteris. Apart from the armour-clad figure, which recalls, above all, the St George from the Royal Epergne (Cat. 53), the other ornamental motifs on the seal handle—the crouching children and the helmeted baby's head—appear again and again in Gilbert's work and are not particularly appropriate to this functional object.

A bronze model for the figure, which was exhibited in London in 1936, is in Montreal. C.G.

PROVENANCE By family descent to the present owner.

EXHIBITIONS Glasgow 1901, no. 124.

LITERATURE Hatton 1903, repr. p. 2; McAllister 1929, repr. opp. p. 163.

60 *The Quirk-Irvine Necklace*

1897–8
Silver round and flat wire: l. 31.7 cm/12½ in
Alan Irvine Esq.

The necklace is constructed of silver wire, partly round in section and partly beaten flat, in a continuous interwoven design with a free-hanging pendant incorporating a claw-set amethyst paste. The form is based on the 'carcanet' ribbon-tied necklet popular in the seventeenth and eighteenth cen-

turies. It is documented as having been made on the spur of the moment for Gilbert's niece, Miss Dorothy Quirk, who was about to go to a ball. C.G.

PROVENANCE Dorothy Quirk; by family descent; sold to The Fine Art Society; bt by present owner, 1975.

EXHIBITION London, The Fine Art Society, 'Jewellery and Jewellery Designs 1850–1930', 1975, no. 105.

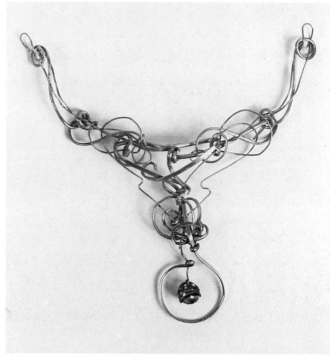

60

61 *The Illingworth Necklace and Pendant*

1920
Ormolu gilded wire in two widths and sheet metal, the pendant incorporating a cast bronze miniature figure of Venus: pendant ht 5.5 cm/2⅛ in; necklace l. 22.1 cm/8¾ in
The National Gallery of Victoria, Melbourne (Felton Bequest)

In 1914 Gilbert's patron Douglas Illingworth commissioned a necklace from him and entrusted him with a pearl to be set in it. Although an unfinished piece was shown to Illingworth in that year, the pearl had disappeared and no more was heard until April 1920 when Illingworth, who was about to be married, received the present necklace accompanied by a covering letter seeming to disclaim any connection between it and the original commission.[1]

The Illingworth necklace is the most elaborate and highly evolved of the pieces of twisted wirework jewellery that Gilbert produced in his later years. The two sides are astonishingly symmetrical, a fact that reflects Gilbert's

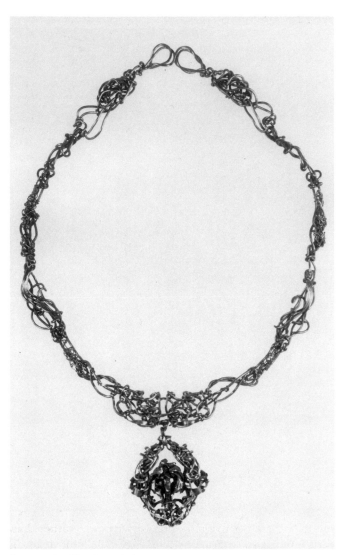

61 *reproduced in colour on p. 69*

innate predisposition towards axial symmetry. He was in the habit of making a design by drawing a form in ink on one side of a fold in a flat sheet of paper which he then folded over to produce a mirror-image of the pattern (see Cat. 117xv); but no such expedient could have served for a piece that must have been wrought and woven freehand. C.G.

NOTE
1. Letter in the possession of Mrs Douglas Illingworth.

PROVENANCE Commissioned from the artist by Douglas Illingworth, who presented it to his wife; sold by Mrs Illingworth, Sotheby's, Belgravia, 30 March 1977, lot 119; The Fine Art Society, 1977; purchased for the National Gallery of Victoria through the Felton Bequest.

LITERATURE Dorment 1985, pp. 282–3, repr. p. 169.

62 *Covered Cup (The Sander Cup)*

1912 (sketch model exhibited); this cast 1937
Silver, cast and chased: ht 64.9 cm/24½ in
Marked by Alfred Ernest Neighbour, London 1937
The Worshipful Company of Goldsmiths, London

The body of the cup is decorated with swirling forms which resolve into female figures. Around the base are more clearly defined mermaid-like forms. The cover is surmounted by

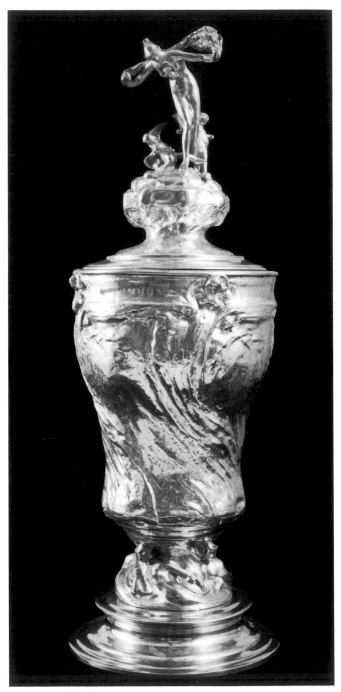

62 *reproduced in colour on p. 74*

it to the Sander family. Swinson reproduces a photograph of a cup which differs in some details from the one here exhibited, but no information about its history or location is given. The differences are not so great—to judge from a rather indistinct photograph—as to preclude the two cups having been cast from the same model.

The explanation of the present cup seems to be that it was cast from a plaster model found in Gilbert's studio after his death by Sigismund Goetze.

Gilbert's *Self-Portrait* in the Jean van Caloen Foundation (*c.* 1912) shows Gilbert with an object similar to the Sander Cup (fig. 52). C.G.

NOTE
1. Letter in the possession of Mrs Douglas Illingworth.

PROVENANCE Sigismund Goetze; his niece, Mrs Cippico; given by her to the Worshipful Company of Goldsmiths, 1951.

LITERATURE: George Ravensworth Hughes, *The Worshipful Company of Goldsmiths as Patrons of their Craft 1919–1953*, 1965, no. 95 (illus.); Arthur Swinson, *Frederick Sander: The Orchid King*, 1970, repr. opp. p. 191.

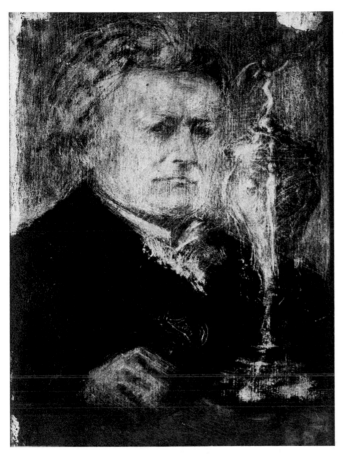

Fig. 52 Alfred Gilbert, *Self-Portrait*, oil on canvas, *c.* 1912 (Jean van Caloen Foundation, Loppem)

a nude female figure holding a wind-blown scarf and bending down towards two children at her feet. The cup stands on a plain turned foot which bears the hallmark.

In a letter to Douglas Illingworth (see Cat. 61) dated 21 May 1912, Gilbert wrote: 'If you visit the Royal Horticultural Exhibition you will see a sketch model of a cup to be executed in silver for Mr. Sander the great orchid grower.'[1] Frederick Sander (1847–1920), known as 'The Orchid King', had an international reputation as a horticulturist. Much of his business was based in Bruges, and it was there that he made Gilbert's acqaintance. The cup was to be presented by the Royal Horticultural Society to the best amateur orchid grower.

Whether the cup was eventually executed during Gilbert's life and in what form is not clear. This commission suffered from all the problems associated with the period in Gilbert's career spent in exile in Bruges, and Arthur Swinson, Sander's biographer, implies that at some time before 1918 it had been completed and then pawned, and that a Baron John de Brouwer, a rival horticulturist in Belgium, acquired it from the pawnbroker and refused to surrender

63 *A Set of Spoons*

c. 1930(?)
Wood and wax, painted and lacquered
i) *Europa and the Bull*: ht 23.5 cm/9¼ in
ii) Unknown subject: ht 22.2 cm/8¾ in
iii) *A Woman between two Scroll Arabesques*: ht 23.5 cm/9¼ in
iv) *Man with a Dragon*: ht 22.2 cm/ht 8¾ in
v) *Dancing Apollo*: ht 24.1 cm/9½ in
The Trustees of the Victoria and Albert Museum

The likely date for this set of fantastic spoons is after Gilbert's return to England in 1926—and perhaps later rather than earlier in the eight years he lived here before his death in 1934. The lacquered wooden ladles are Japanese and painted in geometric designs. They might have been purchased at Liberty's, indicating that Gilbert was attracted to the decoration of objects, quite apart from any intention to realise them in silver. He was practical enough to know that his wax designs for the handles could never have been carried out in metal.

Gilbert's passion for designing keys and spoons dates from the early 1890s (see Cat. 55, 58), and was commented upon by several contemporaries. From the evidence of what actually survives, relatively few of his designs were translated into silver or bronze. Adrian Bury's description of Gilbert at work might have been written about these spoons: 'Gilbert . . . enjoyed most doing minute and intricate work. With commissions awaiting completion, he would spend days weaving copper wire, lead and tin-foil paper or the lids of sardine tins into fantastic rings and chains, or designing handles for spoons that could have no other purpose

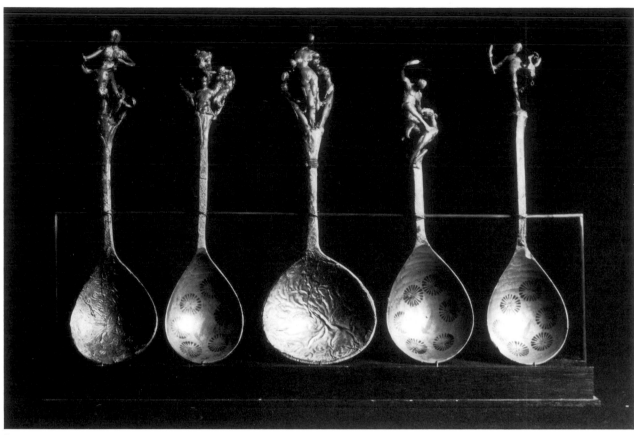

63

than to amuse his restless mind and fingers and to be presented to friends.'[1]

NOTE
1. Bury 1954, p. 57.

PROVENANCE In the artist's studio at the time of his death, 1934; bt Sigismund Goetze and the National Art-Collections Fund and presented to the Museum, 1936.

EXHIBITION London 1936, nos. 48–50.

LITERATURE Bury 1954, p. 70.

64 *Standing Cup (The Portland Cup)*

1931–4
Gold inset with enamelled armorial bearings: ht 49.5 cm/ 19½ in
Assayed 1949
Inscribed in blue enamel round the base: THE WORK OF ALFRED GILBERT TO REPRESENT THE ASCOT GOLD CUP WON BY THE DUKE OF PORTLAND'S BROWN COLT ST SIMON / YEARS OLD IN THE YEAR 1884
The Worshipful Company of Goldsmiths, London

Gilbert's last completed commission, from the 6th Duke of Portland for a single gold cup to be made from two of the

Duke's melted-down gold racing cups, was begun in 1931. As ever, the completion of the work was repeatedly delayed. The cup is stilll incomplete since it lacks the galleon in full sail designed to form the cover. On receiving the finished cup the Duke wrote of his 'beautiful flagon . . . I think the model of the little ship on the top of the lid is very well made and it makes a fine finish to the work'. The cup was sold at Sotheby's on 11 May 1950. It was assayed for sale, but problems arose with the precious metal content of the cover. Possibly there was not time to make a case for assaying it separately and a decision may have been taken to melt it. The appearance of the cover can be reconstructed from the plaster models which survive; but there is now no trace of a gold version. The amorphous forms on the body of the cup are suggestive of figures in movement. These might have been more fully realised had the sculptor worked still longer on the commission. By the time the cup was delivered to the Duke, Gilbert was in the grip of his last illness. His son wrote in reply to the Duke's letter of appreciation, that his father was in a nursing home too ill 'to reply to correspondence, or even to read it'. C.G.

PROVENANCE 6th Duke of Portland (d. 1943); 7th Duke; sold Sotheby's, 11 May 1950; various owners until B. Welch Esq.; sold by him Christie's, 19 May 1965, lot 173; ht Goldsmiths' Company, 1968.

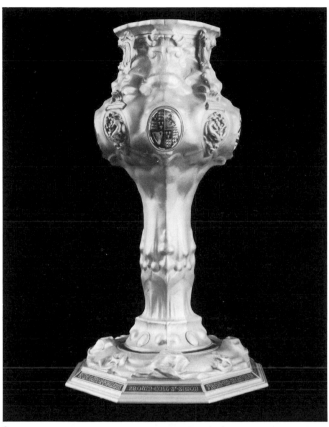

64

EXHIBITIONS Royal Academy 1933 (model); Brighton, 1984, no. 174.

LITERATURE Bury 1954, p. 69; Graham Hughes, *Modern Silver*, 1967, pl. 238; Dorment 1985, p. 331, pl. 200.

65 *Jewellery Executed in Wirework and Set with Pastes*

c. 1934
Wirework set with pastes
i) Necklace: chain l. 31.7 cm/12½ in; pendant
 ht 11.4 cm/4¾ in
ii) Pendant: ht 11.2 cm/4½ in
iii) Pendant: ht 11.5 cm/4¾ in
iv) Pendant set with turquoise and rose-coloured paste:
 ht 8.8 cm/3½ in
The Trustees of the Victoria and Albert Museum

These examples of the kind of hand-wrought wirework jewellery that Gilbert made at the very end of his life were in his studio at the time of his death. They were bought with the other studio contents by Gilbert's fellow artist, Sigismund Goetze, and distributed to selected museums in order to provide a record of the working methods of a great sculptor (see p. 212). The jewellery is unlike anything made

at that date and is among the most forward-looking of the sculptor's work. C.G.

PROVENANCE In the artist's studio at the time of his death, 1934; bt Sigismund Goetze and the National Art-Collections Fund and presented to the Museum, 1936.

EXHIBITION Royal Academy 1934, no. 1512.

LITERATURE *Victoria and Albert Museum Summary Catalogue*, 1982, p. 149.

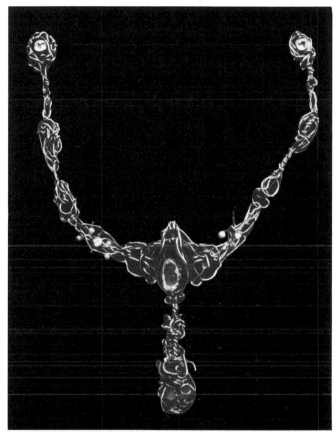

65i *reproduced in colour on p. 70*

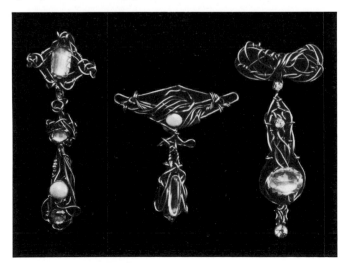

65ii, iii, iv *reproduced in colour on p. 70*

HE death of Prince Albert Victor, Duke of Clarence and Avondale, on 14 January 1892, brought Alfred Gilbert into the heart of the sorrowing Royal Family. The Prince and Princess of Wales asked him to create a memorial at Windsor for their first son on a scale suitable for a man who, had he lived, would have held what Queen Victoria called 'the greatest position there is'. Gilbert worked night and day for years to model and cast one of the most elaborate of all English royal tombs, a colossal filigreed masterpiece in polychromed bronze and aluminium, filling the tiny Albert Memorial Chapel at Windsor Castle in which it stands.[1] Gilbert became obsessed with the Tomb, designing and redesigning the grille. The commission dragged on unfinished throughout the 1890s. The sculptor's work on the intricate figures of the saints took time away from his other—more profitable—work, and thus contributed to his final bankruptcy in 1901. Anxiety, exhaustion and depression ultimately made work on the Tomb impossible for Gilbert. For his part, King Edward VII (as he had become in 1901) finally lost patience with the wayward sculptor. In 1903 Gilbert settled permanently in Bruges, leaving five niches on the grille empty of the saints they were to hold. Only in 1927 did Gilbert finally finish these five saints, which were placed on the Tomb in March 1928. Gilbert's masterpiece had taken thirty-six years to complete.

NOTE

1. Memorial to H.R.H. The Duke of Clarence and Avondale, KG, Albert Memorial Chapel, Windsor, 1892–9, with additions 1926–8. Bronze, marble, aluminium, ivory and brass: ht 175.3 cm/69 in; l. 322.6 cm/ 127 in. Inscribed (south side): THIS MONUMENT WAS RAISED IN THE YEAR OF GRACE 1898 AND THE 61ST YEAR OF THE REIGN OF HER MOST GRACIOUS MAJESTY VICTORIA QUEEN OF GREAT BRITAIN AND IRELAND EMPRESS OF (east side): INDIA TO HRH ALBERT VICTOR CHRISTIAN EDWARD DUKE OF CLARENCE & AVONDALE KG.KP.LLD HON CANTAB (north side): CAPTAIN XTH HUSSARS WHOSE BODY LIES WITHIN BY HIS SORROWING PARENTS ALBERT EDWARD PRINCE OF WALES & ALEXANDRA CAROLINE DAUGHTER OF CHRISTIAN OF DENMARK (west side): HE WAS BORN JAN 8TH 1864 DIED JAN 14TH 1892 AT SANDRINGHAM IN NORFOLK LOVING KIND & TRUE.

H.R.H. Prince Albert Victor (Eddy), son of the Prince of Wales and heir to the throne of England, died of pneumonia at Sandringham House on 14 January 1892. With the death of Joseph Edgar Boehm thirteen months earlier, a gap had arisen in the royal household: there was no Sculptor in Ordinary to Queen Victoria upon whom Prince Edward could call to design his son's Tomb. Although he had known Alfred Gilbert personally for some time, Edward may also have been influenced by the admiration of his sister, Princess Louise, whom Gilbert was then advising on her own work as a sculptor. On 23 January Gilbert was called to Sandringham and invited to submit a sketch-model for the Tomb of Prince Albert Victor, Duke of Clarence and Avondale.

Here was an uparalleled chance for Gilbert to prove himself the finest English sculptor of his generation. Unlike Boehm, who took his many royal commissions in his stride, Gilbert invested royalty with a romantic awe. It was not that he exaggerated the importance of the commission—he could hardly do that—but he idealised it, tying himself up in knots of anxiety in his search for perfection, refusing to follow a plan because he believed that a plan prevented improvement at every turn, and the day would come when a plan could be seen to have been completed. He worked in clay and plaster as though they were pencil and paper, a process which is reflected in the sketches for the Tomb: Gilbert began with a simple model in wax showing the sarcophagus, effigy, and angel (fig. 58); in the plaster scale-model of 1894 he added an elaborate grille with dancing angels and saints (Cat. 67); in the monument itself any vestige of simplicity has vanished (fig. 53).

The Albert Memorial Chapel, renovated for Queen Victoria by George Gilbert Scott with a painted roof and stained glass, and with a patchwork of polychromed marble mosaics designed by Triquetti in 1869, called for a tomb of the utmost simplicity to contrast with the profusion of decoration around it. But Gilbert chose instead to beat the Chapel at its own game. He designed a neo-Gothic extravaganza in bronze, aluminium and marble. Prince Albert Victor was shown in a realistic uniform of the Xth Hussars made of bronze and brass. His head and hands are made of white marble, while his cloak and the angel at his head are created in a pale grey aluminium. At his feet crouches a weeping angel. Gilbert surrounded the Tomb with a dense bronze grille punctuated by eighteen painted bronze uprights and twelve polychromed figures of saints—intricate, doll-like *pleurants* symbolising the realms over which Eddy would have ruled, his orders and titles, and his accomplishments (see Cat. 69, 73–81). Particularly enchanting are twelve pairs of pirouetting twin angels, sophisticated court ladies with wings, whose stylised feathers and swirling cloaks form graceful flying buttressess against each upright while, like heraldic beasts with shields, they present each saint to us. In these angels we are a long way from Fra Angelico: there is nothing fresh about the Clarence Tomb.

The whole is almost impossible to take in on one visit. The effigy is hidden by the grille, while angels, uprights and saints fail to resolve themselves into separate elements. To help remedy this, Gilbert painted the black bronze of the grille with gold highlights to pick out and separate the dark scrolls of tangled bronze.

The symbolism of the Tomb is allusive rather than explicit. Gilbert meant the grille to suggest a tree of Jesse, with each saint a flower in the Prince's lineage. These saints, set beneath glass lantern-like candle holders, also act as guiding lights to the traveller on life's journey. Throughout,

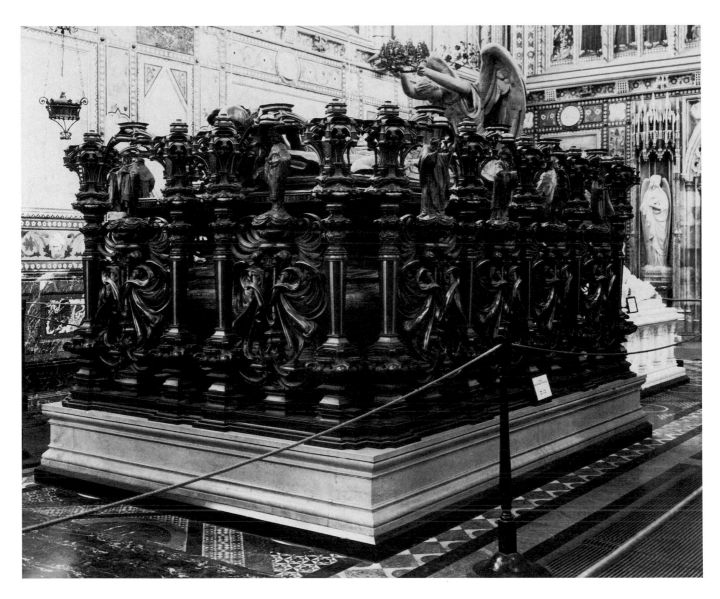

Fig. 53 Alfred Gilbert, the Tomb of the Duke of Clarence, 1892–1928
(Albert Memorial Chapel, Windsor Castle)

Gilbert never uses natural forms—no leaves, waves or branches actually appear on the Tomb. But, intrigued as he was by the imagery of Burne-Jones, it is not too much to see the grille as a thicket enveloping the sleeping Prince who, like the Briar Rose, will one day waken. The saints, then, are sentries around the Prince's sleeping form.

The elaboration and complexity of the Tomb is in direct proportion to the difficulty of pointing to any virtues of the deceased. Eddy may have been loving, kind and true, as Gilbert's inscription states, but he was neither intelligent nor manly—poor material for a future ruler. But this did not lessen the sorrow of Prince Edward and Princess Alexandra; they loved their son, and their simple wish was to see a private family memorial completed and dedicated.

This is what Gilbert could not do. By 1901 the whole was as we see it today, but missing five figures of the saints. The

King had been patient with Gilbert. At the time of the sculptor's bankruptcy in 1901 Edward continued to offer him rooms at Windsor in order to facilitate the completion of the commission. After his coronation in August 1902 the mood at Court cooled, and when Gilbert asked him whether he might publish photographs of the Tomb in the *Magazine of Art*'s Easter number for 1903, Edward replied with a furious 'no'. Little did he realise that Gilbert had made and sold versions and replicas of four of the figures (Cat. 69, 73, 75, 76). No doubt reasoning that figures of the saints in a private collection could not be considered 'the Tomb', the sculptor went ahead and published photographs of these statues, labelling the four bronze figures 'working models'.

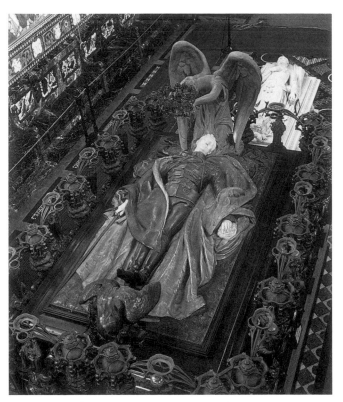

Fig. 54 Alfred Gilbert, the Tomb of the Duke of Clarence, 1892–1928: view from above (Albert Memorial Chapel, Windsor Castle)

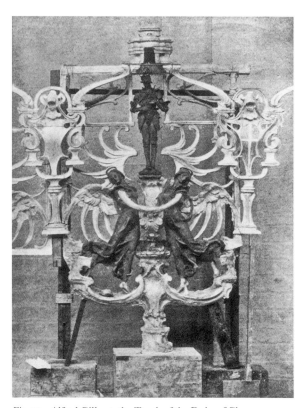

Fig. 55 Alfred Gilbert, the Tomb of the Duke of Clarence: preliminary study for the grille section with *St George* (Albert Memorial Chapel, Windsor Castle)

To have sold the figures was not illegal, but to the sorrowing mother and father, seeing parts of their son's unfinished tomb for sale on the art market, Gilbert's action was painful. After publication, the King said he would have nothing more to do with Gilbert—and never did. Queen Alexandra, 'crying in despair', tried in vain to coax Gilbert into completing the Tomb, but she too died without seeing the dedication of her son's memorial. Only in 1926 did George V succeed in extracting these final figures from Gilbert (Cat. 77–78), and by the time they were placed on the Tomb in 1928 they were modelled and cast in a very different, more 'expressionist' style than their predecessors.

In its form, Gilbert's Tomb paid tribute to the tombs of Cardinal Wolsey and Henry VIII, which had been planned for the site of the Tomb of the Duke of Clarence but never carried out. Furthermore, the Tomb can be seen as a paraphrase of such diverse sources as works by Torrigiano, Benedetto de Rovezanno, Peter Visscher the Elder and the Tomb of the Empress Mary of Burgundy in Bruges (1495–1502). But Gilbert's design remains essentially of his own time. He loathed the term 'Art Nouveau' and yet ironically created a masterpiece in the style. His aim, he said, was not to imitate Gothic but to express what he '. . . took ancient Gothic to be to those who practised it, the best expression of a living artist'.[1]

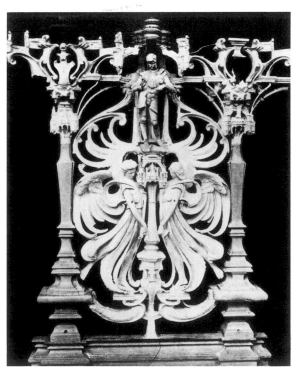

Fig. 56 Alfred Gilbert, the Tomb of the Duke of Clarence: detail showing *St George* (Albert Memorial Chapel, Windsor Castle)

NOTE
1. Hatton 1903, p. 26.

LITERATURE Spielmann 1901, pp. 81–2; Hatton 1903, pp. 2, 6–7, 26–32; Ganz 1908, p. 109; Macklin 1910, pp. 102, 114, 117; Spielmann 1910, p. 7; William St John Hope, *Windsor Castle: An Architectural History*, 3 vols, London 1913, repr. pl. 79; McAllister 1929, pp. 98–101, 129–36, 160–1, 163, 168, 172–3, 194, 218–23, 229, repr. frontispiece and opp. p. 134; Maryon 1933, pp. 11, 155, 225, repr. pl. 111, fig. 203; Ganz 1934, pp. 4–5, 8, 10, 13–14; London 1936, no. 9a–f, repr. pls 6, 7; Bury 1954, pp. ii, 15–18, 21–2, 25, 29, 33–5, 37–8, 47–51, 63, 66, 87, repr. pl. xx, opp. p. 43; Shelagh Mary Bond (ed.), *The Monuments of St George's Chapel, Windsor Castle*, Windsor 1959, p. 232; James Pope-Hennessy, *Queen Mary 1867–1953*, New York 1960, pp. 215–16; repr. foll. p. 238; Mark Roskill, 'Alfred Gilbert's Monument to the Duke of Clarence: A Study in the Sources of Later Victorian Sculpture', *Burlington Magazine*, vol. cx (1968), pp. 699–704; Handley-Read 1966, p. 10; Handley-Read 1967, pp. 21–2; Handley-Read 1968, I, p. 26; Handley-Read 1968, II, pp. 85–91; repr. pp. 85, 90–1; Handley-Read 1968, III, pp. 144–51; Manchester, Minneapolis, Brooklyn 1978–9, pp. 192–5; Read 1982, pp. 314, 337, 347–8, 352, repr. fig. 373 (detail) p. 314, fig. 404 p. 338; Beattie 1983, pp. 6, 162, 165, 180, 193, 231, repr. pl. 160 p. 165; Dorment 1985, pp. 108, 155, 159–60, 182, 190, 198, 201, 226, 238, 263, 316, repr. pls 92–3 pp. 153–4, pls 94–5 pp. 156–7, pls 96–7 p. 158, pl. 100 p. 161, pls 101–2 pp. 162–3.

The Identities of the Saints on the Tomb of the Duke of Clarence

The most reliable guide to the identity of the saints on the Tomb of the Duke of Clarence is a long article published in *The Times* on 4 August 1898. Based on information supplied by Alfred Gilbert himself, this article has the added advantage of describing where on the Tomb each saint was intended to be placed. This is the more useful as the iconographies of the saints were often made up by Gilbert without regard for their traditional representation. According to *The Times*, on the west end of the Tomb are St George (see Cat. 68–72) and the Virgin (Cat. 75). Moving round to the north side were the saints Elizabeth of Hungary, (see Cat. 76), Michael (see Cat. 73), Margaret and Patrick, the last two being the patron saints of Scotland and Ireland respectively. Facing the altar would be Edward the Confessor and Edward King and Martyr. On the south side would be Nicholas of Myra (see Cat. 78), Ethelreda of Ely (see Cat. 80), Hubert of Liège (see Cat. 77) and St Barbara. The *Times* list remains accurate except that Gilbert substituted St Catherine of Siena (Cat. 79) for Edward King and Martyr, and St Catherine of Egypt (Cat. 81) for St Barbara. It is not known why the substitutions took place. However, it is possible that Gilbert, although he had finished the figure of St Barbara, was desperate to complete the Memorial to Lord Arthur Russell at Chenies (see Cat. 90–3), and thus placed that figure on the Russell Memorial and renamed her *Courage*. Certainly the figure at Chenies is stylistically the earliest of the four virtues on the candlestick and far more intricate than the others. Also, she carries the attributes of the martyr saint's palm and sword. Against this

Fig 57 Plan of the Tomb of the Duke of Clarence showing the positions of the saints

theory is the fact that George Gilbert refers throughout the diaries to the figures of St Barbara and St Boniface. These can only be the statues listed in *The Times* as Margaret and Patrick. The figure of St Margaret shows a crowned Celtic queen holding a great scroll with seals—attributes one would expect to find on a Scottish Queen famous for her benevolent rule. Margaret was not martyred, so the palms she holds may refer to peace, as in Gilbert's *Victory* (Cat. 34). Alternatively, Gilbert may have combined the identities of St Barbara and St Margaret, as he tried to do with the two St Catherines (see Cat. 78, 81, 98). Likewise, the Celtic bishop St Patrick would seem to have a natural place on the Tomb as the patron saint of Ireland. It is just possible that an ivory and bronze head, unfinished by Gilbert and labelled 'St Edward the Confessor' in Hatton's 1903 interview with Gilbert (Cat. 74) represented the initial stages for the figure of St Boniface. Some of this confusion exists because Gilbert attempted to work out entirely original representations of the saints—giving *St Michael*, for example, cloven hoofs, or wrapping the Virgin in roses. It is noticeable that in 1903 Gilbert was at pains to explain to Hatton the meaning of his more obscure allusions, but where he did not identify the figures or give them obvious attributes, questions may arise. Finally, in the figures made in 1926–7 Gilbert had each display his or her attribute in a much more straightforward manner.

ARTHUR ROBERTSON (*draughtsman*) and ALFRED GILBERT (*designer*)

66 *The Tomb of the Duke of Clarence Presentation Book*

1894
i) *Title page*
Pencil, ink, bodycolour and gold and silver leaf on Bristol
board: 30×40 cm/$11\frac{7}{8} \times 15\frac{3}{4}$ in
Inscribed: AN ACCOUNT OF THE MONUMENT ERECTED IN
THE ALBERT MEMORIAL CHAPEL WINDSOR TO HRH THE
LATE DUKE OF CLARENCE AND AVONDALE KG KP LLD
(HON CANTAB)

ii) *The effigy and grille looking south*
Pencil, watercolour and ink on card:
37×47.5 cm/$14\frac{1}{2} \times 18\frac{3}{4}$ in

iii) *View of the Tomb from the altar*
Bodycolour on cardboard:
47.5×36.5 cm/$18\frac{3}{4} \times 14\frac{3}{8}$ in

iv) *St George (executed by Alfred Gilbert)*
Bodycolour and gold leaf on cardboard:
40.5×30.5 cm/16×12 in
Inscribed in Alfred Gilbert's hand in pencil: AN
ILLUSTRATED ACCOUNT/OF THE MONUMENT ERECTED IN
THE ALBERT MEMORIAL CHAPEL WINDSOR TO H.R.H. THE
DUKE OF CLARENCE AND AVONDALE/ALFRED GILBERT
The Jean van Caloen Foundation, Loppem

Gilbert's lavish volume on the Tomb and its heraldry was
completed in 1894. The Tomb as depicted here corresponds
with the 1894 sketch-model (Cat. 67) and was therefore
soon out of date. Not only did Gilbert redesign the grille
at least twice, but he also raised the sarcophagus on a marble
base. The grille was then placed around it in such a way
as to completely obscure the effigy and the angels. Gilbert
later claimed that this was deliberate but the evidence of
this presentation book suggests that he made some error in
calculating the height of the grille. King Edward VII always
objected to not being able to see his son's effigy.

Cat. 66iv, one of Gilbert's first studies for St George
(Cat. 68–72), is an alternative design for the title page.
Instead of a sword the Saint carries a crown in his right
hand. Nowhere has Gilbert indicated the angels attendant
on each of the niche figures.

PROVENANCE Alfred Gilbert; his widow, Stéphanie; bt Baron Jean van
Caloen, 1935.

LITERATURE Dorment 1985, p. 166.

66i

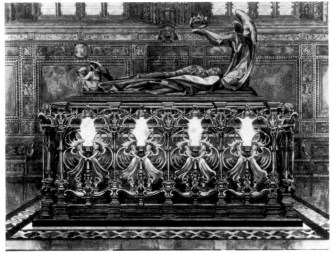

66ii *reproduced in colour on p. 62*

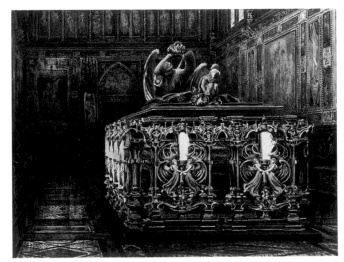

66iii *reproduced in colour on p. 62*

66iv

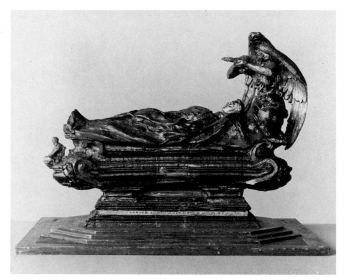

Fig. 58 Alfred Gilbert, the Tomb of the Duke of Clarence: sketch-model
for the sarcophagus and effigy, wax on plaster and wood armature, 1892
(Victoria and Albert Museum, London)

67 *Sketch Model for the Tomb of His Late Royal Highness the Duke of Clarence and Avondale KG. To be placed in the Memorial Chapel, Windsor*

1892–4
Polychrome plaster on marble base; effigy of the Duke:
 l. 63 cm/24 in, w. 31.5 cm/12 in, each upright, from base
 to lantern: ht 33 cm/13 in
H.M. The Queen

Gilbert stayed at Sandringham from Saturday until Monday, 23–5 January 1892. His account of the genesis of the Tomb is as follows: 'During Sunday night, until just in time to catch my train on Monday, I conceived and designed the ensemble of the entire monument as it now stands.'[1] Back in London he locked himself in his studio for four days, eating his meals off a tray and hardly sleeping. On the fourth day the Prince of Wales visited him, saw the model, and was satisfied: 'He told the artist', Miss McAllister writes, 'he considered his achievement was nothing short of a miracle.'[2]

What Gilbert modelled was a demonstration for the patron's approval, and as such represents a first idea which Gilbert inevitably changed in almost every detail. It is now in the Victoria and Albert Museum (fig. 58).[3] Three figures —the effigy, the angel and the putto at the Prince's feet— were on the sarcophagus from the beginning. However, the sarcophagus was ultimately enlarged so that the effigy and angel would not be cramped; the larger angel in the first sketch was given a baroque twist to her torso which disappeared as the artist developed his idea in the final monument; and the tiny putto in the sketch-model became a small angel. Above all, there is no hint of (or indeed place for) a grille.

It was this model that Gilbert brought to Windsor on 6 March 1892 for Queen Victoria's inspection.

Cat. 67 is the sketch-model for the Tomb which Gilbert's father noted in his diary (25 April 1894) that Gilbert had completed ('Magnum Opus!!!') and delivered to the Royal Academy. It seems to have been made more for exhibition than as a working tool, and certainly was finished long after Gilbert had begun to model the full-sized effigy and angels in clay. These last were commented upon by Queen Victoria on 10 March 1893 when she visited Gilbert's Maida Vale studio and saw a monument 'only in the clay, which is beautiful + so like. The angel bending over his figure holding a crown is quite lovely, + so is the little angel of love against the wings of which his feet rest. . . . Mr. Gilbert showed me too a small wooden model of the grillage which is to go round the tomb, on which different figures of the saints are introduced.' The order in which Gilbert worked was to finish the onyx sarcophagus first, then begin the full-

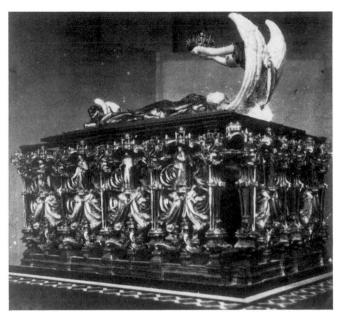

General view of the plaster model (Cat. 67) at the Royal Academy in 1894

sized effigy and angels. Only when these were under way did he turn his attention to the grille and saints. At the time of Queen Victoria's visit he had just started to work out the design for the grille after completing research on the history of the Chapel in which the Tomb was to stand.

This model is, therefore, a vivid statement made to give the public some idea of what the Tomb would look like, and comparable to his presentation book of the same date (Cat. 66). When exhibited at the Royal Academy it received extensive Press coverage. *The Builder* said that the model had 'been placed a little too high so that [the] recumbent figure can hardly be seen, and the spectator has the impression—which may be the correct one—that the artist has been more occupied with the surroundings of the tomb than with the monumental effigy itself'. This writer also criticised the heavy, massive wings of the angels—and these, whether he read the review or not, Gilbert altered at least twice. No review was really critical, but D. S. MacColl in the *Spectator* wrote that 'the decorator has triumphed over the architect in its design'.

The history of this model is in itself of interest. It remained in Gilbert's studio until the time of his bankruptcy in August–September 1901. Although Gilbert later created the impression that he smashed all his statues to save them from the bailiffs, much was spared. Clients were able to purchase their own works if they wished. In a letter of 3 February 1903, Sir Dighton Probyn (1833–1924), King Edward VII's equerry, told the sculptor that this sketch-model was at Buckingham Palace because he had purchased it from

the bailiffs.[4] Eventually—probably after Edward VII's death in 1910—it was moved to St Mary Magdalene, Sandringham, as a memorial to the Prince. There it remained until about 1950, when it was removed on the instructions of King George VI. It was crated and transferred to an outhouse on the estate where it was rediscovered in 1984, and restored for this exhibition.

NOTES
1. McAllister 1929, p. 129.
2. Op. cit., p. 130.
3. 1892. Bronzed green wax on a plaster and wood armature: ht 31 cm/ 11¾ in; l. 42 cm/16½ in.
4. Royal Archives, Windsor, z 475/261.

PROVENANCE Alfred Gilbert; purchased from bailiffs by Sir Dighton Probyn on behalf of King Edward VII, 1901.

EXHIBITIONS Royal Academy 1894, no. 1849; London 1909, no. 318 (lent by Queen Alexandra).

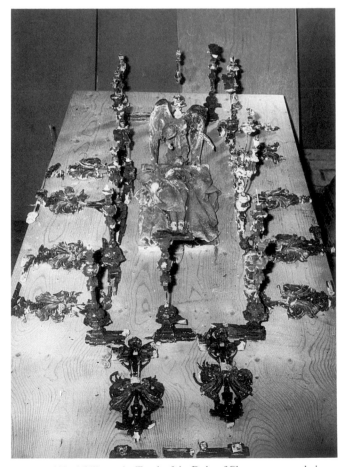

Fig. 59 Alfred Gilbert, the Tomb of the Duke of Clarence: general view of the plaster model (Cat. 67) before restoration, 1984

LITERATURE 'Sculpture at the Royal Academy', *The Builder*, vol. CXVI (30 June 1894), p. 492; 'The Royal Academy', *Athenaeum* (7 July 1894), p. 39; 'The Royal Academy', *Saturday Review* (12 May 1894), p. 494; Claude Phillips, 'The Royal Academy II', *The Academy* (9 June 1894), p. 482; D. S. MacColl, 'The Royal Academy II', *The Spectator* (9 June 1894), p. 791; Hatton 1903, p. 32; 'Passing Events', *Art Journal* (May 1909), p. 158; McAllister 1929, p. 172; Bury 1954, p. 68; Handley-Read 1968, II, p. 87, repr. fig. 5 p. 87; Handley-Read 1968, III, detail repr. p. 146; Manchester, Minneapolis, Brooklyn 1978–9, p. 194; Beattie 1983, p. 6; Dorment 1985, pp. 152, 164, 269.

St George

Cat. 68–72 are intended to demonstrate the range and variety Gilbert was capable of achieving from a single initial design: exhibited are the patterns from which sand moulds would be made (Cat. 68); the plaster model to which Gilbert has given chain mesh (Cat. 70); and the figure cast in white metal with ivory details (Cat. 69), entirely in aluminium (Cat. 71), and plain bronze (Cat. 72).

68 *Patterns for Casting St George*

*c.*1896
Metal
Private Collection

These patterns were used in the foundry to form the sand moulds from which *St George* was cast. The figure or pattern is subdivided in order to simplify the mould making. Each of the smaller components would only need a relatively simple sand mould in two halves.

Variations in the angles of the arms and hands in different casts of *St George* are due to this method of assembling parts, as opposed to casting the statue in one piece.[1]

NOTE
1. Information kindly supplied by Duncan James.

PROVENANCE Deposited with the Compagnie des Bronzes by 1926.

EXHIBITION London 1968, no. 74.

LITERATURE Manchester, Minneapolis, Brooklyn 1978–9, p. 197; Dorment 1985, p. 168, repr. pl. 104, p. 165.

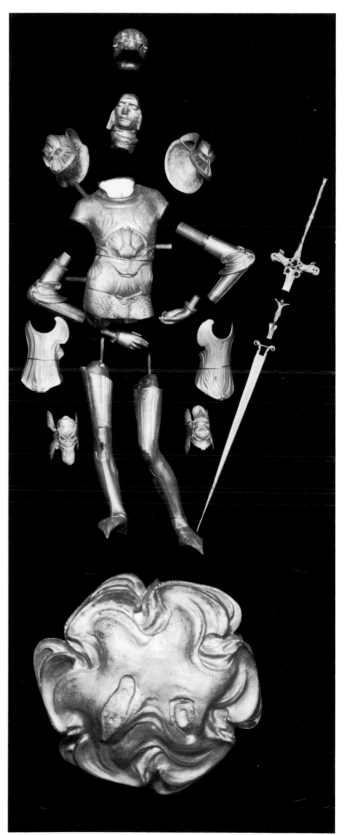

68

69 *St George*

1895
White metal and ivory: ht 48.2 cm/19 in
Cast by George Broad & Son
St Mary Magdalene, Sandringham; lent by
 H.M. The Queen

Cast by Broad & Son, this was the first *St George* to be completed. It was delivered to Sandringham on 10 November 1895 as a private 'household' memorial to the Duke of Clarence (see Cat. 117xviii). Gilbert had this piece cast in white metal with ivory details. The figure on the Tomb, of aluminium with ivory face and hands, was put into place in March 1898. The patterns for *St George* are shown as Cat. 68. Later aluminium casts date from 1899 (Cat. 71), as do Gilbert's first bronze casts of *St George* (Cat. 72), which he continued to produce in this century. The Sandringham cast differs from that on the Tomb in having a winged Anteros on the Saint's breastplate, a slightly different helmet, and a straight sword rather than a stanchion. The expression on the face of the Sandringham *St George* is notably more gloomy than on the replica at Windsor.

St George blesses us languidly, a high-church aesthete out of the pages of *The Yellow Book*. His fantastic pauldrons are shell-shaped, his poleyns winged, his sabatons extravagantly pointed. Gilbert said of this armour that it had the appearance of Gothic, 'and yet . . . there is not the slightest resemblance to anything we know of Gothic work, unless the use of shells and other natural forms may be said to have influenced me as they doubtless did the Gothic craftsmen of mediaeval times'.[1]

Although he looks back to Giorgione's dreamy *Castlefranco Madonna* (1504–5; Castlefranco, S. Liberale), Gilbert's *St George* also has a prototype in Pieter Visscher the Elder's *King Arthur* on the Monument to the Emperor Maximilian I (*c.* 1512) in the Innsbruck Hofkirche. When knights in armour appear in Gilbert's own work—*Fortitude* in the Fawcett Memorial (Cat. 31) or *St George* on the Jubilee Epergne (Cat. 53)—they are manly fellows in comparison to this St George. This difference may be due to the fact that Gilbert's inspiration for *St George* lay in the androgynous figures of Burne-Jones: an oft-cited source for his armour is Burne-Jones's costumes for Henry Irving's 1895 production of J. W. Comyns Carr's *King Arthur*.[2] Gilbert claimed that if made to scale, *St George*'s armour could be worn.

The question of duality or syncretism arises in several of the figures of the saints on the Tomb of the Duke of Clarence. Here the Christian saint wears the pagan symbol for selfless love on his breastplate and carries an oversized sword with a hilt in the form of a crucifix which symbolises his role as both warrior and saint. As, for example, in the works of Walter Pater (1839–94), this overlapping and mixing of symbols is a phenomenon of the 1890s in England.

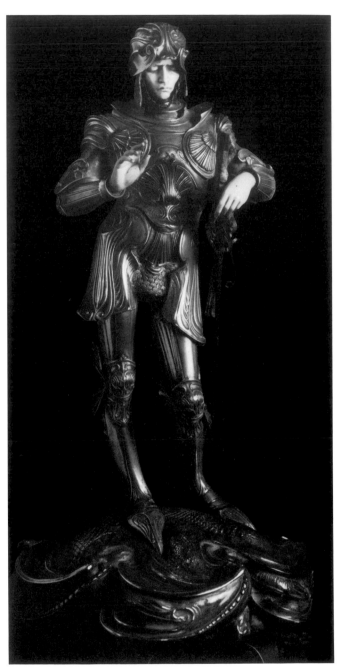

69 *reproduced in colour on p. 56*

NOTES
1. Hatton 1903, p. 30.
2. Aymer Vallance, 'The Decorative Art of Sir Edward Burne-Jones, Baronet', *Extra Number of the Art Journal*, London 1900, *passim*.

EXHIBITIONS Royal Academy 1968, no. 684.
(Windsor cast) Royal Academy 1896, no. 1909.

LITERATURE McAllister 1929, repr. opp. p. 163; Bury 1954, pp. 67–8; Handley-Read 1966, p. 15, repr. fig. 6 p. 15; Handley-Read 1968, I, p. 26, repr. fig. 14 p. 27; Manchester, Minneapolis, Brooklyn 1978–9, p. 197; Read 1983, p. 337; Dorment 1985, pp. 159, 166.
(Windsor cast) Hatton 1903, pp. 30–2; Spielmann 1910, p. 7; McAllister

1929, pp.132–4, 223; Bury 1954, pp. 48–50, 54, 85, 86, repr. pl. xv;
Handley-Read 1968, ii, p. 89; Handley-Read 1968, iii, repr. p. 90;
Manchester, Minneapolis, Brooklyn 1978–9, p. 197; Beattie 1983,
pp. 165, 180, 259 (n. 42); Dorment 1985, pp. 166, 168, repr. pl. 103 p.165.

70 *St George*

c. 1895
Plaster and chain mesh: ht 44.4 cm/17½ in
Castle Museum, Nottingham

PROVENANCE In the artist's studio at the time of his death; bt
Sigismund Goetze and the National Art-Collections Fund and presented
to the Museum, 1936.

EXHIBITION London 1936, no. 9(b).

LITERATURE McAllister 1929, repr. opp. p. 128; Bury 1954, p. 72;
Manchester, Minneapolis, Brooklyn 1978–9, p. 197.

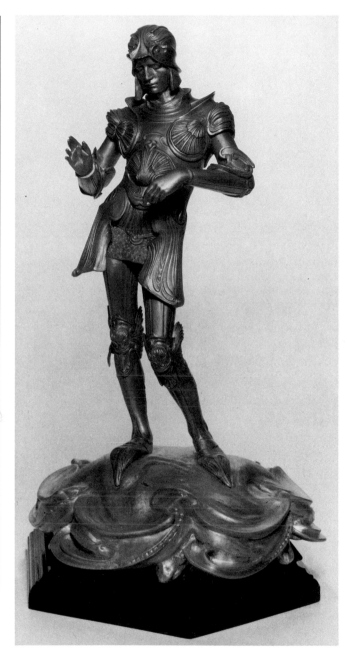

71 *reproduced in colour on p. 57*

71 *St George*

1898–9
Aluminium: ht 45.7 cm/18 in
Founder: Compagnie des Bronzes, Brussels
Trustees of the Cecil Higgins Art Gallery, Bedford

This is one of two aluminium casts of *St George* made by the
Compagnie des Bronzes in 1899. The first was sent to 11
Great Stanhope Street, the home of the art dealer Sir Wil-
liam Agnew (1825–1910), on 9 February that year. The

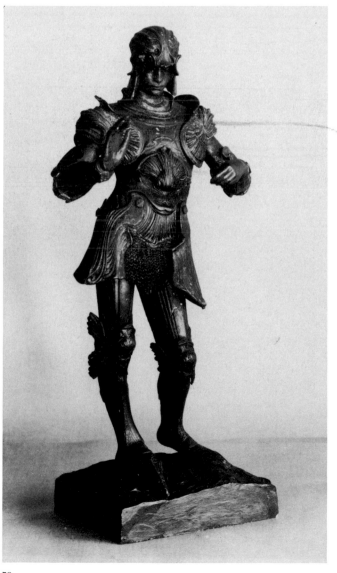

70

second cast is recorded as being delivered to Gilbert's studio on 20 February 1899, and was sold to Robert Dunthorne.

Sir William was delighted with his cast. Later in the year he asked to exchange his cast of the *Study of a Head* (Cat. 14) for another of Gilbert's works. It was arranged that he should accompany Gilbert to Windsor and there take his pick from the figures on the Tomb.[1] Whether this expedition ever took place—and whether the Royal Family ever learned of it—is unrecorded.

NOTE
1. See Dorment 1985, p.201.

PROVENANCE Sold by the artist to Sir William Agnew, 1899(?); Handley-Read Collection; purchased by the Cecil Higgins Art Gallery, 1972.

EXHIBITIONS 'Art Nouveau in Britain', Art Gallery and Museum, Glasgow, Laing Art Gallery, Newcastle-upon-Tyne, Glynn Vivian Art Gallery, Swansea, Brighton Art Gallery, City Museums and Art Gallery, Birmingham, Leicester Museum and Art Gallery, 1965, no. 36; London 1968, no. 72; London 1972, no. F 26.

LITERATURE Handley-Read 1968, III, pp. 144–6, repr. fig. 4 p. 146; Manchester, Minneapolis, Brooklyn 1978–9, p. 197.

72 *St George*

1899–1900
Bronze: ht 45.7 cm/18 in
Private Collection

PROVENANCE Bt from the artist by Robert Dunthorne, 1899; bt William Vivian, 1899; by descent to present owner.

EXHIBITIONS 'Art Nouveau in Britain', Art Gallery and Museum, Glasgow, Laing Art Gallery, Newcastle-upon-Tyne, Glynn Vivian Art Gallery, Swansea, Brighton Art Gallery, City Museums and Art Gallery, Birmingham, Leicester Museum and Art Gallery, 1965, no. 36; London 1968, no. 72; London 1972, no. F 26.

LITERATURE Handley-Read 1968, III, pp. 144–6, repr. fig. 4 p. 146; Manchester, Minneapolis, Brooklyn 1978–9, p. 197.

73 *St Michael*

1889–1900
Bronze: ht 48.2 cm/19 in
Private Collection

St Michael wears scaly bat-like armour and two sets of wings—huge enveloping feathers from his shoulders, and the smaller pinions on his helmet. The tiny hill-town at his feet (Windsor?) establishes the colossal scale of the figure, while the object he holds and contemplates with withdrawn intensity is not a sword but the scales of the Last Judgement. In one of the shell-shaped balances a naked female soul is dragged down by a pursuing winged demon with horrible claws. In his right hand St Michael holds a crucifix which he may or may not place in the empty balance, and so save

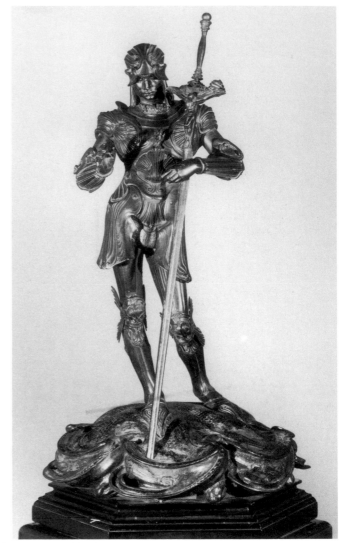

72 *reproduced in colour on p. 55*

the soul from damnation. The elaborate ornamental scales also suggest a huge key, an allusion to the keys to the Kingdom of Heaven. Nowhere else in the œuvre is Gilbert as allusive, subtle, and clever as in this figure. As Lavinia Handley-Read has demonstrated, many of the saints on the Tomb partake of dual or multiple identities.[1] *St Michael*, although unquestionably the archangel (and placed on the Tomb, according to Gilbert's statement to *The Times* of 4 August 1898, to refer to the Order of St Michael), has one startling attribute: instead of feet he has been given cloven hoofs. To give the very symbol of Lucifer to *St Michael* was perverse; at one point (29 November 1899) Gilbert's son even referred to the *St Michael* as 'The devil weighing the damned soul down', a reference which might however also suggest that he was only thinking of the demon and the soul on the scale. In addition, his bat-like presence irresistibly

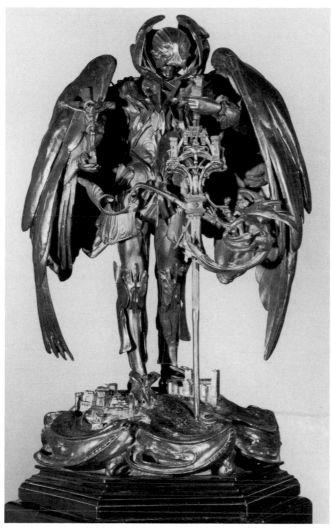

73 *reproduced in colour on p. 58*

In the autumn of 1899 Gilbert quarrelled with Parlanti, who never worked for him again. Cat. 73 is less fine a cast than that of the Saint on the Tomb: it is missing a second 'soul' who, in the Windsor cast, reaches up to the cross (itself missing from the Windsor cast but present in Cat. 73). The Windsor *St Michael* also has sweeping flaps of beaten metal emerging from beneath the Saint's armour.

Only two bronze casts seem to have been made. Cat. 73 is a companion to Cat. 72, Vivian's cast of *St George*.

NOTE
1. Handley-Read 1968, III, p. 149.

PROVENANCE Bt from the artist by Robert Dunthorne; bt William Vivian, 1899; by descent to present owner.

EXHIBITION Manchester, Minneapolis, Brooklyn 1978–9, no. 110.

LITERATURE (Cat. 73) Hatton 1903, repr. p. 28; Macklin 1910, repr. p. 105; Spielmann 1910, p. 7 (which cast is not clear); Dorment 1985, pp. 199, 201, 228, 277, repr. fig. 127 p. 202.
(Windsor cast) Handley-Read 1968, III, pp. 144–5, repr. p. 145; Read 1982, repr. fig. 405 p. 339; Beattie 1983, pp. 165, 167, repr. fig. 160 p. 164; Dorment 1985, p. 175, repr. fig. 107 p. 171.

74 *A Bishop Saint*

1899
Bronze and ivory: ht including ebonised base 30.5 cm/12 in
Private Collection

In August 1899 Gilbert delivered to Robert Dunthorne this small bronze and ivory bust of a bishop in cope and mitre.

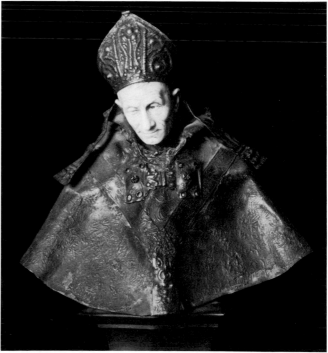

74 *reproduced in colour on p. 63*

recalls Gilbert's close friendship with Bram Stoker (1847–1912), author of *Dracula* (1897).

The polychrome bronze figure now on the Tomb was finished and bought directly by Dunthorne for Vivian on 5 August 1899. On 11 August Vivian returned *St Michael* to Gilbert for alteration. Pressed to finish the Tomb, Gilbert on the following day placed the Dunthorne/Vivian figure on the grille, as he thought, 'temporarily'. However, Gilbert left the figure *in situ*, and made a new *St Michael* (Cat. 73) for Mr Vivian. This was not finally finished until the end of January or beginning of February 1900.

The polychrome *St Michael* on the Tomb was cast by Parlanti. The colouring of this and other figures, Gilbert told Hatton, was neither paint nor enamel, but a medium devised by him and composed of oxides 'and certain liquids of natural but imperishable lacquers'. Some of the colours, he added, were vitreous.

Although Alfred Gilbert offered to present the figure to him, Dunthorne paid him £70, and sold it at once to the collector William Vivian. The piece was certainly conceived for the Tomb of the Duke of Clarence, and given that Gilbert appears to have been so close to completing the figure at a moment when to finish the Tomb would have altered the course of his life, his decision not to use it is puzzling. To sell a work so far advanced for £70 strikes one as foolhardy; and yet Gilbert's perfectionism was beyond reason: one simply cannot tell what displeased him about the figure.

This piece was wrongly identified by Hatton in the caption under the reproduction in his 1903 article as 'St Edward the Confessor'; the error was repeated by the present author in 1978, and corrected (Dorment 1985) to 'A Bishop Saint'.

PROVENANCE Bt from the artist by Robert Dunthorne, 1899; bt William Vivian, 1899; by descent to present owner.

LITERATURE Hatton 1903, repr. p. 27 as 'St Edward the Confessor'; Manchester, Minneapolis, Brooklyn 1978–9, no. 111 as 'Edward the Confessor'; Dorment 1985, p. 201, repr. pl. 126 p. 200.

75 *The Virgin*

1899
Bronze, painted: ht 49.5 cm/19½ in; wooden base ht 7.6 cm/ 3 in; bronze base ht 125.7 cm/49½ in; wooden floor base ht 8.9 cm/3½ in
Founder: Alessandro Parlanti
A parish church in Scotland

The *Virgin* was included among the saints on the Tomb of the Duke of Clarence because the chapel in which the Tomb stands had once been a Lady Chapel and was therefore dedicated to the Virgin, as well as bearing a secondary dedication to St George. Only two casts exist—the one on the Tomb and the one exhibited here. Both are made entirely of bronze, although their faces are painted to look like ivory. One was cast in April 1899, the other in August of the same year. On 11 August Cat. 75 was sold to Dunthorne; on 16 August the other bronze was installed on the Tomb.

Both statues are polychromed and the figures themselves are identical. However, the rose-bushes, each cast separately in *cire perdue*, are quite different, as are the haloes—that of Cat. 75 is apparently made from a curtain-ring. The suggestion that there may have been a third cast[1] is untenable, as Cat. 75 was unquestionably the cast belonging to William Vivian. The pedestals for this figure and that of *St Elizabeth of Hungary* (Cat 76), quite different from the uprights on the Tomb itself, were commissioned and cast in 1899. The *Virgin* is the most enigmatic and arguably the most purely symbolist saint on the Tomb. As with all the saints, her iconography is entirely Gilbert's invention, but he strayed so far from any traditional representation of the Virgin in art that he was forced to give the public an exegesis on her meaning:

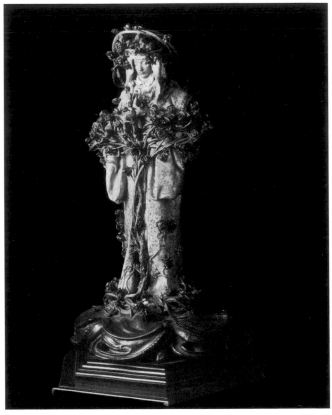

75 *reproduced in colour on pp. 66–7*

'I have represented her as standing in the midst of a wild rose-bush. Circling her feet, it forms a natural Crown of Thorns, which, sprouting, send their shoots upwards around the figure, in their turn giving off roses to within reach of her clasped hands, when a white lily rises to her touch. Thence the fronds ascend and twine around her head and form a natural crown of full-blown roses. The Virgin is simply draped, with a head-covering overshadowing her half-sad expression of features; and she is meant to be in an attitude of resignation rather than that of prayer.'[2] The last sentence suggests that Gilbert identified the *Virgin* with the mourning Queen Alexandra.

Maryon (1933, pl. CXII, fig. 206) reproduces a photograph of this bronze with a caption stating, incorrectly, that it is in the National Gallery of Melbourne.

NOTES
1. Manchester, Minneapolis, Brooklyn 1978–9, no. 108.
2. Hatton 1903, pp. 30–1.

PROVENANCE Bt from the artist by Robert Dunthorne; bt William Vivian; by descent to Valentine Vivian who sold it in the 1930s; London art market 1936; bt Sir D. Y. Cameron, who gave it to present owners.

EXHIBITIONS London 1968, no. 75G; London 1981, no. 20; Manchester, Minneapolis, Brooklyn 1978–9, no. 108.

LITERATURE Hatton 1903, pp. 27–8, 30–1, repr. frontispiece; Macklin

1910, p. 117, repr. p. 107; Maryon 1933, repr. pl. 112, fig. 206; London 1936, p. 18 no. 9g; Handley-Read 1968, III, p. 146, repr. p. 147; Beattie 1983, p. 259 (n. 42); Dorment 1985, pp. 198–9, 228, repr. col. pl. v p. 186. (Windsor cast) McAllister 1929, pp. 132–3, 135, repr. facing p. 131; Bury 1954, pp. 49, 85, repr. pl. xiv; Handley-Read 1968, II, p. 89; Handley-Read 1968, III, pp. 144–6, 149, 150, repr. p. 144; Manchester, Minneapolis, Brooklyn 1978–9, pp. 197–8; Beattie 1983, pp. 162, 165, 231, repr. fig. 158 p. 163; Dorment 1985, pp. 170, 279.

76 *St Elizabeth of Hungary*

1899
Bronze, ivory and tin inlaid with mother-of-pearl and semi-precious stones: ht 53.3 cm/21 in; wooden base ht 7.6 cm/3 in; bronze pedestal ht 125.7 cm/49½ in; wooden floor base ht 8.9 cm/3½ in
Founder: Alessandro Parlanti
A parish church in Scotland

This is the first and most elaborate of three casts of *St Elizabeth of Hungary*. It is polychromed bronze with an ivory face, inset with details in semi-precious stones and mother-of-pearl.

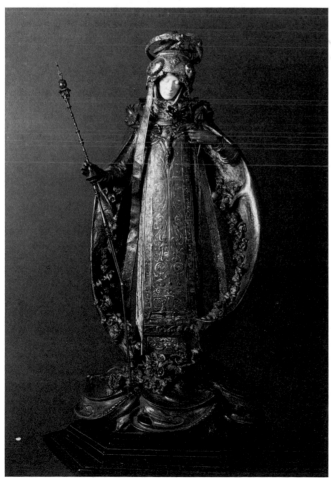

76 reproduced in colour on pp. 64–5

On 18 March 1899 this cast of *St Elizabeth of Hungary* was completed, and two days later was sent to Robert Dunthorne, seen by William Vivian, and returned to the studio. The figure was finally delivered to Vivian on 8 April. On 14 April, Parlanti delivered a second cast of *St Elizabeth of Hungary*; it is this second cast that is on the Tomb. The two casts are identical, except for the bronze face of the second, its colouring, and the simpler headdress which did not have to be made separately to fit the head.

St Elizabeth of Hungary, an ancestor of Prince Albert, was Landgravine of Thuringia and a Christian queen with a pagan husband. On her way to deliver food concealed in her cloak to the poor, she met her husband who asked her what her cloak contained. 'Only roses,' she replied, whereupon her cloak fell open to reveal miraculous roses tumbling to her feet.

The face of St Elizabeth here appears to be a portrait of Nina Cust (see Cat. 83).

A third cast of *St Elizabeth of Hungary* was made in 1900. It is today in the National Gallery of Victoria, Melbourne.[1] This cast Gilbert attempted to sell to Robert Dunthorne in an uncompleted state. However, Dunthorne was not willing to buy an unfinished statue. In February 1901 he sent the cast back to Gilbert's studio, telling him to continue to work it up. In June, Dunthorne again refused to buy the figure for the asking price of £60. In 1902 the figure was for sale for £300 at the Fine Art Society. The fact that replicas of figures from the Tomb of the Duke of Clarence had been for sale in Bond Street did Gilbert's reputation much harm.[2] However, this *St Elizabeth of Hungary* was not the only cast sold on the open market; the figure of *St George* is known in at least seven bronze and two aluminium casts, any of which might have found its way to Bond Street.

NOTES
1. 1900–1901. Bronze and cloth stiffened with gesso plaster: ht 41.1 cm/16⅛ in. The National Gallery of Victoria, Melbourne.
2. Bury 1954, pp. 95–6.

PROVENANCE Bt from the artist by Robert Dunthorne; bt William Vivian; by descent to Valentine Vivian, who sold it in the 1930s; London art market 1936; bt Sir D. Y. Cameron, who gave it to present owners.

EXHIBITIONS London 1968, no. 76G; Manchester, Minneapolis, Brooklyn 1978–9, no. 109; London 1981, no. 21.

LITERATURE Hatton 1903, pp. 30–2, repr. p. 30; Handley-Read 1968, III, p. 145; London 1968, p. 15; Dennis Farr, 'The Patronage and Support of Sculptors', in Sandy Nairne and Nicholas Serota (eds), *British Sculpture in the Twentieth Century* (exhibition catalogue), London 1981, p. 46; Beattie 1983, p. 259 (n. 42); Dorment 1985, pp. 199, 201, 228, repr. col. pl. vi p. 187, pl. 128 p. 202.
(Windsor cast) McAllister 1929, pp. 134–5; Bury 1954, pp. 48–9; Handley-Read 1968, III, pp. 145–6, 150, repr. fig. 8 p. 148; Manchester, Minneapolis, Brooklyn 1978–9, p. 200; Beattie 1983, pp. 162, 165, repr. fig. 159 p. 163; Dorment 1985, pp. 170, 201, repr. fig. 106 p. 169.

The Later Figures for the Tomb of the Duke of Clarence

Largely through the efforts of Isabel McAllister (1870–1945), Alfred Gilbert returned to London from Bruges in August 1926. He was given the use of a studio at Friary Court, St James's Palace, belonging to Lady Helena Gleichen (d. 1947). He worked tirelessly on the five missing figures which were ready for the founder in February 1927 and cast with money advanced by King George V. Four of these were finally placed on the south side of the Tomb, and one on the east, in March 1928. To anyone who had not followed Alfred Gilbert's evolving style, the new figures may have seemed bizarre—mannered, elongated, missing the intricate detail of the earlier seven saints. However, compared with works such as *St George and the Dragon, Victory Leading* (Cat. 101) or *The Chatelaine* (Cat. 109) and *The Virtuoso* (Cat. 110), they merely reflect Gilbert's search for a more expressive, freer manipulation of bronze. It is also true that the later figures have a gaiety and liveliness absent from the earlier ones—the saints here seem to smile with a satisfaction that is absent from their far more sombre brethren on the opposite side of the Tomb.

77 *St Hubert of Liège*

1926–8
Plaster, tinted: ht 48.9 cm × 19¼ in
The Royal Academy of Arts

St Hubert of Liège, patron saint of hunters, shares the legend of St Eustace: while out hunting he was converted to Christianity by the appearance of a stag with a crucifix between its antlers. He became a bishop.

PROVENANCE In the artist's studio at the time of his death, 1934; bt Sigismund Goetze and the National Art-Collections Fund and presented to the Royal Academy of Arts, 1936.

LITERATURE (Windsor cast) McAllister 1929, pp. 221–2; Bury 1954, pp. 35, 50; Dorment 1985, p. 311, repr. pl. 180 p. 312.

78 *St Nicholas of Myra*

1926–8
Plaster, tinted: ht 48.3 cm/19 in
The Royal Academy of Arts

St Nicholas, Bishop of Myra in Lycia (Asia Minor) in the fourth century, was patron saint of sailors in distress and also of children. He was included on the Tomb as a reference to the naval career of the Duke of Clarence. He carries his attributes of a boat and a crozier.

77 *reproduced in colour on p. 60*

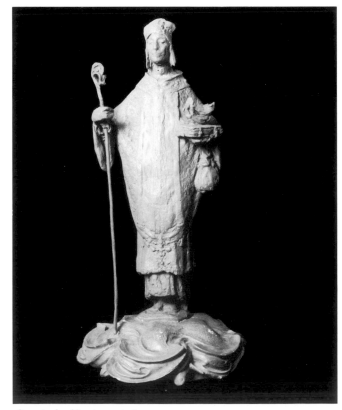

78 *reproduced in colour on p. 60*

PROVENANCE In the artist's studio at the time of his death, 1934; bt Sigismund Goetze and the National Art-Collections Fund and presented to the Royal Academy of Arts, 1936.

LITERATURE (Windsor cast) McAllister 1929, pp. 221, 223; Bury 1954, p. 35; Dorment 1985, p. 311, repr. pl. 182 p. 313.

79 *St Catherine of Siena*

1926–8
Plaster, tinted: ht 47 cm/18½ in
The Royal Academy of Arts

St Catherine of Siena (1327?–80) is shown in a mystic union or marriage with the infant Jesus. The history of this figure begins with a statue now known as *The Miraculous Wedding* (Cat. 98), a group initially begun for the Tomb of the Duke of Clarence but never placed on the grille—possibly because the treatment of the theme was considered inappropriate for a royal tomb.[1] Lavinia Handley-Read published a photograph of Gilbert's second attempt at this figure,[2] although this should perhaps be dated to *c.* 1907, not 1898. Perceptively, she pointed to the multiple identities of the figures on the Tomb—and suggested that Gilbert intended the 1907 figure to share the attributes of *St Catherine of Siena* and *St Catherine of Egypt*. In 1926–7 he made two figures, this one and Cat. 81.

NOTES
1. Dorment 1985, p. 215.
2. Handley-Read 1968, III, p. 151 fig. 14.

PROVENANCE In the artist's studio at the time of his death, 1934; bt Sigismund Goetze and the National Art-Collections Fund and presented to the Royal Academy of Arts, 1936.

LITERATURE (Windsor cast) McAllister 1929, pp. 221–2; Bury 1954, p. 35; Handley-Read 1968, III, fig. 16 p. 151; Dorment 1985, p. 311, repr. pl. 179 p. 312.

80 *St Ethelreda of Ely*

1926–8
Plaster, tinted: ht 48.9 cm/19¼ in
The Royal Academy of Arts

St Ethelreda, or Audrey (*c.* 630–79), was a virgin abbess and founder of the monastery at Ely on the site where the present cathedral stands. She was perhaps the most revered of all Anglo-Saxon saints and is included on the Tomb as a reference to Prince Albert Victor's year at Cambridge University.

PROVENANCE In the artist's studio at the time of his death, 1934; bt Sigismund Goetze and the National Art-Collections Fund and presented to the Royal Academy of Arts, 1936.

LITERATURE (Windsor cast) McAllister 1929, pp. 221–2; Bury 1954, p. 35; Dorment 1985, p. 311, repr. pl. 181 p. 312.

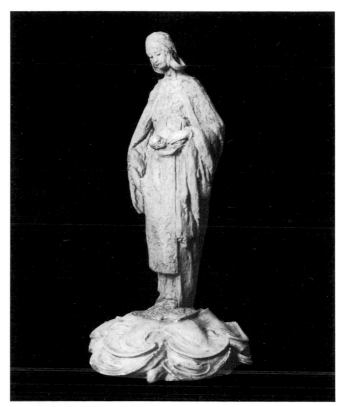

79 *reproduced in colour on p. 60*

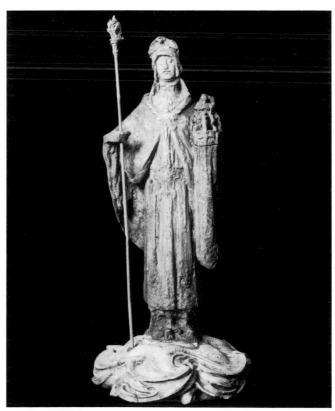

80 *reproduced in colour on p. 61*

81 *St Catherine of Egypt*

1926–8
Plaster, tinted : ht 47.6 cm/18¾ in
The Royal Academy of Arts

St Catherine of Egypt or of Alexandria was not an historical
figure. Her legend tells of a high-born maiden who refused
to worship pagan idols and was therefore sentenced to death
by the Emperor Maxentius. The spiked wheel on which she
was to be martyred miraculously broke into pieces, and she
was finally beheaded. Gilbert gave this figure the features
of Violet, Duchess of Rutland.[1]

NOTE
1. McAllister 1929, p. 223.

PROVENANCE In the artist's studio at the time of his death, 1934; bt
Sigismund Goetze and the National Art-Collections Fund and presented
to the Royal Academy of Arts, 1936.

LITERATURE (Windsor cast) McAllister 1929, pp. 221, 223; Bury 1954,
pp. 35, 54; Dorment 1985, p. 311, repr. pl. 183 p. 313.

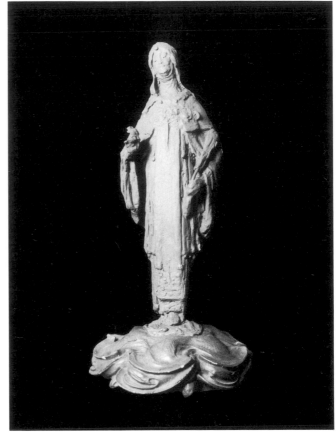

81 *reproduced in colour on p. 61*

ILBERT ranks as one of the foremost British portraitists working in any medium in the 1890s. He first experimented successfully with the half-length format in *Sir George Birdwood* (Cat. 29), but he was equally skilful in the brilliant head-and-shoulders bust of *Sir George Grove* (Cat. 84). Comparing the latter to Gilbert's early *G. F. Watts* (Cat. 25) is instructive, for the sculptor has shaken off the slight formality of the earlier work to achieve a new sense of animation and intimacy. Yet Gilbert was above all an artist of the imagination. Not surprisingly, he created his masterpieces in portraiture when he was free to follow his own poetic fancy, as in the bust of *John Hunter* (Cat. 82). Almost amounting to a third category is his remarkable group of portraits of children, *Hon. John Neville Manners* (Cat. 86), *Mary Swan* (Cat. 87) and *Thoby Prinsep* (Cat. 85), in which Gilbert's ability to express the undefended innocence of a child's face places them among his most likeable creations.

82 *John Hunter*

> 1893–1900
> Bronze: ht 101.6 cm/40 in
> Founder: Alessandro Parlanti
> St George's Hospital Medical School

Gilbert's fanciful portrait of the eighteenth-century surgeon John Hunter (1728–93) is his masterpiece in the half-length format. As his bust of *Sir George Grove* makes plain (Cat. 84), the sculptor was more than capable of catching brilliant likenesses in his portraits from life. But in his imaginary portraits, such as *John Howard* in the Market Square, Bedford (1890–4), freed from the restraints of the live model, he surpassed himself. *John Hunter* is primarily an evocation of benevolence and wisdom, expressed in the near-smile which brings the face to life, the look of gentleness and intelligence in the alert eyes, around which every vein and wrinkle is carefully described. He is shown in the act of lecturing: he holds an anatomical figure in his left hand and gestures with his right. His costume—soft hat, neckcloth, suit and surgeon's gown—is rendered with scrupulous realism. Indeed, it is through costume that Gilbert convinces us of the reality of his imagined sitter: every button and buttonhole is placed where it should be, Gilbert even suggesting a certain carelessness in the surgeon's attitude towards his loose, ill-fitting gown.

The bust was commissioned by the Board of St George's Hospital (then still at Hyde Park Corner) in the centenary year of Hunter's death, 1893. Gilbert was officially given the commission in the spring of 1894, and the summer of 1895 saw the installation in the main hall of a plaster cast. Then, following the pattern of so many works from Gilbert's

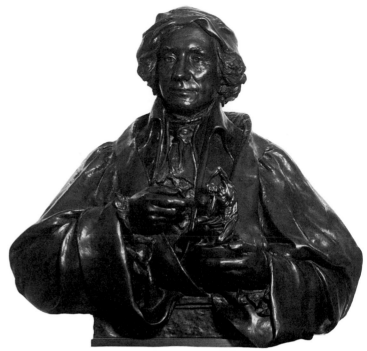

82 *reproduced in colour on p. 91*

hand, silence descended. The bust was eventually cast four years later by Parlanti, the head and hands being cast separately from the torso. The Hospital took possession of the bust in March 1899, when it was placed in the board-room.

In 1924 a new gate was built on the Knightsbridge side of the Hospital as an entrance to the Medical School. The portrait was placed above this portal where it became a surprisingly effective London landmark, best seen from the top of a bus. In 1980 both hospital and bust moved to Tooting.

PROVENANCE Commissioned by St George's Hospital, 1893.

EXHIBITION London 1909, no. 288.

LITERATURE 'School Notes', *St George's Hospital Gazette* (10 June 1893), p. 110; 'School Notes', *St George's Hospital Gazette* (18 July 1893), p. 129; 'School Notes', *St George's Hospital Gazette* (19 March 1894), p. 56; 'School Notes', *St George's Hospital Gazette* (7 May 1900), pp. 70, 73; Spielmann 1908, p. 75; Rinder 1909, p. 123; McAllister 1929, p. 161; Bury 1954, p. 53; George Edwards, 'The Bust of John Hunter in Knightsbridge', *St George's Hospital Gazette* (summer 1960), pp. 103–4; Read 1982, p. 327, repr. fig. 388 p. 328; Dorment 1985, pp. 122, 268, repr. pls 71–3 pp. 122–3.

83 *Mrs Henry Cust*

> 1894
> Tinted plaster: ht (with base) 77.5 cm/30½ in
> The Acland Museum, University of North Carolina at Chapel Hill
> Not exhibited at the Royal Academy

Emmeline (Nina) Cust (1867–1955) was brought to Gilbert's studio by Lady Granby, later Duchess of Rutland (1856–1937), in May 1894. She returned (sometimes with

Lady Granby as a companion) for over twenty sittings during that summer and early autumn. Gilbert's friendship with the artist and sculptor Violet Granby—which was to last to the year of his death—blossomed at about this time (see Cat. 122).

The purpose of this portrait of Nina Cust is not clear: certainly the sitter's husband Harry Cust (1861–1917), who

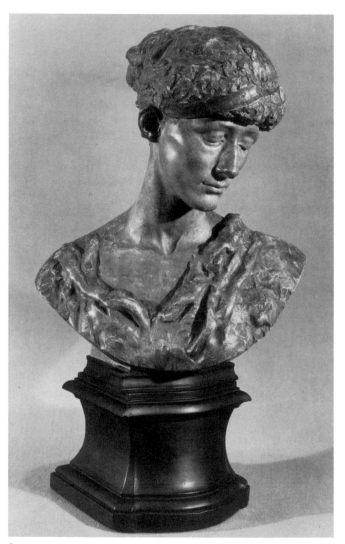

83

was also Violet Granby's lover, did not order it, and there is no hint that either Nina Cust or Violet Granby ever expected to possess it. Ganz, in September 1907, saw a small ivory head of Nina Cust in Gilbert's Bruges studio (untraced), and the face of *St Elizabeth of Hungary* (see Cat. 76) on the Tomb of the Duke of Clarence would appear to be a portrait of Nina. Gilbert may simply have found Mrs Cust's slim, slightly withdrawn but distinctive looks attractive and decided to use her portrait for the face of *St Elizabeth*.

Nina Cust, educated and highly cultivated, has been called 'a beautiful bluestocking' and at different periods in her life excelled as a translator, poet, anthologist and sculptor.[1] Her love for Harry Cust, MP, Editor of the *Pall Mall Gazette* and brilliant social figure, caused her much unhappiness: Gilbert has captured in this portrait the aura of melancholy and aesthetic lethargy mentioned in written descriptions of her personality. Cust's circle of friends (but not Nina's) were known as the 'Souls'—by all accounts generally livelier and more outgoing than the soulful woman in Gilbert's portrait. The Souls were among the most discriminating patrons of the arts in England in the 1880s and 1890s and were painted by Sargent and Burne-Jones and sculpted by Rodin. Apart from Nina Cust and Violet Granby, Gilbert was patronised by or was friendly with many other members of the circle—Lady de Vesci (see Cat. 37, 59), Lady Pembroke, Lady Brownlow, Lady Cowper and George Wyndham. But he was perhaps an artist too closely associated with the Prince of Wales's set and Court circles for the taste of the majority of the Souls. Gilbert's

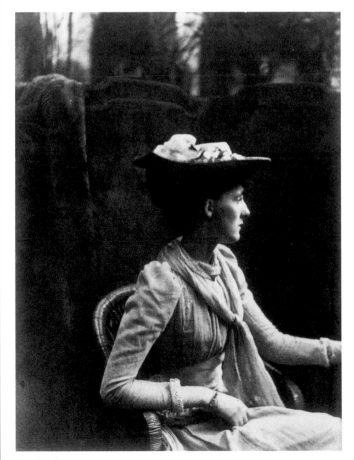

Fig. 60 Photograph of Nina Cust, c. 1895

art is in general ostentatious—its flamboyance was well suited to the Court, but perhaps a touch flashy for the Souls. It is therefore fascinating to see Gilbert at work on a portrait of someone associated with the group, for in the head of Nina Cust one detects a quieter, more introspective mood which

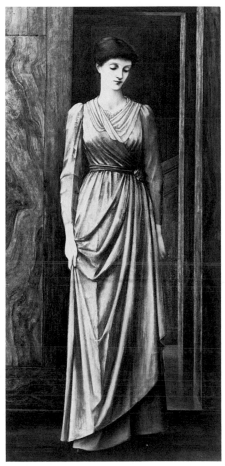

Fig. 61 Edward Burne-Jones, *Lady Windsor*, oil on canvas, 1893 (Collection of Lord Plymouth)

may have as much to do with his sensitivity to the ambience in which the sitter moved as to the personality of the sitter herself.

NOTE
1. Jane Abdy and Charlotte Gere, *The Souls*, London 1984, p. 81.

PROVENANCE Presented by the artist to his nephew, Adrian Bury; presented by Adrian Bury to Sir Charles Wheeler, PRA; Christie's, 18 July 1968, lot 270, bt Hon. Christopher Lennox Boyd; bt Heim Gallery; Acland Art Museum.

EXHIBITIONS Royal Academy 1900, no. 2020; London 1968, no. 80F; Manchester, Minneapolis, Brooklyn 1978–9, no. 88.

LITERATURE Spielmann 1901, p. 79; Hatton 1903, p. 32; McAllister 1929, p. 161; Bury 1954, p. 68; Dorment 1985, pp. 131, 220, repr. pl. 80 p. 130.

84 *Sir George Grove*

1895; cast 1898
Bronze: ht 48.2 cm/19 in
Inscribed on the back: Cᴹ DES BRONZES
Founder: Compagnie des Bronzes
The Royal College of Music, London

This portrait was commissioned by a number of Sir George Grove's (1820–1900) old pupils at the Royal School of Music, where he had been the first Director. Grove first sat to Gilbert on 8 May 1895. The bust proceeded rapidly, for, as with the bust of *Paderewski* (Cat. 30), Gilbert seemed to have no difficulty in establishing a rapport with his musical subject; Gilbert was himself a gifted pianist, his father an editor of musical texts and organist, and his mother a professional singer. If the Gilberts were not already friendly with Grove, they became so during the sittings—for the sitter always stayed to lunch. Grove was an animated talker, and Gilbert captures that zest in his brilliant portrait head, which is the more remarkable for being a head with only the suggestion of shoulders. Gilbert modelled the head in about one month. Late in the sittings he wrote to the committee who had commissioned the bust asking whether they would prefer it executed in marble. They replied that they were determined it should be cast in bronze. Curiously, although worked up so quickly, the bust was not cast until 1898. It was sent to Grove's house in Lower Sydenham on 5 January 1899.

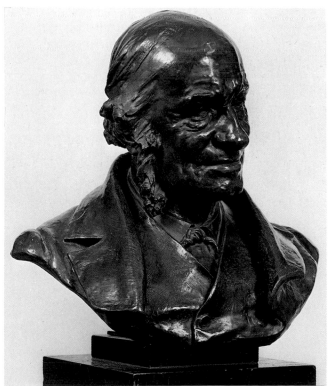

84

PROVENANCE Commissioned by the Royal College of Music and presented to Sir George Grove, 1899.

EXHIBITION (Plaster) Royal Academy 1896, no. 1890; London, Clifford Gallery, 'Exhibition of Cabinet Pictures, Sculpture, and Stained Glass by Members of the Surrey Art Circle', May 1898, no. 103 ('sketch portrait').

LITERATURE Hatton 1903, p. 32; Spielmann 1910, p. 7; Bury 1954, p. 68; McAllister 1929, p. 161, repr. opp. p. 166; Percy M. Young, *George Grove 1820–1900: A Biography*, London 1980, p. 251; F[rederick] G[eorge] E[dwards], 'Grove, Sir George', *The Dictionary of National Biography*, vol. XXII, Supplement, Oxford 1973, p. 796; Dorment 1985, pp. 91, 122, 190, repr. pl. 115 p. 180.

85 *Thoby Prinsep*

1898
Bronze: ht 48.2 cm/19 in
Mr V. Prinsep and Mrs S. Meynell

Frederick Thoby Prinsep (b. 1886) was the son of the painter Valentine Cameron Prinsep (1838–1904) and Florence Leyland Prinsep. Gilbert executed this bust when Thoby was about twelve years old, and from his few surviving letters to the parents it is clear that Gilbert regarded all the family with great personal affection. The melancholy expression, pierced eyes, and fantastic helmet look back to *Head of a Girl* (Cat. 12), though the sheer vulnerability here (a characteristic of all Gilbert's portraits of children) places this bust in a category by itself. The bust of Thoby was delivered to 1 Holland Park Road in January 1899. Later that year, in a warm letter to Mrs Prinsep (daughter of the industrialist Frederick Leyland), Gilbert agreed to execute a bust of 'my dear little friend Anthony'—Thoby's brother Antho—but only on the condition that he be allowed to present it to the child's parents. This companion was never, as far as we know, executed.

On 8 April 1900 Gilbert wrote to Val Prinsep referring to two casts of Thoby's effigy, 'the one *I have*—which is yours, will go to the Academy, thus, the one you have will not be called [for]'.[1] Gilbert sent a bronze to the Academy, not a plaster, which implies that a second bronze exists which has not been traced.

NOTE
1. Letter in the collection of Mrs S. Meynell.

PROVENANCE Commissioned from the artist; by descent.

EXHIBITIONS Royal Academy 1900, no. 1967 (not this cast); Glasgow 1901, no. 98, as 'Bronze Head' lent by Val Prinsep.

LITERATURE Spielmann 1901, p. 79; Hatton 1903, p. 32; Bury 1954, p. 68; Dorment 1985, p. 179, repr. pl. 116 p. 180.

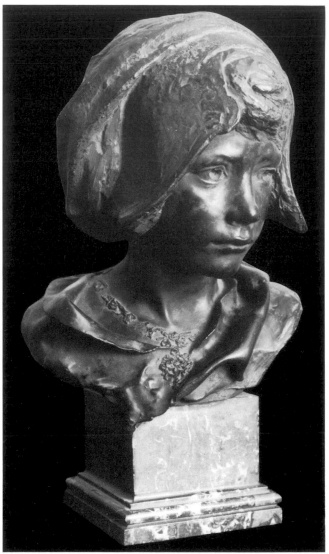

85

86 *Hon. John Neville Manners*

1903–4; cast 1922
Bronze: ht 30.5 cm/12 in
Private Collection

At the time of Gilbert's bankruptcy, one of his staunchest friends, the Duchess of Rutland, urged her friends—including Queen Alexandra—to offer Gilbert commissions and so help him get on to his feet again. One of these friends was Lord Manners (1852–1927) of Avon Tyrell in the New Forest. On 16 February 1903 the Duchess wrote to Gilbert on behalf of Lord Manners, inviting the artist to go to Avon Tyrell during the Easter holidays to model a head and shoulder of their eldest son, John (1892–1914).[1] The rest of the story is well told by McAllister and by John Manners's sister, Angela Ruthven.[2] The house was filled with the chil-

dren of the Souls—Desboroughs, Grenfells, and Horners. John and his friends went off on a paper-chase. At the end of the day, Gilbert was walking with Lady Manners on the terrace when he saw the young boy on his pony riding towards them. Gilbert turned to his hostess with emotion and said: 'But he might be a Greek god!' Gilbert later recalled John as 'a gallant boy, with all the makings of a hero, which he looked; a true type of what England alone can produce to the highest point of excellence'.[3] John Manners was killed in the Great War.

Angela Ruthven continued: 'The head by Gilbert is now at last in our possession, but for twenty years, and not alas! till after my mother's death did we get it from Gilbert. He was never satisfied with it: altered it, destroyed it and did

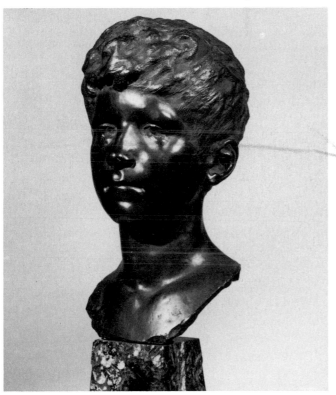

86

it again and again, and in spite of continual appeals he would not give it up, and my poor parents made four unsuccessful journeys to Brussels to try and get it. Mr Gilbert was always delightful, and would say, "But I see him still on that pony and I haven't got that head." Finally in 1922 I went over and made what seemed to me a forlorn but last attempt to get it, and moved by the thought of my father's longing for it, and my mother's death he gave it me (in wax). Two casts were made. . . .' A second cast is in a private collection in England and a plaster cast in the Walker Art Gallery, Liverpool.

NOTES
1. Letters in the collection of Air Chief Marshal Sir John Barraclough.
2. 'John: A Private Collection of Papers and Letters, Compiled by Angela Ruthven, sister of John Manners' (in the possession of Nancy Ruthven).
3. McAllister 1929, p.217.

PROVENANCE Bt from the artist, 1922; by family descent.

LITERATURE McAllister 1929, pp. 163, 216, repr. opp. p. 201; Bury 1954, p. 75; Dorment 1985, p. 237, repr. pl. 143 p. 236.

87 *Mary Swan*

c. 1900–5
Painted plaster: ht 20.3 cm/8 in
Private Collection

Mary Swan was the daughter of the painter and sculptor of animals John Macallan Swan (1847–1910), Gilbert's friend since their days together in Paris in the 1870s. Gilbert's son Francis referred to this bust as completed in a letter to his grandmother of 4 July 1905; when it was begun is less clear, but several of Gilbert's friends endeavoured to help him around the time of his bankruptcy by commissioning portraits of their children (see Cat. 85, 86) and one might place Mary Swan in that group. Since Cat. 87 belonged to the sitter and no bronze has either appeared or is documented, one must assume that the portrait was never cast.

PROVENANCE Presented by the sitter to Herbert Olivier; by descent.

LITERATURE Dorment 1985, p. 237, repr. pl. 142 p. 236.

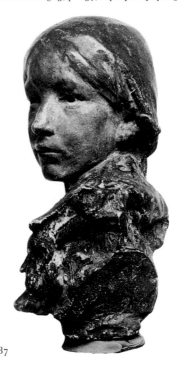

87

ILBERT applied external polychromy to his casts to achieve his effects of rich colour on the Fawcett Memorial of 1887. But later, in the 1890s, under the influence of the metallurgist Sir William Chandler Roberts-Austen, he began to experiment by substituting gold or silver for tin or zinc in his alloys to create dramatic purplish or silvery patinations. In these experiments he was assisted by the founder Alessandro Parlanti; comparison of casts made by Parlanti with those of other bronze founders of the time reveals how important the skill of the founder could be in achieving the results the sculptor sought.

88 *Post Equitem Sedet Atra Cura*

c. 1883–7
Bronze roundel set in a circular bronze frame: diam. without
 frame 42.2 cm/16½ in
Birmingham Museum and Art Gallery

This is the earliest of three casts of *Post Equitem Sedet Atra Cura*. (The other two, in the Victoria and Albert Museum [Cat. 89] and in the Royal Scottish Academy, Edinburgh,

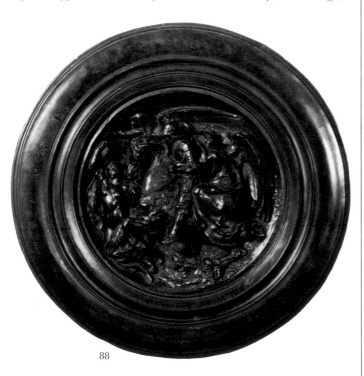

88

were both cast in 1899 by Alessandro Parlanti and are discussed under Cat. 89.) A high-relief plaque in bronze, it depicts an equestrian knight in armour riding forth in quest of pleasure and riches, which are personified by a nude sprite, who might also represent Fortune, holding up a sack

of gold like a carrot before a donkey. At the knight's back is the shrouded, faceless figure of Care, an incubus tightly clasping his waist, though capable of flying off on great, Gilbertian wings. In the upper right-hand corner, just above Fortune, a masked female representing Envy or Deceit points the way forward with a snake-entwined arm and spurs on the haggard hero with a torch. Under the belly of the horse are an owl and a skull—the knight's predecessor made wise too late. The title is from Horace: 'Behind the rider sits dark care'.

The imagery and symbolism of the plaque are inspired by a number of Renaissance works: Donatello's *Gattamelata* (1445–50) and Verrocchio's *Bartolomeo Colleoni* (1481–96), or Dürer's *Knight, Death, and Devil* (1513). In addition, one

Fig. 62 John Gilbert, *The Enchanted Forest*, watercolour and gouache on paper (City Art Gallery, Manchester)

might easily cite works by Sir John Gilbert (1817–97; fig. 62) and Sir John Everett Millais (1829–96) as precursors. However, much closer than any of these are the works of G. F. Watts, and in particular his *Orlando Pursuing the Fata Morgana* (begun 1846; Leicester Museum and Art Gallery) and *Life's Illusions* (1849; London, Tate Gallery). Gilbert had certainly seen Watts's retrospective exhibition at the Royal Academy on his visit to England in 1881, the repercussions of which can be found in Gilbert's designs for the tomb cover of the Baroness von Fahnenberg (Cat. 9) of 1884 where he drew directly from Watts's monumental symbolist vocabulary in the shrouded figure of Death. From early in his career Gilbert adopted the habit of reworking and reusing his figures. Thus from *Post Equitem Sedet Atra Cura* no less than three of the characters, Care, the Knight, and Fortune, reappear as *Zeal*, *Fortitude* and *Sympathy* on the Fawcett Memorial (Cat. 31).

Cat. 88 was commissioned by Somerset Beaumont, though whether he ever actually owned the plaque is not known. According to Gilbert's father's list of 1890, Alfred

Gilbert began the plaque in Italy. The plaster was exhibited at the Royal Academy in 1887, and was only afterwards cast in bronze. Cat. 88 was cast in England before 1890, and thus its patina has an even, black tonality. The horse's bridle is constructed from a free-swinging chain, which does not appear in the cast now in the Victoria and Albert Museum (Cat. 89).

PROVENANCE Sir Alexander Maitland; Evan M. James; bt Birmingham City Museum and Art Gallery, 1974.

EXHIBITIONS (Plaster) Royal Academy 1887, no. 1819.
(This cast) London 1902, no. 94; Manchester, Minneapolis, Brooklyn 1978–9, no. 93.

LITERATURE Claude Phillips, 'Correspondence d'Angleterre; Expositions d'été de la Royal Academy et de la Grosvenor Gallery', *Gazette des Beaux-Arts*, 36 (1887), pp. 86–7; *Architect*, 41 (1889), repr. opp. p. 266 (plaster); Spielmann 1901, p. 170; Hatton 1903, p. 32, repr. p. 24; L[ouis] Forrer, *Biographical Dictionary of Medallists*, London 1904, II, p. 263; Bury 1954, p. 67; Read 1982, pp. 313, 321.

89 *Post Equitem Sedet Atra Cura*

Cast 1899
Bronze: diam. 42.2 cm/16½ in
Founder: Alessandro Parlanti
The Trustees of the Victoria and Albert Museum, London

Both Cat. 89 and a cast of *Post Equitem Sedet Atra Cura* in the Royal Scottish Academy were cast and chased by Alessandro Parlanti in March 1899. Both were sold immediately

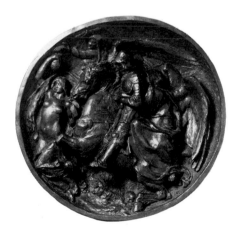

89 *reproduced in colour on p. 84*

to Robert Dunthorne of the Rembrandt Gallery, Vigo Street, who delivered a cheque for them in May 1899. Since Gilbert was harassed by creditors at this period, it is possible that Dunthorne suggested he recast an early bronze for quick sale. Nothing suggests that Gilbert oversaw the casting or chasing, which took place in Parlanti's foundry at Parson's Green, and a comparison of Cat. 89 and the earlier Birmingham cast (Cat. 88) reveals how important the role of the founder could be. The startling polychromed effect of the Victoria and Albert Museum version was achieved by casting the medallion in an alloy of lead, copper and gold, the latter replacing the usual zinc and tin so that after the application of certain pickling solutions (verdigris, sulphate of copper, nitre, common salt, sulphur, water, vinegar) a rich reddish patination was obtained. This patination was not attempted in all Parlanti's casts (see the bust of *John Hunter* [Cat. 82] for example), but in every case where these polychromed effects are achieved Parlanti was the founder.

The second Parlanti cast was presented to the Royal Scottish Academy on the retirement of Sir James Guthrie as President in 1911.

PROVENANCE Robert Dunthorne; Handley-Read Collection; bt Victoria and Albert Museum, 1972.

EXHIBITIONS London 1909, no. 293 (lent by Dunthorne); London 1968, no. 65; R.A. winter 1968, no. 687; London 1972, no. F 22.

LITERATURE Handley-Read 1968, I, p. 25, repr. p. 25; Handley-Read Dec. 1968, p. 714, fig. 91; London 1968, pp. 12, 15; Manchester, Minneapolis, Brooklyn 1978–9, pp. 176–7; Dorment 1985, pp. 53, 77, 215, 279, repr. pl. 24 p. 52.

The Memorial to Lord Arthur Russell

The history of Gilbert's Memorial to Lord Arthur Russell,[1] brother of the Duke of Bedford, has been told at length elsewhere.[2] Briefly, Lady Arthur Russell approached the sculptor in 1892 with the offer of the commission; Gilbert accepted, but then delayed and delayed again. On 4 April 1900, eight years after their first meeting, the Memorial was completed and in place in the Bedford family chapel at Chenies in Buckinghamshire. Gilbert's letters to Lady Arthur—and many of her first drafts to him—are preserved, and are a revealing commentary on Gilbert's dealings with a long-suffering and ultimately sympathetic patron.

There was little floor or wall space in the crowded chapel at Chenies. Thus Gilbert designed a 9ft-high candlestick, essentially a variation and enlargement of one of the uprights on the Tomb of the Duke of Clarence (fig. 53). Circling the middle knop were enamelled shields, inscriptions and four bronze figures, again closely related to their counterparts on the Tomb of the Duke of Clarence. Gilbert originally intended to use ivory for the figures' faces and hands, but as with the Tomb's saints, the process proved too time-consuming. On the Russell Memorial the figures are named *Charity* (see Cat. 91), *Truth* (see Cat. 92), *Piety*

(see Cat. 93) and *Courage*. *Courage* is stylistically different from the other three figures on the Memorial. The statue is also technically distinct, its martyr's palm, sword and laurel-wreath being cast in individual piece moulds. Furthermore, whereas replicas of the other three virtues exist, *Courage* appears to be a unique piece. These discrepancies between *Courage* and the other statues might be explained by the fact that, given the former statue's iconography, she could represent St Barbara, a saint which we know that Gilbert intended to place on the Tomb of the Duke of Clarence (see p. 157). Since no such saint has ultimately been included on that Tomb, it is possible to surmise that Gilbert, hopeful that the completion of the figures for the Tomb of the Duke of Clarence could be postponed indefinitely, took a figure intended for the Tomb and placed it on the Russell Memorial in order to finish the work and receive much-needed payment.

The form of the Memorial, a column bearing a candle, which needed, according to Gilbert, 'constant care', symbolised strength, wisdom and remembrance. Gilbert's source for the design was the St Bavon Candlesticks by Benedetto da Rovezzano (1530), originally made for the tomb of Cardinal Wolsey and then appropriated for the tomb of Henry VIII. Gilbert could have encountered these candlesticks in two ways: in the Plaster Court of the South Kensington Museum, where they existed in plaster casts, or in a reproduction published by Alfred Higgins in 1894 as part of his reconstruction of the Tomb of Henry VIII.[3]

NOTES

1. The Memorial Candlestick to the Rt Hon. Lord Arthur Russell, St Michael, Chenies, Buckinghamshire, 1892–1900. Bronze: ht 274.3 cm/ 108 in; marble plinth: ht 20.3 cm/8 in. Inscribed on enamel panels underneath the four bronze allegorical figures: IN MEMORY OF ARTHUR RUSSELL/BROTHER OF THE NINTH DUKE OF BEDFORD/MEMBER OF PARLIAMENT FOR TAVISTOCK FROM 1857 TO 1885/BORN JUNE 13TH 1825/ HE FOUND REST IN CHRIST APRIL 4, 1892 THIS MONUMENT WAS ERECTED BY LAURA HIS WIFE/DAUGHTER OF THE VICOMTE DE PEYRONNET AND BY HIS CHILDREN THE LORD GAVE AND THE LORD HATH TAKEN AWAY. BLESSED BE THE NAME OF THE LORD/STILLE LEIDEN, STILLE WERKE,/UND EIN ALLTAGS ANGESICHT/DASS DI WELT ES NUR NICHT MERKE/DENN DIE WELT BEGREIFT ES NICHT./GOETHE
2. Manchester, Minneapolis, Brooklyn 1978–9, pp. 189–90; Dorment 1985, pp. 193–7.
3. Alfred Higgins, FSA, 'On the Work of Florentine Sculptors in England in the Early Part of the Sixteenth Century', *Archaeological Journal*, LI, second series, vol. 1 (1894), pp. 177–8 and see pl. VIII.

LITERATURE Adeline Marie Bedford, *Chenies Church and Monuments*, privately printed at Chiswick Press, London 1901, pp. 134–8; Hatton 1903, model repr. p. 7; Macklin 1910, model repr. p. 117; Spielmann 1910, p. 7; McAllister 1929, p. 162, repr. opp. p. 185; Bury 1954, pp. 18, 67; Handley-Read 1967, p. 21, repr. fig. 8 p.24; Handley-Read 1968, III, pp. 144, 146, repr. fig. 6 p. 148; Manchester, Minneapolis, Brooklyn 1978–9, pp. 189–90; Read 1982, p. 327; Beattie 1983, pp. 193, 244; Dorment 1985, pp. 193–7, repr. pls 123–5 pp. 194–5.

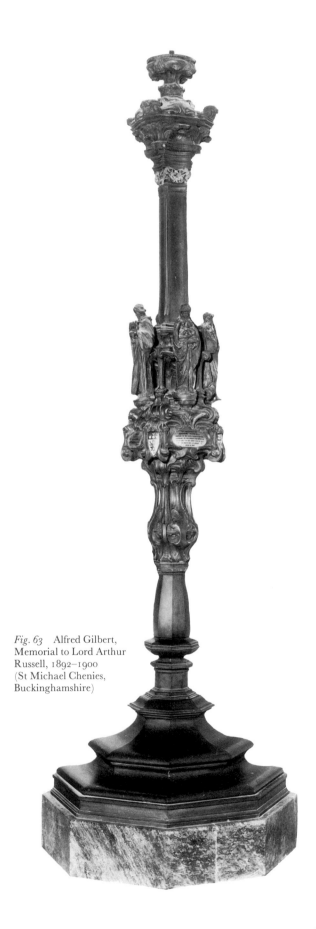

Fig. 63 Alfred Gilbert, Memorial to Lord Arthur Russell, 1892–1900 (St Michael Chenies, Buckinghamshire)

90 *Charity*

1899
Bronze: ht 38.1 cm/15 in
Founder: Alessandro Parlanti
The Trustees of the Victoria and Albert Museum

This figure was cast by Alessandro Parlanti in August 1899. The patination is achieved by the substitution of gold for tin in the alloy. A pickle applied selectively to the bronze produced the hotter colour in the flesh areas (see Cat. 89). *Charity* is Gilbert's last work carried out in polychromy. When compared with the cast of *Charity* in the set sold by the Fine Art Society in about 1920 (Cat. 91), the modelling of Cat. 90 is finer.

PROVENANCE The family of Alfred Drury, RA; Anthony Radcliffe; Handley-Read Collection; bt Victoria and Albert Museum, 1972.

EXHIBITIONS London 1968, no. 71F; London 1971, no. 98; London 1972, no. F29; Manchester, Minneapolis, Brooklyn 1978–9, no. 104.

LITERATURE 'Acquisitions of Modern Art by Museums', *The Burlington Magazine*, vol. CXV, no. 848 (November 1973), p. 768, repr. fig. 97.

91 *Charity*

1899; this cast *c.* 1920
Bronze: ht 38.1 cm/15 in
The Visitors of the Ashmolean Museum, Oxford

92 *Truth*

1900; this cast *c.* 1920
Bronze: ht 36.8 cm/14½ in
The Visitors of the Ashmolean Museum, Oxford

93 *Piety*

1900; this cast *c.* 1920
Bronze: ht 34.9 cm/13¾ in
The Visitors of the Ashmolean Museum, Oxford

In November 1899 Gilbert quarrelled with Alessandro Parlanti, who had by that date delivered only three of the figures for, or related to, the Russell Memorial: a bronze cast each of *Charity* and *Courage*, which were placed on the Memorial itself, and a second cast of *Charity* (Cat. 90). The

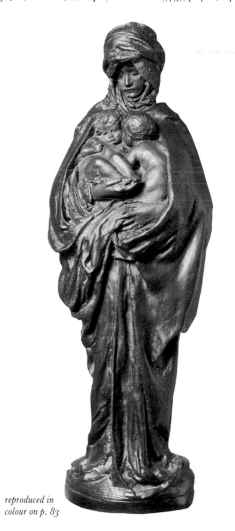

90 *reproduced in colour on p. 83*

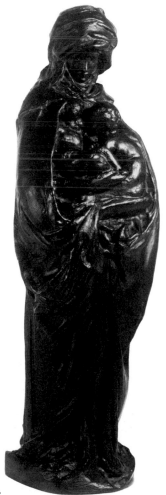

91 *reproduced in colour on p. 82*

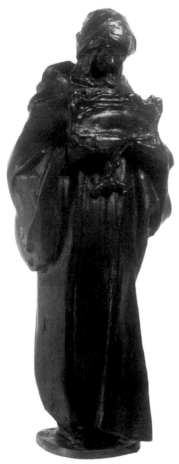

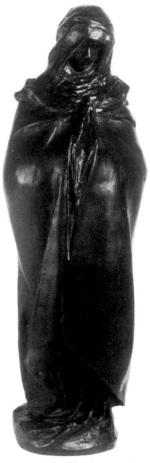

92 *reproduced in colour on p. 82*

93 *reproduced in colour on p. 82*

remaining two figures, *Piety* and *Truth*, Gilbert gave to a founder named O'Neill, who cast them and delivered the last figure on 1 April 1900. O'Neill's casts were less elaborate and lack the polychromy of those by Parlanti (see Cat. 189–90).

The casting history of the figures does not imply that the set exhibited here were those cast by O'Neill. Four days after the completion of the Russell Memorial, on 7 April 1900, Gilbert's adviser, Thomas Humphry Ward (husband of the novelist), commissioned for £200 replicas of each of the figures. Whether or not Ward received his casts is not, however, recorded; nor, indeed, is it certain as to whether further bronze casts of the Russell Memorial figures were made at that time.

The three Ashmolean bronzes belonged to the Rev. J. W. R. Brocklebank, a keen collector of Gilbert's work whose correspondence with the sculptor is preserved in the Ashmolean Museum. That correspondence, covering the years 1910–13, contains no mention of the Russell Memorial figures. Unlike other Brocklebank bronzes which were cast by the Compagnie des Bronzes, there is no mention in the surviving records of *Charity, Truth* and *Piety* being cast by

that foundry in the second decade of this century. Rather, Cat. 91–3 were sold through the Fine Art Society after the First World War, when Gilbert gave the Society sole right to reproduce his works. Presumably Brocklebank purchased them at that time.

Plaster models for the set are in the collection of Patrick Synge-Hutchinson, London.

PROVENANCE (Cat. 91–3) The Rev. J. W. R. Brocklebank Bequest, 1927.

EXHIBITIONS (Casts: Cat. 91) Liverpool, Walker Art Gallery, 'Jubilee Autumn Exhibition', 1922, no. 1542; London 1932, no. 6; London 1935, no. 15; London 1968, no. 71F; London 1972, no. F29.
(Casts: Cat. 92) Liverpool, Walker Art Gallery, 'Jubilee Autumn Exhibition', 1922, no 1541; London 1932, no. 5, as 'Hope'; London 1935, no. 15; London 1968, no. 71F; London 1971, no. Q8; London 1972, no. F28; Manchester, Minneapolis, Brooklyn 1978–9, no. 105.
(Casts: Cat. 93) Liverpool, Walker Art Gallery, 'Jubilee Autumn Exhibition', 1922, no. 1540; London 1932, no. 4; London 1935, no. 15; London 1968, no. 71F; London 1971, no. Q8; London 1972, no. F27; Manchester, Minneapolis, Brooklyn 1978–9, no. 106.

LITERATURE (Cat. 91–3) C. F. Bell, 'Report of the Keeper of the Department of Fine Art and the Hope Collection of Engravings for the Year 1927', *Report of the Visitors of the Ashmolean Museum*, Oxford 1927, p. 30.

94 *Baby Girl*

1899
Bronze: ht including base 21.6 cm/8½ in
Founder: Alessandro Parlanti
Perth Museum and Art Gallery

Parlanti delivered this bronze on 17 February 1899. Like many of the works cast by Parlanti, the quality of this *cire perdue* cast is exceptional. It is not connected with any known project.

PROVENANCE D. Y. Cameron; presented to the Art Gallery and Museum, Perth.

94

95 *A Whistling Girl in Pantaloons and Wooden Shoes*

c. 1914?
Bronze: ht 21 cm/8¼ in
Private Collection

This is a *cire perdue* casting with the system of runners attached to the bronze casting as it appears once the plaster/grog mould has been broken away. Originally these runners were constructed in wax and appended to the wax model, with an extra arrangement leading to the pouring cup. Air has been trapped in the course of investing the wax with the plaster/grog slurry, forming untidy pockets at various

95

points which have subsequently filled up with bronze. The bubbles on the surface of the figure were likewise formed when air bubbles trapped in the investment filled with bronze. The reason why the bronze has failed at the ankles is probably because the mould was filled via the base and the ankles, the air venting out through the runners on each side. Everything filled up satisfactorily until the molten metal in the solid body of the figure began to contract. As it cooled, it dropped or pulled away at the ankles. The investment around the ankles may well have been the hottest part of the mould, having taken the main flow of metal, so it may also have remained hot for longer. In short, the casting probably failed because the bronze in the body of the figure drew away from the ankles as it cooled and contracted.

Like Cat. 106, *The Whistling Girl* was discovered in Gilbert's old house at 44 rue des Corroyeurs Blancs by a subsequent owner. Its subject and size suggest that it may be one of those small objects made for local shops which Gilbert is known to have sold from time to time (see Cat. 106). The failed cast may be the result of an experiment in casting in a home-made kiln; no finished bronze is known. The darker colour of the figure is due to someone rubbing polish into the surface to create an objet d'art. D.J.

PROVENANCE Discovered in Gilbert's former home, 44 rue des Corroyeurs Blancs, Bruges, by present owner's father.

HE years 1898–1906 were a time of intense crisis for Gilbert, culminating in his bankruptcy in 1901 and the decision to live permanently in Bruges in 1903. But throughout the period he continued to work and to exhibit at the Royal Academy, where his statues attracted the by now usual critical praise. As always with Gilbert, his private pain found expression in his art, and it is possible to see a statue such as *The Broken Shrine* (Cat. 99) as a commentary on his own shattered illusions. At the same time, however, he produced straightforward portraits and figures, in which he sought a new breadth of expression in the bronze—if we compare *St George and the Dragon, Victory Leading* (Cat. 101), or even *The Miraculous Wedding* (Cat. 98), with the early figures of the saints on the Tomb of the Duke of Clarence (Cat. 69–76), one fact emerges: Gilbert now rejected the intricate, tight realism of the Tomb figures for a freer, more expressive style which would point the way towards the 'expressionism' of his later work.

96 *Decorative Sword for the Tomb Cover of H.R.H. Prince Henry of Battenberg*

1898
Bronze: 162.6 cm × 61 cm/64 × 24 in
The Rector of Whippingham

Prince Henry of Battenberg, husband of Queen Victoria's youngest daughter Princess Beatrice, died on 22 January 1896 of a fever contracted on the Gold Coast while accompanying the Ashanti Expedition. He was entombed near Osborne in the church of St Mildred, Whippingham, on the Isle of Wight. Gilbert's memorial chapel to him, commissioned by Queen Victoria in March 1896 and finished by January 1897, consisted of a bronze grille screening off the Tomb from the rest of the church to create a private chapel. The ornate bronze screen has no counterpart in English art at this date. One must look to the Continent, and particularly to Hector Guimard's (1867–1942) Paris Métro stations of 1899–1900 for a comparable use of a rhythmic line almost resolving itself into a natural form but remaining fully abstract.

The decorative sword was completed after the screen. Queen Victoria's journal entry for 21 December 1898, written at Osborne, reads: 'Went out with Vicky [the Empress Frederick], Beatrice, & Drino [Prince Alexander of Battenberg], & went to Whippingham, where, in the little chapel Mr. Gilbert was placing the fine sword he has made, on the sarcophagus. The sword is beautifully carried out.' A portrait by Seymour Lucas of Gilbert working in his London studio in 1891 shows a sword in progress held in

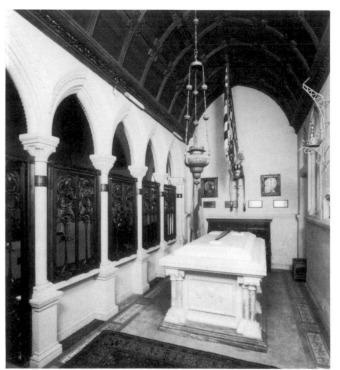

96

96 (*detail*)

a vise behind the sculptor.[1] The Duke of Clarence's effigy holds a sword almost as elaborate as this one (see fig. 54).

NOTE
1. McAllister 1929, repr. opp. p. 121.

PROVENANCE Commissioned by Queen Victoria, 1896.

LITERATURE McAllister 1929, p. 164; Dorment 1985, p. 186, repr. pl. 117 p. 184, pl. 119 p. 185

97 *Athena*

1899–1900
Bronze: ht 35 cm/$13\frac{7}{10}$ in
Founder: Hatfield
Mrs Samuel Reed

Athena (or *Minerva*) was commissioned by Trinity College, Cambridge, as a memorial to the classical scholar Harry Chester Goodhart (1859–95). A. H. Clough, who paid for the monument, approached Gilbert in 1897, and the memorial was in place over the entrance to 1 staircase, Nevile's Court, by December 1900. Despite his pressing need for cash, Gilbert regarded the commission as 'an honour and pleasure and not to be reckoned with the things done for a living'.[1] *Athena* is based on the smaller helmeted *Britannia* on the back of the throne of the Jubilee Memorial to Queen Victoria at Winchester (Cat. 32–6), but is an independent work of art, not an enlargement or variant. This exhibit is the only known replica of the bust on the monument. The plaster model was in the University Arms Hotel, Cambridge, in 1968 but has subsequently been lost. Another plaster is preserved at the Mill of Kintail, Almonte, Ontario (see Cat. 105).

NOTE
1. Robson 1968, p. 27.

PROVENANCE Sotheby's, New York, October 1982, bt Faber Donoughe, from whom bt by present owner.

LITERATURE Roberts Robson, 'Si monumentum requiris . . .', *Trinity Review* (Lent Term 1968), pp. 27–8; Dorment 1985, p. 207, repr. fig. 132 p. 205.

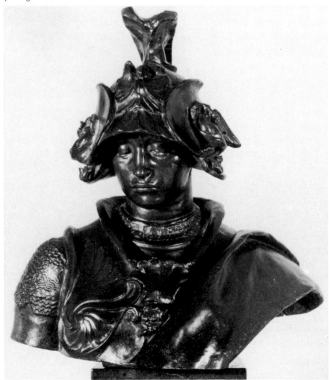

97

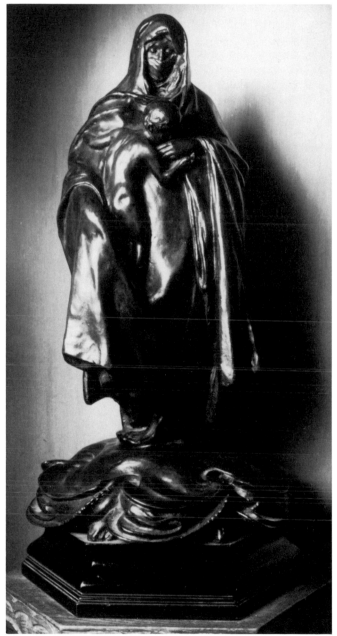

98 *reproduced in colour on p. 59*

98 *St Catherine ('The Miraculous Wedding')*

1900
Bronze: 49.5 cm/$19\frac{1}{2}$ in
A parish church in Scotland

In *The Times* list of the saints planned for the grille of the Tomb of the Duke of Clarence published on 4 August 1898 (see p. 157), no mention was made of a figure of St Catherine. Yet on the Tomb as finally completed, Gilbert included two St Catherines—of Siena (Cat. 79) and of Egypt (Cat. 81). Thus only after 1898 did he begin to think about

the representation of the saint. The statue now known as *The Miraculous Wedding* is a fusion of the imagery of both St Catherine of Egypt, represented as a heavily veiled eastern woman, and St Catherine of Siena, who mystically wed the Christ Child. Gilbert rejected the statue for the Tomb of the Duke of Clarence, but in October 1900 a cast by O'Neill, documented as by Gilbert in the studio diary, was sold to a Mrs Richardson.

In 1914 Gilbert wrote to the Press warning the public against pirated casts of *The Kiss of Victory* (Cat. 7) and 'a sketch for a small group, one of a number of subjects of its size, destined for the tomb of the Duke of Clarence for a better rendering. . .'.[2] In 1978 the present author suggested that this 'small group' might be *The Miraculous Wedding*.[3]

NOTES
1. Bury 1954, pp. 95-6.
2. McAllister 1929, p. 194.
3. Manchester, Minneapolis, Brooklyn 1978-9, no. 99.

PROVENANCE Bequeathed by Sir D. Y. Cameron.

EXHIBITIONS (Casts) London 1909 (lent by Robert Dunthorne); London 1932, no. 19, as 'Motherhood'; London 1935, no. 11; London 1968, no. 77; London 1971, no. 96; London 1972, no. F 32; Manchester, Minneapolis, Brooklyn, 1978-9, no. 99.

LITERATURE Handley-Read 1968, III, p. 148, repr. fig. 15 p. 151; Dorment 1985, pp. 213, 215, 268, 279, repr. pl. 138 p. 214.

99 *The Broken Shrine*

c. 1900
Bronze: 36 cm/14 in
Inscribed on the back: THE BROKEN SHRINE, ALFRED GILBERT: SIX COPIES WERE MADE THIS IS THE 3RD
The Trustees of the Tate Gallery

Gilbert returned to the theme of the Mother and Child throughout his career, but particularly when his own children were infants (see Cat. 4, 8). In *Mother Teaching Child* (Cat. 8) of 1881-3, the mother is seated on a corinthian column, the symbol, as M. H. Spielmann pointed out (relying on Gilbert's words), of 'traditional beauty in art and life'. *The Broken Shrine* harks back to this early work, but here the mother cradling two children is a crone crouching by a wayside shrine which once contained the image of the Virgin.[1]

The Broken Shrine refers to Gilbert's own life. He executed the plaster near the time of his bankruptcy, when he was weighed down by defeat and despair. A few years later, in a letter to Spielmann, Gilbert referred to himself as 'a broken edifice' which he hoped to rebuild.[2] It is significant that the work contains both an empty niche, such as those on the Tomb of the Duke of Clarence (Cat. 66-76), and, at the mother's feet, a fountain, referring, perhaps, to the Shaftesbury Memorial (Cat. 43-52). By 1900 three of Gilbert's works, the Shaftesbury Memorial, the Jubilee

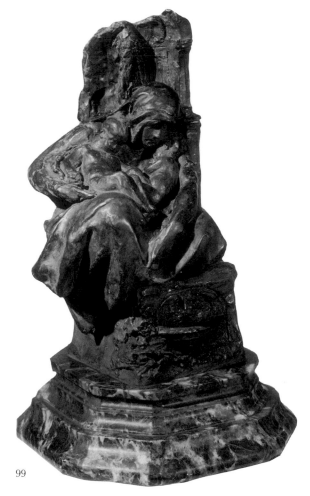

99

Memorial to Queen Victoria at Winchester (Cat. 32), and the St Albans Reredos (p. 19; col. pl. p. 76) had been vandalised. Here, however, Gilbert refers to his broader feeling that the beauty he had hoped to create had been despised and rejected.

This bronze signals a new departure for Gilbert. To compare it with *Charity* from the Russell Memorial (Cat. 90), of only a year or so earlier, is instructive. The difference between the two works lies not only in the rejection of the fastidious, Cellini-like refinement of the first for a more monumental, Michelangelesque treatment in the second, but also in the directness of feeling and urgency of expression which were quite new to Gilbert's art. This was recognised by the critic for the *Art Journal*: 'A passion for the essential, for the spirit of that which he desires to express, gives to this rudely fashioned sketch of Mr. Gilbert a character apart. . . . Without years of wrestling with at first refractory lines and masses, without an overwhelming desire to express the inexpressible, without lofty vision, "The Broken Shrine" could never have been.'

Behind this change in direction for Gilbert lay a renewal of his friendship with G. F. Watts. *The Broken Shrine* owes

much to Watts's *Peace and Good Will* (London, St Paul's Cathedral), begun, according to Watts's wife, in the winter of 1888.[3] Significantly, she adds that the composition was first worked out in wax and it is possible that Gilbert, who was engaged in modelling Watts's portrait that year (Cat. 25), watched Watts at work on the wax model.

More than one plaster cast exists, one of them in the collection of David Barclay, London, inscribed to Howard Ince.

NOTES
1. 'Some London Exhibitions', *Art Journal*, August 1901, pp. 253–4.
2. 23 November 1908, SP 7/77/2.
3. Watts 1912, vol. II, p. 124.

PROVENANCE Presented to the Tate Gallery by Maurice Yorke, 1938.

EXHIBITIONS (Plaster) London 1901, no. 122; London 1968, no. 78; London 1972, no. F30; Manchester, Minneapolis, Brooklyn 1978–9, no. 100.

LITERATURE 'Some London Exhibitions', *Art Journal*, August 1901, pp. 253–4, repr. p. 254; Hatton 1903, repr. p. 1 (plaster); Bury 1954, p. 75; Chamot, Farr, Butlin 1964, p. 225, cat. 4977; Handley-Read 1968, III, pp. 146, 148, repr. fig. 10 p. 149; Beattie 1985, p. 162, repr. fig. 156 p. 162; Dorment 1985, pp. 211–13, 279, repr. pl. 137 p. 212.

100 *Christ Supported by Angels*

Before 1903
Bronze: 12 × 10 cm/4¾ × 3⅞ in
Private Collection, New York

In September 1907 Henry Ganz saw in Gilbert's Bruges studio 'the headpiece of a dead Christ supported by Angels . . . nearly complete in metal'. Although it is not certain that this was a cast of this piece, it does sound probable. If this is so, then the work was cast in metal and Gilbert was chasing it by that date. Although related to the headpiece of the crozier of the figure of *St Patrick* on the Tomb of the

100

Duke of Clarence, the purpose of Cat. 100 is still unknown. It seems never to have been used by Gilbert, and we first hear of it in the possession of Gerald Keith, Gilbert's solicitor and major legatee. This is where Lady Helena Gleichen saw it, one month after Gilbert's death, for she wrote to Spielmann stating that Keith had 'one or two lovely things in his safe in Southampton St. 2 crucifixes, quite small, which are superb but I do not think he realizes this'.[1] One of these (possibly that exhibited here) was bought by the painter Sigismund Goetze (1866–1939). *Christ Supported by Angels*

Fig. 64 Albert Toft, enlarged version of Alfred Gilbert, *Christ supported by Angels* (Goetze Family Grave, Paddington Cemetery, Willesden Green, London)

was enlarged by the sculptor Albert Toft (1862–1949) for use on the Goetze family grave at Paddington Cemetery, Willesden Green, London (fig. 64). A posthumous cast by Morris Singer Foundry is in the possession of Patrick Synge-Hutchinson.

A plaster cast related to this bronze was published by Hatton in 1903.

NOTE
1. 2 December 1934 (letter in the collection of the late Roger Machell).

PROVENANCE The Fine Art Society, 1983, from whom bt by present owner.

EXHIBITION (Plasters) London 1936, no. 66a, b; no. 67a, b.

LITERATURE Hatton 1903, plaster sketch repr. p. 18; Ganz 1934, p. 6.

101 *St George and the Dragon, Victory Leading: Sketch-Model for Proposed War Memorial*

1904; cast 1923
Bronze: 43.8 cm/17¼ in
Stamped on the pennant in Gothic letters: ALFRED
 GILBERT
Founder: Compagnie des Bronzes
The Syndics of the Fitzwilliam Museum, Cambridge

The extent to which Gilbert relied on his dreams for inspiration is worth remarking upon. *The Kiss of Victory* (Cat. 6) 'was the outcome of a dream',[1] and the *Enchanted Chair* 'entirely suggested by my dreams'.[2] He began Cat. 101 after dreaming on 15 May 1904 that he was at work on an equestrian *St George and the Dragon*, and the wild distortions, arbitrary changes in scale and sense of exaggeration and unreality might all be attributed to their initial existence in Gilbert's dream world. He actually began work on this sketch-model that May in the hope that he would receive a commission for an over life-sized memorial to the dead of the Boer War from the Lancashire regiment of Lord Grey. This never came to pass but the plaster was shown at the Royal Academy in 1906. Through George Gilbert's diaries for May and June 1904 we know of the order in which

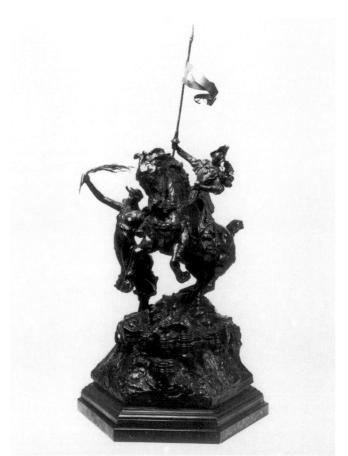

Gilbert worked up the plaster model. St George was to be shown 'shouting out with joy' and urging his horse over the body of the slain dragon. The horse was 'prancing on its hind legs with fear'. The dragon was spread out over a town composed of pinnacles and turrets, a device first used in the Windsor *St Michael* (see Cat. 73).

Gilbert later added the figure of *Victory* to the original group of horse and rider, and last of all placed the group on a six-sided base. Perhaps because it was designed as a war memorial, the composition of this sketch-model works from any direction, and the spectator is invited to walk around it to view it from different sides. At what point Gilbert completely redesigned the original plaster is not known. It is probable that this happened after a photograph of the first design appeared in Macklin's 1910 *Studio* article about Gilbert. In the earlier version, *Victory* was a static figure, with wings so extravagantly large as to be positively lethal in appearance. *St George* was always the dainty, puppet-like fellow who rides out in the final bronze on the same splendid rearing horse.

Cat. 101 was cast in bronze by the Compagnie des Bronzes for the Fine Art Society in 1923.

NOTES
1. Hatton 1903, p. 9.
2. Op. cit., p. 11.

PROVENANCE Purchased from the Handley-Read Collection, 1972.

EXHIBITIONS (Plaster) Royal Academy 1906, no. 1773; London 1909, no. 284A.
(Casts) London 1932, no. 16; London 1935, no. 13; London 1972, no. F31; Manchester, Minneapolis, Brooklyn 1978–9, no. 101; London 1981, no. 22.

LITERATURE (Plaster) Macklin 1910, repr. p. 117; Ganz 1934, pp. 4–5; Bury 1954, p. 69; Dorment 1985, p. 238, repr. pl. 145 p. 239.
(Bronze) Bury 1954, pp. 75, 86; Handley-Read 1968, III, p. 148, repr. fig. 12 p. 150; Dorment 1985, pp. 238, 246, 264, 268, 277, 299, repr. pl. 146 p. 239.

102 *The Mother of the 9th Symphony: Bust Study of a Head for a Contemplated Monumental Homage to Beethoven*

1904
Plaster: ht including base 69 cm/27⅛ in
Private Collection

Gilbert exhibited two portrait busts of his mother Charlotte, one at the Royal Academy of 1903 (untraced) and this plaster cast, entitled *The Mother of the 9th Symphony*, in 1904. He actually began this piece in the spring of 1903, but did not finish it in time for exhibition at the Royal Academy that year. In his diary for 31 March 1904, Gilbert's son George noted that his father had added to the bust a hood 'after the style of the Brugeois'. The sculptor hoped that a rich

101 *reproduced in colour on p. 85*

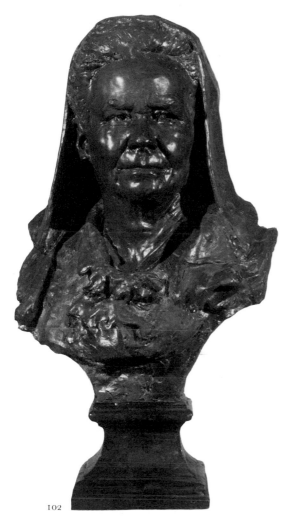

102

enthusiast for music would commission a memorial to Beethoven, but by 10 August 1904 George recorded that *The Mother of the 9th Symphony* had been bought by Guildford Lewis, a solicitor, 'for a few shillings'.

On the face of it, Gilbert's belief that his own mother's portrait might serve as a monument to his favourite composer may seem odd. At least one witness remarked on Gilbert's own physical resemblance to Beethoven[1]—and, indeed, on its exhibition at the Royal Academy the bust was mistaken for a likeness of the composer wearing a bonnet. This was the puzzled reaction of the critic for the *Spectator*: 'The work in the Sculpture Gallery attracts by its strangeness and genius. . . . The face is that of Beethoven, but the strange overhanging draperies are feminine, and the effect of the whole is enigmatical; but the power is extraordinary and the skill of modelling wonderful. The originality of the workmanship, as well as of the conception, marks out the bust as the most striking thing in the room.'[2]

Simply as a portrait of Charlotte Gilbert, the bust has character beyond even Gilbert's high standards. From what

we know of this forceful woman, whose ambition for her son provided him with the impetus to struggle through adversity, Gilbert has conveyed both strength and a certain grim endurance. Seventeen years earlier Charlotte had posed for the head of Queen Victoria in the monument at Winchester (Cat. 32); a comparison between this indomitable head and the head of the queen reveals how much of his mother's own personality Gilbert infused into the portrait of his sovereign.

Cat. 102 was cast in bronze around 1970 (Private Collection).

NOTES
1. Macklin 1910, p. 106.
2. *Spectator*, 7 May 1904, p. 731.

PROVENANCE Guildford Lewis Esq., 1904; bt Isabel McAllister, *c.* 1935; Adrian Bury; presented to Air Chief Marshal Sir John Barraclough; sale, Christie's, 2 July 1971, lot 24, bt in.

EXHIBITION Royal Academy 1904, no. 1714.

LITERATURE Ganz 1934, p. 5; Bury 1954, pp. 69, 88, plaster repr. pl. XXIII after p. 58; Handley-Read 1968, III, p. 148; Dorment 1985, pp. 237, 264, bronze repr. pl. 144 p. 237.

103 *Eliza Macloghlin*

1906
Bronze: ht 44 cm/17¼ in
Inscribed on back: ELIZA MACLOGHLIN 190(?6)/ALFRED GILBERT SCULP./EHEU/FUGACES!
Founder: Württemberg Electro Plate Co.
The Trustees of the Tate Gallery

Gilbert modelled this portrait in 1906, at the height of his friendship with Eliza Macloghlin (1863–1928)—a relationship that was over by June 1907 when she revealed to the *Magazine of Art* the identity of the portraits in *Mors Janua Vitae*, (see Cat. 104) then on view at the Royal Academy's Summer Exhibition. At that time Gilbert intervened with the editor of the *Magazine of Art*, M. H. Spielmann, and asked him not to mention the work in any article he might write on the Academy exhibition, calling her action 'entirely unauthorized' and 'irresponsible'.[1] No correspondence about the present bust seems to have survived, suggesting that it was modelled while Eliza was staying in Bruges, where she had come originally to commission *Mors Janua Vitae* (fig. 66), her memorial to her late husband. A contemporary photograph (fig. 65) shows the sitter to have been an extremely attractive widow, who, according to both Spielmann and McAllister, gave Alfred Gilbert a renewed will to live at a moment when, after his separation from his wife, despair and loneliness engulfed him. The inscription *Eheu Fugaces!* [*Labuntur anni!*] means 'Alas! the fleeting years glide by!'

Gilbert's portrait of Eliza Macloghlin is curious: it may be regarded as a superb example of a symbolist portrait,

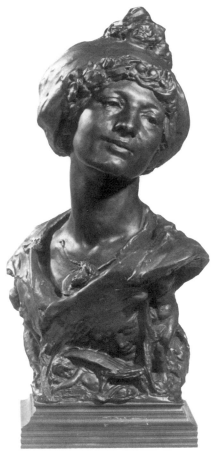

103 *reproduced in colour on p. 89*

Fig. 65 Photograph of Eliza Macloghlin, December 1904

all the more powerful for what we know of the personality of the sitter. For Gilbert suggests the compelling vivacity we know the sitter to have possessed, and also the mental unbalance that eventually led to her suicide in 1928. Thus, at first glance, the tossed head seems to have the gaiety of a poster by Jules Chéret (1836–1932) in three dimensions; then, a closer examination of the bust reveals putti of varying sizes swarming under the lower half of the statue, like insects discovered under a rock. The pendant around Eliza's neck might have hung limp, but here seems about to break with the violence of the swing of the sitter's head. Even her eyes—if we are not reading too much into them—have an intensity and also an absence of focus which is simply not found in Gilbert's other female portraits.

This bust was cast by Albert Toft at the Württemberg Electro Plate Company using the copper deposit method in an alloy of copper, tin and zinc. Toft destroyed the plaster after making six casts. Three of these are in the National Gallery of Canada, Ottawa, the National Gallery of Ireland, and the National Gallery of Victoria, Melbourne. One cast was formerly in the Louvre but has been missing since the Second World War. A sixth cast may have been in the possession of Miss Beatrice Millard, sister or niece of Mrs Macloghlin, but is now untraced.

NOTE
1. June 1907, SP/7/64.

PROVENANCE Presented to the Tate Gallery by Mrs Macloghlin, 1915.

EXHIBITIONS London 1968, no. 79; Manchester, Minneapolis, Brooklyn 1978–9, no. 89a.

LITERATURE Macklin 1910, plaster repr. p. 100; Bury 1954, pp. 55, 70; R. H. Hubbard, *National Gallery of Canada, Catalogue of Painting and Sculpture*, Toronto 1959, II, p. 195; Chamot, Farr, Butlin 1964, p. 222, cat. 3039; Handley-Read 1968, III, p. 148, repr. fig. 13 p. 150; Handley-Read Dec. 1968, p. 715; Dorment 1985, p. 256, repr. pl. 157 p. 257.

104 *Mr and Mrs Edward Percy Plantagenet Macloghlin*

1905–6; cast 1909
Bronze: ht from top of base to head of male 55.9 cm/22 in; base ht 30.5 cm/12 in
Founder: Württemberg Electro Plate Co.
Grundy Art Gallery, Blackpool

Eliza Millard Macloghlin met Alfred Gilbert in 1905 when she commissioned a memorial to her husband, the surgeon Edward Percy Plantagenet Macloghlin (1855–1904), to be placed in the Royal College of Surgeons of England. Mrs Macloghlin's memorial took a form new in

Gilbert's work: a pair of half-length portraits surmounting an altar-like base (see fig. 66). Gilbert dressed the Macloghlins in fantastic medieval or Renaissance robes (including the by now obligatory helmet for Eliza). He showed the couple with their arms around each other and hands intertwined, gazing rapturously at a cinerarium in which their own ashes were to be mingled. *Mors Janua Vitae* became a memorial not simply to an obscure provincial doctor, but to the survival after death of the mutual love of a man and woman.[1]

Before Gilbert had finished the monument, Mrs Macloghlin had become infatuated with its sculptor, and asked him to incorporate into her own head on the memorial a lid into which Gilbert's ashes might one day be placed. Gilbert made the ornate knop at the back of Eliza's head as requested. Had the figure been cast as planned, presumably this would have been hinged, and, like the cinerarium, sealed with a lock. That Alfred Gilbert complied with Mrs Macloghlin's wish to possess his ashes suggests at the least a willingness to lie near her in the hereafter. Alas, when,

as was his custom, he failed either to finish or to surrender *Mors Janua Vitae*, Mrs Macloghlin, enraged, stoned the windows of his studio in Bruges until he handed the work over. By the time it was cast in Germany by Albert Toft in 1909, there was no use for a hinge on the head of her effigy. When she erected the memorial in the lobby of the Royal College of Surgeons of England, Mrs Macloghlin had the following inscription carved on its base: 'UNFINISHED FOR A SYMBOL'.

Cat. 103 is a cast of the head and shoulders of the couple made by Toft at the same time as he was overseeing the casting of *Mors Janua Vitae*.

NOTE
1. For a full discussion of *Mors Janua Vitae* and its symbolism see Richard Dorment, 'The Loved One: Alfred Gilbert's *Mors Janua Vitae*', in Manchester, Minneapolis, Brooklyn 1978–9, pp. 42–51.

PROVENANCE Uncertain, probably presented to the Grundy Art Gallery by Mrs Macloghlin.

LITERATURE Manchester, Minneapolis, Brooklyn 1978–9, p. 46, repr. fig. 19 p. 45; Dorment 1985, p. 254, repr. pl. 155 p. 255.

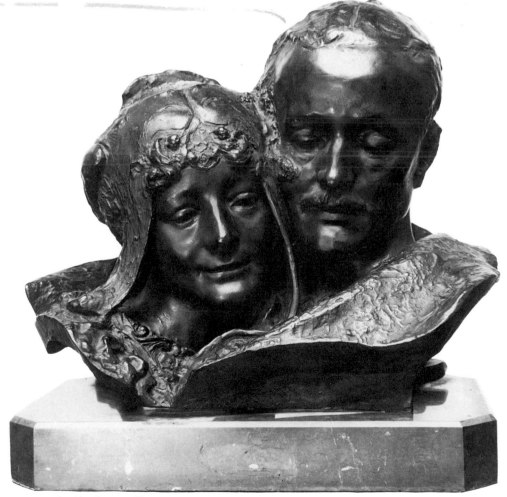

104 *reproduced in colour on p. 88*

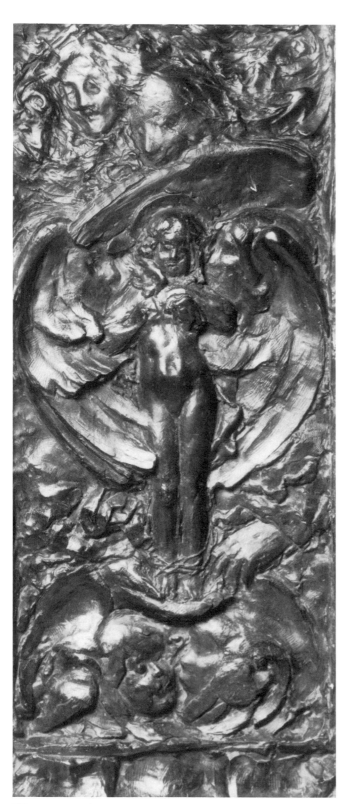

105

105 *Love Bound by Whispering Angels*

1905–6; cast 1909
Bronze: ht 71.5 cm/28⅛ in
Founder: Württemberg Electro Plate Co.
The Royal College of Surgeons of England

This replica of the central relief panel on the base of *Mors Janua Vitae* (see fig. 66) shows a nude, winged female child, bound at the feet, with a nimbus around her head. In low relief two larger winged angels in profile emerge from swirls of bronze; one of these holds the female child in the palm of her hand. The lower half of *Mors Janua Vitae*, of red and green marble inset with four bronze reliefs in Gilbert's later, symbolist style, takes as its theme many of the subjects that obsessed Gilbert throughout his working life: Eros and Anteros (here, however, personified not by a young boy, but by two nude adult females) or, as in Cat. 104, the initiation of children into the mysteries of life

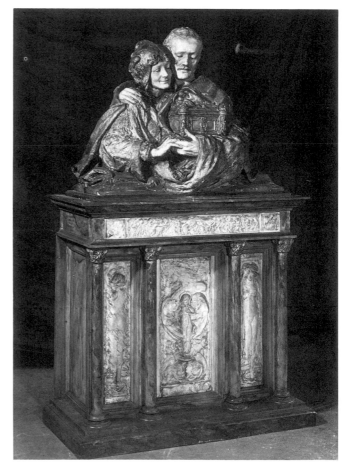

Fig. 66 Alfred Gilbert, *Mors Janua Vitae*, polychrome plaster and wood, 1907 (Walker Art Gallery, Liverpool)

or love, as in *An Offering to Hymen* (Cat. 18), the Lawrence Memorial Medal (Cat. 41) and the Alexandra Memorial (Cat. 111–14). His later, freer handling of clay may have been influenced by his re-examination of the work of G. F. Watts.

Albert Toft, who saw *Mors Janua Vitae* through the casting stage, broke up extra plaster casts of the panels belonging to the group because he felt Alfred Gilbert would be displeased to have them in existence. However, 'I think one or two such pieces may not have been broken up but I really don't know where they may be'.[1] In fact, three plaster casts of the bas-reliefs survived and were bought by the Canadian sculptor R. Tait Mckenzie (b.1867). He incorporated them (together with other plaster casts of Gilbert's work) into a bizarre desk designed by himself (Mill of Kintail, Almonte, Ontario). But Toft must have made a second bronze cast of all the relief panels for Mrs Macloghlin. In her will, dated 28 May 1913 (Library, Royal College of Surgeons of England), she directed that her executors sell at Christie's a number of works by Gilbert then in her drawing room, including 'a bronze frieze and three bronze panels'. However, before she died Mrs Macloghlin herself presented objects to museums throughout the world (see Cat. 105). The bronze frieze and panels found their way to the Royal College of Surgeons: on 15 May 1928 the Secretary of the College wrote to Mrs Macloghlin's solicitors stating that he had these in his custody.[2] The panel exhibited here is the only one still owned by the Royal College of Surgeons.[3]

NOTES
1. Toft to Spielmann, 28 November 1934, SP/19/3/2.
2. Library, Royal College of Surgeons of England.
3. Information kindly supplied by Ian Lyle.

PROVENANCE Eliza Macloghlin; with the Royal College of Surgeons of England by 1928.

LITERATURE Richard Dorment, 'The Loved One: Alfred Gilbert's *Mors Janua Vitae*', in Manchester, Minneapolis, Brooklyn, 1978–9, pp. 43–4, compare fig. 16 p. 44.

ITH the completion of the Wilson Chimneypiece (see fig. 9; Leeds, City Art Gallery) in 1913, Gilbert showed signs of wishing to renew his almost moribund career. He had never stopped work, but found it more and more difficult to see his statues through the casting stage. In 1914 two works commissioned by Douglas Illingworth were all but completed—a necklace (see Cat. 61, a later, post-war reworking) and *Circe* (fig. 40). The latter was ready to be cast in Brussels when the Great War broke out. Gilbert remained in Bruges, and for part of the war went into hiding from the occupying German troops. Apparently he continued to work in plaster, though so very little has survived, or come to light. After the war he hoped to return to England, but could find no studio and was offered no large commission which might have set him financially on his feet again. In 1924 he was granted a stipend from the Royal Bounty Fund, and the following year, due to commissions from the Towneley Hall Art Gallery (Cat. 109, 110), the Fine Art Society, and Mrs Wilson of Leeds, he was able to live in Rome and execute two superb imaginary portraits. The stage was set for his return to England.

106 *Peasant Girl with Ram and Sheep*

> *c.* 1914
> Plaster, tinted: ht 27 cm/10⅜ in
> Private Collection

This plaster was discovered in Gilbert's former house, 44 rue des Corroyeurs Blancs in Bruges, where he lived from 1901 until 1914. It is known that Gilbert occasionally made pot-boilers for sale in the local shops—and these would have been carved in wood or cast in plaster, not bronze. The unusual subject of the girl with a ram and flock of sheep, a genre-like bibelot (the subject of which might have been treated by Millet or Dalou) quite different from Gilbert's usual interest in myth or allegory, may reflect a desire to appeal to potential customers. But even so, Gilbert was incapable of insensitivity: each ewe is rendered with exquisite precision, reminding us that Gilbert claimed to have begun his career as a sculptor as an *animalier*, like Antoine-Louis Barye.[1] Particularly powerful is the ram nuzzling the shepherdess. The long, slender arms and bandeau of this female figure are almost inadvertent signatures by the sculptor.

NOTE
1. McAllister 1929, pp. 49–50.

PROVENANCE Discovered in Gilbert's former home, 44 rue des Corroyeurs Blancs, Bruges, by the present owner's father.

LITERATURE Dorment 1985, p. 293, repr. pl. 171–2 p. 292.

107 *War*

> *c.* 1915–18
> Plaster tinted in gold, blue and red, on wooden base: ht including base 50 cm/19½ in
> Private Collection

108 *Peace*

> *c.* 1915–18
> Plaster, tinted gold, metal, on wooden base: ht including base 50 cm/19½ in
> Private Collection

War and *Peace* are two of only three works (see Cat. 106) that have so far come to light from the period in Gilbert's life 1914–25. They were commissioned by the Belgian symbolist artist Louis Beyaert (or Beyaert-Carlier), a fact which is in itself significant in that it represents one of Gilbert's few documented personal contacts with a Belgian artist. That friendships with local artists sprang up (if not in Bruges then in Brussels where Gilbert stayed frequently to be near his studio and foundry at the Compagnie des Bronzes) would seem probable. Beyaert's own speciality, the enigmatic female face, might epitomise one prominent facet of literary and pictorial symbolism which flourished in Belgium in the closing decades of the nineteenth century. The question of the importance of Belgian painting and literature for Alfred Gilbert's later work has yet to be fully investigated.

The symbolism of the two statues is straightforward. Gilbert sees the subjects of War and Peace entirely through the eyes of the women and children, not of the soldiers. The

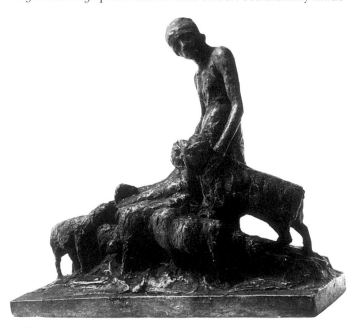

106

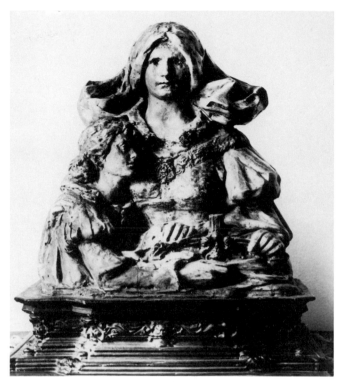

107

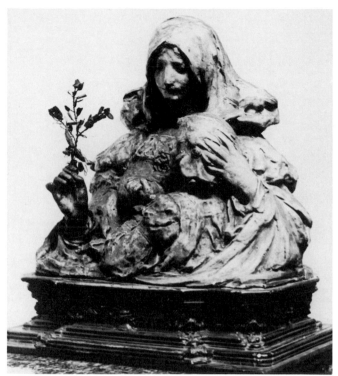

108

theme of the first statue, *War*, is mute endurance in the face of the sword. Here a mother in Bruggian headdress stares stoically ahead, while her daughter looks up to her questioningly. Each touches the hilt of a broken sword (decorated with Gilbertian putti). In *Peace* the theme is renewal. It contains the same pair as *War*, the mother now bending slightly in a gesture of resignation and holding up a flower. What saves the two statues from triteness, although not entirely from sentimentality, is the naturalism of pose and gesture and the absolute simplicity of each group. Elaboration occurs in costume and accessories (flower, necklace, swordhilt), but in the central figures themselves Gilbert understates his deeply-felt theme. He has placed each pair on a wooden base so that one might imagine each serving as a small altarpiece. Each half-length group is reminiscent of *Mors Janua Vitae* (see fig. 66) in style, and can be seen as a thematic precursor of the woman and child on the Memorial to Queen Alexandra (see Cat. 111–14).

The dating of these two works to the years of the Great War is conjectural. In style, one might place them closer to the intricate naturalism of *Mors Janua Vitae* of 1906–7 than to the broader, more stylised handling of the *Chatelaine* and *Virtuoso* of 1925 (Cat. 109–10).

PROVENANCE Commissioned from the artist by Louis Beyaert-Carlier; by descent.

LITERATURE (Cat. 107) Dorment 1985, pp. 293–4, repr. pl. 173 p. 294; (Cat. 108) Dorment 1985, pp. 293–4, repr. pl. 174 p. 294.

109 *The Chatelaine*

1925–6
Bronze: ht 81 cm/32 in
Inscribed: FOND A. BRUNO ROMA
Founder: A. Bruno
Towneley Hall Art Gallery, Burnley Borough Council

The Chatelaine is Gilbert's imaginary portrait of Alice Mary Towneley, First Baroness O'Hagan (1846–1921), benefactor of the town of Burnley, whose family home, Towneley Hall, was bought by the Town Corporation for use as an art gallery in 1901. Gilbert's work was commissioned by the Corporation in 1925 at the suggestion of the sculptor Walter Gilbert (no relation; 1871–1946). It was partly on the advance paid for this piece and *The Virtuoso* (Cat. 110) that Gilbert was able to live and work in Rome from March 1925 until June 1926. The importance of this commission in the sculptor's life was enormous: *The Chatelaine* and *The Virtuoso* represent the first important new works cast by him since the Leeds Chimneypiece, which he had finished in 1913.

Papers preserved in the Towneley Hall Art Gallery relating to the commission show that the Corporation dealt with Gilbert cautiously. They received assurances from Walter Gilbert that he would redo the busts if Gilbert failed to fulfil the commission. In addition, they refused to pay the second part of the advance until they had received a signed statement from the artist swearing that he had completed the

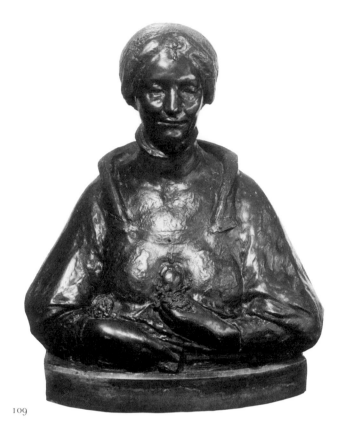

109

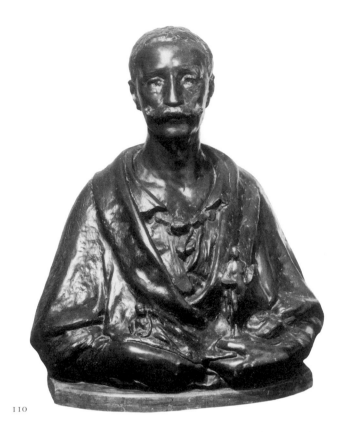

110

models of the busts and sent them to a named founder in Rome for casting. Gilbert's statement to this effect was attested in February 1926 by the British Consul in Rome at the request of the Corporation.

Difficulty came not from delay on Gilbert's part, but from another source. When *The Chatelaine* was delivered in November 1926, Lord O'Hagan protested at the bust's 'complete + utter want of resemblance in any shape or contour or form or proportion' to his mother. He saw that 'the thing as an artistic bit of work has great merit', but he felt that 'it is impossible to acquiesce in accepting this as a portrait or memorial of her!'[1]

Walter Gilbert explained to the Town Clerk that Alfred Gilbert himself had given the busts the titles *Chatelaine* and *Virtuoso*—so that he hardly considered them as portrait likenesses. Walter Gilbert persuaded the Corporation to accept the works on their own merits, 'by the greatest imaginative artist of our time'.[2] He then made two much more realistic busts to serve as memorials to Stocks-Massey and Lady O'Hagan. Tactfully, he never told Gilbert what he had done.[3]

Lady O'Hagan is shown with a key in her right hand and flowers in her left. The brooch at her breast was originally attached to a necklace, now missing.

NOTES
1. Lord O'Hagan to Mr Walmesley, 1 December 1926 (Towneley Hall Art Gallery).

2. Walter Gilbert to Colin Campbell, 1 February 1927 (Towneley Hall Art Gallery).
3. Walter Gilbert to Frank Walmesley, 25 January 1927 (Towneley Hall Art Gallery).

PROVENANCE Commissioned by the Towneley Hall Art Gallery, 1925.

LITERATURE McAllister 1929, p. 217; Bury 1954, p. 33; Dorment 1985, pp. 302–3, repr. pl. 177 p. 303.

110 *The Virtuoso*

> 1925–6
> Bronze: ht 81 cm/32 in
> Inscribed: FOND A. BRUNO ROMA
> Founder: A Bruno
> The Towneley Hall Art Gallery, Burnley Borough Council

The Virtuoso forms a pair with *The Chatelaine* (Cat. 109) as an imaginary portrait of Edward Stocks-Massey, a benefactor of the Towneley Hall Art Gallery. In his right hand he holds a reclining winged Eros; in his left a nude, cloaked female figure holding a palette in her right hand and a lyre in her left. As in *The Chatelaine*, the quality of this *cire perdue* bust is superb. The face has a brown patina, and the cloak is darker.

PROVENANCE Commissioned by the Towneley Hall Art Gallery, 1925.

LITERATURE McAllister 1929, p. 217; Bury 1954, p. 33; Dorment 1985, pp. 302–3, repr. pl. 178 p. 303.

THE MEMORIAL TO QUEEN ALEXANDRA AND
LATE WORKS 1926–1932

ARGELY through the energetic campaigning of the journalist Isabel McAllister, Gilbert returned from self-imposed exile to England in August 1926. Working from a studio in St James's Palace borrowed from Lady Helena Gleichen, he finished the five figures, missing since 1899, for the Tomb of the Duke of Clarence (Cat. 77–81). Even before their completion it was clear that Gilbert was the only artist suitable to undertake the memorial to his old patron and friend Queen Alexandra at Marlborough Gate.[1] The result, his last, late masterpiece, might epitomise, in the rhythmic swirl of bronze drapery, the Byzantine-style crowns and the Salomé-like loincloth of the central figure, the age of Aubrey Beardsley and Oscar Wilde—not the year 1932, the date when it was finally unveiled. The monument's aura of the *fin de siècle*, its mixture of the erotic and sacred, has less in common with the sensibility of English sculptors working in the late 1920s and 1930s than with that of French and Belgian artists of the 1890s. It was not that time stood still for Gilbert but that his own vision was timeless: his Memorial to Queen Alexandra eerily suits its subject in a way that not even the most conservative

Fig. 67 Alfred Gilbert, Memorial to Queen Alexandra, 1926–32 (Marlborough Gate, London)

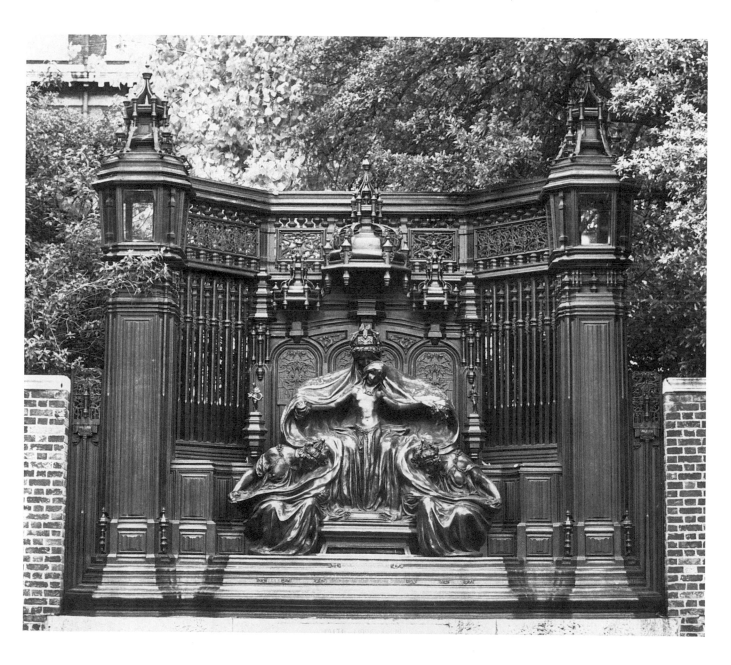

monument by an artist more in step with the arts of the twentieth century could have done.

NOTE
1. Memorial to Queen Alexandra, Marlborough Gate, London, 1926–32.
 Bronze: ht (base of bronze to top of lantern) 408.9 cm/161 in;
 l. 548.6 cm/216 in. Inscribed: FAITH HOPE LOVE/THE GUIDING
 VIRTUES OF QUEEN ALEXANDRA.
 Founder: A. B. Burton, Thames Ditton, Surrey.

LITERATURE McAllister 1929, pp. 224–5; Bury 1954, pp. 35–7, repr. pl. XXIV opp. p. 59; Handley-Read 1967, p. 24, repr. fig. 13 p. 23; Dorment 1980, pp. 47–54, repr. pls 65, 68–71; Read 1982, pp. 347–8, repr. fig. 415 p. 348; Beattie 1983, p. 245; Dorment 1985, pp. 279, 312–22, repr. pls 189–91 pp. 318–20.

It is rare for a sculptor to have been personally associated with the person whose memorial he is called upon to create. Gilbert's regard for Queen Alexandra began in 1863 when, as a schoolboy, he was taken to Gravesend to witness her arrival on the shores of England for her marriage to the Prince of Wales. As a grown man working on the tomb of her son, the Duke of Clarence (see Cat. 66–76), Gilbert romanticised his royal patron; to his mother he wrote on 25 January 1892: 'Think of the beautiful Princess, who one could imagine God himself would not dare to afflict, bowed down like the humblest peasant with grief for her first born. . . .'[1] And his remarks about the figure of the *The Virgin* (Cat. 75) on the Tomb of the Duke of Clarence suggest that he identified her with the sorrowing Princess Alexandra.[2] For her part, Alexandra had been good to Gilbert. In 1903 she tried to help him in his financial difficulties by commissioning her portrait (begun by Gilbert but never completed; it is now untraced). In the following year she sent him money in Bruges;[3] and when news of the sale of replicas of figures of the saints from the Tomb of the Duke of Clarence reached the ears of Edward VII, Gilbert maintained that 'the only person who believed in my honesty and loyalty was Her Majesty Queen Alexandra, the only one who always helped me to the uttermost although even she was unable to persuade King Edward of my honesty'.[4]

It was therefore appropriate that, a year after her death in 1925, King George V should ask Gilbert to create her memorial, and not surprising that the memorial itself proved to be one of Gilbert's most intimate—and moving—works.

Even before the Committee for the Erection of a Memorial to Queen Alexandra approached Gilbert on 14 December 1926, he had evolved a design for a wall fountain with three crowned female figures, Faith, Hope, and Charity, guiding a child across the river of life. Throughout the Memorial, formal patterns are given the weight of symbols. In the three female figures bowing and ministering to the child Gilbert alluded to the imagery of the Passion, and specifically to the three women who mourn over the body of Christ at the Crucifixion, or attend the prostrate Virgin

Mary at the foot of the cross. Each pose and gesture is symbolic: Charity, the greatest of the Christian virtues, whispers into the ear of the child, and holds up her arms to form a cross, while Faith and Hope make up a trinity from which the child, positioned between the legs of the central figure, is born. It is through such symbols that Gilbert embraced the themes of birth, mourning, and the passing on of wisdom from one generation to the next. The further theme of guidance is embodied in the lanterns on either side of the throne: these are lit at night literally and symbolically to guide the traveller home. The three 'Guiding Virtues' of Queen Alexandra are thus inherited by the child. But the Memorial has one more symbolic dimension, impossible to prove, but entirely typical of the way in which Gilbert's mind worked. With his long experience in dealing with three generations of the Royal Family, the sculptor certainly took note when a female heir to the throne of England, Princess Elizabeth, was born only five months after Queen Alexandra's death. While Gilbert worked on the Memorial, this child was (and would remain) heir presumptive. In referring to the Memorial in its early stages, Gilbert always called the figure of the child a boy; but at a late stage he changed the sex, and in so doing suggested that by the example of her life Queen Alexandra had passed her virtues on not only to a new generation of children, but to one child in particular, a future Queen of England.

The theme of the mother teaching child is one that Gilbert had treated early in his career (Cat. 8). Similarly, the theme of the transition from adolescence to man or womanhood, so central to the meaning of his early bronzes, was nowhere more engagingly treated than in *An Offering to Hymen* (Cat. 18; see also Cat. 41). The young girl in this early statue should be compared to the one in the Memorial to Queen Alexandra, for in both the physical changes in puberty are alluded to: in the earlier work by the offering to the god of marriage; in the later by the child's low girdle and body *en fleur*. The difference between them is that in the Memorial to Queen Alexandra the transition from youth to maturity is shown to be a spiritual experience, passed on from one generation to the next.

Unveiled at Marlborough Gate on 8 June 1932, the Memorial to Queen Alexandra was Gilbert's 'Swan Song'—he was already seventy-three when he began work on it, and knew that it would be his last public monument. The Memorial is the third of his overwhelming masterpieces, a worthy successor to the Shaftesbury Memorial (Cat. 43–50) and the Tomb of the Duke of Clarence (Cat. 66–81).

NOTES
1. Windsor, Royal Archives, Add. x/200.
2. See Cat. 75.
3. See Dorment 1985, pp. 227, 232.
4. Lady Helena Gleichen, typescript dated 4 November 1934, SP/10/38/2.

111

111 *Photograph of the Model for the Memorial to Queen Alexandra*

*c.*1927.
The Royal Academy of Arts

This photograph shows the earliest version of Gilbert's proposed Memorial to Queen Alexandra. He originally envisaged ornate bronze work on each side of the figural group, divided into five bays by six lanterns. Whether he thought of this decorative bronze work as gates or a grille is unclear. In either case, passers-by would be able to see past into the garden of the royal residence beyond. This drawback, together with the vast cost of so elaborate a grille, prevented its construction. According to Lady Helena Gleichen, Gilbert had toyed with other sites for the Alexandra Memorial, and originally wished to place it in the middle of the road at Marlborough Gate surrounded by a large reflecting pool with traffic moving on either side.[1]

NOTE
1. SP 10/38/13.
PROVENANCE M. H. Spielmann; presented to the Royal Academy by his son Percy after 1949.
LITERATURE Dorment 1980, p. 48, repr. fig. 66; Dorment 1985, p. 317, repr. pl. 186 p. 316.

112 *Model for the Memorial to Queen Alexandra*

c. 1927
Wood and plasticine: ht 36.8 cm/14½ in; l. 45.7 cm/18 in
Museum of London

Gilbert presented this wood and plasticine model of his proposed Memorial to Queen Alexandra at Buckingham Palace at the end of March 1927. The composition is remarkably similar to the Memorial as cast, except that the figure of the child is male. In fact a little boy, ten-year-old Hilary Eccles-Williams, posed for this figure, and the sex

112

of the child was changed at the casting stage—certainly after 18 October 1930, when one of Gilbert's patrons still referred to the figure as a boy.[1] Gilbert's use of plasticine for this model, and for the full-scale model of the Memorial itself, was unusual in his œuvre. Its advantage lay in the sculptor's not needing to water it constantly as is necessary with clay to prevent it from drying and cracking. Other sculptors, notably Albert Toft, disliked working in plasticine because one could not obtain the subtlety of modelling possible in clay.[2] It is possible that some of the slightly soap-like, bland quality of the surface of the Memorial, particularly in the faces of all four figures, is due to Gilbert's decision to use plasticine.

NOTES
1. See Dorment 1980, pp. 48, 51.
2. Patrick Synge-Hutchinson, Toft's former assistant, in conversation with the author, 1 November 1985.
PROVENANCE In the artist's studio at the time of his death, 1934; presented to the Museum by Sigismund Goetze and the National Art-Collections Fund, 1936.

EXHIBITION London 1936, no. 14 (a).

LITERATURE Bury 1954, p. 71; Dorment 1980, p. 48, repr. fig. 67; Dorment 1985, p. 318, repr. pl. 187–8 p. 317.

113 *An Allegorical Figure (Truth?)*

c. 1930; cast 1935–6
Bronze: ht 27 cm/10⅝ in
Founder: Morris Singer
Private Collection

114 *An Allegorical Figure (Religion?)*

c. 1930; cast 1935–6
Bronze: ht 26.7 cm/10½ in
Founder: Morris Singer
Private Collection

Truth and *Religion* were cast from one of two sets of plasticine models which were left in Gilbert's studio at the time of his death. Albert Toft had these unique casts made and presented the plasticine models to the present owner. The second pair of models was presented to the Museum of London. The two figures were placed as finials for the throne of Charity on the Memorial to Queen Alexandra. Their identification as *Truth* and *Religion* is purely speculative, since Gilbert nowhere spoke or wrote about them. These figures have a sketchiness different even from his late figures of saints for the Tomb of the Duke of Clarence. However, they may be dated late in the course of his work on the Memorial, perhaps towards 1930 when the sculptor was already seventy-six.

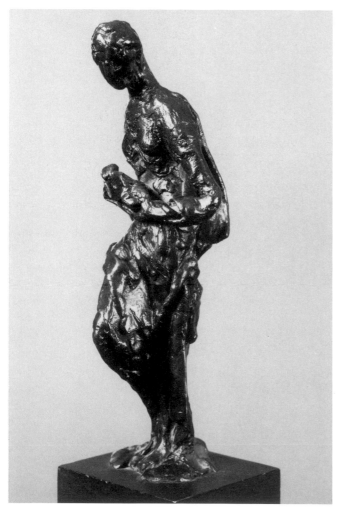

113

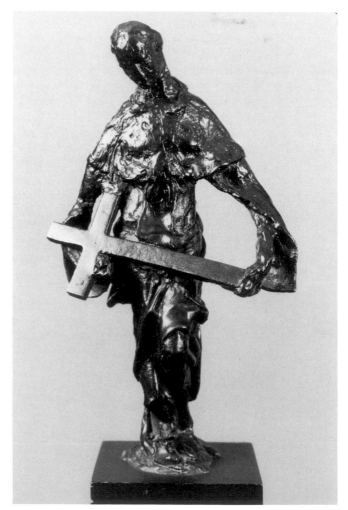

114

PROVENANCE (Cat. 112, 113) Albert Toft; given by him to present owner.

EXHIBITIONS (Plasticine model: Cat. 113) London 1936, no. 14(b).
(Plasticine model: Cat. 114) London 1936, no. 14(c).

LITERATURE (Plasticine model: Cat. 113) London 1936, p. 11, repr. pl.
XI; Bury 1954, pp. 71, 87, repr. pl. XXI opp. p. 58; Dorment 1980, p. 51,
repr. fig. 73.
(Plasticine model: Cat. 114) London 1936, p. 11; repr. pl. XI; Bury
1954, pp. 71, 87, repr. pl. XXI opp. p. 58; Dorment 1980, p. 51, repr.
fig. 72; Dorment 1985, p. 321, repr. pl. 192 p. 321.

115 *Samuel Taylor Coleridge*

1933
Plasticine: ht 33 cm/13 in
Mr A. D. Coleridge

115

In the 1890s, after one of his first nights, Henry Irving introduced Gilbert to the Hon. Stephen Coleridge with the words: 'You two ought to know each other'.[1] In fact, their friendship took forty more years to blossom, and then because Coleridge, an amateur artist and dilettante, wrote to *The Daily Telegraph* praising the Shaftesbury Memorial, re-erected on 28 December 1931 in Piccadilly Circus after the completion of renovation work on Piccadilly Circus Underground Station. A correspondence with Gilbert ensued, and Coleridge suggested that, because 1934 was the centenary of the poet Samuel Taylor Coleridge's death, and he intended to write a short book of appreciation, Gilbert might make a statuette of the poet which would be sold on the book stalls with his volume. On 24 April 1933, Gilbert replied: 'Far from thinking your suggestion of "no value or interest" I was so struck by it, that I immediately set to work to try and realize, in however slight a way, the inspiration it gave me, and I spent a very happy day yesterday in realising my impression of your great kinsman, and one of our Country's greatest Poets.' In another letter, of May 1933, Gilbert spoke of the poet as 'my idol, from my earliest youth'. And on 12 July he noted that he was in the midst of reading about Coleridge, 'in order to come to some proper estimate of your illustrious forbearer's genius, character, and personality. I have read all I could come upon, including De Quincey'. This last is an intriguing glimpse of how Gilbert steeped himself in the character of the men whose imaginary portraits he modelled. In the same letter of 12 July he stated that the model would be ready for inspection shortly.

The lively model in plasticine was unfinished at the time of Gilbert's death and is visible in photographs of his Kensington Palace studio.[2]

Stephen Coleridge undertook to edit and find a publisher for Gilbert's Royal Academy lectures (1901–4), recorded in a few notes, and in newspaper clippings reporting their content. He gave the task up as hopeless, although he got as far as assembling a volume in typescript for Gilbert to read. When Gilbert died, on 4 November 1934, Coleridge wrote his *Times* obituary.

NOTES
1. All quotations in the entry: MSS 'Letters from Sir Alfred Gilbert, R.A., Lord Sankey and Others to Stephen Coleridge' (in the possession of Francis Coleridge Esq.).
2. Dorment 1985, p. 327, pl. 194.

PROVENANCE Hon. Stephen Coleridge; by descent.

LITERATURE Dorment 1985, p. 331, repr. pl. 199, p. 330.

WORKS ON PAPER
AND THE VAN CALOEN ALBUM

 ILBERT was an artist who worked by instinct, preferring to model his ideas at once in clay, rather than to work them out first on paper. As a result, few detailed sketches for his works are known. Of those that survive, the most important are in the van Caloen Album, containing his first ideas for jewellery, sculpture, and stucco work.

116 *Landscape*

> *c.* 1895(?)
> Lithograph: 16.5 × 25 cm/$6\frac{1}{2}$ × $9\frac{7}{8}$ in
> Signed in the plate at the lower left with monogram: AG
> The Trustees of the British Museum

The date of this work is not known. One possibility is 1895 when, in the autumn, an Exhibition of Lithography was held in Paris: 'Lord Leighton and Mr. Alfred Gilbert were keenly interested in making the British contribution a success.'[1] The two men involved artists who were not necessarily printmakers, and they called upon the printer Frederick Goulding, who offered 'to send the necessary crayons and transfer papers to any number of artists, and to make himself responsible for the printing. Leighton and Gilbert were enthusiastic about the first results obtained,

116

and by correspondence and personal appeal induced a number of distinguished artists to make experimental drawings'. Among those who responded were Edwin Austen Abbey (1852–1911), Solomon J. Solomon (1860–1927), Lawrence Alma-Tadema (1836–1912), J. D. Linton (1840–1916), G. F. Watts (Cat. 25), Matthew Ridley Corbet (Cat. 38), Frank Dicksee (1853–1928), William Goscombe John and Phil May (1864–1903). Hardie reported that 'some remarkable results were obtained, and the lithographs, after being exhibited in Paris, were shown, in November 1895, by Mr

Dunthorne, at the Rembrandt Gallery in Vigo Street [London].' Gilbert himself did not contribute nor is it recorded that he experimented with lithography, but his labours on behalf of the exhibition presume an interest in the technique. Cat. 116 is Gilbert's only known print.

NOTE
1. Martin Hardie, ARE, *Frederick Goulding, Master Printer of Copper Plates*, Stirling 1910, p. 106.

PROVENANCE Bequeathed to present owners by Campbell Dodgson, 1947.

117 *The van Caloen Album*

> *c.* 1890–*c.* 1906
> Album of 139 numbered leaves in a board and cloth binding, containing 194 numbered designs for sculpture, metalwork and jewellery, in pencil, pen and wash, chinese white and chalk, and four jewellery designs in gouache and metal paint on a ground of metal foil and raised gesso: page size 29.8 × 24.1 cm/$11\frac{3}{4}$ × $9\frac{1}{2}$ in
> Inscribed inside front cover in Alfred Gilbert's hand: TO GEORGE GILBERT FROM HIS FATHER: ALFRED GILBERT; in pencil in another hand: ALFRED GILBERT RA, MAIDA VALE N W
> Inscribed on a pastel notebook leaf in the hand of Baron Jean van Caloen: A CAUSE DE CETTE DÉDICACE À SON FILS J'AI FAIT DEMANDER À MADAME GILBERT SI ELLE AVAIT BIEN EU LA DROITE DE VENDRE CELA ET NE DEVAIT LE RAVOIR. ELLE FÎT RÉPONDRE PLUSIEURS FOIS QUE SON MARI AVAIT DIT QUE TOUT CE QU'IL LAISSAIT À BRUGES ÉTAIT POUR ELLE (SAUF CERTAINS MOULES QUE SON FILS VINT PRENDRE) ET QU'ELLE POUVAIT EN FAIRE TOUT CE QU'ELLE VOULAIT. IL L'AURAIT CONFIRMÉE DEPUIS SA MORT DANS SON TESTAMENT. ELLE L'A DIT ET REPETÉ À POPPE DE LA RUE ST. GEORGES NO 1
> The Jean van Caloen Foundation, Loppem

The drawings in this album can be roughly dated by the projects to which they relate; for example, the pen and ink sketch of a winged putto (117xiii) inscribed 'Comedy and Tragedy (first idea) Dec. iii.90 Alfred Gilbert' is the earliest dated drawing, but a number appear to relate to earlier commissions such as the 1887 Art Union Jubilee Medal (Cat. 39) and the Preston Mayoral Chain (col. pl. p. 71). If this is the case, the Album might have to be dated even earlier. The latest recorded date is 1906 (117xxi) but some of the bold pen and wash abstract designs may have been executed at even later dates.

PROVENANCE George Gilbert; Stéphanie Gilbert; Baron Jean van Caloen by 1935.

EXHIBITION Manchester, Minneapolis, Brooklyn 1978–9, no. 112.

LITERATURE Handley-Read 1967, p. 20; Handley-Read 1968, II, p. 87.

117i

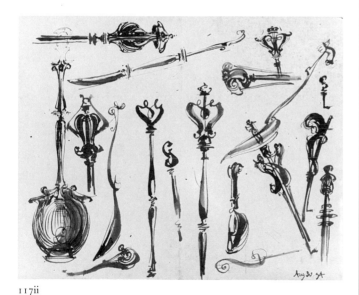

117ii

interest and among the most significant can be numbered the following:

i) f. 6 no. 11 Two designs: a collar centring on affronted peacocks surmounted by a royal crown, and a ceremonial chain with inscribed links
Pencil: 17.1 × 18.5 cm/6¾ × 7¼ in

ii) f. 10 no. 17 Designs for spoons and spoon handles; inscr. AUG 30, 94
Pen and wash: 18 × 22.7 cm/7 × 8⅞ in

iii) f. 21 no. 39 Elevation of a royal tomb, possibly that of Edward and Alexandra; inscr. 12 FEET LONG and ALL OPENWORK ENCLOSING SARCOPHAGUS OCT. 29.93
Pencil: 14.9 × 14 cm/15⅞ × 5½ in
The pasted-in sheet is supplemented by two rapid sketches of a bird's-eye view of the tomb which reveal that it was to be for a double effigy, thus supporting the identification proposed by Lavinia Handley-Read. Although intended to be on a far larger scale even than the Tomb of the Duke of Clarence (see Cat. 66–82), the source of inspiration is still a precious metalwork casket or reliquary.

LITERATURE Handley-Read 1968, II, p. 87, repr. fig 6 p. 88; Manchester, Minneapolis, Brooklyn 1978–9, p. 202.

117iii

These drawings are for the most part ideas jotted down at the very outset of work on a commission. They are not in any sense working drawings, and bear few notes or instructions. In general the arrangement of the Album is chronological, with an overwhelmingly numerous representation from the mid-1890s. The pasting up of the pages seems to have been carried out more or less concurrently with work on the projects (see iii below). In this important record of a very active period in Gilbert's career, every leaf is of

iv) f. 28 no. 47 Designs for jewellery composed of symmetrical arabesques of Renaissance inspiration and motifs using letters (e.g. 'R' and 'FS' in monogram) and a musical treble clef
Chinese white on buff paper: 17 × 12 cm/6⅝ × 4¾ in

v) f. 37 no. 60 Ornamental design with a galleon and sea-monster; inscr. MARCH 27. 94
Pen and wash: 12 × 6·5 cm/4¾ × 2½ in
(Repr. fig. 15, p. 29)
If this design is for a plaque ornamented with inlaid or laminated coloured metals, it is one of the most technically explicit drawings in the book, and one of the few from which an outside craftsman might have been expected to work.

vi) f. 45 no. 72 Page of sketches mostly related to an ornamental mace; inscr. MACE FOR MANCHESTER JANUARY 24. 94
Pencil: 19.4 × 15 cm/7⅝ × 5⅞ in
The inscription is quite explicit but the mace has so far not come to light.

vii) f. 55 no. 93 Design for the figure at the top of the Shaftesbury Memorial; inscr. on the folio in another hand SHAFTESBURY MEMORIAL PICCADILLY CIRCUS FIRST IDEA
Pencil: 16.5 × 10 cm/6½ × 3⅞ in
(This design has been catalogued in the section 'The Shaftesbury Memorial 1886–1893', as Cat. 48.)

viii) f. 58 no. 96 Detailed sketch in two parts for the base of the Shaftesbury Memorial; inscr. on the folio in another hand PICCADILLY CIRCUS FOUNTAIN FIRST IDEA (SEE 97–98–99)
Pencil: upper part 17.6 × 16.2 cm/6⅞ × 6⅜ in; lower part 5.9 × 16 cm/2¼ × 6¼ in
(This design has been catalogued in the section 'The Shaftesbury Memorial 1886–1893', as Cat. 43.)

ix) f.59 no. 97 Design for the Shaftesbury Memorial
Pencil on tracing paper: 14 × 12.4 cm/5½ × 4⅞ in

x) f. 60 no. 98 Design for the Shaftesbury Memorial
Pencil on tracing paper: 17.8 × 10.6 cm/7 × 4⅛ in

xi) f. 64 no. 105 Design for an ornamental sword-hilt; inscr. within the monogram AG AUG 3. 96
Pencil with pen and ink overdrawing: 11.3 × 17.5 cm/4½ × 6⅞ in
The date suggests that this is the first design for the Battenberg sword which was not used (see Cat. 96).

xii) f. 69 no. 109 Boldly executed calligraphic designs of Renaissance inspiration for ornamental metalwork
Pen and ink: 18 × 22.6 cm/7 × 8⅞ in

xiii) f. 70 no. 110 First design for 'Comedy and Tragedy'; inscr. COMEDY AND TRAGEDY (FIRST IDEA) DEC III 90 ALFRED GILBERT
Pen and ink on grey paper: 17.5 × 11.2 cm/6⅞ × 4½ in
(See Cat. 22.)

117iv

117vi

117ix

117x

117xi

117xii

117xiii

xiv) f. 71 no. 111 Designs for jewellery: interlaced forms of Renaissance inspiration for execution in enamelled gold with pendent pearls
Pencil with pen and chinese white overdrawings on grey paper: 11×17.3 cm/$4\frac{3}{8} \times 6\frac{7}{8}$ in

f. 71 no. 112 Designs for a chain and pendant composed of monograms, 'GM' and 'CM'; inscr. CHAIN FOR MRS MCCULLOCH'S BUST
Pencil with touches of chinese white on buff paper: 10.2×15.7 cm/$4 \times 6\frac{1}{8}$ in.
The portrait bust of Mrs McCulloch was executed by Gilbert in 1897 and the marble carved in 1899 (unfinished; marble, painted plaster and metal alloy: ht 57 cm/22 in; Aberdeen, City Art Gallery). Mrs McCulloch, subsequently Mrs James Coutts Michie, was the wife of the collector, George McCulloch, who died in 1907 (see Cat. 22). The chain and pendant were not executed.

xv) f. 78 no. 126; f. 80 no. 127; f. 82 no. 128; f. 88 no. 131
Four highly finished designs for jewelled pendants
Pencil with chinese white, watercolour and metallic gold ink on paper prepared with gesso, worked to form a shallow relief of the lines of the jewel, some traces of foil overlay on the gesso: diam. 7.2 cm/$2\frac{7}{8}$ in, 7.9 cm/$3\frac{1}{16}$ in, 8 cm/$3\frac{1}{8}$ in, 6.9 cm/$2\frac{3}{4}$ in respectively (f.88 no. 131 repr. fig. 20, p. 31 and colour pl. p. 96)
Surprisingly for such highly finished designs, these pendants do not seem to have been executed in the precious materials suggested by the elaborate techniques of the drawing.

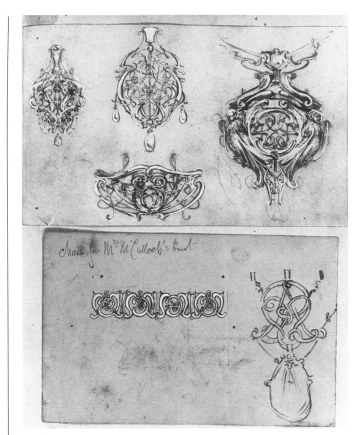

117xiv

117xv

117xv

117xv

xvi) f. 90 no. 132 Designs for a necklace and pendant and a ring
Pencil with chinese white and ochre watercolour used to suggest
gold: 15×21 cm/$5\frac{7}{8} \times 18\frac{1}{2}$ in
Recorded rings from the period covered by this album were made
for the artists Lawrence Alma-Tadema and Joseph Edgar Boehm.

f. 90 no. 133 Design possibly for a frieze in stucco
Pencil and chinese white on grey prepared paper:
7.5×12.5 cm/$9\frac{15}{16} \times 4\frac{7}{8}$ in

xvii) f. 91 no. 134 Design for the centre-piece of a ceremonial
chain, in the form of a Renaissance-style arabesque surmounted
by a royal crown
Pencil with pen and chinese white overdrawing coloured with
watercolour and metallic gold ink, on a base of raised and worked
gesso following the lines of the design:
15×9.7 cm/$5\frac{7}{8} \times 3\frac{3}{4}$ in
(see also no. xiv above)

xviii) f. 100 no. 148 First design for *St George* (1892–6)
('household' memorial to the Duke of Clarence, St Mary
Magdalene, Sandringham)
Pencil with pen and ink overdrawing, on a double sheet of
embossed Sandringham writing paper with a narrow black
mourning border: 18×11.4 cm/$7 \times 4\frac{1}{2}$ in
Gilbert was at Sandringham for the weekend of January 23–5
1892, only nine days after the death of the Duke of Clarence, but
it seems likely that royal mourning etiquette would have dictated
a very much wider black border on the family's writing paper in
the first days of mourning. Although the 'household' memorial
may have been discussed it is improbable that this drawing was
made on that occasion (see Cat. 69).

117xvii

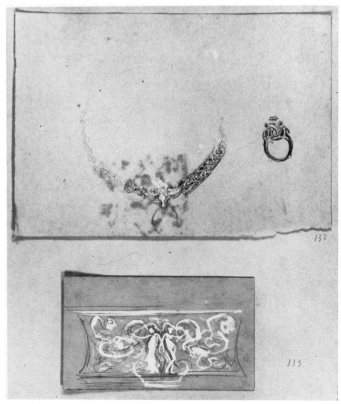

117xvi

117xviii

xix) f. 105 no. 153 Ornamental design
Pencil, ink and chinese white on grey card:
25.4 × 20.1 cm/10 × 7⅞ in

xx) f. 118 no. 167 Design for a key; inscr. SILVER WEDDING
KEY. LADY BROWNLOW DEC 18TH 1893.
Pencil on pale buff paper: 25 × 17.2 cm/9⅞ × 6¾ in (at widest
point)
A carefully finished and clearly explicit drawing for an ornamental
key, the shaft of which would have been executed in tempered steel
by a professional locksmith (see Cat. 55).

xxi) f. 124 no. 174 Inscr. LIFE IS BUT A WEARY SAD JOURNEY
TWIXT THE THROES OF A MOTHER/AND THE CONDESCENSION OF
A GOD/DEATH SO DREADED, IS BUT AN IDEAL FORM OF SLEEP/SO
COVETED. FROM DEATH THERE IS NO AWAKENING BUT/FROM
SLEEP,/THE REGAINING OF CONSCIOUSNESS IS AWAITED/BY
DESPAIR
Quill pen and ink: 13.4 × 22.4 cm/5¼ × 8¾ in

f. 124 no. 175 Inscr. BY YOUR FRIEND ALFRED GILBERT BRUGES
SEPT XIII 1906: A PALETTE IS/BUT A SLAB FROM WHICH TO
ASSEMBLE/COLOUR WHEREWITH TO DEPICT LIFE'S COLOUR/
CLAY BUT A MEDIUM WHEREWITH TO MOULD LIFE'S
ACTUALITIES, AND/COLOURED SHADOWS RESULT
Quill pen and ink with 'palette' in pencil:
13.4 × 22.4 cm/5¼ × 8¾ in

xxii) f. 128 no. 179 Boldly executed interweaving calligraphic
ink design, given symmetrical form by folding the paper and
offsetting while still wet
Pen and ink on paper: 16 × 42.2 cm/6¼ × 16⅝ in

xxiii) verso of f. 135 & f. 136 nos 189 & 190 Two sheets of
designs based on the artist's signature given symmetrical form as
no. xxii above
Carapace in calligraphic ink: 26.2 × 20.4 cm/10¼ × 8 in,
17.8 × 22.6 cm/7 × 8⅞ in respectively

117xix

117xx

117xxii

117xxi

117xxiii

118 *Circe*

1912
Gouache on board heightened with white:
22.2 × 12 cm/8¾ × 4¾ in
Inscribed in blue chalk on verso: ALFRED GILBERT
The Trustees of the Victoria and Albert Museum

This work is related to Gilbert's lost *Circe*, modelled in clay by September 1912, but never cast in bronze (see fig. 40). To the man who commissioned *Circe*, Douglas Illingworth, Gilbert wrote in 1912 that he had painted a version of *Circe* and sent it to England with a photograph of the clay model so that Illingworth might compare the two: 'Good, bad, or indifferent, the essay at painting is . . . the first I have as yet allowed to leave my studio. I will not say it will be the last, for I have hopes of someday substituting the brush for the spatula'.[1] Gilbert's paintings are very rare. The dimensions, appropriate for sending through the post with a photograph, style and subject of Cat. 62 make it likely that this is the work to which Gilbert referred in the letter to Illingworth. The finial on top of the Sander Cup (Cat. 62) could be seen as a variation of the figure of *Circe* here.

NOTE
1. Correspondence in the possession of Mrs Douglas Illingworth.

PROVENANCE Bequeathed by H. H. Harrod, 1948.

LITERATURE Dorment 1985, p. 280, repr. pl. 168 p. 281.

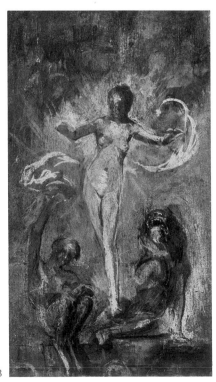

118

119

119 *Atalanta*

1931
Conté crayon on paper: 13.9 × 8.9 cm/6½ × 3½ in
Inscribed on reverse: SUNDAY MARCH 15TH 1931. ORIGINAL SKETCH MADE ON THIS DAY FOR A LITTLE STATUETTE OF 'ATALANTA' BY ALFRED GILBERT (G.G.)
The National Museum of Wales, Cardiff

As George Gilbert's inscription states, Alfred Gilbert first thought of creating a statuette of *Atalanta* in 1931. He continued to work on it for the next two years and the plaster was cast on 4 October 1933. This plaster is untraced but may be seen in a photograph of Alfred Gilbert's studio in Kensington Palace taken in 1935.[1] The work was not cast in bronze.

The subject of Atalanta, the huntress of Greek myth who challenged her suitors to outrun her in order to win her hand, may have been chosen as the last statement in the autobiography Gilbert was writing in bronze—the final statue in the progression from *Perseus Arming* (Cat. 10), *Post Equitem Sedet Atra Cura* (Cat. 88), *Icarus* (Cat. 15), *Comedy and Tragedy* (Cat. 22), *The Broken Shrine* (Cat. 99), *Circe* (fig. 40) and the Leeds Chimneypiece (fig. 9). For Hippomones devised this ruse to outwit the maiden: as they ran, he dropped three golden apples in Atalanta's path. Distracted by their glitter, she stopped to pick them up; Hippomenes would run ahead each time she faltered, until he won the race. Although Gilbert never commented upon the meaning of the myth of Atalanta in relation to himself, it is possible that he saw himself as Atalanta, and his life as a race lost by the distracting glitter of worldly ambition.

NOTE
1. Dorment 1985, pl. 196, p. 327. The statue might be the nude female holding a ball at the far end of the table.

PROVENANCE In the artist's studio at the time of his death, 1934; bt Sigismund Goetze and the National Art-Collections Fund and presented to the Museum, 1936.

EXHIBITIONS London 1936, no. 120; Manchester, Minneapolis, Brooklyn 1978–9, no. 113.

LITERATURE Dorment 1985, p. 334, repr. pl. 201 p. 334.

120 *Alfred Gilbert's Tools*

Sculptor's tools contained in a soft folding case
Private Collection

'Chasing, repoussé work, ''riffling'', the making and tempering of tools were daily tasks, and, of course, the fitter's shop was of the utmost importance. . . . There was no end to the ingenious contrivances made or adapted to serve the master's ends. For example: a draw-bench for drawing out wire to a thinner gauge was skillfully adapted to draw out wire in strips of moulding of varied design. A sausage-making machine was one day commandeered from the kitchen, and it was found that by inserting specially cut out discs and feeding the machine with wax instead of meat, surprisingly good results were obtained. It is this mastery over his materials that proclaims the master mind. If he has not got the tool he wants, he makes it.'[1] Thus Isabel McAllister described Gilbert's habit of creating his own tools when readymade ones were not adequate for his purpose. In his toolcase are a soldering iron and rasping tool for metalwork, and many other tools made by Alfred Gilbert, including two rough pieces of wood with sandpaper wrapped around them for working plaster. Some are mysterious in that they were personal to him, conceived and made in a moment for his requirements, and not the kind of tools available from a commercial supplier.

NOTE
1. McAllister 1929, p. 169.

PROVENANCE In Gilbert's studio at the time of his death, 1934; given to present owner by Albert Toft.

HOWARD INCE

121 *Designs for no. 16 Maida Vale*

1893

i) Perspective of the house from the courtyard with small-scale plan
Pen and coloured crayons on paper:
45.5 × 58.5 cm/18 × 23 in
Inscribed: HOUSE IN ST JOHN'S WOOD FOR GILBERT SCULPTOR HOWARD INCE INVT. ET DELT. MARCH '93

ii) Sections through gateway with elevation of arcade side of courtyard
Pen and coloured washes on paper:
49.5 × 72.5 cm/19 × 28½ in

iii) Sections through the studio and private studio; and elevation of studio with section through heating chamber
Pen and coloured washes on paper:
49.5 × 72.5 cm/19 × 28½ in
The British Architectural Library Drawings Collection

Howard Ince's design for Alfred Gilbert's house and studio were carried out during the winter of 1892/3. Gilbert and his family took up residence there in August of 1893. The house, which was pulled down in 1965, stood on the east side of Maida Vale between Hall Road and Clifton Road.

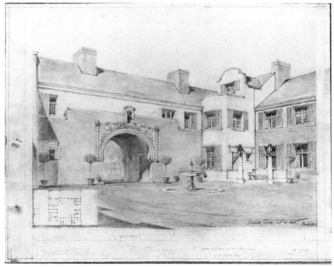

121i

A low brick wall surmounted by a wooden fence faced the pavement. The visitor approached the plain façade by a shallow, semicircular carriage drive through a central archway leading to a spacious courtyard. Straight ahead and to the left lived the family in imposing rooms which Miss McAllister described as hung with silks and with expensive rugs. Ince's designs show the drawing, music and dining rooms, and the wine cellar. To the right of the courtyard stood the studios: a long lower studio with cement floor

121ii

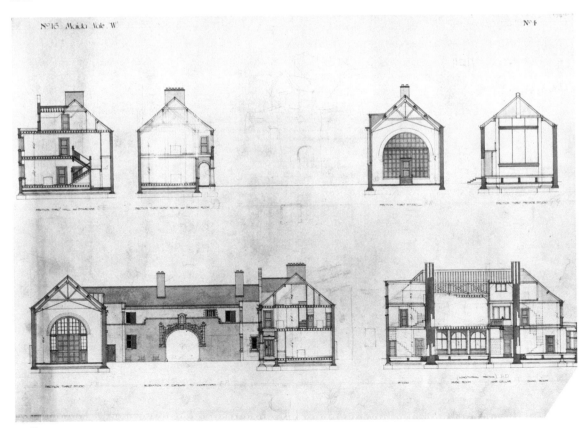

121iii

which opened directly on to the street to permit removal of colossal works, and a second, smaller studio with a wooden floor and sliding doors which were pushed back for family parties, amateur theatricals and meetings of the Madrigal Society. At the back of the house Gilbert built a foundry oven for the casting of larger works. In the lower studio he built a special kiln for smaller, delicate works cast in *cire perdue*.

No. 16 Maida Vale seems to have been the only house Howard Ince actually built. He outran his estimate by thousands of pounds, adding to the mountain of debt that eventually led to Alfred Gilbert's bankruptcy. His name is never mentioned by Isabel McAllister in her biography of Gilbert, but she blamed the whole débâcle on an untried architect.

Gilbert himself wrote bitterly about no. 16 Maida Vale, blaming himself for its grandeur and expense. 'The new home and studio I built in Maida Vale was the scene of the commencement of a life as new, and on a scale commensurate with the vastness of my folly in burdening myself with such a shell. The very walls and beams, at times, seemed to be closing in, and ready to crush me.'[1]

NOTE
1. Alfred Gilbert, 10 December 1924, MS (Windsor, Royal Archives, Add. X/215).

PROVENANCE Presented to present owners by Mrs. I. M. Ince, 1947.

EXHIBITION (Cat. 121i) Royal Academy 1893, no. 1651.

LITERATURE (Cat. 121i) Jill Lever (ed.), *Catalogue of the Drawings Collection of the Royal Institute of British Architects, G–K*, Farnborough, Hants, 1973, p. 155 [1] 2.
(Cat. 121ii, iii) Jill Lever (ed.), *Catalogue of the Drawings Collection of the Royal Institute of British Architects, G–K*, Farnborough, Hants, 1973, p. 154 [1] 1.

VIOLET GRANBY

122 *G. F. Watts Painting the Portrait of Alfred Gilbert*

1894
Pencil on paper: 23 × 17.5 cm/9 × 7 in
Inscribed by Violet Granby: AFTER WATTS/DOES THIS AMUSE?/IT IS TO REMIND YOU OF VG/I COULDN'T FINISH IT— COS' HIS SITTER HAD/ TO GO, & I WITH HIM—WATTS ALSO WANTS/YOU TO REMEMBER HIM & I MORE SITTING.
The Jean van Caloen Foundation, Loppem

Violet Granby (1856–1937), later Duchess of Rutland, was Gilbert's lifelong friend and ally, championing him at Court and ultimately working to ensure his return to England to finish the Tomb of the Duke of Clarence (Cat. 66–8) and

to execute the Memorial to Queen Alexandra (Cat. 111–14). The present sketch was executed in September 1894 when Gilbert sat to Watts in exchange for the portrait in bronze which the sculptor had made of the painter (Cat. 25). Watts's portrait of Gilbert is untraced. In the months just before this sketch was executed, Gilbert had met Lady Granby often in the company of Nina Cust, on whose bust he worked in the summer of 1894 (Cat. 83).

Violet Granby was a portraitist of distinction, her preferred medium being the pencil sketch, as here. She was also a sculptor whose best-known work is her memorial in plaster to her nine-year-old son, Lord Haddon, who died in 1895. Executed in marble by another hand, the monument is in the chapel at Haddon, Leicestershire. The plaster is now in the Tate Gallery.

PROVENANCE Alfred Gilbert; his widow Stéphanie Gilbert; bt Jean van Caloen.

LITERATURE Ganz 1934, p. 4; Dorment 1985, repr. pl. 122, p. 192.

122

In June 1936, almost two years after Alfred Gilbert's death, the contents of his studio at Kensington Palace, consisting of sketch models and plaster casts, were jointly purchased by his executor and fellow-artist, Sigismund Goetze and the National Art-Collections Fund, with the intention that they should be distributed to public institutions in Great Britain and the Commonwealth.

The then director of the Victoria and Albert Museum, Sir Eric Maclagen, together with a group of distinguished sculptors who had known Gilbert, between them made a selection from this material on behalf of the Fund. The pieces chosen were taken to the Victoria and Albert Museum, and, after being sorted and identified by Gilbert's fellow-sculptor and close associate, Albert Toft, were offered by the National Art-Collections Fund to the Victoria and Albert Museum, the Royal Academy of Arts, the London Museum and other institutions. In the autumn of 1936, before its dispersal, this group of models and casts was put on exhibition at the Victoria and Albert Museum (see *Illustrated London News*, 12 September 1936, p. 450). The catalogue, by E. Machell Cox, contains much valuable information about the models and their relationship to Gilbert's finished sculptures.

Relocation of collections, the exchange of items between individual institutions and the hazards of war have taken their toll of these pieces; by no means all have survived. Although the intention—namely the instruction and pleasure of students and fellow sculptors—behind this distribution of Gilbert's models was admirable, the results have been less than satisfactory. The long-term conservation of wax and plaster presents many problems and a number of the delicate models have either perished altogether or been so damaged as to destroy their usefulness for the understanding and appreciation of Gilbert's genius. Only the most important of the pieces are listed. There were also many fragments, alternative versions and unidentified details.

The institutions that received gifts of plaster and wax models, and wirework jewellery, were as follows:

GREAT BRITAIN

BIRMINGHAM, *City Museum and Art Gallery*
Jubilee Memorial to Queen Victoria (see Cat. 32–6): wax model (Cat. 32) and full-size models of four of the six niche figures (see Cat. 35). Sketches in gilded plaster for portrait medals and models for jewels and goldsmith's work.

CARDIFF, *National Museum of Wales*
Bronzed plaster model for the head of the reduced version of *Icarus* (see Cat. 16, 17); drawing, *Atalanta* (Cat. 119), and designs for goldsmith's work and jewellery. Wirework jewellery and wax jewellery models.

HULL, *Municipal Museums*
A model, 44.5 cm (17½ in) high, of a winged figure with flowing draperies, 'Fame' or 'Victory' (see Cat. 34). A number of casts of ornamental details; a large casket; a collection of keys and two plaques.

LEEDS, *City Art Gallery*
A number of sketch models including keys and jewellery; studies for the Wilson Fireplace including the cock on a skull in wax, derived from Dürer, which Gilbert is shown holding in his portrait by F. P. Paulus (1909; Jean van Caloen Foundation, Loppem).

LIVERPOOL, *Walker Art Gallery*
Plaster model for the bust of the *Hon. John Neville Manners* (see Cat. 86).

LONDON, *Leighton House*
Many small plaster models for and casts of ornamental details and jewellery; pieces of wirework jewellery.

London Museum
Plasticine model for the Memorial to Queen Alexandra (Cat. 112), and models for four other details of the same.

Royal Academy of Arts
Plaster and bronze busts of G. F. Watts (see Cat. 25); two salt cellars. Models in plaster, lead and wax for jewellery and goldsmith's work.

St Bartholomew's Hospital
Designs for the William Lawrence Medal (see Cat. 41).

Victoria and Albert Museum
A large number of models and sketches including a model for *Comedy and Tragedy* (see Cat. 22–4); a wax sketch model for the sarcophagus and effigy of the Tomb of the Duke of Clarence (see Cat. 67; fig. 53); a wax model for the *St George and the Dragon* on the cover of the *Rosewater Ewer and Dish* (see Cat. 57), and a *Nymph and two Cupids*, possibly for the *Sander Cup* (see Cat. 62). Wirework jewellery (incl. Cat. 65) and sketch models for a set of spoons.

MANCHESTER, *City Art Gallery*
Gilded plaster cast from the original clay model of the bust of *Paderewski* (see Cat. 30), made as an intermediate stage in the casting of the bronze.

NOTTINGHAM, *Castle Museum*
Model of the John Howard Centenary Memorial, Bedford; model of the ship for the cover of the *Portland Cup* (see Cat. 64); bronze sword and other details from the Tomb of the Duke of Clarence including *St George* (Cat. 70; see also Cat. 66–72); an elephant fully caparisoned and carrying a howdah (possibly for a chessman).

PERTH, *Museum and Art Gallery*
Larger than life-size bust of Queen Victoria (see Cat. 26); a working model for the Shaftesbury Memorial (Cat. 47). A number of plaster details including a crucifix figure; models for keys.

PRESTON, *Harris Museum and Art Gallery*
Model for the Preston Mayoral Chain, exhibited at the R.A. in 1888 (see pp. 27–8).

SHEFFIELD, *Graves Art Gallery*
Models for two equestrian groups (possibly for the *St George and the Dragon* on the cover of the *Rosewater Ewer and Dish*; see Cat. 57). Models for metalwork and jewellery including spoons and keys; several pieces of twisted wire and foil jewellery.

SWANSEA, *School of Arts and Crafts*
A number of small examples of modelling and casting intended for the instruction of art students and sculptors.

WINCHESTER, *City Museum*
Various models and details on the base of *An Offering to Hymen* (see Cat. 18); designs for a medal with a crowned head of Queen Victoria. A number of small models and casts of ornamental details.

THE COMMONWEALTH

CANADA, *Montreal Art Association*
Unidentified fragments for a structure similar to the Wilson Fireplace; a model for the figure of *St George* on the de Vesci Seal (see Cat. 59). Sketch-models for pendants in wax and plaster.

JAMAICA, *Kingston Institute*
Model for the figure of a saint in plaster, wax and foil; other figures. C.G.

CHRONOLOGY

Richard Dorment and MaryAnne Stevens

ALFRED GILBERT	OTHER CULTURAL AND POLITICAL EVENTS (BRITAIN)	POLITICAL AND CULTURAL EVENTS (OUTSIDE BRITAIN)
1854 Born 12 August, in Berners Street, off Oxford Street, London		**1854–6** Crimean War
	1855 R.A., Leighton exh. *Cimabue's celebrated Madonna is carried in Procession through the Streets of Florence*	**1855** Paris: Exposition Universelle (Courbet's 'Pavillon du Realisme') Paris: Whistler, Poynter, Du Maurier, Armstrong, Val Prinsep study in Gleyre's atelier (to 1859)
	1856 R.A., Holman-Hunt exh. *The Scapegoat*	
	1857 Manchester Art Treasures Exhibition Alfred Stevens, Wellington Memorial (St Paul's Cathedral; to 1875)	**1857** Indian Mutiny
	1859 Whistler settles in London	**1859** War declared between Italy and Austria
1860	**1860** Birth of George James Frampton	
1861 Family moves to 89 Maida Vale, London	**1861** Death of Prince Albert Foundation of Morris, Marshall, Faulkner & Co. Gilbert Scott, Albert Memorial (Kensington Gardens)	**1861** France: birth of Maillol
	1862 London, International Exhibition Birth of Albert Toft	
	1863 Marriage of Prince of Wales to Alexandra of Denmark	**1863** Paris: Salon des Refusés
1865 Enters Aldenham School, Elstree, Herts.	**1865** G. F. Watts builds own house and studio	
	1866 G. F. Watts executes first sculpture commission (*Memorial to Thomas Owen*)	**1867** Paris: Exposition Universelle
	1868 R.A., G. F. Watts exh. *Clytie* (sculpture) William Morris, *The Earthly Paradise* (to 1870)	
	1869 Modelling classes initiated at R.A. Schools R.A., Alma-Tadema exh. *The Pyrrhic Dance*; decides to settle in England	**1869** Opening of the Suez Canal
1870	**1870** G. F. Watts begins equestrian bronze of *Hugh Lupus* (finished 1883); Dudley Gallery, exh. *Love and Death*	**1870** Outbreak of Franco-Prussian War; abdication of Napoleon III
	1871 R.A., Carpeaux exh. four sculptures (incl. *Ugolino*)	**1871** France: Paris Commune; establishment of 3rd Republic Treaty of Versailles; establishment of a unified Germany under Kaiser Wilhelm I Unification of Italy
1872 October, fails scholarship examination to Middlesex Hospital; enters Hetherley's Art School in Newman Street		
1873 Working in the atelier of Joseph Edgar Boehm; enters R.A. Schools to attend classes 5–8 pm	**1873** R.A., Carrière-Belleuse exh. (terracotta statuette)	**1874** Paris: 1st Impressionist Exhibition
1875 Loses R.A. Gold Medal to Hamo Thornycroft	**1875** Death of Alfred Stevens Arthur Balfour commissions Burne-Jones *Perseus* series Morris, Marshall, Faulkner & Co. becomes Morris & Co.	**1875** France: death of Jean-Baptiste Carpeaux; Rodin works on *Age of Bronzes*
1876 January, marries his cousin, Alice Gilbert; departs for Paris to study at the École des Beaux-Arts Birth of son, George, 9 May	**1876** Queen Victoria proclaimed Empress of India Fine Art Society established in Bond Street, London R.A., Alfred Stevens exh. *Valour and Cowardice* (Wellington Memorial)	**1876** Paris: Salon, Moreau exh. *Salomé, Apparition* Rumania: birth of Constantin Brancusi

CHRONOLOGY

ALFRED GILBERT	OTHER CULTURAL AND POLITICAL EVENTS (BRITAIN)	POLITICAL AND CULTURAL EVENTS (OUTSIDE BRITAIN)
1877 Birth of daughter, Mary, 1 September Competition for Memorial to Byron; Gilbert and Rodin enter without sucess	**1877** R.A., Leighton exh. *Athlete struggling with a Python* Inaugural exhibition of Grosvenor Gallery (incl. Burne-Jones, Crane, Herkomer, Leighton, Legros, Moreau, Watts, Whistler; Boehm, Chapu, Delaplanche, Dubois) William Morris writes manifesto: 'To the Working-men of England' Dalou teaches at South Kensington Schools (to 1881)	
1878 April, Gordon Gilbert, his adored younger brother, dies; Alfred returns to London Returns to Paris; executes sketch for *Kiss of Victory* September, leaves for Rome to execute *Kiss of Victory*	**1878** Leighton elected PRA Ruskin vs Whistler	**1878** Paris: Exposition Universelle (Mercié exh. *David with Head of Goliath*; Bartholdi exh. *Statue of Liberty* [reduced]) Congress and Treaty of Berlin
1879 Birth of son, Francis, 28 July	**1879** Whistler declared bankrupt; to Venice with commission from Fine Art Society for a series of etchings	**1879** France: Rodin submits *Call to Arms (The Defence)* for competition for memorial to Franco-Prussian War
1880 Birth of son, Alfredo, 22 December	**1880** Whistler returns from Venice R.A., Thornycroft exh. *Artemis* Winter, Grosvenor Gallery, G. F. Watts	**1880** France: Rodin receives commission for *Gates of Hell*
1881 Birth of daughter, Charlotte Emily (Caprina), 13 September Winter, Sir Henry Doulton commissions 1st casting of *Perseus Arming* and *Mother Teaching Child*	**1881** Formation of Marxist Social Democratic Federation R.A., winter, G. F. Watts retrospective exhibition	**1881** Dalou returns to France Germany: birth of Wilhelm Lehmbruck
1882 R.A. exh. *Kiss of Victory* Grosvenor Gallery exh. *Perseus Arming*	**1882** Grosvenor Gallery (incl. Gilbert, Clausen, La Thangue, Sargent, Whistler, Rodin, Thornycroft) Rodin visits London R.A., Rodin exh. *St John the Baptist*	
1883 Paris Salon exh. *Perseus Arming* (hon. mention)	**1883** Formation of Fabian Society William Morris, 'Art and the People'	**1883** Brussels: Formation of 'Les XX'
1884 R.A. exh. *Icarus*; confirms Gilbert as the leading talent of his generation	**1884** Foundation of Art Workers Guild R.A., Rodin exh. *Age of Bronze*; Thornycroft exh. *The Mower*	**1884** France: Rodin receives commission for the *Burghers of Calais* Paris: 1st Salon des Indépendents Brussels: 1st Exposition des XX
1885 January, working in London; immediately overwhelmed with commissions	**1885** Burne-Jones elected ARA William Morris, *Useful Work Versus Useless Toil* R.A., Bates exh. *Aeneid Triptych*	
1886 Receives commission for Shaftesbury Memorial	**1886** Gladstone Home Rule Bill Whistler elected President of Society of British Artists London, 1st exhibition of New English Art Club R.A., Burne-Jones exh. for first and last time; Onslow Ford exh. *Folly*	**1886** France and USA: patents deposited for cheap aluminium process Paris: Moréas and Kahn publish symbolist manifestoes Paris: 8th and final Impressionist Exhibition Van Gogh arrives in Paris
1887 Elected ARA Complains to Hamo Thornycroft of pressures of work and frustration of dealing with committees Preston Mayoral Chain and Epergne; launches second career as goldsmith	**1887** Queen Victoria's Golden Jubilee 13 November, 'Bloody Sunday' (incl. Morris) Foundation of Arts and Crafts Exhibition Society Manchester, Royal Jubilee Exhibition Burne-Jones withdraws from Grosvenor Gallery Grosvenor Gallery, Bates exh. *Rodope* (cire perdue)	**1887** France: death of Carrier-Belleuse Russia: birth of Alexander Archipenko
1888 5 October, joins Art Workers Guild Liverpool, December, Gilbert elected president of sculpture section at 1st congress of National Association for the Advancement of Art and its Application to Industry	**1888** Whistler, 'Ten O'Clock Lecture' G. Moore, *Confessions of the Artist as a Young Man* Unveiling of Hamo Thornycroft, *General Gordon* Hamo Thornycroft elected RA Whistler forced to resign presidency of Society of British Artists December, Liverpool, 1st congress of National Association for the Advancement of Art and its Application to Industry	**1888** France: Mallarmé meets Whistler and translates 'Ten O'Clock' Lecture Nietzsche writes *Der Antichrist* (published 1895)

ALFRED GILBERT	OTHER CULTURAL AND POLITICAL EVENTS (BRITAIN)	POLITICAL AND CULTURAL EVENTS (OUTSIDE BRITAIN)
	1889 London County Council created *The Dial* founded	**1889** Paris: Exposition Universelle (opening of Eiffel Tower); English sculpture section incl. works by Gilbert, Onslow Ford, Leighton, Thornycroft Paris: Café Volpini exhibition (incl. Gauguin) France: Rodin receives commission *Victor Hugo* Paris: Salon, Frampton exh. *Angel of Death, Christabel*
	1890 1st(?) trip of Maeterlinck to England; Eng. transl. of *La Princesse Maleine* Whistler, *The Gentle Art of Making Enemies* Death of Joseph Edgar Boehm London, Agnew's, Burne-Jones exh. *Briar Rose* series (bt Alexander Henderson, Buscot Park)	**1890** Paris: Théâtre d'Art founded by Paul Fort and Lugné-Poë (symbolist theatre) France: death of van Gogh Germany: Wilhelm I dismisses Bismarck as Chancellor
1891 Inundated with work passed on to him by Boehm's executors; later he will cite this (and also debts incurred in casting Shaftesbury Memorial) as reason for bankruptcy	**1891** William Morris, *News from Nowhere*	**1891** France: death of Henri Chapu Lithuania: birth of Jacques Lipchitz
1892 14 January, receives commission for the Tomb of the Duke of Clarence (1st son of Prince and Princess of Wales) December, elected RA	**1892** Death of Duke of Clarence Death of Alfred Lord Tennyson Winter, London, New Gallery, 'Exhibition of Works of Edward Burne-Jones'	
1893 February, begins to borrow money June, unveiling of Shaftesbury Memorial August, moves into 16 Maida Vale, vast new house and studio designed by Howard Ince	**1893** Marriage of Duke of York (subsequently George V) to Princess May of Teck Independent Labour Party formed Burne-Jones resigns ARA *The Studio* founded R.A., Frampton exh. *Mysteriarch*	**1893** Brussels: Victor Horta completes *Hôtel Tassel* (1st full exercise in 'art nouveau' architecture) Brussels: 10th and final Les XX exhibition Brussels: Les XX re-formed as La Libre Esthétique Brussels: Lugné-Poë and Théâtre d'Art perform Maeterlinck, *Pelléas et Mélisande*
1894 Uses dealer for 1st time	**1894** Edmund Gosse, 'The New Sculpture 1879–1894', *Art Journal* *The Yellow Book* founded	**1894** Brussels: 1st Libre Esthétique exhibition Munich: *Pan* founded
	1895 Trial of Oscar Wilde London, Théâtre de l'Oeuvre presents Maeterlinck's *L'Intruse* and *Pelléas et Mélisande* (in French) R.A., Leighton exh. *Flaming June*	**1895** Paris: Bing founds shop, 'L'Art nouveau' Paris: International Lithograph Exhibition Paris: 'The Baronet vs the Butterfly' (Sir William Eden vs Whistler) Brussels: La Société van de Velde S.A. founded
1896 January, receives commission for Prince Henry of Battenberg memorial, Whippingham, I.O.W.; spends much of year on this commission and falls even further behind with work on Clarence Tomb	**1896** Death of Prince Henry of Battenberg *The Savoy* founded Deaths of William Morris and Frederic Leighton; Millais elected PRA Visit of Tzar Nicholas II and Tzarina to Balmoral	**1896** Munich: *Jugend* and *Simplicissimus* founded
1897 Awarded Royal Victorian Order (4th class) for 'personal services to the Queen and her successors'		**1897** Paris: part of Caillebotte Bequest displayed in Musée du Luxembourg Berlin: *Dekorative Kunst* founded
1898 Becomes Chairman of International Society of Sculptors, Painters and Gravers under presidency of Whistler Writes: 'I have ruined myself by my work'. Solicitors, Collyer-Bristow and Co. representing his creditors, write to clients stating that any money owed to Gilbert should be paid directly to them.	**1898** London, 1st Eng. performance of Maeterlinck's *Pelléas et Mélisande*; Burne-Jones designed some of the costumes, incidental music by Fauré Deaths of Millais and Burne-Jones; Poynter PRA Winter, London, New Gallery, 'Works of Sir Edward Burne-Jones, Bart.' London, 1st exhibition of International Society of Sculptors, Painters and Gravers	**1898** Paris: death of Mallarmé Paris: Salon des Champs-Elysées, Rodin exh. plaster of *Balzac* Vienna: 1st Sezession exhibition (incl. Frampton)
	1899 Death of Bates London, 1st exhibition of Pastel Society	**1899 (to 1902)** Boer War Berlin Secession founded, Liebermann President Munich: *Die Insel* founded

1900	ALFRED GILBERT	OTHER CULTURAL AND POLITICAL EVENTS (BRITAIN)	POLITICAL AND CULTURAL EVENTS (OUTSIDE BRITAIN)
	1900 Elected to Chair of Sculpture at R.A. Schools		**1900** Paris: Exposition Universelle Paris: death of Oscar Wilde Germany: death of Nietzsche
	1901 August–October, sends family to Bruges; declares himself bankrupt; departs for Bruges Delivers lecture at R.A. Schools	**1901** Death of Queen Victoria; succession of Edward VII Death of Onslow Ford	
	1902 Delivers lecture at R.A. Schools	**1902** London, private performance of Maeterlinck's *Monna Vanna* Frampton elected RA	**1902** Paris: death of Dalou Paris: 1st performance, Debussy, *Pelléas et Mélisande* (libretto by Maeterlinck)
	1903 Easter, Joseph Hatton, 'The Life and Work of Alfred Gilbert RA, MVO, LL.D', *Easter Art Annual*; incl. photographs of versions and replicas of the bronze saints on the Tomb of the Duke of Clarence sold to a dealer; door closed to further royal commissions; Gilbert effectively abandons work on Tomb Settles permanently in Bruges; October, opens own art school (closed by 1908) Complains that pirated casts of his most popular works have got into circulation Begins monumental *Victory* for the Fallen of the Boer War, commissioned by the Duke of Rutland for the County of Leicester Delivers lecture at R.A. Schools	**1903** Death of Whistler Rodin elected President of International Society of Sculptors, Painters and Gravers.	**1903** Paris: 1st Salon d'Automne France: death of C. Pissarro Marquesas Islands: death of Gauguin Berlin: Meier-Graefe, *Entwicklungsgeschichte der moderne Kunst*
	1904 Separates from Alice	**1904** *Entente cordiale* (Britain and France) Death of G. F. Watts	**1904** Entente cordiale (France and England) Brussels: Vie et Lumière founded by Belgian 'Impressionists' Paris: death of Frederic-Auguste Bartholdi
	1905–6 Julia Frankau commissions memorial to her husband; Gilbert accepts advance payment but fails to deliver statue; she exposes him in the magazine, *Truth*; Gilbert is pilloried as a thief and a liar	**1905** Hamo Thornycroft, memorial to Gladstone (Strand, London)	**1905** Paris: Salon d'Automne, 'Cage des fauves' Dresden: Die Brücke formed France: death of Paul Dubois
			1906 France: death of Cézanne
	1907 R.A. exh. *Mors Janua Vitae*; last time he exhibits at R.A. until 1932	**1907** Fitzroy Street Group formed Rhodesia House (Strand): figure sculpture by Jacob Epstein	
	1908 Failure to complete war memorial commission for Duke of Rutland causes another scandal; resigns from the R.A.	**1908** London, Franco-British Exhibition	
	1909 London, New Gallery, small retrospective exhibition with Society of Sculptors, Painters and Gravers September, death of his mother; plunged into deep depression Writes to *The Times* denouncing 'wholesale manufacture of reproductions of works of mine'	**1909** London, performance of Maeterlinck's *L'Oiseau bleu*	**1909** Italy: Futurist Manifesto
1910		**1910** Death of Edward VII; succession of George V London, Grafton Galleries, 'Manet and the Post-Impressionists' Frampton completes *Peter Pan* (Kensington Gardens)	**1910** Russian-German Alliance Berlin: Walden founds *Der Sturm* Die Brücke artists move to Berlin
		1911 Unveiling of monument to Queen Victoria (outside Buckingham Palace): Thomas Brock sculptor, Aston Webb architect	**1911** Munich: Der Blaue Reiter formed
		1912 Death of Alma-Tadema London, Grafton Galleries, 2nd Post-Impressionist Exh.	**1912** First Balkan War Renewal of Triple Alliance

CHRONOLOGY

ALFRED GILBERT	OTHER CULTURAL AND POLITICAL EVENTS (BRITAIN)	POLITICAL AND CULTURAL EVENTS (OUTSIDE BRITAIN)
1913 Finishes the Leeds (Wilson) Chimneypiece: 'A Dream of Joy during a Sleep of Sorrow'	**1913** 1st issue of *Blast: Review of the Great English Vortex* Omega Workshops founded	**1913** Second Balkan War New York: Armory Show
1914–18 Lives in German-occupied Bruges, partly in hiding; three works only are known from these and the years immediately following the war	**1914** Wyndham Lewis establishes Rebel Art Centre	**1914** Outbreak of First World War
1916 Death of Alice Gilbert		**1916** Zürich: formation of Dada Paris: death of Antonin Mercié
		1917 USA enters war Russian Revolution and Civil War (to 1920) France: deaths of Rodin and Degas
	1918 Poynter retires as PRA	**1918** Armistice Germany: Kaiser Wilhelm II abdicates; establishment of Weimar Republic
1919 Marries Stéphanie Quagehebeur in Bruges	**1919** Sir Aston Webb elected PRA Death of Poynter	**1919** Treaty of Versailles Weimar: Bauhaus formed by Gropius France: death of Renoir
1920		
1923 March–July, in Rome with commissions from the Fine Art Society Meets Isabel McAllister for second time; she becomes his secretary and begins work on his biography		
1924 Granted £400 from Royal Bounty Fund	**1924** Sir Aston Webb retires as PRA; Frank Dicksee elected PRA	**1924** France: Breton publishes First Manifesto of Surrealism
1925–6 March–June 1926, living in Rome executing commissions for Towneley Hall Art Gallery, Burnley	**1925** Deaths of Queen Alexandra and Hamo Thornycroft	
1926 February, *Eros* removed from Piccadilly Circus; renewed attention focused on Gilbert March, McAllister starts letter-writing campaign urging Gilbert's return to England August, returns to England permanently	**1926** General Strike	**1926** France: death of Monet
1927 March, last five figures for Tomb of the Duke of Clarence placed in hands of the founder April, officially granted commission for Memorial to Queen Alexandra		
1928 Spring, moves into studio at Kensington Palace	**1928** Deaths of Dicksee and Frampton; William Llewellyn elected PRA	**1929** New York: Wall Street crash
1929 Isabel McAllister, *Alfred Gilbert* (Gilbert advises on design of layout, etc.)		
1930		
1932 June, dedication of Alexandra Memorial Receives knighthood Resumes R.A. membership London, Fine Art Society, retrospective exhibition		**1933** Germany: Hitler becomes Chancellor
1934 4 November, dies in London; memorial service held at St Paul's Cathedral on 13 November		
1935 Contents of London studio bought by NACF		
1936 London, Victoria and Albert Museum, exh. contents of London studio; subsequently dispersed to museums in Great Britain and Commonwealth		

BIBLIOGRAPHY

Beattie 1983 Susan Beattie, *The New Sculpture*, New Haven and London 1983

Bury 1954 Adrian Bury, *Shadow of Eros: A Biographical and Critical Study of the Life and Works of Sir Alfred Gilbert, R.A., M.V.O., D.C.L.*, London 1954

Chamot, Farr, Butlin 1964 Mary Chamot, Dennis Farr and Martin Butlin, *Tate Gallery Catalogues: The Modern British Paintings, Drawings and Sculpture*, vol. I, A–L, London 1964

Dorment 1980 Richard Dorment, 'Alfred Gilbert's Memorial to Queen Alexandra', *Burlington Magazine*, vol. CXXII (1980), pp. 47–52

Dorment 1985 Richard Dorment, *Alfred Gilbert*, New Haven and London 1985

Ganz 1908 Henry F. W. Ganz, *Practical Hints on Modelling Design and Mural Decoration with Foreword by Alfred Gilbert, M.V.O., R.A., D.C.L.*, London 1908

Ganz 1934 H[enry] F. W. Ganz, *Alfred Gilbert At His Work*, London 1934

Gilbert 1888 Alfred Gilbert, 'Colour in Sculpture', *Universal Review*, 15 August 1888

Gosse 1894 Edmund Gosse, 'The New Sculpture, II', *Art Journal*, 1894, pp. 199–203

Handley-Read 1966 Lavinia Handley-Read, 'The Wilson Chimneypiece at Leeds: An Allegory in Bronze by Alfred Gilbert', *Leeds Arts Calendar*, no. 59 (1966), pp. 10–16

Handley-Read 1967 Lavinia Handley-Read, 'Alfred Gilbert and Art Nouveau', *Apollo* vol. LXXXV (1967), pp. 17–24

Handley-Read 1968, I Lavinia Handley-Read, 'Alfred Gilbert: A New Assessment, Part 1: The Small Sculptures', *Connoisseur*, vol. CLXIV (1968), pp. 22–7

Handley-Read 1968, II Lavinia Handley-Read, 'Alfred Gilbert: A New Assessment, Part 2: The Clarence Tomb', *Connoisseur*, vol. CLXIV (1968), pp. 85–91

Handley-Read 1968, III Lavinia Handley-Read, 'Alfred Gilbert: A New Assessment, Part 3: The Later Statuettes', *Connoisseur*, vol. CLXIV (1968), pp. 144–51

Handley-Read Dec. 1968 Lavinia Handley-Read, 'Victorian and Edwardian Sculpture at the Fine Art Society', *Burlington Magazine* vol. CX (1968), pp. 712–15

Hatton 1903 Joseph Hatton, 'The Life and Work of Alfred Gilbert R.A., M.V.O., LL.D.', *Easter Art Annual*, 1903

Hind 1890 [C. Lewis Hind], 'An Hour with Mr. Alfred Gilbert, A.R.A.', *Globe and Traveller*, 27 January 1890, p. 3

Macklin 1910 Alys Eyre Macklin, 'Alfred Gilbert at Bruges', *Studio*, XLVIII (1910), pp. 98–118

Maryon 1933 Herbert Maryon, *Modern Sculpture, Its Methods and Ideals*, London 1933

McAllister 1929 Isabel McAllister, *Alfred Gilbert*, London 1929

Michel 1889 André Michel, 'Exposition Universelle de 1889: La Sculpture', *Gazette des Beaux-Arts*, 3rd series, II (1889), pp. 389–406

Monkhouse 1889, I W. Cosmo Monkhouse, 'Alfred Gilbert, A.R.A.—I', *Magazine of Art*, 1889, pp. 1–5

Monkhouse 1889, II W. Cosmo Monkhouse, 'Alfred Gilbert, A.R.A.—II', *Magazine of Art*, 1889, pp. 37–40

Muthesius 1903 Hermann Muthesius, 'Kunst und Leben in England', *Zeitschrift für Bildende Kunst*, Leipzig 1903, pp. 73–85

Quilter 1892 Harry Quilter, *Preferences in Art, Life and Literature*, London 1892 (reprints of Quilter's reviews in *The Spectator*, 1872–90)

Read 1982 Benedict Read, *Victorian Sculpture*, New Haven and London 1982

Rinder 1909 Frank Rinder, '"Fair Women" at the International', *Art Journal* 1909, pp. 117–23

Sheppard (ed.) 1963 F. H. W. Sheppard (general editor), *Parish of St. James Westminster Parts I and II: North of Piccadilly, Survey of London*, vols XXXI and XXXII, London 1963

Spielmann 1901 M. H. Spielmann, *British Sculpture and Sculptors of To-day*, London 1901

Spielmann 1908 M. H. Spielmann, 'The Fine Art Section', *Souvenir of the Fine Art Section, Franco-British Exhibition 1908*, Derby and London 1908, pp. 70–84

Spielmann 1910 M. H. Spielmann, 'Alfred Gilbert', *Encyclopedia Brittanica*, 11th edn, Cambridge 1910, p. 7

Watts 1912 M. S. Watts, *George Frederick Watts: The Annals of an Artist's Life*, 3 vols, London 1912

UNPUBLISHED

St Albans MS St Albans Cathedral Archive, 'The High Altar Screen of the Cathedral Church of St. Alban' (3 MS vols)

SP London, Royal Academy of Arts, documents relating to Alfred Gilbert from the collection of M. H. Spielmann

Gilbert Sr. MS '"Sculpture" List of Works executed by Alfred Gilbert A.R.A.', compiled by his father and covering the years 1870–90, in the possession of Air Chief Marshal Sir John Barraclough

All other unpublished sources in the text are referred to as MS.

EXHIBITIONS

MANCHESTER 1887 Royal Institution, Manchester, 'Manchester Royal Jubilee Exhibition', 1887

PARIS 1889 Paris, Exposition Universelle, 1889

LONDON 1900 Clifford Gallery, London, 'Exhibition of Cabinet Pictures, Sculpture, etc. By Members of the Surrey Art Circle', 1900

LONDON 1901 Continental Gallery, London, '9th Exhibition of Cabinet Pictures, Sculpture, etc. By Members of the Surrey Art Circle', 1901

GLASGOW 1901 Art Gallery and Museum, Kelvingrove, Glasgow, 'International Exhibition', 1901

LONDON 1902 Fine Art Society, London, 'First Exhibition of Statuettes by the Sculptors of To-Day British and French', 1902 (introduction by M. H. Spielmann)

LONDON 1908 White City, London, 'Franco-British Exhibition', 1908 (catalogue of the Fine Art Section by Sir Isidore Spielmann)

LONDON 1909 New Gallery, London, 'The International Society of Sculptors, Painters & Gravers Art Congress, Exhibition of Fair Women', 1909

LONDON 1932 Fine Art Society, London, 'An Exhibition of Bronze Statuettes by Sir Alfred Gilbert, R.A.', 1932

LONDON 1935 Fine Art Society, London, 'Exhibition of Bronze Statuettes by the Late Sir Alfred Gilbert, R.A.', 1935

LONDON 1936 Victoria and Albert Museum, London, 'Commemorative Catalogue of an Exhibition of Models and Designs By the Late Sir Alfred Gilbert, R.A.', 1936 (catalogue by E. Machell Cox)

LONDON 1968 Fine Art Society, London, 'British Sculpture 1850–1914', 1968 (catalogue by Lavinia Handley-Read)

R.A. winter 1968 Royal Academy of Arts, London, 'Royal Academy of Arts Bicentenary Exhibition 1768–1968', 1968–9 (catalogue compiled and edited by St John Gore)

LONDON 1971 Victoria and Albert Museum, London, 'Victorian Church Art', 1971–2

LONDON 1972 Royal Academy of Arts, London, 'Victorian and Edwardian Decorative Art, The Handley-Read Collection', 1972 (catalogue of sculpture by Lavinia Handley-Read)

MANCHESTER, MINNEAPOLIS, BROOKLYN 1978–9 The Minneapolis Institute of Arts, City of Manchester Art Galleries, The Brooklyn Museum, 'Victorian High Renaissance', 1978–9 (essay, biography and catalogue on Alfred Gilbert by Richard Dorment)

LONDON 1981 Whitechapel Art Gallery, London, 'British Sculpture in the Twentieth Century', 1981 (catalogue edited by Sandy Nairne and Nicholas Serota)

BRIGHTON 1984 Royal Pavilion, Art Gallery and Museums, Brighton, 'Beauty's Awakening: The Centenary of the Art Workers' Guild', 1984

ROYAL ACADEMY TRUST

FRIENDS OF THE ROYAL ACADEMY

BENEFACTORS

Mrs Hilda Banham
Lady Brinton
Sir Nigel and Lady Broackes
Keith Bromley Esq.
The John S. Cohen Foundation
The Colby Trust
Michael E. Flintoff Esq.
The Lady Gibson
Jack Goldhill Esq., FRICS
Mrs Mary Graves
D. J. Hoare Esq.
Sir Anthony Hornby
Irene and Hyman Kreitman
The Landmark Trust
Roland Lay Esq.
The Trustees of the
 Leach Foundation
Hugh Leggatt Esq.
Mr and Mrs M. S. Lipworth
Sir Jack Lyons, CBE
The Manor Charitable Trustees
Lieutenant-Colonel
 L. S. Michael, OBE
Jan Mitchell Esq.
The Lord Moyne
The Lady Moyne
Mrs Sylvia Mulcahy
C. R. Nicholas Esq.
Lieutenant-Colonel
 Vincent Paravicini
Mrs Vincent Paravicini
Richard Park Esq.
Philips Fine Art Auctioneers
Mrs Denise Rapp
Mrs Adrianne Reed
Mrs Basil Samuel
Sir Eric Sharp, CBE
The Reverend Prebendary
 E. F. Shotter
Dr Francis Singer
Lady Daphne Straight
Mrs Pamela Synge
Harry Teacher Esq.
Henry Vyner Charitable Trust
Charles Wollaston Esq.

CORPORATE SPONSORS

American Express Europe
 Limited
Bankers Trust Company
Barclays Bank plc
Bourne Leisure Group
 Limited
The British Petroleum Company
 Limited
Brixton Estates plc
Charter Medical of England
 Limited

Christie Manson and Woods
 Limited
Christ's Hospital
Citibank
P & D Colnaghi & Co. Limited
Courage Charitable Trust
Coutts & Co.
Delta Group plc
Esso UK plc
Ford Motor Company plc
The General Electric
 Company plc
The Granada Group
Arthur Guinness and Sons plc
Guinness Peat Group plc
Alexander Howden
 Underwriting Limited
IBM United Kingdom Limited
Imperial Chemical Industries plc
Investment Company of North
 Atlantic
Johnson Wax Limited
Lex Services plc
London Weekend Television
 Limited
Marks and Spencer plc
Mars Limited
Martini & Rossi Limited
Worshipful Company of Mercers
Messrs Nabarro Nathanson
The Nestlé Charitable Trust
Ocean Transport and Trading
 plc (P. H. Holt Trust)
Ove Arup Partnership
Rowe and Pitman
The Royal Bank of Scotland plc
RTZ Services Limited
Save & Prosper Educational Trust
J. Henry Schroder Wagg &
 Company Limited
Shell U.K. Limited
W. H. Smith & Son Limited
Sotheby & Co.
The Spencer Wills Trust
Thames Television Limited
J. Walter Thompson Company
 Limited
Ultramar plc
United Biscuits (U.K.) Limited
Vacuum Instruments and
 Products Limited

INDIVIDUAL SPONSORS

I.F.C. Anstruther Esq.
Mrs Ann Appelbe
Dwight W. Arundale Esq.
Edgar Astaire Esq.
Sir Richard Attenborough
W. M. Ballantyne Esq.
Miss Margaret Louise Band

E. P. Bennett Esq.
Mrs Susan Besser
P. G. Bird Esq.
Mrs C. W. T. Blackwell
Miss Julia Borden
Peter Bowring Esq.
Mrs Susan Bradman
Cornelius Broere Esq.
Jeremy Brown Esq.
Mr and Mrs R. Cadbury
Mrs L. Cantor
W. J. Chapman Esq.
Citicorp International Private
 Bank
Henry M. Cohen Esq.
Mrs N. S. Conrad
Mrs Elizabeth Corob
Philip Daubeny Esq.
The Marquess of Douro
William Drummond Esq.
Mrs Gilbert Edgar
Mrs Sylvia Edwards
Mrs R. Entwhistle
S. Isern Feliu Esq.
Robert S. Ferguson Esq.
Dr Gert-Rudolf Flick
Graham Gauld Esq.
M. V. Gauntlett Esq.
Stephen A. Geiger Esq.
Lady Gibberd
Peter George Goulandris Esq.
Gavin Graham Esq.
Russell Wallington Green Esq.
J. A. Hadjipateras Esq.
R. Hamilton-Wright Esq.
Mrs I. M. Harvey
Ernest Hawkins Esq.
Mrs Penelope Heseltine
Mrs Mark Hoffman
Charles Howard Esq.
Norman J. Hyams Esq.
Mrs Manya Igel
Mr and Mrs Evan Innes
J. P. Jacobs Esq.
Ms John C. Jaqua
Alan Jeavons Esq.
Irwin Joffe Esq.
Mrs T. Josefowitz
Mrs M. L. Julius
S. D. M. Kahan Esq.
Mr and Mrs S. H. Karmel
Peter W. Kininmonth Esq.
Mrs J. H. Lavender
Miss Ailsey Lazarus
S. J. Leonard Esq.
David Levinson Esq.
David Lewis Esq.
Owen Luder Esq.
Mrs Graham Lyons
Ciarán MacGonigal Esq.
Mrs S. McGreevy
Peter McMean Esq.

Stuart Macwhirter Esq.
Dr Abraham Marcus
Mrs P. C. Maresi
R. C. Martin Esq.
M. H. Meissner Esq.
Mrs V. Mercer
Stamatis Moskey Esq.
The Oakmoor Trust
Raymond A. Parkin Esq.
The Hon. Mrs E. H. Pearson
Mrs G. R. Perry
Mrs Olive Pettit
Mrs M. C. S. Philip
Harold Quitman Esq.
Miss Laura Lee Randall
David Rauch Esq.
Cyril Ray Esq.
Mrs Margaret Reeves
John Ritblat Esq.
Miss Lucy Roland-Smith
Mrs B. E. Rogers
The Rt Hon. Lord Rootes
J. A. Rosenblatt Esq.
Baron Elie de Rothschild
Mr and Mrs O. Roux
The Hon. Sir Steven
 Runciman, CH
Sir Robert Sainsbury
Mrs Bernice Sandelson
Miss Verena Schiessle
Mrs Bernard L. Schwartz
Peter J. Scott Esq.
Claude Sere Esq.
Mrs Pamela Sheridan
R. J. Simia Esq.
Mrs D. Spalding
Thomas Stainton Esq.
Cyril Stein Esq.
James Q. Stringer Esq.
Mrs A. Susman
Robin Symes Esq.
J. E. Thomas Esq.
Mr and Mrs Theo Waddington
The Hon. Mrs Quentin Wallop
K. J. Wardell Esq.
J. B. Watton Esq.
Christopher Watts Esq.
Sidney S. Wayne Esq.
Frank S. Wenstrom Esq.
Miss L. West-Russell
David Whitehead Esq.
Mrs Bella Wingate
David Wolfers Esq.
Brian G. Wolfson Esq.
Lawrence Wood Esq.
Fred S. Worms Esq.

*There are also anonymous
Benefactors and Sponsors.*

223

SPONSORS OF PAST EXHIBITIONS

AMERICAN EXPRESS FOUNDATION ('Masters of 17th-Century Dutch Genre Painting', 1984)

ARTS COUNCIL OF GREAT BRITAIN ('Clatworthy/Sutton', 1977; 'Robert Motherwell', 1978; 'Rodrigo Moynihan', 1978; 'John Flaxman', 1979; 'Ivon Hitchens', 1979; 'Algernon Newton RA', 1980; 'New Spirit in Painting', 1981; 'Gertrude Hermes RA', 1981; 'Carel Weight RA', 1982; 'Elizabeth Blackadder RA', 1982; 'Allan Gwynne Jones RA', 1983; 'The Hague Schools', 1983; 'Peter Greenham RA', 1985)

B.A.T. INDUSTRIES plc ('Murillo', 1983; 'Paintings from the Royal Academy US Tour 1982–4', 1984)

BECK'S BIER ('German Art in the 20th Century', 1985)

BENSON & HEDGES ('The Gold of El Dorado', 1979)

CALOUSTE GULBENKIAN FOUNDATION ('Portuguese Art Since 1910', 1978)

CHRISTIE'S ('Treasures from Chatsworth', 1980)

COUTT'S & CO. ('Derby Day 200', 1989)

THE DAILY TELEGRAPH ('Pompeii AD 79', 1976; 'Treasures from Chatsworth', 1980)

DEUTSCHE BANK AG ('German Art in the 20th Century', 1985)

ESSO PETROLEUM COMPANY LTD ('British Art Now: An American Perspective', 1980)

FINANCIAL TIMES ('Derby Day 200', 1979)

FIRST NATIONAL BANK OF CHICAGO ('Chagall', 1985)

Friends of the Royal Academy ('Allen Gwynne Jones', 1983; 'Peter Greenham', 1985; 'Carel Weight RA', 1982; 'Elizabeth Blackadder RA', 1982)

DR ARMAND HAMMER & THE ARMAND HAMMER FOUNDATION ('Honoré Daumier', 1981; 'Leonardo da Vinci Nature Studies and Codex Hammer', 1981)

ARTHUR GUINNESS plc ('Light Fantastic', 1977)

HOECHST (UK) LTD ('German Art in the 20th Century', 1985)

IBM United Kingdom Limited ('Post Impressionism', 1979; Summer Exhibition, 1983)

IMPERIAL TOBACCO LIMITED ('Pompeii AD 79', 1976)

THE JAPAN FOUNDATION ('The Great Japan Exhibition', 1981)

LUFTHANSA ('German Art in the 20th Century', 1985)

MARTINI & ROSSI LTD ('Painting in Naples from Caravaggio to Giordano', 1982)

MELITTA ('German Art in the 20th Century', 1985)

MELLON FOUNDATION ('Rowlandson Drawings', 1978)

MERCEDES-BENZ ('German Art in the 20th Century', 1985)

MIDLAND BANK plc ('The Great Japan Exhibition', 1981)

MOBIL OIL COMPANY LIMITED ('Treasures from Ancient Nigeria', 1982; 'Modern Masterpieces from the Thyssen-Bornemisza Collection', 1984)

MOËT & CHANDON ('Derby Day 200', 1979)

THE OBSERVER ('Stanley Spencer', 1980; 'The Great Japan Exhibition', 1981)

OLIVETTI ('Horses of San Marco', 1979; 'The Cimabue Crucifix', 1983)

OVERSEAS CONTAINERS LIMITED ('The Great Japan Exhibition', 1981)

PRINGLE OF SCOTLAND ('The Great Japan Exhibition', 1981)

REPUBLIC NEW YORK CORPORATION ('Andrew Wyeth', 1980)

ROBERT BOSCH LIMITED ('German Art in the 20th Century', 1985)

SEA CONTAINERS & VENICE SIMPLON ORIENT EXPRESS ('Genius of Venice', 1983)

SHELL (UK) LTD ('Treasures from Chatsworth', 1980)

THE SHELL COMPANIES OF JAPAN ('The Great Japan Exhibition', 1981)

SIEMENS ('German Art in the 20th Century', 1985)

SOTHEBY'S ('Derby Day 200', 1979)

SWAN HELLENIC ('Edward Lear 1812–1888', 1985)

JOHN SWIRE ('The Great Japan Exhibition', 1981)

TRAFALGAR HOUSE ('Elizabeth Frink', 1985)

TRUSTHOUSE FORTE ('Edward Lear 1812–1888', 1985)

UNILEVER ('Lord Leverhulme', 1980; 'The Hague School', 1983)

WALKER BOOKS LIMITED ('Edward Lear 1812–1888', 1985)

WEDGEWOOD ('JOHN FLAXMAN', 1979)

WINSOR & NEWTON WITH RECKITT & COLMAN ('Algernon Newton', 1980)